Michael Freeman

THE NEW COMPLETE GUIDE TO
DIGITAL
PHOTOGRAPHY

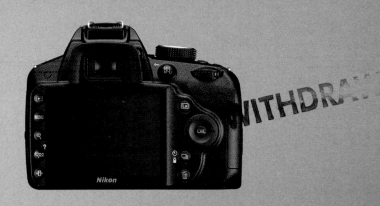

I L E X

First published in the UK in 2012 by

I L E X

210 High Street

Lewes

East Sussex BN7 2NS

www.ilex-press.com

Copyright © 2012 The Ilex Press Limited

Publisher: Alastair Campbell

Associate Publisher: Adam Juniper

Managing Editor: Natalia Price-Cabrera

Specialist Editor: Frank Gallaugher

Editor: Tara Gallagher

Creative Director: James Hollywell

Senior Designer: Ginny Zeal

Designer: JC Lanaway

Colour Origination: Ivy Press Reprographics

British Library Cataloguing-in-Publication Data:
A catalogue record for this book is available from
the British Library.

ISBN: 978-1-78157-000-5

Printed and bound in China.

10 9 8 7 6 5 4 3 2 1

DOWNLOADS

For more information about this book,
including digital versions of some of
the images featured, go to:

www.ilex-press.com/resources

CONTENTS

INTRODUCTION

Photography, synonymous for nearly two hundred years with a light-sensitive emulsion developed in chemicals, has now crashed headlong into the digital world. Of course this is guaranteed by a commercial inevitability, and all the camera and film manufacturers have recognized the digital changeover, even though it has cost them dearly to implement it. Film will probably never disappear completely, but its role will give it a specialized, and therefore limited, place in photography's future.

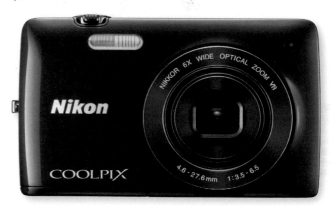

Front view of a consumer digital compact camera.

Like desktop computers, with which digital cameras have a promiscuous relationship, and mobile telephones, digital cameras are a disruptive technology. That is to say, they evolved not because the industry thought they would be a good idea, but because the technology made them possible and, more importantly, their advantages caught on among users. The manufacturers have been compelled to invest and produce in order to survive. The new technology is disrupting them, and the beneficiaries are the consumers who like the idea of the move to digital —you and me, in other words.

Front of a professional digital SLR camera.

6

And the advantages of recording images digitally? Many, and they all stem from the simple fact that the images are captured in a processable way—as a string of numbers, if you like. In the course of processing the image from capture to print (or whatever final form you want), correction and manipulation are easily performed. What is more, none of the changes that you make need incur any loss of image quality. The corollary of this is that digital images don't fade, and copies are identical—in contrast to film-based photography, where each generation of an image away from the original negative or transparency is degraded. If you have a desktop computer and printer, or even a printer alone if it is one of the latest designs, you can perform all the steps yourself at home. No darkroom is needed, and no more trips to the lab.

And while on the one hand this streamlines photography for those who simply want a fast, trouble-free means of making pictures, it also offers more control than was ever possible to the enthusiast

and perfectionist. Enter the electronic darkroom, neither dark nor messy but a clean desktop with computer, monitor, and a few peripherals. With this hardware you can make the kind of adjustments and fine-tuning that would conventionally be done in a darkroom with an enlarger by a specialist printer: cropping, shading, printing-in, altering contrast, brightness, tone, color balance. In addition, you can now undertake procedures that would be painstaking or even impossible by conventional means, such as sharpening and certain kinds of color adjustment.

The miniaturization of computing within digital cameras means that they are able to perform more and more processing as the technology continues to develop. The practical benefit for us is instant feedback. The camera's LCD display screen shows you the image before you shoot, and then immediately after you have shot; if you don't like what you see, you can delete it and shoot again. Or continue shooting and edit a little later. Depending on the level of the camera, the screen can also display technical information. Beyond all this, the media that digital cameras use—built-in memory and removable memory cards—are reusable, which makes up financially for the higher initial cost of the camera.

Digital procedures are changing photography in more subtle ways, too. Now, High Definition video recording is commonly found alongside a camera's ability to capture still photographs, and ever more sophisticated processing options are being taken from the computer and placed in the camera itself: high contrast recovery tools, digital filters, and even rudimentary Raw file processing. In short, digital photography has become much more than its film-based predecessor, and the possibilities are growing all the time.

SECTION 1 HARDWARE

In the beginning is the pixel, the smallest unit of brightness and color in an image. The word is a contraction of "picture element," and although we may not have thought about them much until recently, they have been around in one form or another for some time. Halftone printing, as used in this book and in almost every other print publication, uses dots of a few pure colors packed closely together to mimic the effect of a smoothly gradated picture. The 19th-century French Impressionist painter Georges Seurat, among others, built up pictures by painstakingly applying small dots of paint to the canvas. The effect is the same: stand back far enough and the eye fails to resolve the dots, instead processing the information into a recognizable image.

Even silver-halide grains on film work to produce a photographic image in a similar way. On exposure, an invisible speck of metallic silver is formed within each tiny crystal, which with later development turns opaque black. In a digital camera, a similarly small sensor measures the light as an electrical charge; when converted into a tone or color it becomes a pixel. Seen in this context, digital photography is less a sea-change than a natural development, using electricity rather than chemicals, inks, or oil paint.

The overwhelming difference is that the signal that senses the light can be processed mathematically, in any number of ways. The silver-halide grain, once developed, sits embedded in its emulsion, but the information that defines a pixel can be transmitted, changed, compared with other pixels, and used to manipulate the entire image. This is the promise of digital photography, and it extends from the moment you shoot, through processing the images on a computer, to the final output, which might be a print, film, publishing, or on-screen. If the last, the opportunities extend as far as the Internet, which is very far indeed.

For a long time, resolution was seen as the premium quality in digital cameras, and for certain camera models that continues to be the case. The more the better, although not always the more costly. Before anything else, each model is characterized (and advertised) by how many pixels its sensor contains, measured in megapixels (one million pixels). However, the absolute resolution figures have changed massively over a short time. Take as an example the evolution of Nikon's range of digital SLR cameras. In 1999, the company launched the Nikon D1, arguably the first of the truly manufacturer-made digital SLRs that we know today. Yet despite a hefty price tag, its resolution of 2.6 megapixels is tiny by today's standards. Indeed, within just the Nikon line, the resolution "standard" rose to 6.1 megapixels with the launch of the Nikon D100 in 2002, before increasing to 12.3 megapixels with the D2x in 2004, and peaking at 36 megapixels in 2012 when the company announced its latest DSLR, the D800. This is more than a tenfold increase in resolution in just over a decade.

However, these "megapixel wars" are, to a degree, beginning to subside. In fact, the flagship professional cameras from Nikon and Canon have settled on 16–18MP as striking the right balance between resolution and high-ISO image quality. While it may seem counterintuitive that the more expensive cameras have less absolute resolution, it's come down to a matter of priorities, as no sensor can perform perfectly in all areas. There are different tools for the job, and a photojournalist or sports photographer has different priorities (burst speeds, high-ISO performance) than, say, a studio or landscape photographer (resolution).

In any case, to enter this world of digital camera hardware you will have to accept rapid obsolescence. For a while at least, the only certainty is that whatever camera you buy this year will look inferior to the latest models next year.

REPLACING FILM

This may be slightly contentious for some people, but film has now largely gone the same way as the emulsion-coated glass plates that preceded it, with digital photography putting an end to film-based photography in all but a few specialized areas. When you look at the relentless pursuit of digital capture technology it is easy to see how this has transpired; the cost of digital cameras has plummeted, the expense of buying film and having it processed is all but negated, and there's the luxury of instant feedback that tells you if you've got the shot you are after. Of course, this is merely the tip of a very extensive list of digital advantages, but the more you think about digital photography, the harder it is to understand why anyone would wish to go back to using film—no 35mm SLR could shoot movies, tag your images with the precise location they were taken, and produce high-quality, poster-sized prints.

At the heart of all of this is the sensor, either a CCD (charge-coupled device) or CMOS (complemen-

tary metal-oxide semiconductor) depending on the camera. During digital photography's infancy, CCD sensors were considered the superior technology, but they were limited by high production costs, whereas CMOS sensors were cheaper, yet not quite so good when it came to image quality. Today, however, there is little to separate the two in terms of image quality, with a number of manufacturers having invested heavily in CMOS design and research to produce imaging chips that combine the advantages of both low cost and high quality. It is hardly surprising that manufacturers such as Nikon—once staunch advocates of CCD technology—are now fitting their latest SLR cameras with high resolution CMOS chips instead.

Regardless of whether it's CCD or CMOS, an imaging chip carries an array of elements called SPDs, or silicon photodiodes, each of which accumulates a charge according to the quantity of light that falls on it. Such light-measuring elements are not new—they have, in fact, been used for years in the through-the-

> **Film has now largely gone the same way as the emulsion-coated glass plates that preceded it**

Photosites

A sensor is made up of millions of silicon photodiodes (also known as photosites) that create an electrical charge when struck by light. This analog charge is converted into a digital signal, with each photosite creating a single pixel in the final image. Its brightness is determined by the amount of charge received, while the color is produced as a result of the color filter array over the sensor and interpolation.

PHOTOSITES

Photosites create an electrical charge when struck by light. An absence of light means no electrical charge, resulting in black. On the other hand, if light continues to strike a photosite beyond its "holding capacity" the result is pure, featureless white. This accounts for the linear response of digital sensors to light rather than the subtle fall-off that allows film to capture a relatively wide dynamic range.

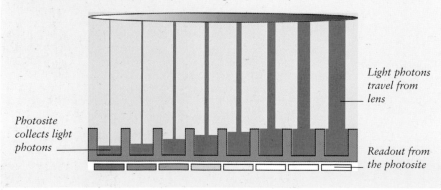

Light photons travel from lens

Photosite collects light photons

Readout from the photosite

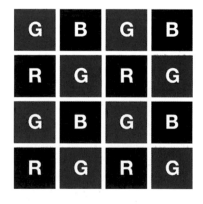

Color interpolation

The sensor array is covered with a Color Filter Array (CFA)—a mosaic of red, green, and blue, with one color covering each receptor. This means that for a full-color image, the colors must be interpolated for each pixel from the information in the surrounding pixels. How this is done depends on the CFA pattern, but the most popular configuration, shown here, is the Bayer pattern, which uses twice as many green filters as red and blue (because the human eye is more sensitive to green).

HARDWARE

lens metering systems of cameras. Taking them to the next step of actually recording an image has involved organizing numbers of them in such a way that they can be read in sequence.

Like silver-halide film, the receptors on a sensor measure only monochrome light, so all digital sensors would effectively record shades of gray unless something else is done. (Kodak even went as far as developing a number of SLRs that would only record black-and-white images.) As almost any color can be created by combining just three basic ones (red, green, and blue), the digital solution to recording color is simple: some receptors are filtered for red, others for green, and others for blue, with the missing information supplied, or "interpolated," from nearby receptors. The result of this is the creation of a full-color pixel in the image, where the receptor has recorded the brightness, and the interpolation process has provided the color.

Full frame
36mm × 24mm

APS-C
23.6mm × 15.7mm

**Four Thirds
(and Micro Four Thirds)**
17.3mm × 13mm

1/1.7-inch sensor
7.6mm × 5.7mm

Sensor sizes
Sensors are available in a wide range of sizes, but three sizes dominate digital SLRs: full frame, APS-C, and Four Thirds. They are illustrated here at their relatives sizes, along with a 1/1.7-inch sensor for comparison. This is a common sensor size in compact cameras.

THE DIGITAL ADVANTAGE

Digital cameras have not only replaced their film-based counterparts as a more convenient and cost-effective means of taking photographs, but they have also revolutionized what a camera actually is. Until digital imaging arrived, the fundamental purpose of a camera had remained largely unchanged for over a century—it was a light-tight box that allowed a light-sensitive emulsion to be exposed to light to create a still image. Digital technology has cast this notion aside. Yes, a digital camera can achieve a similar end product, but it can also do much more:

Video: Video recording has been a feature of digital cameras since their earliest appearance, although this was largely limited to low-resolution clips lasting just a few seconds, and was always restricted to compact-style cameras. Now, however, movie clips can be shot in High Definition on many digital SLR cameras, with user-selectable frame rates and recording times that are measured in minutes or limited only by the capacity of the memory card.

Live View: Now an established feature on many digital SLR cameras, Live View allows the photographer to preview and compose their images using the camera's rear LCD screen instead of through the viewfinder. In part, this allows movies to be recorded with an SLR as the mirror can be moved out of the way of the light path, but it is also an incredibly useful feature for landscape photography as well.

Geotagging: A small, but increasing number of digital cameras now have built-in global positioning systems (GPS) that tag your images with the precise location where it was taken. Although this information may not be essential for many photographers, for traveling professionals it can be beneficial to future image sales if you can identify precisely where in the world a photograph was taken. External GPS units are also available for those who don't have the technology built into their camera, allowing the location data to be added to images as they are downloaded to the computer.

Magnified pixelation
Magnifying a digital image reveals, at some point, the individual pixels. Each square is the tone and color information captured by one individual sensor on the CCD or CMOS array. The higher the resolution of the image, the more it can be magnified without the effect visible here, called pixelation, being noticed.

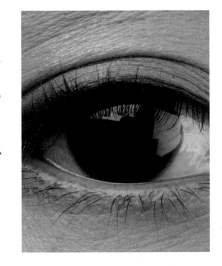

THE LANGUAGE OF DIGITAL IMAGING

Taking photographs electronically calls for different ways of measuring and describing them—precise and, of course, digital, which is to say in consistent steps. For any photograph, silver-halide or digital, this depends on four things: how much detail it contains; the range of brightness it can record; how true its colors are; and its level of imperfections. Digitally, these are known as resolution, dynamic range, bit depth, and noise.

The issue with digital cameras is an all-important difference between optical resolution and interpolated resolution

Resolution is the measure of detail, and depends on the number of pixels for a given area of the image. The most common way of expressing this is per inch, as in 300ppi (pixels per inch). Unnecessarily, there are two other terms in use, lines-per-inch (lpi) and dots-per-inch (dpi), which originated in the printing industry to measure half-tone screens. From our point of view they are completely interchangeable, and for the most part I use ppi. The metric figures are commonly prefixed by "Res" (for resolution)—hence 12 pixels per mm, approximately the same as 300ppi, is called "Res 12." Naturally, the resolving power of the lens determines the detail focused on the sensor.

The big issue with digital cameras, because many manufacturers would like to cheat a little, is an all-important difference between optical resolution and interpolated resolution. Optical resolution is the real thing, a measure of the actual information focused by a lens onto the sensor. Interpolation is a technique of digital manipulation, in which a program fills in the gaps between pixels to create more information—and so delivers what looks like higher resolution. The result is good to the eye, but the magnification is false. When you find a manufacturer trying to pass interpolated

Resolution
A detail of the same image at 300ppi (right) and at 1200ppi (far right). Pixelation has occurred at the lower resolution, meaning that the image has been enlarged beyond its resolution.

Dynamic range
A digital camera or scanner with a limited dynamic range will lose highlights and shadows, particularly in a contrasty scene, as at far left. A wide dynamic range (left) reveals the sun and details in the darker areas.

14

resolution off as optical, it is being dishonest and you can trust the rest of the specifications accordingly.

Dynamic range governs the breadth of information from highlights to shadows. Looking at a digital image from a scanner with a small dynamic range is like seeing a print on too hard a grade of photographic paper. Dynamic range is measured on a scale from 0 (pure white) to 4.0 (pure black), but no film or sensor can (yet) capture the full range. The brightest level at which a sensor, or film, can detect detail is known as DMin, and the darkest DMax. The difference between the two is its dynamic range—if it can record from 0.3 to 3.5, this would be 3.2D, for example.

Bit depth, also called color depth, is the measure of how many different colors a single pixel can display, and being digital, it is a number of discrete steps. For photo-quality images, there must be sufficient steps to fool the eye into seeing a continuous tone. In practice, 256 works fairly well and is the maximum for most software. Following mathematical notation for large numbers, bit depth is expressed as 2 raised to whatever power. So, 256 steps are 2^8—that is, 8-bit. Higher is even better, capturing finer nuances, and some cameras and scanners work at 10-bit (1,024 steps) and 12-bit (4,096). In software this is converted down to 8-bit, or up to 16-bit (65,536)—standards the computer is comfortable with. Confusingly, though, an RGB image with three 8-bit channels is often called 24-bit.

Bit depth and banding
The image on the left has a very delicate gradation across a wide expanse of the frame (the sky). As a 16-bit TIFF file, it holds up well enough.

Dropping the bit depth
However, if we convert it to an 8-bit JPEG and begin adding some contrast and saturation (below), things quickly fall apart.

Color blotching and banding
There aren't enough subtle variations of color to account for the full range of sky tones, and so the colors start to exhibit banding—abrupt jumps from one color to the next. This is clearly seen in the blotchiness of the sunset around the boat (as seen in the 100% crop left).

The histograms tell all
It's also visible in the histogram, which quickly fragments and displays numerous gaps and spikes.

HARDWARE

15

LENSES & FOCUS

One of the key specifications of a lens is its focal length, because this determines the character of the image it delivers. Focal length, measured in millimeters, is the distance from the point in the lens where the light rays that have entered begin to diverge, and the focal plane where the film or sensor is positioned. The greater the focal length, the more magnified the image will be—magnified, that is, beyond the view that approximates that of the unaided human eye. In principle, the focal length that gives a "normal" unmagnified view equals the diagonal measurement of the image, and for a 35mm camera that is 50mm. (Well, yes, the diagonal measurement is actually 43mm, but traditionally it has been rounded up to 50mm.)

For more than half a century, most photographic film was 35mm, with a standard frame size of 24mm x 36mm. Cameras were, indeed, built around film, which imposed certain mechanical constraints (the Leica was designed to make use of 35mm motion picture stock). So, the image area was standardized, and that meant that any given focal length of lens had the same angle of view. 50mm was considered normal, 28mm was distinctly wide-angle, and so on.

All that has changed, for the simple reason that sensors come in different shapes and sizes, mainly on the small side. With hindsight, it would have been more useful if we had classified lenses by their angle of view. In a broad sense we did, with the categories of wide-angle, normal, and telephoto, but the standard practice of using focal length as an expression of coverage has simply made a muddle out of the lenses for digital cameras. This calls for a rethink, and specifically it means knowing the sensor's dimensions. In this, the number of pixels and the resolution do not matter, but the diagonal measurement does. By way of example, attached to a fairly common 1/1.7-inch sensor, a zoom lens with a range of 6.1–30.5mm is the equivalent of

Digital cameras need higher resolution lenses because of the small size of the individual sensor elements

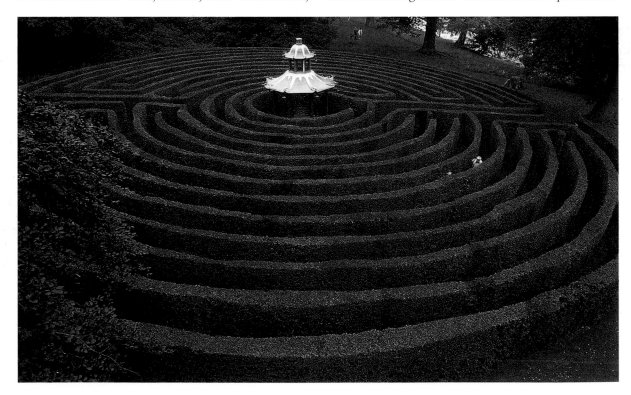

Wide angle
Above all, wide-angle lenses take in more of a scene. This overhead view of a maze at Woburn Abbey, in England, needed a wide-angle lens to include everything from the modest height of about 33 feet (10 meters). The angle of coverage varies according to the focal length, from around 60° (moderate) to around 100° (ultra-wide). Here, the result is the equivalent of using a 20mm lens on a 35mm full-frame camera.

a 28–140mm lens on a 35mm full-frame camera. So while the 35mm format is still the reference standard for focal lengths, don't expect this to continue for ever. Another related issue is the image shape, which for decades was a fixed 3:2, but now is not necessarily so. A ratio of 4:3 is common.

Digital cameras need higher resolution lenses because of the small size of the individual sensor elements. The appearance of sharpness depends on both the optics of the lens and on the resolving power of the eye, and the traditional measure of this is the circle of confusion. If you focus a lens on a single point, any point in front of or behind this will become, in the image, a small out-of-focus disk. However, at normal viewing distances for prints, the eye is satisfied with the sharpness of this circle of confusion if it is no larger than about 0.05mm, and this has been the standard for most lenses for a long time. The miniaturization of sensor arrays, however, has rather overturned this. Take a chip with 2,000 pixels across the longer side, which measures, say, 20mm. Each pixel takes up just 0.01mm, and to take full advantage of the sensor, the circle of confusion of the lens ought to be no larger than this. As a result, mid-range and high-end digital cameras now have specially designed, high-resolution lenses.

EXPANDING YOUR LENS' ZOOM RANGE

Compacts tend to have fixed zoom lenses to keep the price-point low, at the cost of there being limits as to how wide and far the lens can reach. Some fixed-lens compacts allow you to augment this zoom range by attaching accessory lenses called "converters." So a 0.8× wide converter expands a 28mm lens to a 22mm focal length; and a 1.5× tele converter extends a 140mm lens to 210mm. Although this is a fairly clumsy solution, it may be the only way to achieve certain shots—particularly in the case of wide converters (since it's impossible to crop out and widen in post-production).

original

1.5×

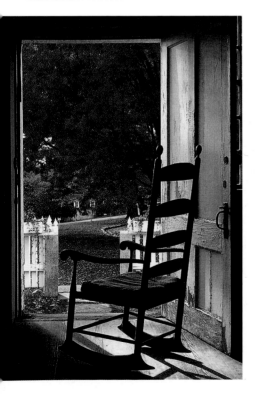

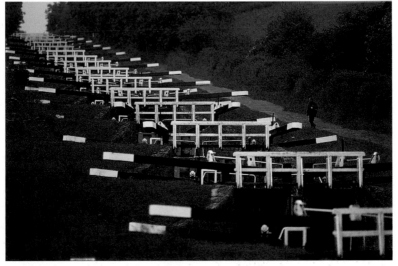

Normal
A view through a doorway much as you would see it with the unaided eye (left)—an angle of coverage of about 50° and the equivalent of 50mm on a 35mm camera.

Telephoto
This telephoto of canal locks in southwestern England is the equivalent of a 600mm lens on a 35mm camera, and a magnification of 12x beyond "normal."

EXPOSURE

T he essentials of making the exposure are the same for digital cameras as those using film. The same three controls interact to deliver light from the lens: the aperture, the shutter speed, and the ISO. The same metering systems are used to measure the brightness of a scene, and then pass this information on to the processor. This in turn instructs the shutter and aperture.

The essentials of making the exposure are the same for digital cameras as those using film

The principles are simple. Slower shutter speeds allow more light to reach the sensor, as do wider apertures, while higher ISO settings effectively make the sensor behave as though it is more sensitive to light. This means that there are different combinations that will deliver the same exposure. The right combination depends on how bright the subject is (the lower the light level, the more restricted the choice), and on whether or not you need the other effects of the shutter and aperture—namely freezing or blurring motion, and depth of field.

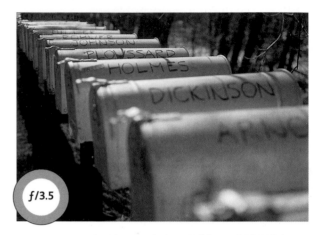

f/3.5

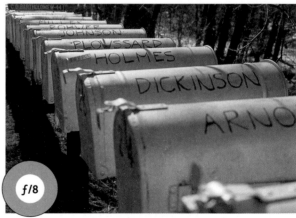

f/8

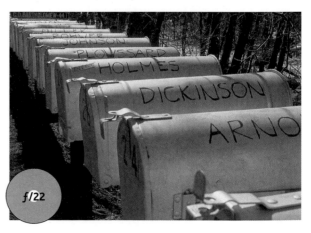

f/22

APERTURE AND ƒ/STOPS

The notation for lens apertures is the ƒ/stop, on a scale that goes ƒ/1, ƒ/1.4, ƒ/2, ƒ/2.8, ƒ/3.5, ƒ/4, ƒ/5.6, ƒ/8, ƒ/11, ƒ/16, ƒ/22, ƒ/32, ƒ/45, ƒ/64 (most lenses operate somewhere in the middle of this range). The reason for the apparent complexity of the numbers is that they are each the ratio of the actual aperture diameter to the focal length of the lens; each refers to the same amount of light passing through, whatever the lens. A higher ƒ-number denotes half the light being passed.

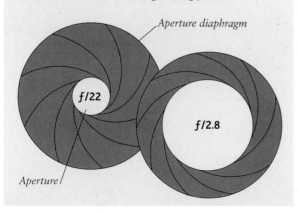

Aperture diaphragm

f/22

f/2.8

Aperture

Shallow depth of field
A row of mailboxes makes a good test subject for the depth of field of a normal lens (equivalent of 50mm on a 35mm camera). Wide open at f/3.5, the acceptably sharp part of the image extends only a little on either side of the focused point.

Average depth
With the lens stopped down mid-way to f/8, the depth of field is increased to a range from 6ft (1.8m) to 9ft (2.7m).

Extended depth
At minimum aperture, f/22, the depth of field is at its maximum for this lens— from 4 ft 6 in (1.4m). to 16ft (4.9m)—taking in most of the view.

Conventionally, the steps in the range of all three controls are arranged so that the exposure is doubled or halved. Thus, one stop slower than 1/125 second is 1/60 sec, which doubles the amount of light passed through to the sensor. Equally, one f/stop larger than f/8 is f/5.6, and it too doubles the amount of light that passes through. Finally, switching from ISO 200 to ISO 400 is a one-stop increase in sensitivity. Therefore, one stop longer on the shutter speed together with one stop smaller on the aperture gives exactly the same exposure at the same ISO.

ISO SENSITIVITY

Unlike film, digital sensors do not have a fixed "speed." Rather, you are allowed the flexibility to change the sensitivity to light on a shot-by-shot basis—increasing the ISO to deal with low light levels, or decreasing the ISO in bright conditions, for example. Today's digital SLRs offer an exceptionally wide range of ISO settings, ranging from ISO 50 up to ISO 6400, ISO 12,800, or even ISO 204,800 in some instances. Of course, image quality declines as the ISO is increased, so many of the higher settings are provided as "extended" ISO options, rather than appearing within the camera's native ISO range. However, they may still prove useful if getting a shot—no matter what the quality—is more important than getting no shot at all.

For less extreme situations, the vast majority of DSLRs perform well up to ISO 1600, and sometimes beyond that, which means some photographers are now setting the ISO to Auto, rather than restricting themselves to a single value. Part of the reason for this is the option to select the highest ISO setting the camera will use when the ISO is switched to Auto.

Conversely, because of this increased versatility of the ISO setting in digital photography, some cameras now feature an ISO priority mode. This works in much the same way as aperture or shutter priority, but the photographer sets their preferred ISO and the camera selects an aperture and shutter speed combination to deliver the correct exposure. This is particularly useful when you don't want to make any compromises over image quality by introducing noise into the picture.

With these controls to play with, choosing the best combination usually hinges on movement and depth of field. If the subject is moving, you would normally want to freeze the movement sharply, and that sets a lower limit to the shutter speed. We deal with action specifically on pages 194–7, but suffice it to say that 1/125 second will work in most situations. Set a shutter speed much slower than this and you are likely to see blur in the image, and even camera shake from not being able to hold the camera sufficiently steady.

Depth of field, which is directly related to the aperture size, refers to how much of the image, from foreground to background, looks sharply focused. A wide aperture gives shallow depth, a small aperture increases it. The amount is up to you, and while there are scenes that naturally call for front-to-back sharpness (and so a small aperture), there are many other occasions when you would want to direct attention to just one part of the image, leaving the background, for example, blurred. Depth of field also depends on the focal length of the lens: a short focal length, as in a wide-angle lens, gives more depth of field than does a longer, telephoto lens. Because most digital cameras use lenses with shorter focal lengths than their 35mm equivalents, abundant depth of field is one of their characteristics—whether you want it or not.

ISO 200

ISO 400

ISO 800

ISO 1600

Compass camera
In these examples from the Compass camera shown left, the details are taken from the lower-left quadrant. The differences are apparent only at magnification, here 400%. Note the color artifacts at ISO 1600.

METERING

Determining the optimum exposure for any particular image is mainly a matter of calculation, but it also involves the photographer's personal preference. Through-the-lens (TTL) metering will now do a good job of analyzing the brightness and contrast of a scene in almost all situations. On the few occasions when it fails, it is because there is no way of predicting exactly what the subject is and the intentions of the photographer. There are three basic and widely used metering methods, although not all are used in entry-level cameras: center-weighted, spot, and matrix.

Center-weighted metering pays more attention to the center of the frame, on the reasonable grounds that this is where most people will place the main subject. Spot metering measures just a small central area (marked on the screen) very precisely, and has more specialized uses. It is particularly good where there is one all-

You can compensate for occasionally tricky lighting situations

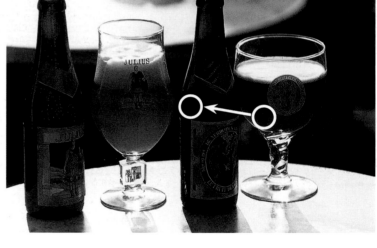

Center-weighted metering
Scenes composed of average brightness, distributed more or less evenly across the frame (above left), suit this standard metering method.

Spot metering
Only the small central circle (above right) is measured—useful for pegging the exposure to one key tone, in this case the beer, which is off-center.

Matrix metering
This multi-patterned system (left) here holds the white highlights below overexposure.

important tone in the picture that must be correctly exposed. Since this is not necessarily in the center of the frame, it is normal to measure first, use the camera's exposure lock, then recompose.

Matrix metering, also known as multi-pattern or evaluative, divides the picture area into a number of segments. These are measured individually, and the processor then applies proprietary algorithms to decide the priorities of the picture. This is partly a matter of comparing the information obtained with the manufacturer's experience of the way in which most people take pictures.

As a simple example, a bright band at the top of the frame is likely to be the sky, and is given a low priority.

If your camera allows you to choose between these methods, you can compensate for occasionally tricky lighting situations. Most of the time, matrix metering works well, but the more unusual the lighting, the less predictable the results. A shaft of light in a darkened room falling on an object, for example, would be a challenge to any metering calculation. Matrix metering might make a passable result out of it—but then again, maybe not. This might be an occasion to switch to center-weighted, or even spot, metering. Interestingly, however, these decisions were more critical with film. A digital camera will show immediately how successful the metering is, and you can then adjust the exposure as necessary.

When to choose one metering method over another also depends on your preferred way of shooting, and on how much time you have. If you need total control, and there is no urgency, spot metering is the way to go. One way of using it is to decide which part of the subject represents the mid-tones, measure this, and shoot. Another way is to set the exposure controls to manual mode, choose the most important part of the scene, measure that, and adjust the aperture or shutter speed accordingly. For example, in a portrait, you might select the skin on the cheek as the key tone, but if it is pale you want it one *f*/stop lighter than average. The spot reading gives 1/125 second at *f*/8, so you set the camera to 1/125 second at *f*/5.6. Yet another way of using the spot meter is to take several readings, from highlight to shadow, and calculate the optimum from this.

The most practical means of adjusting exposure on the fly, however, is the use of your exposure compensation feature—standard on all DSLRs and high-end compacts, and even finding its way into consumer models and phone cameras. In short, exposure compensation allows you to accept the exposure indicated by the metering system—regardless of which mode is currently selected—as a starting point, but then further adjust it by adding or subtracting a specific amount of light (typically measured in 1/3EV increments). It does not function in Manual shooting mode, and that is its purpose: Exposure compensation allows you to adjust exposure while still making use of some of the camera's automatic shooting modes, so you can concentrate on other parameters important to the shot.

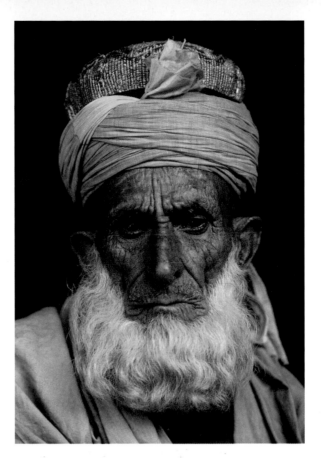

Automatic metering
In this original portrait of a northern Pakistani man, the metering system did a fine job of calculating a bright, evenly illuminated exposure. However, the circumstances of the subject (the dark intensity of the eyes, the weathered skin, etc), called for a more downtrodden and deeper treatment.

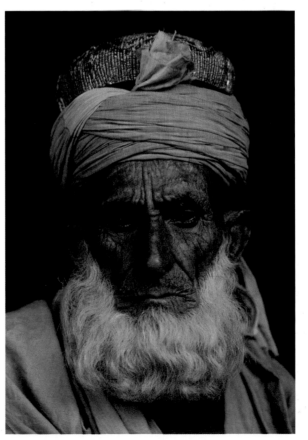

Creative metering
So, while keeping the same composition and metering mode, I simply dialed in -1/3EV of exposure compensation, and the resulting shot, while not being too terribly underexposed, communicates the feel of the moment much more authentically. The important thing to keep in mind here is that the best exposure, just like composition, color tones, and so much else in photography, is often a subjective choice rather than a scientific fact.

FILE FORMATS & MEMORY CARDS

In many ways, the most critical part of the digital operation is how the images are saved. Captured one at a time onto the same sensor chip, each must be downloaded elsewhere and purged from the sensor before it is ready for a new shot. Images are saved in a particular "file format," of which there are several, developed by different organizations over the years. Digital cameras, which are relative newcomers to the digital world, make use of these standard formats, or at least some of them.

In many ways, the most critical part of the digital operation is how the images are saved

Storage space is at a premium inside a camera (because of its size). In order to allow more pictures to be saved, the most common format is one which compresses the information—JPEG. Named from the initials of the International Standards Organization's Joint Photographic Experts Group and pronounced "jay-peg," this is computing's longest-established system, and has been universally adopted by digital photography as the space-saving way to store images. It can compress files by more than 90 percent to give ratios between 10:1 and 40:1. The camera's software often allows you to choose the amount of compression—higher quality means less damage but also larger files.

JPEG works very well for photographic images, which tend not to have hard edges, and less well for type and line artwork, which do. It uses what is called a "lossy" compression method, meaning that some data is thrown away. Because of this, the image is bound to be slightly degraded, but the key is to choose a setting that makes no visible difference. The acid test is a personal one—it works as long as it looks right to the eye. As you can see from the comparisons here, there is

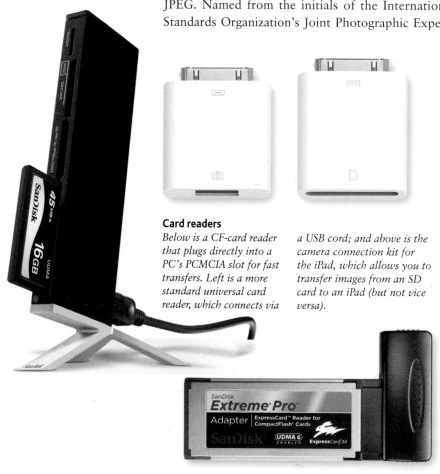

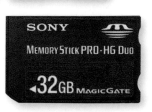

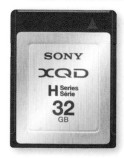

Card readers
Below is a CF-card reader that plugs directly into a PC's PCMCIA slot for fast transfers. Left is a more standard universal card reader, which connects via *a USB cord; and above is the camera connection kit for the iPad, which allows you to transfer images from an SD card to an iPad (but not vice versa).*

Memory cards
Removable memory cards are essential for storing your digital images in the camera. These are the most common formats, clockwise from above: CompactFlash, which is common in pro-spec SLRs; SD, here shown in its newer SDHC form, which is widely used in consumer SLRs; Sony's (Proprietary) Memory Stick, which is used more in compact cameras than the company's SLRs; and the newest format of all: XQD, which promises the fastest write times of all, and sizes up to 1TB (terabyte).

actually very little loss, and what loss there is is mainly in color artifacts at pixel level. Importantly, JPEG can work in 24-bit color—that is, 16.7 million colors, as explained on pages 14–15.

Technically, JPEG uses a system known as Discrete Cosine Transformation to compress, and works on blocks of eight pixels at a time. A new, greatly improved version, JPEG 2000, is being phased in, and this uses wavelet compression to give fewer artifacts (thus better image quality) and about 20% better compression. Normally, cameras allow you to choose three levels of compression for each image you shoot. These go under different names, such as Standard, High, and Super-High, but are all equivalent to highest compression/more degradation, medium compression/medium degradation, lowest compression/least degradation. At the start, make your own tests by shooting a range of different subjects at each level of compression, and decide which is the most acceptable for your needs.

High-end cameras tend to offer, in addition, an uncompressed format, usually TIFF. TIFFs take up more space than JPEGs, but lose nothing, and it is a universally readable format. All DSLRs and some high-end compacts also offer a Raw format, or "digital negative," which stores unprocessed data, completely faithful to the original capture. The advantage is image quality in less space than TIFF (usually around 60% smaller); and the disadvantage is that Raw files need to be converted using a Raw processor before they can be displayed or printed.

Images are stored on removable memory cards, which are available in different capacities. In the past, CompactFlash and SmartMedia formats were dominant, but SmartMedia is now gone and CompactFlash has been displaced in many cameras by the physically smaller SD and SDHC cards. While Memory Sticks are still used in Sony cameras, it is now SD and SDHC cards that dominate, with CompactFlash remaining popular on higher-end cameras due to its high capacities.

Once removed from the camera, memory cards can be read by optional adapters in computers or notebooks. Many desktop printers now have card-reading slots, which enable you to bypass the computer and print directly—a very useful feature. However, most people leave the card in the camera and copy the files directly onto the computer using a cable, which is most usually connected via USB.

Uncompressed TIFF
For those cameras that include an uncompressed format, RGB TIFF is standard. The test image is a close-up (400%) of the Compass camera on page 19, showing an area that includes two challenges for compression: fairly hard edges that include diagonals, and a neutral metallic surface. The camera is a Nikon, but its compression offerings are similar to other makes.

JPEG Fine
The lowest JPEG compression and largest of the three JPEG files shown, but still much smaller than the uncompressed TIFF above. The first impression is how little is lost and how good JPEG is. Close inspection reveals that diagonal straight lines are not perfectly maintained, as in the leg and center of the letter R. Very few artifacts have crept into the gray background.

JPEG Normal
At the medium compression setting, inaccuracies are exaggerated a little more than in JPEG Fine (note the leaking of red from the bottom of the second letter L in DULL), but overall the image is still holding up well.

JPEG Basic
Still a remarkable achievement of compression, although comparison directly with the top uncompressed image shows artifacts. See how the almost imperceptible color difference in the middle of the letter D has been turned into a cyan patch—a feature of false enhancement.

THE DISPLAY SCREEN

One of the most compelling reasons for using a digital camera is that it adds photographic capabilities. Taking an image directly into the heart of the camera's central processing unit—its small on-board computer—allows it to be displayed immediately via a screen on the camera back, and this is the most immediately obvious distinguishing feature of any digital camera. Inconceivable in the days of film, the screen is purely the product of the digital process.

The display screen allows you to take a considered view of the image and to make adjustments to viewpoint or focal length

Depending on the make of camera, the screen may be the only view offered, or there may also be a more traditional optical viewfinder, or even an electronic viewfinder (EVF). In any case, the screen offers the possibility to change the way you shoot. At some point in making a photograph, we all have to make a perceptual leap to translate the scene in front of the camera into a framed, two-dimensional image. The photographer's ability to do this has a great deal to do with the success of a photograph, and not everyone finds it easy. Even when it comes completely naturally, the final proof is always the flat image, and even seasoned photographers can have surprises, pleasant or otherwise, when faced with printed results.

The display screen steps into this process as an immediate means of proofing—and composing. Although small, it gives you the basic form of the image, in the same way as a frame-by-frame contact sheet. In particular, it allows you to take a considered view of the image and to make adjustments to viewpoint or focal length, and this applies whether you are about to shoot or you are reviewing an image that you have just taken. The one identifiable drawback of the screen is that all these possibilities can slow down the photography, which is not likely to matter with subjects such as landscapes, but which can lose you some opportunities with others, such as people and action.

OLED vs LCD
LCD (Liquid Crystal Display) is still the most common technology in display screens, but OLED (Organic Light-Emitting Diodes) displays are steadily increasing in popularity, as they offer better contrast and consume less battery power.

OLED *display*

Touch screens
Some cameras, particularly consumer models, eschew most of their physical controls in favor of a touch-sensitive display.

One type of subject in which display screens really come into their own is macro shooting. At magnifications greater than about half-size (1:2), the scale is quite different from normal experience, but the screen translates it perfectly. In another way, with some models, such as the Canon G12, the screen's swivel mount makes it possible to hold and use the camera in different positions, such as overhead. In all, working from a screen extends camera handling.

With the images and all their information stored on the memory card, the camera also functions as a playback viewer, so that at any time you can go over what you have shot. This provides the photographer with the unique ability to edit a photo taken instantly, which in turn makes for economy and efficiency in shooting. Mistakes can be deleted. This is more than just a mechanical convenience, because, like the display screen, it has the potential to change the way you shoot, in the knowledge that you can edit at any point in the day. There's a caveat here—deleting is actually too easy with a digital camera. Photography on film allows you to rediscover images that you may not have regarded too highly at the time, and to change your mind. You would have to be very confident indeed to make a severe edit of a day's shooting on the spot.

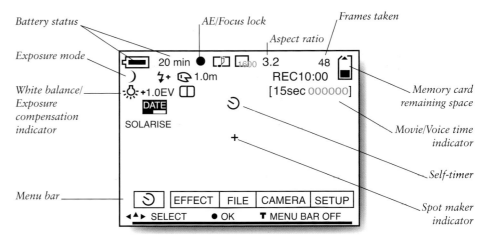

Battery status · Exposure mode · White balance/Exposure compensation indicator · Menu bar · AE/Focus lock · Aspect ratio · Frames taken · Memory card remaining space · Movie/Voice time indicator · Self-timer · Spot maker indicator

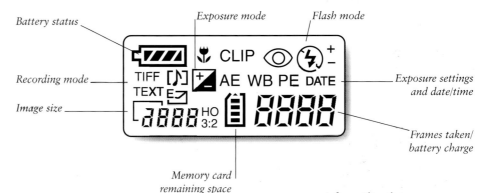

Battery status · Recording mode · Image size · Exposure mode · Flash mode · Exposure settings and date/time · Frames taken/battery charge · Memory card remaining space

Information given
Display screens show a wealth of information, in addition to the image about to be taken or already taken. Battery status, exposures taken, image size, and menu bar are all standard features.

Swivel-mount screen
One feature sometimes adopted by digital compact and SLR cameras alike is a swivel-mount screen. This enables the user to hold the camera at unusual angles.

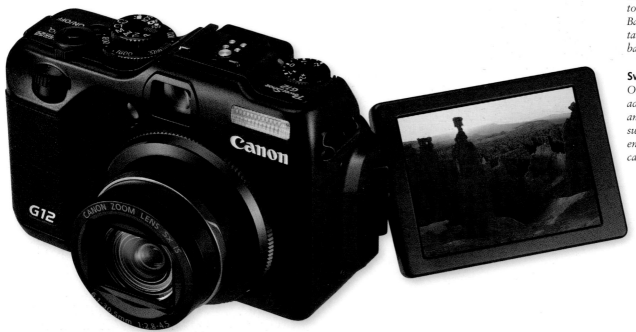

IN-CAMERA CORRECTIONS

The display screen is not the only digital extra that comes as standard. Because the image is captured as data, it can be processed, and that opens up a whole world of possibilities. In essence, this is the theme of this book—that the image can be adjusted, worked on, fine-tuned, and that this can be done at any stage after it has been captured by the sensor. How much data manipulation can go on in the camera itself depends on the power of its processor and on the imagination of the manufacturer. The camera's ability to process the image allows it to display not just the image, but all the information related to it, from the time and date to a map of its tonal values.

This map of tonal values, called a histogram, is the true, objective measure of the exposure, and as we'll see on pages 106–7 it displays the relative proportions of all the tones, from dark to light. Without delving deeply into the image math, one look at the histogram can reveal the basic exposure. Black is on the left, white on the right, and if the pattern falls within it, then the exposure has captured all the tones. If the tones are squashed up against the left, the image is underexposed (probably with some tones lost in the shadows); if hard against the right edge, it is overexposed. Of course, you have to read all of this in the context of the type of image taken—if low-key and intentionally dark, it would be a mistake to make the histogram look "normal." But at least one glance will show you whether or not the exposure is as good as it could be.

One of the most immediate and valuable processes is white balance. Natural light varies in color from the orange of sunrise and sunset to the blue of sky light in the shade under a cloudless sky—this is its color temperature. Our eyes adjust to these different color temperatures easily, but a digital sensor cannot. It needs to know the color temperature of a scene so that areas that should be pure, uncolored white are recorded as precisely that. Setting the white balance to match the prevalent lighting conditions enables this, with many cameras allowing you to fine-tune the result.

The camera's ability to process the image allows it to display all the information related to it

The histogram at a glance
One scene photographed at three different exposure settings. The display screen itself is not necessarily reliable for judging exposure (it depends on the angle at which you view it and on how much ambient light there is), but the histogram is objective. In the top histogram, the range of tones is grouped to the left end of the graph—a sure sign of underexposure—while in the bottom histogram there is an empty gap on the left, indicating no dark tones—in other words, overexposure. In the middle image, almost everything is contained, and the result is an adequately exposed photograph.

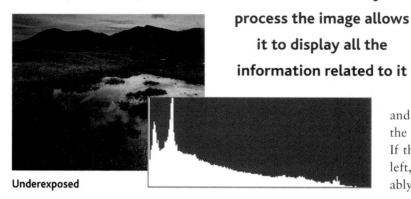
Underexposed

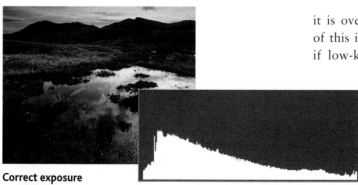
Correct exposure

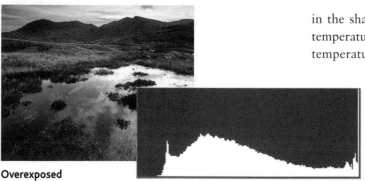
Overexposed

IN-CAMERA PANORAMAS

A panoramic shooting mode that helps you align a sequence of images as you capture them is not new, but the entire concept of shooting a panoramic image has been revolutionized by Sony in some of its most recent compacts. Sony's Sweep Panorama mode allows you to hold down the shutter release and sweep the camera from left to right (or up and down). As you do so, the camera records a series of high-speed frames that it automatically assembles into a large, seamless panoramic image.

IN-CAMERA DYNAMIC RANGE

An increasing number of manufacturers are incorporating features in their digital SLRs, and even some of their compact cameras, that attempt to overcome the restricted dynamic range of the digital sensor. Canon's Auto Lighting Optimizer, Nikon's Active D-Lighting, and Sony's D-Range Optimizer are all designed to assess a scene and help balance the contrast range at the time the photograph is taken. By applying complex algorithms to the image, shadow areas can be lightened to reveal detail, while highlights can be held from burning out, with both adjustments having minimal impact on the exposure as a whole. Depending on the software you use, you may also be able to apply these tools post-capture to a Raw file as part of the Raw-conversion process.

This castle interior would present any digital camera with an impossible task: the scene is simply too high in contrast for a digital sensor to capture detail in the extreme brights and darks. However, by applying in-camera optimization, the shadows have been opened up to reveal more of the room's interior, without any adverse effect on the highlight areas.

Guaranteeing the color balance
A digital camera needs a reference from which to calculate the overall color balance. Film already has its color response built in, but a sensor is open to all suggestions. White is the sum of all colors, and so setting that accurately and to neutral is the task of the white-point balance. The default setting is "auto white balance," in which by means of complex algorithms the processor decides where in the image the white point should be. Different degrees of manual setting are available, according to the camera. In the upper pair of pictures, taken in Tokyo's Tsukiji fish market, the lighting is tungsten. Uncorrected (top), it has a strong orange cast. With the white balance adjusted (bottom), the overall color cast is more neutral.

DIGITAL COMPACTS

Because they are in a constant cycle of obsolescence and improvement, digital cameras do not lend themselves to neat classification. As I mentioned in the introduction to this section, the pixel resolution of the sensors is constantly being improved. What was good last year may be only just acceptable this year. Nevertheless, whatever the resolution, now or in the future, there will always be a category of camera aimed at photographers entering the digital world, or those who simply don't want or need anything more than point-and-shoot simplicity.

However, although not all are endowed with a groundbreaking set of features, most are exceptionally well made, with features that are not far short of mid-range and professional models.

The basic functions for a digital compact at any level are quite comprehensive, including both still image and video capture, a zoom lens, and a choice of image compression. Most go some way beyond this basic specification, but the areas where an entry-level digital compact will differ from more expensive models is in the number of image-processing options (such as sharpening and overriding the white balance) and the overall complexity of operation—most offer little in the way of manual control. They are also usually compact.

> **Entry-level cameras have processing abilities and electronic features not far short of professional models**

Horses for courses
The Olympus Tough below is water- and shockproof, making it an excellent go-anywhere camera; while the Canon Ixus to the left is a more refined, minimalist design, with a zoom lens that retracts into the body for easy storage.

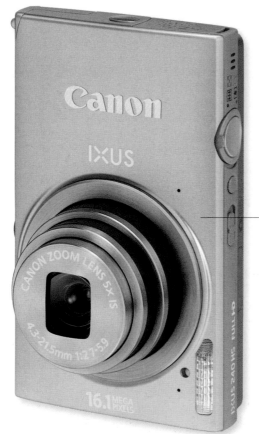

Market-friendly color scheme

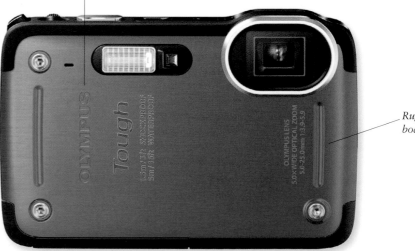

Rugged body shell

Something for everyone
Each manufacturer offers dozens of different compact camera styles, differentiated by styling and feature sets more than image quality, which is generally the same across the board.

HARDWARE

28

CAMERAPHONES

Far from simply being a means of calling home, most cell phones now double up as a music player, Internet access point, and, of course, a digital camera, with many boasting a high resolution, a built-in flash, and many other photographic options. So is this single device that can operate as both a camera and a phone fast becoming a replacement for a dedicated digital camera? Well, yes and no.

The biggest advantage of a cameraphone is its convenience—it's far more likely that you will head out with your phone than your camera, and that means you've always got the option of taking a picture, no matter where you go. Not only that, but you will most likely have the ability to then share that image, either as a picture message to someone else, by posting it online at a website such as Flickr or Facebook, or even uploading your images direct to an online service so you can order and buy prints without the pictures ever having to be downloaded to your computer.

The immediacy granted to photos taken by a cameraphone are not to be underestimated. Citizen journalism has become a significant means of relaying up-to-the-minute images of breaking news stories from the scene. Particularly in the field of photojournalism, where rapid distribution and dissemination of images often trumps the absolute image quality contained therein, cameraphones are assuming an essential role. What's more, some manufacturers are gradually integrating their dedicated DSLRs and high-quality cameras within the mobile ecosystem, offering bluetooth or Wifi connections that can transfer images from the camera to the phone, and from there to the world.

At the same time though, a cameraphone has its drawbacks. First and foremost, it will not match the image quality of a dedicated digital camera, no matter what the advertisers say. The main reason for this is the small imaging sensors used. Because of the sensor's overall size, the photosites are tiny, and these means a limited dynamic range and high levels of noise, especially in low-light conditions. You will also find yourself with a fixed lens, and while many phones offer a digital zoom this is not worth considering in most instances as the quality decreases considerably. This isn't to say a cameraphone can't take great shots, it just needs an "ideal" set of conditions to do so—imperfect conditions are something that a digital camera can deal with more readily.

Always in your pocket
The most popular camera in the world is the iPhone, and has been for some time. While its camera is surprisingly well made, what matters more is that it is always with you, ready to capture fleeting moments and instantly share them online. And unlike with a dedicated digital camera, recorded images can be instantly adjusted—cropped, rotated, even applied with a vast number of "filters" to achieve special effects that would otherwise intimidate users that are less than fluent in Photoshop's capabilities.

THE FUTURE IS THE PHONE

The writing is on the wall: Cell phone cameras have been steadily eating away at the compact-camera market for years, and it's just a matter of time before they succeed in replacing them (almost) entirely. The only limitation is technology—the inevitable progress of which is never to be underestimated. In fact, groundbreaking advances are already finding loopholes around the fundamental small-sensor problem at the heart of cameraphones. Nokia has developed a sensor with a whopping 41 megapixels, but even more importantly, they've also worked out an innovative way of using them. Rather than outputting giant-sized files (41MP reaches into medium-format territory), groups of pixels are "binned" together, combining their information and forming a cleaner signal with better color information and image quality. In short, the sensor can output an image that's better than the sum of its parts. This is just one example of the innovations coming out of the camera phone industry, and you can expect to continue seeing many more such advances in the coming years.

HIGH-END COMPACTS

While the main issue for the digital compacts covered on the previous pages is to provide (relatively) simple, compact models at an affordable price, high-end compacts offer a much broader range of features. This may include resolution, but more commonly it involves a greater range of manual control over the camera settings, with aperture and shutter priority modes and manual joining the automatic options, In addition, there may be the choice of shooting Raw files in addition to JPEGS, and the lenses tend to be of a higher quality.

With this emphasis on improving features, the various high-end models tend to become more specialized tools, with some housing increasingly high zoom ranges to provide an exceptionally versatile range of focal lengths, and others opting for a more restrained zoom for improved optical quality. Video—including High Definition—is now a common option, and the inclusion of a hotshoe allows external flash units to be mounted on the camera for improved flash lighting performance.

The two cameras below are examples of the superzoom class of high-end compacts. Strangely enough, they don't really seem particularly compact, as they are about the same size as entry-level DSLRs, and even copy the SLR styling of a viewfinder hump (unnecessarily—as these cameras do not house a mirror box assembly). However, their compactness becomes apparent once you consider the truly immense range of focal lengths covered by their lenses—from wide angle to the absolute extremes of telephoto. No equivalent zoom lenses exist for a full-sized SLR, but if they did, they would be completely impractical from an ergonomic standpoint.

> **The various high-end models tend to become more specialized tools**

Wide to very, very telephoto
This understated Nikon superzoom has a focal-length range of 24–1000mm. Of course, this mind-boggling zoom range is enabled by a very small imaging sensor, with corresponding effects on image quality.

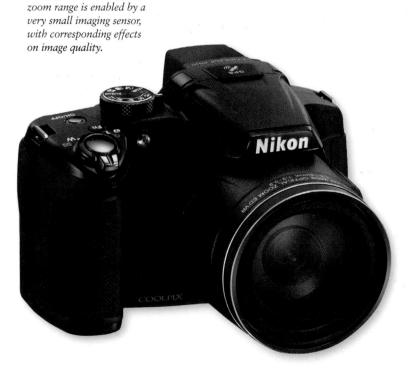

Impressive specifications
All superzooms have electronic viewfinders (EVFs), and their quality ranges from disappointingly glitchy—particularly in low light—to quite impressive. The superzoom above, from Fuji, is of the latter variety, with a high-resolution EVF that it shares with other cameras sporting much larger sensors.

The other half of the high-end spectrum sacrifices massive zoom ranges in an effort to strike a balance between size and image quality. These cameras typically have the largest sensor sizes of any compact camera (though even the largest are still many times smaller than an SLR sensor), and while their lenses can't reach across vast distances to pick out detail on a leaf a mile away, they make up for it by offering very wide apertures. As a result of being able to let in an abundance of light, these lenses mitigate the problems typical of smaller sensors—for instance, while an SLR can shoot a relatively clean image at ISO 800, it might have to do so because its kit lens only goes to $f/5.6$ at a particular focal length; a high-end compact, on the other hand, might have an aperture of $f/2.8$ at that same focal length, and thus be able to shoot the same scene at ISO 200, of which its sensor is perfectly capable.

The advantages of high-end compacts extends beyond size. For instance, all of these cameras use leaf shutters rather than the focal-plane shutters typical of SLRs. Based in the lens, leaf shutters are able to be much quieter (often completely silent, in fact), and they also allow the use of much faster shutter speeds when using flash (which is made all the more useful by their common inclusion of a hot shoe). Whereas even a top-of-the-line DSLR has a flash sync speed (the fastest speed at which a flash can fire at full strength and still expose all of the sensor at once) of 1/250 second, these cameras have basically no limitation on their use of flash, with sync speeds up to and including their fastest shutter speed (usually 1/4000 second).

Pocketable with a drawback
A few of the cameras in this class are indeed small enough to fit into a pocket (the holy grail of compact measurements), but in order to make the lens small enough to retract fully into the body, it is usually only bright at its widest angle. This Canon S100, for example, is f/2 at 24mm, but dramatically narrows down to f/5.9 at 120mm.

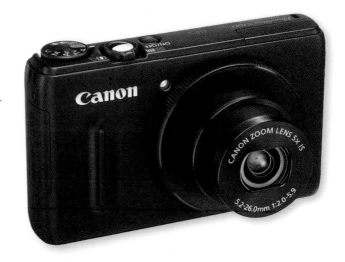

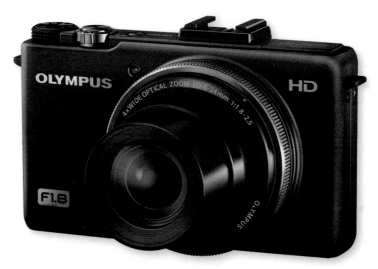

Middle of the road
Other cameras are able to support their wide aperture through more of their zoom range, at the cost of being slightly larger—and at this scale, slightly larger means the difference between fitting in a pants pocket or fitting in a jacket pocket. This Olympus XZ-1, for example, has a 28–112mm zoom range, and stays quite bright throughout it, from f/1.8–f/2.5, but its lens protrudes from the body even when collapsed, and it requires a separate lens cap.

Lots of manual controls
Many high-end compacts give up a great deal of manual control in order to achieve their diminutive sizes. But there exists a distinct class that makes no such compromises, including an abundance of buttons, dials, and switches that make shooting a much more tactile and responsive experience. This Fuji X10, for example, has a manual zoom ring, a focus mode switch, shooting mode and exposure compensation dials, two control wheels, numerous buttons, and even an optical viewfinder. Naturally, it is significantly larger as a result.

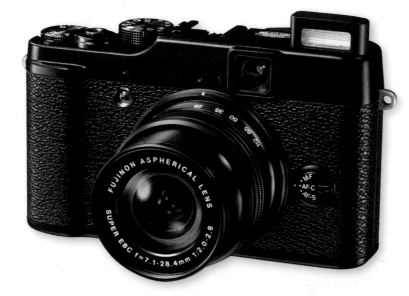

INTERCHANGEABLE-LENS COMPACTS

The newest class of digital cameras signals an exciting innovation in camera design—which in many ways, at least concerning DSLRs, hadn't fundamentally changed since the days of film. The reflex mirror and viewfinder assembly was the only way to see through the lens (TTL) back then, as the film was kept hidden until the moment of capture. Imaging sensors, on the other hand, can be kept running prior to taking the shot, and can thus relay a live preview of the scene as it appears through the lens to a digital playback device. This is, of course, how all digital compacts work, using the Live View image on the rear display screen for composition, exposure settings, etc. So what was keeping this technology from being applied to much larger sensors, and enabling them to function with multiple, interchangeable lenses?

There is a totally new market blossoming in the space between DSLRs and compacts

Nothing but time, it seems; and now that the technology is mature, there is a totally new market blossoming in the space between DSLRs and compacts, with almost every major camera manufacturer putting a horse in the race (as you can see by the assortment below). And while the design principles behind all the various models is the same (large sensor, interchangeable lenses, digital preview via either a display screen or an electronic viewfinder), each camera line, and even each model within each line, takes a particular approach—emphasizing some features over others, and appealing to a certain kind of shooter.

One of the first hurdles to overcome in the development of these cameras was autofocus—namely, Contrast-Detect Autofocus (CDAF). DSLRs use a completely different kind of autofocus known as Phase-Detect AF (PDAF), which is able to be much faster because the AF sensor needs to take only one reading in order to transmit both the direction and distance in which the lens should focus. CDAF, on the other hand, only indicates the direction, and the lens must undergo a series of trial-and-error adjustments until focus is achieved. Compact cameras likewise use CDAF, but their abundant depth of field makes the task quite a bit easier. Large-sensor CDAF systems require a great deal of processing power in order to focus quickly, as well as a unique approach to lens design (involving fewer, lighter focusing elements and a greater number of micro-motors). An advantage, however, is that CDAF is generally more accurate than

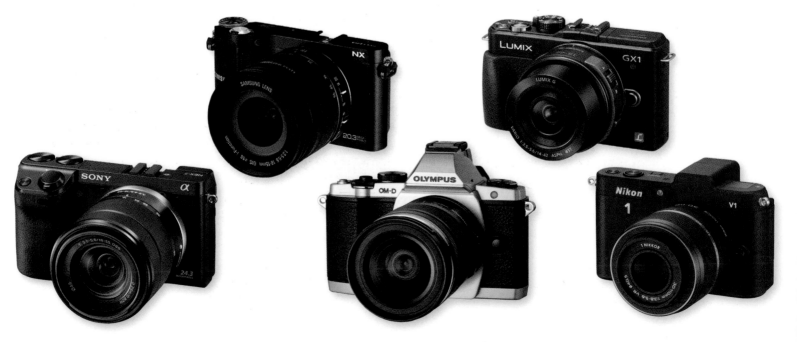

PDAF systems, which are designed to allow a specified amount of tolerance regarding focus acquisition—the idea being that it is too small an amount to ever notice—but it nevertheless results in lenses that sometimes need to be custom calibrated for a particular camera body.

Another major advantage, and one related to CDAF systems, is that these cameras are the ideal platform for HD video recording. While it is true that all new DSLRs have the ability to record HD video, their mirror box at this point becomes nothing but a hindrance, as it must be kept out of the way for the length of the recording—blocking the optical viewfinder in the process. Interchangeable-lens compacts, on the other hand, can switch seamlessly from still-image capture to video recording, and their CDAF system remains in use, allowing autofocusing during recording as well. HD video is increasingly entering the domain of "regular" photographers, as the sensors involved are significantly larger than those typically found in even high-end camcorders. The result is that we are now able to capture HD video with a very shallow depth of field at a fraction of the cost. While this effect isn't necessarily appropriate for all video (any more than it is for all still images), it is a significant tool in your arsenal, and one that can be used to great creative effect.

Finally, it is important to understand that the size advantage of removing the mirror box is not limited to a diminuation of the camera body—the lenses are also scaled down accordingly. By bringing the lens mount closer to the imaging sensor, there is a great deal more freedom allowed in lens design, which can eschew complex retrofocal designs (most usefully exploited for wide-angle focal lengths) and produce high-quality lenses in very compact form factors. And this scales across the complete lens system: Whereas the SLR lenses necessary to cover a range from, say, 14mm all the way to 600mm would require a full-size (and very heavy) backpack, the equivalent focal ranges can be covered by lenses taking up a small fraction of the space and weight. It's also worth noting that many of these systems are producing lens systems that embrace the use of prime lenses, which further keeps the size very compact and capable of sporting wider apertures. Depending on the system, you may also be able to attach an adapter to make use of the full range of lenses offered in that manufacturer's SLR system which, while often negating the size advantage, can help bridge the gap between a full-sized SLR kit and a compact, travel CSC kit.

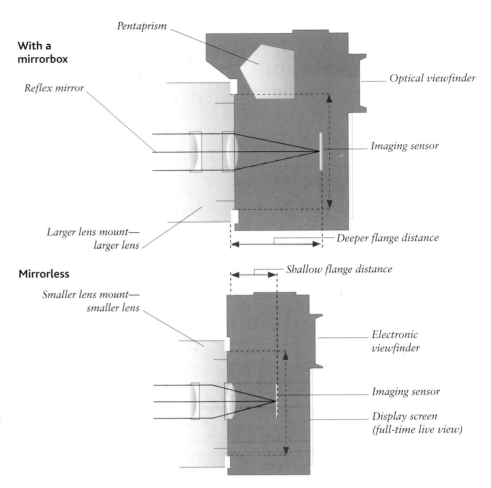

With a mirrorbox

Pentaprism

Optical viewfinder

Reflex mirror

Imaging sensor

Larger lens mount—larger lens

Deeper flange distance

Mirrorless

Shallow flange distance

Smaller lens mount—smaller lens

Electronic viewfinder

Imaging sensor

Display screen (full-time live view)

KEY VIDEO TERMINOLOGY

HD (High definition): A high-quality video format, there are currently two HD standards—720 and 1080 (also referred to as HD and Full HD). The numbers refer to the resolution of the video footage, with 720 measuring 1280 × 720 pixels and 1080 measuring 1920 × 1080 pixels. As with still images, the larger the image recorded, the larger the files size, which is especially important with already-large video files.

Interlaced vs Progressive: You'll often see the resolution spec followed by either a "p" or an "i." For instance—720p or 1080i. This indicates how the video is "scanned" as is it recorded and played back. Progressive video records a complete, single frame at a time, one after the other. Interlaced video divides each frame into a series of horizontal lines, and plays only half of them at a time, with the other half composed of the next image in the sequence—so in effect, each "frame" of interlaced footage is a composite of two images. Generally speaking, progressive is the more desired of these two video formats.

Frame rate: Video footage is essentially made up of a series of still frames that are played back to create the impression of movement—the frame rate refers to the speed at which these are recorded. Common frame rates are 24 frames per second (fps), 25 fps, 30 fps, 50 fps, and 60 fps. Of these, 30 fps is the one most commonly used for general video recording, with 24 fps used to create a "film" look.

DIGITAL SLRS

From the late 50s/early 60s onward, the 35mm single-lens reflex film camera was established as the high-end design for handheld photography. Its great advantage was that its viewfinder showed the exact image about to be captured—a concept familiar now to computer users in the form of the acronym "wysiwyg" (what you see is what you get). This in turn made telephoto lenses practical—the longer ones need to be aimed and focused with an accuracy impossible for a rangefinder camera, at least in the days before autofocus. Digital SLRs occupied the same market position right from the start, partly because the arguments in favor of being able to see through the picture-taking lens are hard to resist, and partly to appeal to existing SLR users. As those of us who make daily use of SLRs know well, the capital value of the equipment is tied up in the lenses. A digital camera body is certainly an expensive purchase, but at least the old lenses you bought will work with it.

The changeover from a 35mm SLR to a digital version is not completely smooth, however. A few models have a 24 × 36mm chip—the same size as a frame of 35mm film—but most have a smaller sensor. This means that with SLRs the confusing matter of angle of view that we looked at on pages 16–17 is a real and

A digital SLR is certainly an expensive purchase, but at least your old lenses will work with it

Hot shoe (clip to hold devices such as electronic flash)

Lens

Typical SLR
The front of a typical digital SLR will look quite familiar to users of traditional cameras. It is the back view that holds the surprises.

Optional supplementary battery back

Viewfinder

Mode dial

Digital control buttons

LCD

Control wheel

HARDWARE

34

practical one. No longer is your 50mm standard lens standard, and the 20mm that you thought was a real problem-solver for cramped spaces will behave like a 35mm lens if it's used on a camera body with an APS-C sensor, or 40mm on a Four Thirds SLR. This is the reason why manufacturers are introducing new very short focal lengths and designing some "digital only" optics that are designed only for these smaller image sensor sizes. The silver lining to this is that your telephotos are all of a sudden more powerful—a 300mm $f/4$ lens can become a very serious 450mm (on an APS-C sensor) or even 600mm (on a Four Thirds sensor) super-telephoto focal length.

Another drawback of digital SLRs which is not immediately obvious, is that changing lenses exposes the chip to the rude environment. If, like me, you are used to leaving bodies lying about with their innards exposed while you rummage for lenses, you are in for a shock when you check the image quality with a digital SLR. Sensor chips are notorious for attracting dust, which will show up on the image as a shadowy patch, although most manufacturers have now recognized this and include some form of sensor-cleaning technology within the camera body.

LENSES

Lenses are arguably just as important—if not more so—than your camera body, so should form part of your decision when deciding which camera system to invest in. A camera body can be easily replaced or upgraded, but it is much harder to replace a full set of lenses if you later decide to switch brands.

Even within a single SLR brand there are decisions to be made about lenses, as all of the main manufacturers, as well as the third-party lens makers, offer an array of focal lengths, from wide-angle to telephoto, with many of them seeming to overlap. The key considerations are the style of photography you do (as well as areas you may be interested in pursuing as your skills develop), and your budget. We would all love to own a full set of focal lengths with fast maximum apertures, but compromises undoubtedly have to be made as to what we want and what we can afford. Or at least convince ourselves we can afford. Your style of photography will dictate the focal length, or focal length ranges that best suit your needs—if you're an avid bird photographer, then telephoto lenses would be your main choice, while landscape enthusiasts would get most use out of wide-angle focal lengths.

The speed of the lens is also important, by which I mean the widest aperture setting. On most consumer-grade zoom lenses this is likely to be $f/3.5$–$f/5.6$, while pro lenses will offer a maximum aperture of $f/2.8$ or wider. This is important, because not only will a faster lens enable you to shoot in low-light conditions, but a faster lens will also enable you to use a very shallow depth of field for creative effect. Pro-spec lenses also tend to deliver higher quality results, so spending more to start with could prove more beneficial to your photography in the long run.

Not all lenses are equal
Nikon's 55–300mm $f/4.5$–5.6 DX zoom (above left) is designed specifically for use on consumer digital SLRs with a Nikon DX (APS-C) sensor. The lens is light, the zoom range expansive, and the price appealing. By comparison, Nikon's 70–200mm $f/2.8$ zoom (above right) is big, heavy, and has a lower zoom range, yet it costs around five times as much. Why? Because it's a fast, pro-spec lens that's compatible with both DX and FX (full-frame) Nikon cameras and delivers superior image quality.

Lens systems
Lenses are the backbone of an SLR system, and the reason why many photographers choose an SLR camera to start with. The wider the range of focal lengths you have in your camera bag, the broader the range of shots you can take—if those lenses also have a fast maximum aperture, then so much the better in my opinion.

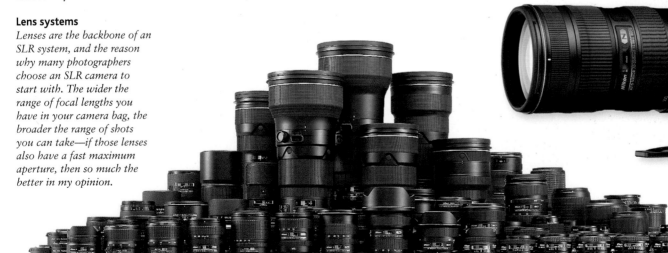

ACCESSORIES

A ccessories comprise any ancillary equipment beyond the basic camera and principal lenses, and range from useful to gimmicky. Much depends on the kind of shooting you do—street photography, for example, has no use for a tripod, while night photography certainly does. Even the small accessories add weight and bulk which might be unnecessary, so consider what you really need.

Mechanical cameras needed very little to keep them working, but digital models are more complex

Digital photography adds a new tier of accessories, certain of which are vital. Old-fashioned mechanical cameras needed very little to keep them working, but digital models are more complex and high-maintenance. At the top of the list are the battery charger, spare batteries, and spare memory cards. For the time being at least, you can forget about nipping into a corner store to pick up one of these. If you think you will need access to a computer while you are out shooting, in order to download or edit images, consider carrying your own cables and card reader.

On the non-digital side, an effective camera support is, for many photographers, the key accessory. This usually means a tripod, and is essential for low-light conditions and small-aperture shooting, when you will need slow shutter speeds. Macro setups benefit from exact positioning, and still-life shots from precise composition—another tripod use. In portrait photography, a loosely locked tripod head makes it easier to talk to your subject. When setting a tripod up, remember that low is more stable than high, that the thickest sections of the legs are the strongest, and that an adjustable center column reduces the stability considerably. Test the firmness by gently tapping the end of the lens.

Lens filters used to be high on the list of camera-bag accessories, but color-correction software in the camera and the ability to apply digital filters later have obviated the need for most of them. UV and polarizing filters, however, still have a role because of the ways in which they reduce light scattering from a scene; neither can be reproduced digitally. In the case of a polarizer, it passes only light vibrating in one plane, and in practice cuts out reflections from metal and glass, and darkens clear skies at right angles to the sun (also by reducing reflections from the atmosphere). If you use a digital SLR and have interchangeable lenses, you may also need stepping rings to fit them to lenses of different diameters.

Filters
Digital color correction has removed the need for most lens filters, but the effects of polarizing (bottom left) and UV (bottom right) filters cannot be reproduced digitally. Stepping rings allow one filter to be used on different lens diameters— useful if your camera has interchangeble lenses.

Charger unit for camera

Spare battery

Spare memory card

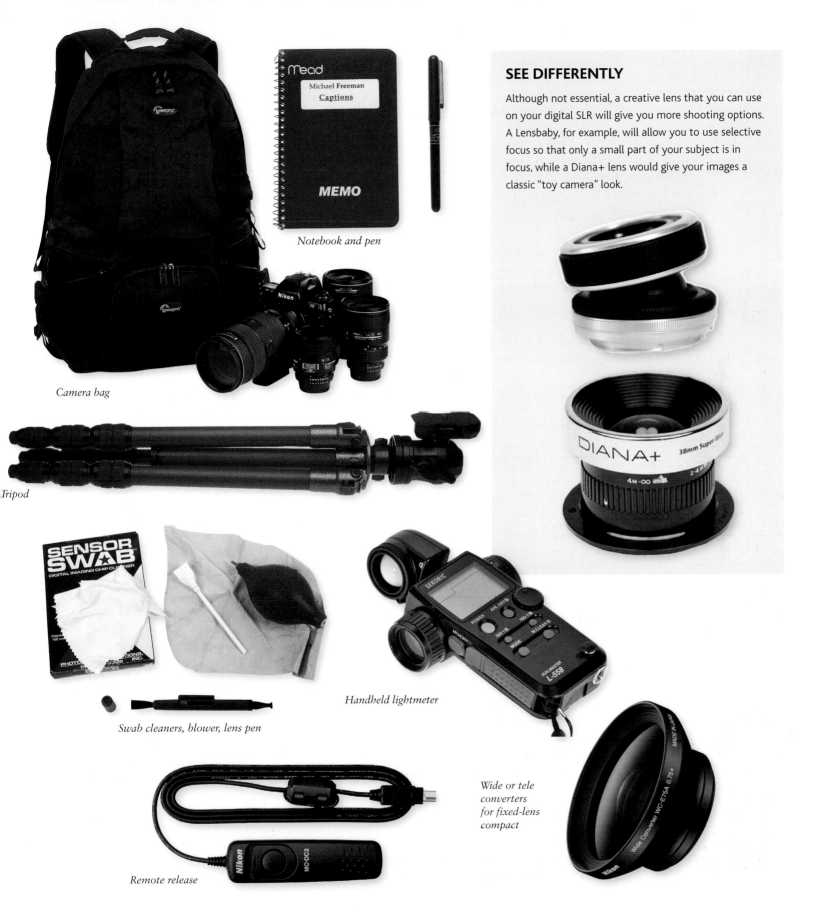

Notebook and pen

Camera bag

Tripod

Although not essential, a creative lens that you can use on your digital SLR will give you more shooting options. A Lensbaby, for example, will allow you to use selective focus so that only a small part of your subject is in focus, while a Diana+ lens would give your images a classic "toy camera" look.

Swab cleaners, blower, lens pen

Handheld lightmeter

Remote release

Wide or tele converters for fixed-lens compact

HARDWARE

37

THE WORKSTATION

I t is the computer that takes digital photography far beyond the moment of shooting, and opens up a new world in enjoying and using the photographs. Taking advantage of this means setting up the necessary equipment first, and that raises the question of what is really necessary. Somewhere between spending a little and a fortune lies a kind of ideal—well, let's say a reasonable compromise.

The physical units of a computer —the hard drive, processor, video card, keyboard, and so on—are the hardware. The programming codes that instruct them how to work are the software, and in basic operation the two are inseparable. Most computer manufacturers offer a wide choice of hardware that affects performance—usually processor speed, size of active memory, and storage space on the hard disk, and we look at these on pages 40–1.

Personal computers stand alone, which is to say that they work independently of others, even though they can be connected to each other to pass files along. There are desktops and laptops, and both can perform well enough to handle most tasks in digital imaging—which may well not be the only use to which you put the computer. Desktops are variously configured. Some, like an iMac, contain everything, monitor included, in one unit; others (the majority, in fact) have the monitor separate from the computer. In addition to this basic setup, you will almost certainly need to connect what are called peripherals—separate pieces of hardware such as a scanner, printer, removable hard-disk drive, or a writable DVD-ROM drive. Anticipate your future needs by making sure that several of these can be connected to the computer at once.

In setting up your workspace, there are three things to consider: what the computer needs, a comfortable working position for you, and good viewing conditions

Typical setup
A typical system should comprise a powerful computer (CPU), a large monitor, a removable media drive for transporting files, and an inkjet printer.

All-in-one computer and monitor, containing CD/DVD drive and hard disk drive

Printer

Portable hard drive

Keyboard

Mouse

HARDWARE

38

In setting up your workspace, there are three things to consider: what the computer needs; a comfortable working position for you; and good viewing conditions. While most of the machinery is robust, it prefers tolerably clean, dry, and cool air—not exactly an Intel laboratory with air scrubbers, but not a dusty toolshed either. Then, particularly if you spend long periods of time using the computer, you should be as comfortable as possible—good chair, right height for the keyboard, and so on.

Because color accuracy is so important in judging and retouching photographs, the ambient lighting needs more attention than might be expected. Eyestrain apart, the only reliable way of judging the color and tones is when the ambient light is neutral and is considerably dimmer than the screen. You really cannot rely on daylight if it floods into the room—it varies too much. On the other hand, working hour after hour in a darkened room is not particularly pleasant, and most people make a compromise. Mine is to work in a room with a view of the garden (for sanity), with a darkroom blind that I can draw occasionally for critical adjustments. For me that's necessary only when scanning and making overall color corrections, but it's a matter of personal priorities.

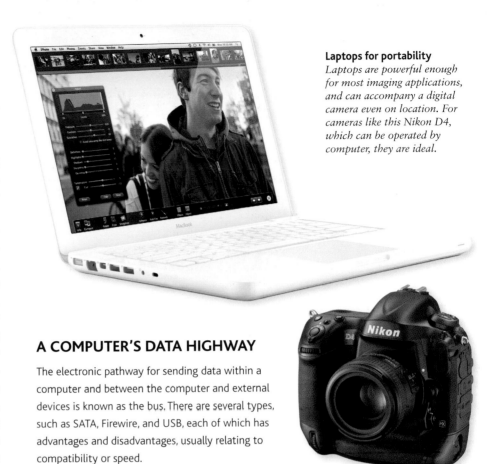

Laptops for portability
Laptops are powerful enough for most imaging applications, and can accompany a digital camera even on location. For cameras like this Nikon D4, which can be operated by computer, they are ideal.

A COMPUTER'S DATA HIGHWAY

The electronic pathway for sending data within a computer and between the computer and external devices is known as the bus. There are several types, such as SATA, Firewire, and USB, each of which has advantages and disadvantages, usually relating to compatibility or speed.

THE INPUT DEVICE

Although the essential input from our point of view is the digital photograph, the way you work on the image demands what the computer industry calls input devices. The two standard ones, common to all desktop computers, are the keyboard and the mouse.

The nature of working with photographs tends to involve drawing, painting, dragging, and so on, which can be intuitively done with a mouse, but for a natural, intuitive way of editing an image, nothing beats a pen and graphics tablet. While it adds to the cost, this electronic drawing board with a stylus is perfect for any freehand drawing action—and image editing involves plenty of this. The working area of the board represents the area of the screen, and when the stylus—a plastic pen—is held within a fraction of an inch of the board, it activates the cursor. Pressing down on the point is like clicking with the mouse, activating the software tool you have selected. In no time at all, working with a stylus becomes like using a physical pen or brush on the surface of the image, with choices allowing you to alter the feel of the tip, the angle at which it will respond, and the functions of different buttons on the stylus.

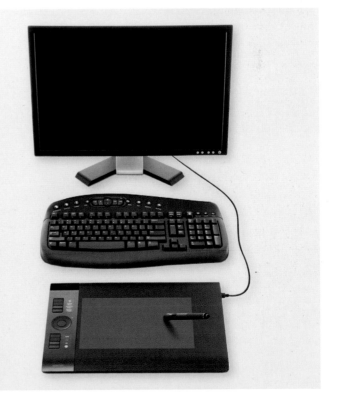

CHOOSING THE PLATFORM

Simple clock speed is not the only thing to consider; what matters more is the performance in the program

In desktop computing, which is what we are dealing with, there are many manufacturers but very few platforms, and it is the platform—the operating system—that controls the way the machine works. Nearly 95% of computers run under one version or another of Microsoft Windows; almost a monopoly, you might say (and it has been said). Surprisingly, then, the small minority of machines that use Apple's OS X operating system have traditionally ruled in digital imaging. "Traditionally," because sheer weight of numbers and marketing pressure is slowly bringing more imaging to Windows, although not, as we shall see, for the best of reasons. In addition, there are two platforms that are even more in the minority: Linux and Unix. The former is a freely developed challenge to Microsoft's dominance; it is stable, neat and efficient, and the choice of many computer enthusiasts. Like the more commercially motivated Mac OS X, Linux is built on Unix, a "core" operating system that is a stable, established standard. This means Macintosh computers ("Macs") enjoy excellent security and reliability, with Apple's own intuitive interface.

Indeed it is this that makes Macs the choice of most graphics professionals, and I must declare my own strong preference. I also use a PC, but not for imaging; its job is to run the office database. Apple's Graphic User Interface (GUI) is widely regarded as the first, though many of the concepts were actually pioneered by Xerox researchers. Either way, Windows was playing catch-up for a long time. Though I'm partisan, it's not without reason. Whatever the advantages of Windows—and there are some compelling ones—they do not extend far into digital imaging.

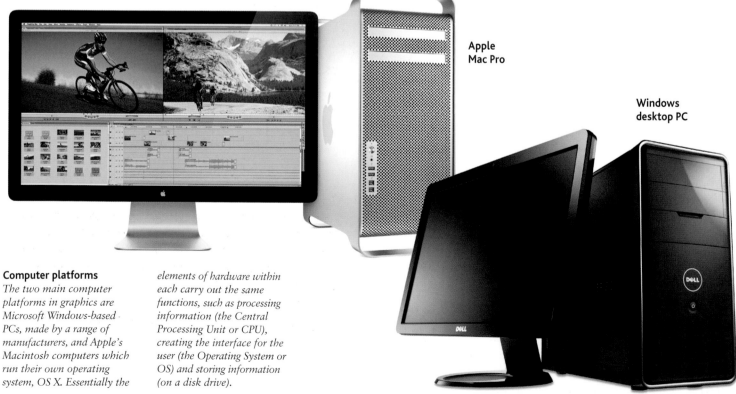

Apple Mac Pro

Windows desktop PC

Computer platforms
The two main computer platforms in graphics are Microsoft Windows-based PCs, made by a range of manufacturers, and Apple's Macintosh computers which run their own operating system, OS X. Essentially the *elements of hardware within each carry out the same functions, such as processing information (the Central Processing Unit or CPU), creating the interface for the user (the Operating System or OS) and storing information (on a disk drive).*

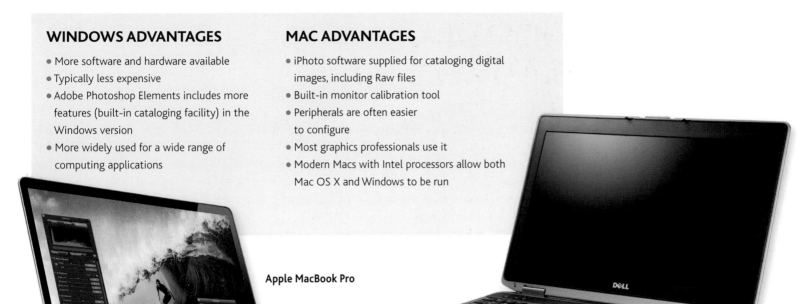

WINDOWS ADVANTAGES

- More software and hardware available
- Typically less expensive
- Adobe Photoshop Elements includes more features (built-in cataloging facility) in the Windows version
- More widely used for a wide range of computing applications

MAC ADVANTAGES

- iPhoto software supplied for cataloging digital images, including Raw files
- Built-in monitor calibration tool
- Peripherals are often easier to configure
- Most graphics professionals use it
- Modern Macs with Intel processors allow both Mac OS X and Windows to be run

Apple MacBook Pro

Windows laptop

The Mac's biggest advantage, taken for granted by those who have never used Windows, was that it has a single video driver at system level. The upshot of this is that any kind of calibration works on every Mac and on every video card, and that means it is easy to get the monitor's display to look right. Accurate color is the starting point for working with digital photographs. Now both Mac OS X and Windows-based computers use a system of color profiles to describe the specific color characteristics of imaging devices (printers as well as monitors), and these profiles are attached to graphic files automatically.

Given that, many would argue that Windows machines are now on equal footing with Macs, combined with a larger installed user base. Because so many computers run on Windows, there is a great deal more software available for it. However, this advantage scarcely applies in digital imaging, and some of the best plugins for Photoshop run only on Macs. Moreover there is virtually always at least one good application in every important category on the Mac, including Microsoft Office.

In all important respects, the hardware in Macs, Windows-based machines, and Linux computers is essentially the same. Processors are all based on the same Intel architecture: RAM chips, interface cables,

and so on are all cross-platform compatible. Indeed most computers can "dual boot," meaning, for example, a new Mac can also run Windows, and most machines can have Windows and Linux installed. The only difference is between 32-bit and 64-bit architecture, the latter making it possible to fit more than 4GB of RAM. This is becoming increasingly important for high-end users.

In the end, this discussion is important only for first-time buyers. Whichever you have, a Mac or Windows computer, it will work well for digital photography. All the necessary software is there.

GIMP

Linux has taken a portion of the computer world (admittedly the most geeky portion) by virtue not only of its free distribution, but because of the "open source" software license which allows users to see how the system was written and make their own changes. This is standard practice on Linux, and the main graphics package on the platform is called GIMP (The GNU Image Manipulation Program), which can also be compiled and installed on Mac OS X and Windows by virtue of its open origins. If you feel you'd like to use it, or get involved in the community, you can download the program (or the source) from www.gimp.org.

SPEED, MEMORY, PERFORMANCE

Image-editing software, which is the kind most used in digital photography, needs all the performance it can get. The reason is that a digital photographic image, always stored pixel-by-pixel as a bitmap, is larger than most other kinds of file. It also has to do with the ambitious operations that image-editing programs can perform on pictures, which are heavy on calculation. But performance costs, and it is not easy to predict how much you will eventually need; my best advice is to make sure that you can upgrade the machine, and begin modestly.

Processing speed, which depends on the chip and is given in GigaHertz (GHz), has the most influence on performance. It is priced accordingly, but as more powerful chips come onto the market, the older ones become cheaper. Beyond this, everything runs much faster if the work can be performed within the computer's memory, which resides on a separate card. Active memory, instantly available to whatever program you are using, is known as RAM (Random Access Memory), and the rule of thumb is that you need three, preferably five, times the size of the image file you are working on. The reason for this is that the program needs to hold copies of the image while you make changes. As you add layers or channels to the image—a convenience offered by all good image-editing programs—the size of the file grows, and it demands more memory. Most modern computers have 2GB or more of RAM fitted as standard, which on its own is more than enough for most image-editing tasks.

However, if you want to have multiple applications open at the same time, having more RAM is beneficial. The reason for this is because your computer has to divide the total RAM between all of the applications you have open. So, while a computer with 2GB of RAM can run an image-editing program without much trouble, if you have multiple applications open the RAM allocated to image-editing will be reduced, possibly slowing down your work. For top performance you should run as few programs as you need, or consider increasing the amount of RAM in your computer. As the price of RAM is very low, there is little reason not to do this, and with the majority of today's desktop and laptop computers it is often a very simple operation to do yourself—though be sure to take all necessary precautions to avoid damaging your system.

> **Performance costs; make sure that you can upgrade the machine, and begin modestly**

Increasing memory
You can increase the amount of random access memory (RAM) available to Photoshop by using its own Preferences panel, or—depending on your version of Windows or Mac OS X—the operating system's memory management. This includes the amount of hard disk space used as "scratch disk" space. This is much slower than the system memory, but still allows you to achieve more.

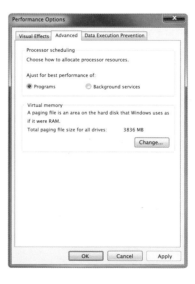

HARDWARE

42

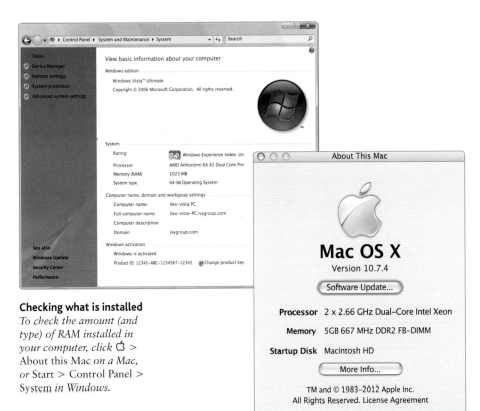

Monitoring your memory
The Activity Monitor, above, gives you a complete profile of your computer, covering memory, disk drives, external devices, and so on.

RAM chips
Computer memory chips are sold on cards, known as DIMMS and the smaller SO-DIMMS (more usually fitted into laptops). Most computer systems make it relatively easy to upgrade these components, and it is well worth doing so.

Checking what is installed
To check the amount (and type) of RAM installed in your computer, click ⌘ > About this Mac *on a Mac, or* Start > Control Panel > System *in Windows.*

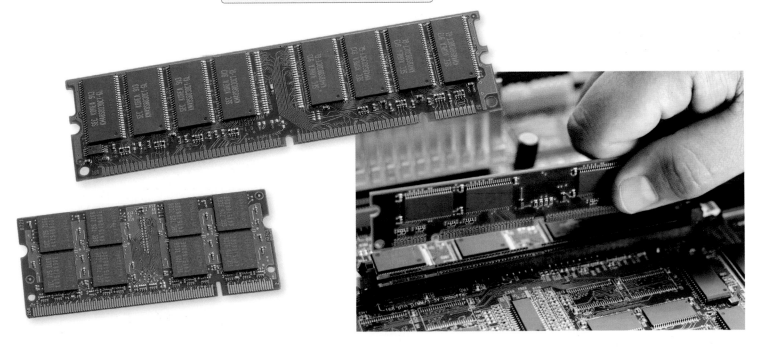

BASIC IMPORTING SOFTWARE

Import software

Apple's iPhoto software allows you to organize and view your images, as well as import them from your camera or memory card. Images can be rated, and there are even some basic image-editing tools. Sharing, too, is made easy, whether you want to email images or send them to an online print service. Photo Mechanic offers comprehensive metadata-tagging and facilitates the easy categorization of images into winners and losers during import (which it calls "ingest").

The camera manufacturers supply software for use with the images you create, but this varies in complexity and features. The simplest programs are essentially browsers, which will transfer your images from your memory card and allow you to look at what you have shot. This is typical of the software supplied with most compact cameras. However, if your camera records Raw images, it is likely there will also be software that allows you to work a little more with your images, not only importing them from your camera, but also enabling you to convert them from Raw files to TIFF or JPEG prior to printing. This software is essential if you want to work directly on the unprocessed image.

As an alternative to the manufacturer's software, you could use one of the many third-party applications on the market or the software that came supplied with your computer. Both Windows and Mac operating systems provide software tools that facilitate the importing of your images in a straightforward fashion. If you are using a Windows computer it will—depending on the version you are using—automatically recognize when a camera or memory card is connected to your computer and ask you if you would like to import your images, taking you through a very simple import process.

Image Capture on a Mac will perform a similar role, although Apple's iPhoto is a superior option as it allows you to not only import your images, but also organize them and tag them with star ratings, captions, and so on. Such is the penetration of the Raw concept that these programs can interpret many camera model's Raw files and, thanks to the Internet, can be easily updated when new camera models come out.

Thanks to the Internet, software can be easily updated when new camera models come out

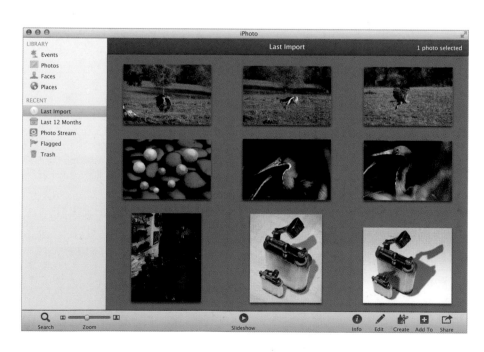

You can copy your images from your camera to your computer hard drive either by manually dragging them from the memory card to the hard disk, or by using software that comes with your camera or your computer's operating system. In the examples here, I am using Windows 7's automatic picture and video import program.

Import Pictures and Videos

Tag these pictures (optional)

Eastbourne ▼

Import settings Import

AutoPlay

PC (E:)

☑ Always do this for pictures

Picture options

📷 Import pictures and videos using windows

General options

📁 Open folder to view files using Windows Explorer

⏱ Speed up my system using Windows ReadyBoost

View more AutoPlay options in Control Panel

1: *Inserting a memory card automatically brings up Windows' AutoPlay dialog, which includes an option to Import pictures and videos.*

You can set the operating system to do this in the future without asking by checking the box toward the top of the dialog.

2: *Using software to copy your files, rather than dragging them from your memory card to the hard drive, usually allows you to rename your files. This is a useful feature as it enables you to add a meaningful tag to the images, rather then using the camera-generated numbering system. It can also prevent images being over-written if the camera resets its numbering every time it is powered up.*

Import Pictures and Videos

PC (E)

Importing item 1 of 2

☐ Erase after importing

Cancel

3: *Once the new file name prefix has been added, the transfer process can begin. The time this takes will depend on the number, and size, of your files. After your images have been transferred, they will open in a new window on your desktop. At this stage it is a good idea to* *back them up to CD or DVD immediately. Although you haven't done anything to them other than renaming the files, it means you can safely format your memory card, knowing that your images are stored on both your computer's hard drive and an external disk.*

TRANSFERRING WITHOUT SOFTWARE

If you prefer not to use software to download the images from your camera to your computer, you can copy the files from the memory card into a folder in your computer and then simply open them into an image editor one by one, just as you might copy a file from a CD or USB flash drive. This may not be the quickest way to work, but it is still valid for many users who want to control every step of their image workflow, or manually choose where—and how—their images are stored.

Card reader
No matter how you choose to transfer the files from your memory card to your computer, a card reader is the fastest option for copying your images.

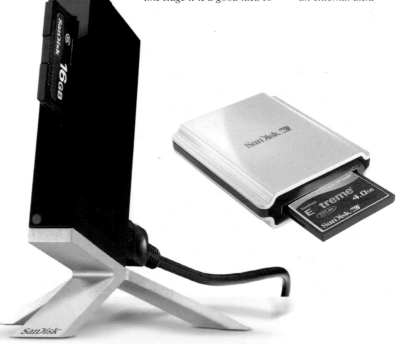

MONITORS

For the majority of computer users, a high-quality monitor is a pleasant addition, no more; but for photographers the best is mandatory. Whatever you see on your screen, and manipulate, will eventually become output in some form or another. It is absolutely essential that the image you see on-screen is sufficiently true to how it will finally appear. It is worth spending as much as you can, as resolution and color depth must be as accurate as possible, while a larger screen is better and easier on your eyes. A widescreen monitor will provide more "real estate" for your editing program's palettes and toolbars.

The majority of monitors use active matrix LCD technology that allows a very thin screen. The size of each pixel as it appears on your display is first deter-

> **It is absolutely essential that the image you see on-screen is sufficiently true to how it will finally appear**

mined by the screen's resolution. This is usually given as the number of pixels horizontally times the number vertically, as in 640 × 480, which is low resolution, or 1280 × 1024, which is relatively high. While the software may allow you to alter the screen resolution, setting an LCD screen to anything other than the "native resolution" (the number of physical pixels the screen is made of) may result in a blurry image.

The larger the screen, the higher the resolution it needs for images to appear the same size and in the same detail. When it comes to making comparisons with camera, scanner, and printer resolutions, which are in pixels (or lines or dots) per inch, the standard figures used for monitors are either 72ppi or 96ppi.

High-res widescreen
LCD displays work best only at their native resolution; using an alternative setting will make the on-screen image appear worse, and often blurred.

BIT DEPTH

Grayscale
256 separate tones, but all in one channel—offering a complete monochrome range from black through gray to white.

256 colors
The same number of distinct tones as the grayscale, but divided between three channels—red, green, and blue—with poor fidelity.

Setting bit depth
You can set the bit depth of your monitor using the Display Settings or Monitors control panel (as seen right).

HARDWARE

46

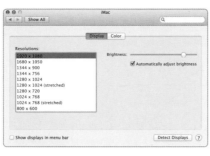

1920 × 1080

What's important is to match your particular display's maximum resolution (showed left in the Mac System Profiler) with your display output (shown right in the Mac Display Preferences).

MONITOR COLORS

	Overall bit depth	Number of colors
Bitmap	1	2
Grayscale	8	256
Indexed color	8	256
High color	16	65 thousand
True color	24	16.7 million
Deep color	30/36/48	+1 billion

These are not precise however, and the actual number depends on the resolution and monitor size, and the distinction matters little. 72ppi and 96ppi are merely the values Macs and PCs assume.

Monitors work in RGB, and so in theory can display most colors. How many in practice depends on the bit depth: Older machines were limited to just 256 colors, while modern computers will display a little over 16 million colors, or 24-bit color.

However, if you rely on a laptop for your image editing, you need to take care with positioning it. Despite advances in laptop screens, the angle at which you view it can still make a significant difference to the brightness of the image. Simply put, you cannot properly judge brightness and color by eye. If a laptop is all you have, go by the numbers and use the on-screen densitometer and the white, gray, and black point droppers; then check the printed results.

RESOLUTION

The most common resolutions, measured in pixels, for three very common sizes of monitor display (measured diagonally in inches) are as follows:

17" 1440 × 900
22" 1920 × 1080
27" 2560 × 1440

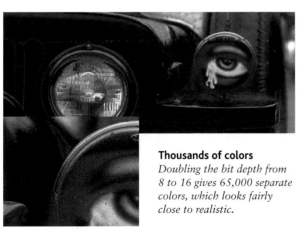

Thousands of colors
Doubling the bit depth from 8 to 16 gives 65,000 separate colors, which looks fairly close to realistic.

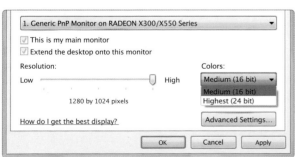

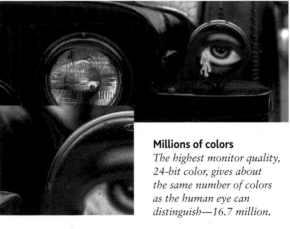

Millions of colors
The highest monitor quality, 24-bit color, gives about the same number of colors as the human eye can distinguish—16.7 million.

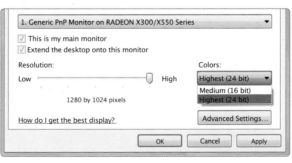

WHAT TO LOOK FOR

- 24-bit color depth
- High resolution
- Size: the larger the better
- Calibration software, either with the monitor or the image-editing program

HARDWARE

47

CALIBRATING FOR ACCURACY

Fresh out of the box, a monitor will probably give a reasonable-looking picture, although the chances are that factory calibration settings favor text over images. You'll want to correct this if the majority of your work is on images, especially since photographs demand more than a "reasonable" picture; the display must be quite accurate. Calibration is the process that gets you closer to accuracy—in shape, brightness, contrast, and color fidelity.

Calibration gets you closer to accuracy—in shape, brightness, contrast and color fidelity

Thankfully, shape has become something of a non-issue since LCD monitors are all built of predictably-shaped pixels. Older Cathode Ray Tube (CRT) monitors may require manual adjustment to ensure that a shape the computer thinks is square appears square on the screen.

Moving on is the issue of gamma, or more strictly, gamma correction. This refers to the value used to compensate for the difference between the linear way computers describe brightness and the final output of the display. In practice this affects the display's overall contrast, and there is little reason to stray from the 2.2 which is now standard on Macintosh and Windows computers. Should you have reason to change it there will usu-

ally be an option in your calibration software. However you go about achieving it, a true gray should look neutral on your monitor, whites should be pure white, and blacks should be pure black.

Even once the gamma is set, however, it is still possible for monitors to display colors some way from those the computer intends. For this reason modern computers support color management systems, which use profiles to describe the idiosyncrasies of attached devices—for example the monitor or printer. If the profile is correct then the color you see on-screen will be as close as possible to the one the image-editing program is attempting to display.

To create your own monitor profile you can now buy, relatively inexpensively, a device called a colorimeter like the i1 from X-Rite. This is attached to a USB port on your computer then placed against your monitor while dedicated software displays a series of

CHANGE THE GAMMA TO SEE THE SHADOWS

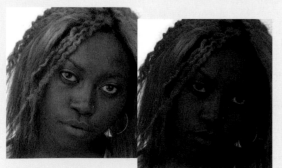

The gamma control, shown here in the Mac Display Calibrator Assistant, allows you to check that your native gamma is being represented correctly, and also switch between 2.2 and 1.8 (the older standard). You can also adjust your target white point.

HARDWARE

48

Colorimeter
This small mouse-like device is placed directly on the display screen, where it reads and measures the colors displayed in the i1Profiler software, shown below.

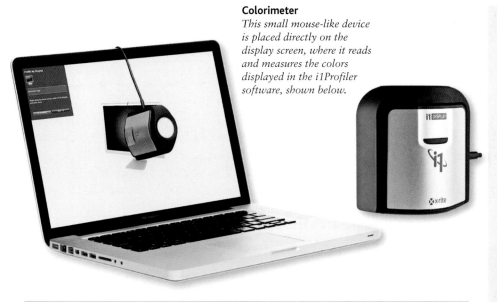

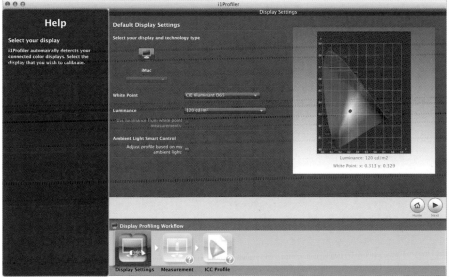

COLOR MANAGEMENT

Color management works because the mathematical values at the core of the system (LAB color) can represent any possible color shade, while both monitors and printers are limited in different ways. As such it also plays an integral part in converting RGB colors to CMYK when a document is printed. Naturally this involves a degree of sacrifice, and more sophisticated applications and printer drivers allow you to choose the method used. Perceptual, for example, attempts to preserve the overall relationship between shades, while Relative Colorimetric makes more of an effort to exactly match shades across color "spaces." It is vital to ensure you do not have two programs—for example Photoshop and a Printer Driver—both trying to apply these conversions.

Original RGB (simulated) *Relative colorimetric*

Absolute colorimetric *Perceptual*

colors. It will take accurate measurements of the colors displayed and create a profile automatically. The i1 also includes a clip-on diffuser so you can measure the ambient light in your work area. It is worth buying one of these devices, and for maximum accuracy you should perform the process once every six weeks, or even more if you use a CRT. If you have more than one monitor (or computer), matching the color this way is essential.

If you scan images on film, you will also need, at some point in the scanning process, to compare the results on the screen with the actual slide. Given that you have adjusted the screen to be as accurate as possible, you must also find a way of viewing the slide

critically. Holding it up to whatever light is available simply won't do if you are trying to match colors and tones. After spending longer than I should relying on the white wall of the house across the garden, I came to see the sense of buying a color-corrected lightbox. While one of these may look much the same as an ordinary lightbox, the combination of special tubes, filters, and translucent plastic makes them significantly more expensive. One saving that you can usefully make is to buy a small one. Because you will usually be viewing only one transparency at a time, the smaller the better, since a large surrounding bright area will actually interfere with your color and tone judgement.

SCANNING BASICS

E ven with the explosion in digital camera technology, silver-halide film is not going to disappear in the next few years, and even when we've all converted to digital there will still be all those transparencies and negatives already shot and hanging in the files that could be digitized. The tool for digitizing conventional photographs is the scanner, and the desktop scanning industry remains very healthy.

The dynamic range and the color accuracy are critical, and both depend on the bit depth

Film carries an extremely high density of information, and the task of the scanner is to capture as much of it as possible. For most photographers, resolution is the prime concern, although it is only one of the relevant image qualities, including dynamic range, bit depth, and noise suppression. Because by far, the majority of film is 35mm, scanning resolutions need to be high to be useful. A frame measures 36 × 24mm, and to enlarge this for printing at, say, 10 inches wide (25cm), the scanner would have to work at 2100ppi. As you would expect, high-end scanners resolve the most detail. The resolving power also depends on the quality of the optics and on the accuracy of the mechanics.

There is more to a good scan than this, just as there is when shooting with a digital camera. The dynamic range and the color accuracy are critical, and both depend very much on the bit depth. Good scanners work at high bit depths—12 or 16, giving 36-bit and 48-bit color respectively in RGB. When the files are

TYPES OF SCANNER

There are three groups of scanner: drum scanners, which are the top-of-the-line professional choice; slide scanners, which use a CCD array and usually fit on a desktop; and flatbed scanners that are designed for larger originals such as prints, but may also come with an adapter that enables them to scan film also. All of them perform the same basic function of digitizing images in a form that can be loaded into a computer for editing and manipulation, so which you use depends on the kind of image you have—and on the quality you need.

Drum scanners offer the highest quality—indeed, the yardstick against which you can measure all scans—with their two advantages being resolution and dynamic range. So when you need the very best, it is worth paying a bureau to make a drum scan for you.

Film scanners were once most photographers' choice, although only a limited number of models now remain. However, many flatbed scanners will allow you to scan film as well as prints, and the resolution of some of the higher-end models is now more than adequate for this purpose.

35mm scanner
Some film scanners accept only 35mm film. The speed of scanning varies, as does the quality.

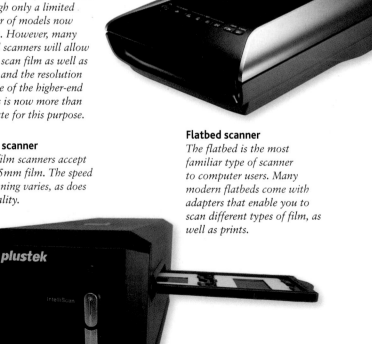

Flatbed scanner
The flatbed is the most familiar type of scanner to computer users. Many modern flatbeds come with adapters that enable you to scan different types of film, as well as prints.

Drum scanner
Drum scanners give excellent results, but are priced at a level that is accessible only to commercial users.

converted downward to the normal 24-bit color, they have a better dynamic range and finer color gradation. The quality of the optics also contributes. Noise degrades the image with a random pattern of "wrong" pixels, and the better-quality scanners are able to suppress it more effectively for better results.

Finally, there are the usual conveniences, or lack of them—the range of color modes that the scanner supports, its speed, ease of use, compatibility with the system you use, and with output devices. And, not least of all, there is price. You largely get what you pay for.

Many output bureaus offer the service of film scanning—and most of them will offer the highest possible quality. Depending on your requirements, an increasingly viable alternative is the purchase of a high-quality slide scanner—the costs of which are now quite reasonable.

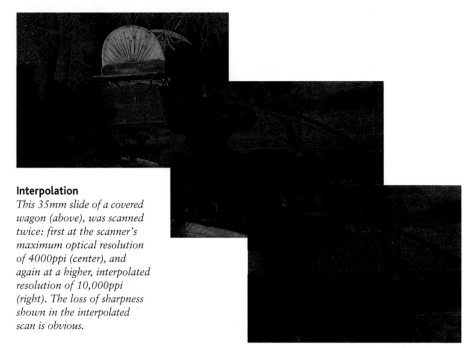

Interpolation
This 35mm slide of a covered wagon (above), was scanned twice: first at the scanner's maximum optical resolution of 4000ppi (center), and again at a higher, interpolated resolution of 10,000ppi (right). The loss of sharpness shown in the interpolated scan is obvious.

SCANNERS

Scan quality
This 35mm Kodachrome transparency was scanned by different machines, from professional to desktop. Direct comparisons are difficult because the resolutions vary, and the scans were at maximum optical resolution. Above is the entire image from a drum scanner—the highest quality.

Flatbed scanner
In recent years, flatbed scanners with transparency heads have greatly improved. This good quality desktop model has a maximum resolution of 1200 x 2400.

Mid-range film scanner
Better-quality results than a flatbed scanner (but not as good quality as a high-end film scanner).

Drum scanner
Best results, obvious in resolution and dynamic range, are from a professional drum scanner.

High-end film scanner
A high-quality CCD film scanner approaches the quality of the drum scan.

ONLY OPTICAL RESOLUTION COUNTS

As with digital cameras, it is essential to pin down the optical resolution of a scanner from its specifications. All scanners include software that will interpolate the real measurements upwards, and all scanner manufacturers are happy to claim these higher figures. What you are paying for, however, is the optical resolution, and you may well be able to do a better job of interpolation yourself later in an image-editing program, if you need it.

THE SCANNING OPERATION

Good scanners (and any other kind is a waste of money for photography) offer a sophisticated array of settings, which can be daunting at first. However, if the software is well written, as most is, you could do worse than follow the automatic setting—the default. The scanner first makes a quick pass over the image; this is the pre-scan, and the purpose is to analyze the values. The image is displayed on the screen, so you can adjust it to how you want it to appear.

For most photographers, image quality can never be too high

For most photographers, image quality can never be too high. Surely, then, the higher the resolution of a scan, the better? Well, it depends on how you are going to use it, because cost, hard-disk space, and image-processing time are all important—and they

all rise with the resolution. There are three standard kinds of output for an image: on-screen, printed, or onto photographic film. Which you choose determines the resolution that you need. In any case the best idea is to scan to the actual size it will be used.

Screen images are fairly straightforward. The resolution is always taken as 72 or 96ppi and, if you are intending to post the image on the web, 1080 × 720 pixels is a reasonable size. Most Internet users prefer smaller initial images, such as 200 x 150, or even as thumbnails, which they click on to see a higher resolution version if they want to.

Print is in two main forms—desktop printing and lithographic—but for both you should work at the same resolution of 300ppi. In half-tone reproduction (repro) for lithography the image is screened, i.e. converted into a grid of dots. The screen frequency for

THE PERFECT SCAN

Load and preview
With the scanner used here, 35mm slides are loaded into a holder. A preview scan is first made, and the crop tool is used to indicate precisely the area of the scanner bed to scan at high resolution.

Input
This particular software, called Vuescan, presents a large panel of tools and options, with a series of tabs at the top. The Input tab allows you to specify the particular source and media of the scan (in this case, a slide), the resolution of both the preview scan and final scan, rotation (if needed), and more. Fortunately, these settings can be saved for future reference, and once you've optimized the workflow for one type of media, you can simply apply the preset to subsequent scans.

Output
At the other end of the panel is the Output tab, in which you specify where to save the scanned image, and in what file format. More is always better, particularly if you are digitizing film for archiving, as in this case. A 64-bit TIFF image is saved with no compression, using an archival filename that makes it easy to find later on for further editing.

HARDWARE

high-quality printing is typically 150 lines per inch; the rule of thumb is to prepare the digital image with twice that amount of information—thus the standard for a high resolution image is considered to be 300ppi.

As a glance at the table below shows, a high-resolution image is very large. Whether it's convenient or even practical to edit an image of such a size depends on the memory and performance of your computer.

NECESSARY RESOLUTION

Output as	Image area mm	Resolution inches	Resolution metric	File size RGB	File size CMYK
Typical website thumbnail	32 × 24	90ppi	35ppm/Res 35	30KB	38KB
Full-screen website image	300 × 200	90ppi	35ppm/Res 35	1.6MB	2.2MB
Postcard-sized print	152 ×102	300ppi	120ppm/Res 12	6.2MB	8.2MB
8" × 10" print	203 × 254	300ppi	120ppm/Res 12	21MB	28MB
16" × 20" print	406 × 508	300ppi	120ppm/Res 12	85MB	107MB
Typical magazine full page	200 × 300	300ppi	120ppm/Res 12	26MB	33MB
Magazine double-page spread	400 × 300	300ppi	120ppm/Res 12	50MB	67MB
6 × 6-cm film	55 × 55	1200ppi	480ppm/Res 48	20MB	27MB
6 × 7-cm film	55 × 70	1200ppi	480ppm/Res 48	26MB	35MB
4 × 5-inch film	95 × 120	1200ppi	480ppm/Res 48	75MB	100MB

Low-key images
Some pictures are intended to be dark, such as this black swan on a lake in shadow. The scanner has no way of knowing this and, set at automatic, it is likely to produce a version that is too pale (above left). As it should be (above right), there is plenty of rich black and the histogram, with all the tones crammed to the left, is perfectly correct.

Final image
The finished scan of this fine old Laotian temple, reduced to 8 bits per channel after retouching and fine adjustment in Photoshop, is 54MB in size and will print at 300ppi to 18 inches (45cm) wide.

Retouch blemishes
Finally, there may be some blemishes to deal with. Here, even though dust and scratches have been taken care of automatically during the scan, the film has been physically damaged by crimping at some point. This is removed using Photoshop's Spot Healing Brush Tool.

INTERNAL, EXTERNAL

Sooner or later, your hard drive will fill up: the answer is removable storage

The first place of rest for digital images, whether from the camera or scanner, is likely to be the hard drive on your computer. The storage capacity of these varies, but is usually substantial—in the order of hundreds of gigabytes, if not a terabyte or more. However, second to video files, digital photographs are among the most space-hungry files in computing. All the text for this book, for instance, takes up less than one megabyte, while a single TIFF from a 24-megapixel camera occupies around 144MB. Sooner or later, your hard drive will fill up.

When you move into image editing, file sizes increase dramatically as you add layers and make copies. Moreover, any reproduction-quality image will need tens of megabytes; for instance, around 30MB for a full-page color picture in a magazine. Photographers are raised on image quality, and most of us will take the highest resolution option if given a choice. Moreover, you will often want to move pictures from one computer to another, and large image files take a very long time to transfer by e-mail.

The answer is removable storage: some means of keeping image files accessible but out of the computer. There are several very different systems available, and each has its own particular advantages. Cost is one issue, but also consider the storage capacity, how secure the data is, and how widely used the system—if you send image files to a service bureau, a printer, a friend, or a client, it will have to be in a form that they can use. A secondary issue is speed—some media allow faster access than others—but if you move images between the hard disk and the removable storage only occasionally, this is not particularly important.

Over the years many storage formats have come and gone, but there are now two main types that are used prolifically: external hard disks (desktop or portable) and blu-ray disks.

Not that long ago, having an external hard disk drive was very much a luxury, but as capacities have increased and costs plummeted, there is no reason at all why you couldn't—and perhaps shouldn't—invest in one. Capacities for desktop hard disks are increasingly being measured in terabytes (TB), rather than gigabytes, and this is ideal for backing up your digital images. Not only

MAINTAIN YOUR HARD DRIVE

Writing, rewriting, and removing files gradually fragments a hard disk. Where there were once large tracts of open space into which entire folders of files could be placed, the disk gradually becomes a patchwork of data, akin to unplanned urban sprawl. This means that new files must be put wherever the system can find space, and so the heads take longer to write and to read. Use a utility such as Norton Disk Doctor every so often.

Portable hard drive
If you're taking photographs with you, one of the most flexible solutions is a rugged portable hard drive like this. Many models can be powered entirely from the USB or FireWire connection to the host computer. If formatted correctly, both Macs and PCs can read them.

Solid-state drive
Unlike a traditional hard disk that uses a spinning magnetic disk to store its information, a solid-state drive stores data on a bank of chips, in a similar fashion to a camera's memory card. This makes them faster, lighter, more robust, and more energy efficient than a traditional hard disk, although they are considerably more expensive and their capacities are lower.

CAPACITY

Media	Number of images (approximate)			
	Typical 18-megapixel* JPEG basic	Typical 18-megapixel JPEG medium	Typical 18-megapixel JPEG best	Typical 18-megapixel TIFF uncompressed
File size	2.2MB	3.4MB	6.4MB	68.3MB
DVD (single-sided)	2,100	1,350	700	65
Blu-ray (single-sided)	10,500	6,750	3,500	325
320GB Hard disk	131,250	84,375	43,750	4,060
1TB Hard disk	420,000	270,000	140,000	13,000

*Figures based on Canon EOS Rebel T3i (EOS 600D)

that, but such a large storage space is also likely to prove sufficient for backing up your entire computer system, so should your computer fail, all your data is recoverable. Yet while a high-capacity desktop hard-disk drive is ideal for backing up your system and storing your images, portability can be an issue, especially if you need to use it with computers in different locations, or with a laptop while you are traveling. In this instance, a portable hard drive may be the better solution. These types of hard drives are connected to—and powered by—the computer's USB or FireWire port, so don't require access to a power outlet, and are often much smaller and lighter than their desktop counterparts.

No matter which type of hard disk you choose, they both have one fundamental drawback: they rely on a spinning magnetic disk. Whenever moving parts are involved there is always the risk of mechanical failure so the recent development of solid-state hard drives that use a similar technology to camera memory cards is an interesting one, especially for photographers on the go. Without any moving parts, the risk of mechanical failure is negated, so the data is stored more securely. Solid-state drive technology is advancing by leaps and bounds, and while they still lag behind traditional hard disk drives in terms of storage capacity (or at least in the cost-per-GB of that storage), this gab is rapidly closing, and it may be wise to future-proof yourself and your images by going this route.

In any case, it is essential to back up your images on not just one, but two external hard drives. One of these drives should then be kept off-site (for instance—at home, if you typically work on your images at the office; or vice versa if you work on them at home). Having only a single copy of your images, even if it is on an extremely reliable hard drive, does not a backup workflow make; redundancy is essential in case the the unexpected occurs. It is best to get in the habit of doing a mass-backup every few months.

There is one solid-state media that is both available, cost effective, and durable: DVDs. DVD recorders are fitted to almost all new computers as standard, with the discs offering a capacity of over 4.7GB. This may not sound like much, but the low cost of the media and its high compatibility with other drives makes it one of the most popular way of sharing, transporting, and archiving files. A downside to using DVD is that you do need to avoid scratches and fingerprints on the recording side, so a protective sleeve is essential.

WHAT TO LOOK FOR IN REMOVABLE STORAGE

- Widely used by others
- Storage capacity (GB or TB)
- Long-lasting
- Permanent or re-writable?
- Low likelihood of obsolescence

Beyond DVD
Blu-ray disks may look the same as a DVD, but whereas a DVD stores 4.7GB in its single-sided format, a single-sided Blu-ray disk will hold 25GB of data. However, few computers come with a Blu-ray drive fitted as standard, so sharing your files may be more problematic.

BACKUPS & ARCHIVES

Things will sometimes go wrong, especially in computing, and often for obscure reasons. Always remember that it is easier for a digital photograph to be deleted by accident than for a slide or negative to be destroyed. However, copies are identical to the original, unlike those of silver-halide film, and easy to make, so there is every good reason to make them regularly. As the polite version of the maxim has it, "to prevent mess-ups, make backups."

Copies are identical to the original, unlike those of silver-halide film, and easy to make

Although there is hardware and software available dedicated just to making backups, you can use any procedure that suits your working method. In fact, method is the key, because it takes a small but necessary amount of self-discipline to make backups regularly. While easy to do, it's also easy to put off, because it takes time just when you want to shut down the computer and go away.

There is, actually, a formula for working out how often to make backups of your work. It is the amount

WHICH STORAGE SYSTEM?

System	Pros	Cons	Best use
CD-R	Cheap media Works in virtually all CD and DVD drives CD recorder drives cheap and widespread Discs impervious to magnetic fields Images permanently stored	Discs vulnerable to scratching 700MB capacity may not be enough Write-once only	Transferring files Sending files to bureaus Archiving
DVD-R/DVD+R	Large capacity Optional rewritability Discs impervious to magnetic fields Images permanently stored	CD-Rs can work out cheaper Discs vulnerable to scratching	Transferring large collections Sending large files/ collections to bureaus Archiving large files/collections
BLU-RAY	Huge capacity Optional Rewritability Discs impervious to magnetic fields Media and drive prices falling	Discs vulnerable to scratching Won't work in DVD or CD drives Most people do not have Blu-ray drives	Personal backup
RAID hard disc	Huge storage capacity Fast Built-in redundancy	Initial outlay Large RAIDs are not easily portable	Backing up huge collections
Tape	Huge storage capacity	Searching and writing very slow Vulnerable to magnetic fields Media and drive relatively expensive	Backing up huge collections

of time backing up takes in relation to how long it would take to redo all the lost work without flying into a rage, and so depends not only on how quickly you work, but how short your temper is.

Backups are easiest to do on the hard drive—just make a copy—but they remain vulnerable to a computer crash. It's safer to make them to an external drive—and then remove the backup to another room. Tape or RAID (Redundant Array of Independent Disks) drives are standard in professional computing, because they can handle huge amounts of data and use software that plans the backup without your having to think about it, such as updating only the parts that have changed since the last backup. Nevertheless, the drives are not cheap.

For most desktop users, the simplest method is to use the fastest removable drive that you have, buy a few discs or cartridges and rotate them. So, if you were to back up every week and used four cartridges, you would have four progressive copies that rotated monthly.

Archives are permanent storage, and so have some of the functions of backups, but demand that the data remains unchanged and readable almost for ever—has "integrity" in computerspeak. That eliminates magnetic and rewritable media and favors write-once CD-R and DVD-R/DVD+R. Nevertheless, these are vulnerable to scratching, which means handling them carefully and keeping them in their jewel-cases. As your collection grows, you will then have to find a way of cataloging them and keeping some reference of what is where. That is the job of image-management software, yet another program to play with, which is explained on the following pages.

An intriguing alternative to this is online storage. This is a service to which you send digital images and which then makes them available for viewing on a website—*see pages 74–75*. Be circumspect if you use one, unless you have boundless confidence in the typical dot.com business model. Give them copies, and make sure to keep the originals.

CD-ROM archive
My own archiving is on non-rewritable CDs. As soon as I have accumulated about 600MB of new images, they are burned onto a new CD, which is titled in sequence (98, 99, 100, and so on)— and labelled. An image manager (next page) keeps track of everything.

CLOUD STORAGE

"The Cloud" has become a buzzword in technology circles as of late, and its features and options are rapidly being integrated into a variety of photographic applications. You have your choice of nearly identical services from all the big tech companies—Google, Microsoft, Apple, Amazon, Adobe, and others all offer various services, all with initially free storage options ranging from 1–10GB, with payment options reaching into the terabytes.

While the opportunities and interconnectedness of these services are legitimately exciting, the technology is simply too new and untested to yet serve as your primary backup. There is no substitute for having copies of your data recorded on physical storage media kept in a safe, off-site location and regularly tested for durability. That said, the ease with which cloud storage allows you to access your archives from a variety of digital devices anywhere in the world at any time is certainly worth looking into, perhaps as a secondary or temporary backup solution. As these technologies develop, this is very likely to become more and more accepted in the photographic industry, and we discuss the other implications of cloud storage on pages 210–211.

Choices abound
As you might be able to surmise based on their common approach to their marketing schematics (that's Apple iCloud above, Adobe Creative Cloud above right, and Google Drive on the right), the principles of cloud storage are generally consistent across the board: You can seamlessly share, work on, and distribute your files across many different devices in different locations, while keeping the files themselves safe in the cloud.

MANAGING THE LIBRARY

Only a computer database can keep track of all this, but it requires careful planning

Image managers (or digital asset managers) are programs that collect images and their information in such a way that they can be viewed, cataloged, arranged, and organized. There are a large number of them and, as you might expect, they vary in their ambitions (also in their achievements). Those supplied with the camera tend to be fairly simple because their main job is to transfer images to the computer; at the opposite end of the scale are databases for managing large collections at a professional level.

File browsers like Photo Mechanic and Adobe Bridge are excellent for previewing all of your image files as thumbnails, including details as to its EXIF data, keywords, metadata, rating info, and so on. Because they are always searching live, these browsers will always be current, accurately showing the locations of all your files; but the tradeoff is that they can be quite slow for larger archives. PhaseOne Media Pro, Apple Aperture, and Adobe Lightroom are visual databases, and have a powerful search engine

that allows them to find images anywhere on the hard drive. A database will build its own catalog that can then be used unconnected, which is much more efficient for large archives. Aperture and Lightroom also include an extensive set of image-editing tools, and Lightroom and Media Pro integrate seemlessly into Photoshop and Capture One, respectively.

There is no shortage of choice, and while you should investigate which of the many specifications best suits your needs, the core functions are generally the same. More important is what you do with the image manager, and that means planning how to

WHAT TO LOOK FOR IN AN IMAGE-MANAGEMENT SYSTEM

- Compatible with your platform
- Can read all the file formats you are likely to produce
- Allows you to add information
- Efficient search engine
- Ability to change the file name

FILE-NAMING CONVENTIONS

In the example here, the image number has a suffix ifit is a version of an original. Retouched and corrected images are considered versions, but substantially altered images are treated as originals; in both cases, the original source(s) is identified. Discs, the basis of the library, are numbered consecutively as they are written, and filed in order on a shelf

Record	Description	Example
#	(unique number)	17118_15
Title/subject	simple name	IceHotel lobby
Description	more detailed	Chairs carved out of ice
Where	place shot (not applicable if created in the computer)	Kiruna
When	date shot or created	Mar 6, 2001
Keywords	for searching	ice, hotel, chair, cold
Source	original digital (camera), from film (scanner), edited digital, or CGI	original (D1)
Other version(s)	if altered digitally	117118.15/01 (enhanced blue)
Size & format	file size (MB), color mode, file format, compression	3.1MB RGB TIFF uncompressed
Physical location	which drive if digital, or which tray/cabinet of film	CD #105

catalog your picture library. Digital images call for a new way of thinking about photographs. The basic unit is not a slide or negative, but an image that has no physical presence. Moreover, there may be several versions as you alter them. If you follow normal practice you will be building up an archive on CDs or similar media.

The first step to keeping chaos at bay is to give each image a unique locator number. This can be in any form, but numerals make searching easy, and you may as well make the system logical, such as numbering in the order in which the photographs are shot, or beginning with the year. The next step is to identify where each digital image is stored (such as on what number disk) and, if you are scanning slides and negatives as well as shooting digitally, you will also have to identify where the original film is kept. Other information you record depends on what is important to you, but do not include so much of it that it becomes a chore to catalog each picture.

Only a computer database can keep track of all this, but it calls for careful planning before you start. The record for each image is likely to carry more information than if you were filing film, partly because you will need to create links between the different versions of an image, and partly because there is much more technical information associated with a digital image—its file size, how it was scanned, what was done to it, and so on.

Presentation
Most image managers work in a similar manner, with the initial interface a window containing thumbnails, as in this catalog opened in iView, a shareware program. The window can be adjusted in size, and the thumbnails then reorder automatically. To add images, the manager searches the available drives, including whatever removable storage is loaded, and creates its own thumbnails. Photoshop's Bridge tool (or File Browser) works in a similar way.

Entering information
For each image, descriptions, keywords, and search fields can be added by the user, in addition to the basic information automatically stored by the program. This information can then be used for searching and display.

Customizing thumbnails
A dialog box allows you to customize this image manager, Portfolio from Extensis, to suit your way of working. This includes choosing the information to be displayed and the size of thumbnails—large to the left, small above.

IMAGE FILE FORMATS

There are numerous ways of storing digital images. These are called file formats, and they differ according to the computer platform—whether Mac, PC, Linux, or Unix—and they differ again according to the hardware and software. None of this would matter very much if you only had to work with one, but in practice you will have to deal with several, as the images you work on are moved from one application to another: scanner to computer to an image-editing program to the web, and so on. As digital cameras were latecomers to the digital-imaging scene, they all comply with the long-established file formats, in particular JPEG and TIFF.

Each file format has features that make it more suited to one kind of image or use than another

Each file format has features that make it more suited to one kind of image or use than another. Working with photographs, you need to be familiar with half a dozen and have a nodding acquaintance with another few. They are identified by a suffix to their name, such as .psd, just like any other kind of file. Just to confuse matters, some file formats, like JPEG, are also methods of compression.

Image compression is the key to keeping large images manageable, as we saw with digital cameras. It is a solution to the usual digital problem of memory and speed—if memory and storage space were unlimited and all files could be moved around instantly, we wouldn't need compression. But they aren't, they can't, and we do. This is a highly technical area, but because of its implications for the quality of an image, it's as well to be aware of what happens.

We're talking about bit-mapped images here and, without compression, the program simply counts all the pixels and their values in an order it can reproduce. Imagine a landscape photograph taken on a sunny day; start at the top row of pixels and check them off one by one. Because the sky is blue, some of the pixels will have the same value—on the first row, say from the 93rd to the 140th. Instead of logging the values for each, you could write, in much less space, that 93 to 140 were at such-and-such value. That is,

in fact, more or less how one well-known compression system, LZW (Lempel-Ziv-Welch), works. Most methods, though, are more complex.

Compression can be either "lossless" or "lossy," which are fairly self-explanatory terms. LZW is lossless, and when the image is decompressed, nothing has been lost. However, lossless compression does not reduce the file size very much—perhaps by 50%. If you want a small file, lossy compression such as JPEG is the solution, but you will lose some detail. You can select the amount at the time of saving the image. Depending on how you intend to use the photograph, the amount of loss may not matter so much, but you should make your own tests at different settings before settling for a particular level of compression—and compare the results at 100-percent magnification. It is not, however, useful for image editing, because it compresses each time you save an image, thus degrading it each time.

NATIVE OR TRANSFER

Digital cameras and imaging software may use their own proprietary way of writing images, known as a native format, to take full advantage of their special features. Other programs cannot read these, so images are usually saved in a transfer format.

FILE FORMATS

TIFF (.tif)
As we saw on page 23, TIFF files (Tagged Image File Format) are used by digital cameras for saving photographs without compression and in a widely readable form. Originally developed by Aldus, TIFF has become a standard in image-editing. It supports 24-bit color and some versions allow lossless LZW compression, which can reduce file size by more than 50 percent.

Photoshop (.psd)
The most widely used of all image-editing programs has its own native format to cope with layers, transparency and other special features.

PNG (.png)
A file format for Web images that provides 10–30 percent "lossless" compression, and supports variable transparency through "alpha channels," cross-platform control of image brightness and interlacing.

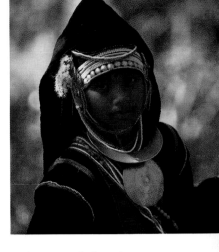

Uncompressed TIFF
The standard against which to judge compressed versions— the best quality that the camera or scanner can deliver.

LZW-compressed TIFF
This system is lossless, does not degrade the image in any way, and so is perfectly safe to use and reuse.

JPEG High quality
Compared with the two images to the left, the highest quality JPEG shows little loss of detail or change of color.

JPEG Low quality
At maximum compression all kinds of destruction takes place, to detail and color, with many artifacts.

In this image, the loss of quality with compression is visible only at substantial enlargement, and is most obvious at the greatest compression (the right-hand pair of the four). At maximum compression the gradation of tones becomes less subtle, with distinct hard-edged blocks of color becoming noticeable.

JPEG (.jpg)

Described on pages 22–23, JPEG is a storage format as well as a compression system. A new improved version, JPEG 2000, uses wavelet compression instead of the original Discrete Cosine Transform (DCT) compression system for 20 percent higher compression, better color preservation and the addition of a lossless compression setting.

GIF (.gif)

The Graphics Interchange Format was developed by Compuserve for transmitting images, and is widely used on the Web. However, supporting only 256 colors, it is intended for illustration rather than photographs. It supports LZW compression.

DNG (.dng)

Digital Negative files were devised by Adobe as a solution to the problem that all cameras produce different Raw files. They contain Raw file data, together with changes made in software.

Proprietary Raw formats

Whereas all the other image formats described here seek to establish various standards across platforms and operating systems, in order to ensure compliance and avoid obsolescence, proprietary Raw formats frustratingly do quite the opposite. Each camera manufacturer (with the notable exceptions of Leica, Pentax, and Ricoh) have their own unique file formats for recording the Raw data recorded straight off their sensors. The major ones are .CR2 (Canon), .NEF (Nikon), .ORF (Olympus), .SR2 (Sony), .RW2 (Panasonic), .X3F (Sigma), .SRW (Samsung), and .RAF (Fujifilm). If you read your camera's manual, you'll be encouraged to use that manufacturer's correspondingly proprietary software in order to convert your Raw files for post-production. As camera manufacturers are in no way software companies, this software often leaves much to be desired. Fortunately, all the most popular image-editing programs eventually "crack the code" of these proprietary formats, allowing you to use their own software for your Raw conversions.

WHY TO AVOID COMPRESSION

A typical photograph contains a mass of irregular detail, which compression is not good at handling. Almost every piece of photographic equipment aims to improve image quality. Lossy compression goes in the opposite direction, although at minimum compression the effects may be undetectable.

HARDWARE

61

VIDEO FILE FORMATS

Just as there is a variety of image file formats, so different video formats have been developed with particular strengths (and weaknesses). However, unlike still image files, these don't really become important until you want to start editing and outputting your video files to share them with other people, and even then it is often not an issue. The reason for this is that camera manufacturers don't provide you with a choice over the video recording format. This isn't like choosing to shoot a Raw file instead of a TIFF or a JPEG—when you switch to video mode, the file type will be set automatically, based on what the manufacturer feels is the best option for their camera.

When you switch to video mode, the file type will be set automatically

A large part of the manufacturer's decision will be based on the level of compression that a particular file format offers, and the quality of the file. This is a very important consideration when it comes to recording video as the data being recorded can produce huge file sizes that make compression essential rather than optional. For this reason, the video file format is only part of a more complex equation (see box: containers and codecs).

Despite the files being compressed, shooting video still places a high demand on storage space, and this requires a slightly different approach to shooting stills. The first thing you need to accept is that you may need to invest in new memory cards. A 4GB memory card, for example, might easily last a day if you are shooting still images, but if you switched to recording High Definition video you might get just 12 minutes of footage. That includes both video and audio data, but this isn't a great amount so, if you are serious about shooting video, you may need to consider investing in high-capacity memory cards: 8GB should be considered the minimum, with 16GB or more being the ideal.

Unfortunately, it is not just the capacity of the card that you need to consider, but also the speed. When you shoot a burst of still images, you may find that your camera will temporarily "lock" when its internal buffer has filled, and you have to wait as it clears the data to the memory card. The same is true of video,

COMMON VIDEO FILE FORMATS

.AVI (Audio Video Interleave)
A video format developed by Microsoft that can be played by a variety of Windows and Mac video players. This is the file type used by video-enabled digital SLRs from Nikon.

.MOV (Apple QuickTime Movie)
This common file format was developed by Apple, but can be played on a wide range of computers using the company's freely available QuickTime Player. This is the file type used by Canon's video-enabled digital SLR cameras.

.MPEG (Moving Picture Experts Group)
Developed by the Moving Picture Experts Group, an MPEG is, broadly speaking, the video equivalent of a JPEG. It uses lossy compression to reduce the size of the video file and because of the small file sizes that can be achieved, it is a popular format for video on the Internet.

.WMV (Windows Media Video)
A video file compressed using Windows Media compression, a Microsoft-developed algorithm. These files are commonly encountered, but work best on Windows computers. Macs often need a plugin installed to play them.

and although HD footage is shot at a lower resolution than still photographs, the number of frames shot is considerably higher. Cards offering write times of at least 8x speed will help prevent this, while a fast, FireWire 800 card reader will help when it comes to downloading the high volume of data to your computer once your memory card is full.

There are, of course, a variety of ways in which you can attempt to overcome these drawbacks. To start with you could consider shooting your videos at a lower quality. Instead of shooting in HD, you could lower the resolution to 640 x 480 pixels, for example, in which case you might be able to squeeze almost 30 minutes of footage onto a 4GB card. However, this does mean you have to accept inferior video quality, which is often not ideal.

As an alternative, you could consider switching off the in-camera sound recording (if available). This will mean that the camera is only sending video data to the memory card, which can help you record more footage, albeit without sound.

Video Memory
Recognizing that video footage makes different demands to still images, some manufacturers have started to release memory cards designed with video in mind. These cards from SanDisk combine both high capacity and high speed.

CONTAINERS AND CODECS

While an image file for a still photograph is comprised of only one element—the image data—a video file needs to accommodate at least two different elements: video and audio. As a result, video files are made up of two components: a "container" and a "codec."

The container is the video file itself (MOV, AVI, MPEG (Motion JPEG), and so on) and can be thought of as a box in which both the video and audio information is stored. The codec is the algorithm used to encode and (often) compress that information.

This is an important consideration as you not only need to have the right software to play a video file, but that software may also need to support the codec used to create the file in the first place. Without it, it may not be able to decode the information correctly, although this isn't usually a problem with the most common file types, such as those listed right.

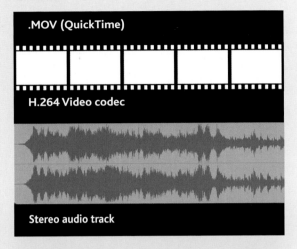

.MOV (QuickTime)
H.264 Video codec
Stereo audio track

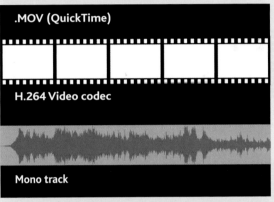

.MOV (QuickTime)
H.264 Video codec
Mono track

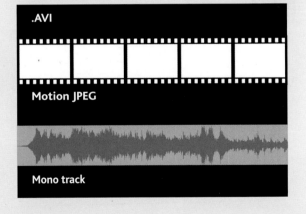

.AVI
Motion JPEG
Mono track

HARDWARE

63

PRINTING

Printing is both a science and an art. At the commercial level, such as in producing a magazine or a book like this, it is best left to professionals, but at a personal level, any computer owner can easily achieve good results with desktop printing. There is such a range of technology in use among desktop printers that we will have to look at each type at a time, but here I'd like to introduce the principles that they have in common, which are quite different from the methods used by digital cameras, scanners, and monitor screens for handling pictures.

Any computer owner can easily achieve good results with desktop printing

In everything I've dealt with so far, colors have been created by combining red, green, and blue (RGB), the so-called additive primaries. A printed image, however, works by reflection, and uses a different set of colors: cyan, magenta, yellow, and black (CMYK for short, with K used for black to avoid any confusion with B for blue). The first three—cyan, magenta, and yellow—are the opposites of RGB on the color wheel, and each can be created by mixing two of the others, so that green and blue, for example, make cyan. Because printing inks and pigments are laid down on white paper, they absorb light, so that in theory at least, cyan, magenta, and yellow on top of each other make black. For this reason, they are called subtractive primaries. In practice, because ink spreads into the paper, the result is dark brown, so a separate black ink is added. A few more colors are possible in RGB than in CMYK, although CMYK can create some colors that RGB cannot. Image-editing programs, as we'll see, can convert from one to the other, but in either case throw

COLOR SEPARATIONS

Color complexity
This British ceremonial military uniform appears at first to contain blocks of simple and clearly differentiated color. However, when broken down for printing, each single color is made up of a combination of all four inks.

Cyan

Magenta

Yellow

Black

Cyan, magenta, and yellow

Four color separation
Color printing usually uses four plates. Printers can adjust the intensity of any of these in order to achieve the balance that is closest to the desired result. Unlike RGB color, the printing process requires a separate black.

HARDWARE

64

some colors away. RGB screens are only capable of displaying red, green, or blue colors, so CMYK colors are simulated by blends of these three. Because the color ranges are slightly different, however, there are some mutually exclusive shades, and the RGB simulation will choose the nearest color, sometimes resulting in a slightly inaccurate match. If you convert unnecessarily from RGB to CMYK, your photograph will lose some of its range. Desktop printers, although they print in CMYK, make their own conversion from RGB, and that is the color model to work in. In commercial printing, like this book, photographs and illustrations are scanned in a process that makes four passes over the image. Each one "reads" for one of the CMYK colors, from which individual printing plates are made. The second big difference in the way that printing reproduces a photograph is that it uses dots to create the illusion of smooth changes in color and tone, and at high magnification they show up as a pattern. A photograph has continuous tones, so the printer needs a mechanism for converting these into the dot pattern. The traditional method is called halftoning, in which each of the four printing colors is converted into a screen of dots. The principle is simple—fewer or smaller dots in an area of a color screen gives more weight to the other colors, while the more empty spaces there are between dots, the more white shows through and so the paler the color to the eye.

Most desktop printers do something approximating this, called dithering. Fortunately this does not demand many decisions from the user. Only if you were preparing an image to go directly for repro on a printing press would you have to calculate halftone screens for yourself—and even then it is usually better to leave it to the experts at the other end.

Coated papers

Print quality is often as much about the paper as the ink. Coated paper, shown on the right, allows for richer images with a wider dynamic range,

since highlights are preserved (because the ink does not seep into even the smallest specular), and dark areas do not lose their richness through spread.

DITHERING

Dithering is a process whereby a printer (or computer) mixes pixels of different colors so as to suggest that more colors are present. Although the number of colors appears greater, the cost is lower resolution, as shown in this detail (right) of a temple in Miyajima.

HARDWARE

65

INKJET PRINTERS

In the late 1990s desktop printing broke through an important barrier, and started to make photographic quality available at a low price. Interestingly, the type of machine that achieved this was the lowly inkjet printer, which many felt was a technology that laser would kill off, or at least push into small sectors of the market, like portables.

The arrival of color, and rapid quality improvements, made photo printing possible—and for most people the entire process could be completed at home, in one place. Printer manufacturers quickly recognized this golden opportunity and are now working hard to take photo prints away from retail outlets. They make their money from the inks, which is why the printers themselves are such good value. Of course, this means that your operating costs can be high, but there are solutions even to that, as you can save money by using third-party suppliers and continuous inking systems.

The quality of reproduction from even an inexpensive machine is remarkable, and from the more advanced models specifically designed for photography you can expect results almost indistinguishable from a real, continuous-tone photograph (on the right paper). There is, however, a catch, and that is durability. Most inkjet prints run if water is dropped on them, and they fade. Both of these limitations are being reduced by new developments, such as fade-resistant inks and archival paper that has a special ink-receiv-ing layer that also resists fading, or is coated with an anti-UV film. Some printer manufacturers claim between 45 and 100 years of light-fastness depending on the paper used. In all cases though, you'll get the best results when properly mounting your prints and accepting nothing lasts forever.

The quality of reproduction from even an inexpensive machine is remarkable

Desktop printer
The humble inkjet printer, standard accessory to even low-cost domestic PCs, produces good color results with the normal four colors, and even better if the model takes six colors.

Although a standard for storing object-oriented files, inkjet printers are not usually capable of handling the Postscript graphics—more correctly termed Encapsulated PostScript (EPS)—that are commonly output by vector-based drawing applications. Software solutions known as RIPs (Raster Image Processors) are available for many printer models. These enable Postscript graphics to be reprocessed in ways that can be interpreted and printed by the printer.

Image quality
Enlargement of inkjet printed image.

HARDWARE

66

Inkjet printers are loaded with liquid ink in cartridges—black ink is always delivered in a separate cartridge, but the color inks can either be separate or combined into a single cartridge. Better quality is possible if more inks are included; these are usually a light cyan and a light magenta (this is known as CMYKcm or CcMmYK printing). As the printing head passes over the paper, hundreds of tiny nozzles squirt these inks into clusters of small dots to make up each pixel in the image, and the combination of these overlaid inks, which are transparent, determines the color. Some printers can vary the dot size as well, so as to achieve even more subtle color variations.

As with digital photographs and scans, resolution depends on the number of pixels per inch—or rather, the number of dot clusters that fill the pixels, and a top quoted resolution of 1400 or even 2800 dpi is usual. However, there are other factors in printing, and the

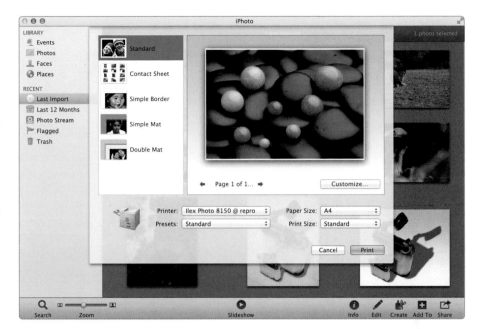

size of the drops of ink makes an important difference (these are measured in picoliters). The smaller they are, the better the resolution looks, with good printers using more than three dozen for each pixel. Beyond this, even a high-resolution inkjet print is unlikely to look as good as dye-sub print (see the following pages) made at 300 dpi.

Optimizing printing
Programs such as iPhoto, shown here, streamline the process of producing high-quality prints from digital cameras. They allow you to import your images, select your favorites, then print them on the page quickly and simply.

A CHOICE OF PAPER

There are four key figures to check when buying paper for any type of printer with the aim of achieving photographic-quality output: weight, thickness, opacity, and brightness. These parameters are usually printed on the paper packs. Weight (which is broadly related to thickness) is quoted in grams per square meter (g/m²). A heavyweight, glossy paper would typically have a weight of 255g/m², corresponding to a thickness of 0.25mm. Such papers would have an opacity of around 97% and a brightness of around 92%.

It is particularly important with inkjet printers to ensure that the paper used is compatible with the ink. Some printers and inks are tolerant of different papers whereas others (notably Epson) are less so. In cases of incompatibility, inks will dry more slowly and the full resolution of the picture is often lost. Color casts and reticulation (a surface texturing) can also result from using incompatible media. It is important to ensure that selected media are capable of photographic (or "photorealistic") quality results—some aren't. Some papers offer "archival" quality—permanence for up to 100 years. Unsurprisingly these papers do cost more.

INK SAVINGS

One of the frustrations of most printers is that the entire color cartridge must be replaced when just one of the inks has emptied. One way around this is to acquire a continuous inking system. This is a set of large reservoir bottles connected by tubing to permanent cartridges in the printer. After connecting them and using a vacuum pump to draw up the ink, nothing else needs to be done but keep the bottles filled.

PRINTING FROM MEMORY CARDS

You don't have to use a computer to print images from a camera's memory card. Some printers will print directly from the memory card and even allow some basic manipulations. Insert the memory card into the printer slot and print off an index print showing thumbnails of the images. You can then select the images you want to print.

OTHER PRINTERS

There is no doubt that inkjet technology is now the established standard in the desktop printer market, with models capable of producing a wide range of image sizes onto an equally wide range of print media. However, if you are looking for a small-format, standalone printer that is capable of producing photographic-quality 6x4-inch prints, then dye-sub printers are a viable alternative.

"Dye-sub" is short for "dye sublimation," a process in which solid dye is transferred from a ribbon or roll onto paper without going through a liquid stage. The transfer roll carries consecutive panels of cyan, magenta, yellow, and, usually, a clear protective coating, each of which is the size of a single sheet of the printing paper page. Most transfer the dye by diffusion caused by heating, so as the first color panel on the roll passes over the paper, a thermal printing head heats the dye, which diffuses directly onto the surface of the paper. The process is repeated for the other two colors and protective layer, in perfect registration.

This process makes it possible to vary the amount of dye—the key to a continuous-tone image—as the hotter the head, the more dye is vaporized. The temperature of the heating elements in the head can be adjusted, very quickly, to any of 256 settings—in other words, 8 bits for each dye, which is exactly what is needed for photorealism, giving a total of 16 million possible colors. As the dyes are transparent, they are overprinted, which does away with the need for halftoning or dithering as is found in inkjet printers, so the prints display a true continuous tone.

> **"Dye-sub" is short for "dye sublimation," a process in which solid dye is transferred from a ribbon or roll onto paper**

Dye-sub printer
Although dye-sub printing is, by digital industry standards, an "old" technology, its continuous-tone reproduction is ideally suited to photography. It is the technology of choice for most direct photo printers that allow you to print straight from your camera or your memory card.

Dye-sub image quality
This enlargement of the same image as was shown on page 68, now printed on a dye-sub printer, shows the superior results produced by this type of machine in relation to those from an inkjet printer.

LASER PRINTER

Color laser printers used to be regarded as a superior printing option to inkjet, but this is most definitely no longer the case— at least not for photographic prints. Although at their best they are capable of photorealistic images, for the most part they simply do not match the quality of inkjet machines and don't offer the same range of papers for photographic prints. While they may be ideal for a small home office, color laser printers are best avoided if photographic prints are your aim.

PRINTING SERVICES

While great results can be achieved using an inkjet or dye-sub printer, the best printing quality comes, not surprisingly, from high-end printers that most people would simply be unable to buy for their own use. We are talking here about the minilabs and kiosks found in photographic labs and stores that allow you to get chemically-processed photographic prints made on heavyweight photo paper from your digital files. The results are smooth and rich, with all the subtlety and range that you would expect from a top-quality conventional photographic print. Blacks are dense and the image is as stable as that of a photographic print.

It is in part because of these services that desktop dye-sub printers are now less prolific than they were a few years ago; the quality is generally higher, and the price-per-print much lower.

In addition to the photo printing kiosks that are appearing in a wide range of stores, there is also a high number of online print providers. These are perhaps an even more attractive proposition providing you have a fast Internet connection, as there's no need to step away from your computer to order prints. With just a few clicks to upload your images, you can be ordering multiple copies of your pictures in an array of sizes, formats, and finishes, all delivered to your door, perhaps even the following morning. And it isn't just photographic prints; calendars, greetings cards, photo gifts, and photographs on canvas and acrylic are just a few of the options available. Many of the companies in this highly competitive market will offer a number of free prints to entice you to use their services, so be sure to take them up on their offer before deciding which service is best for you.

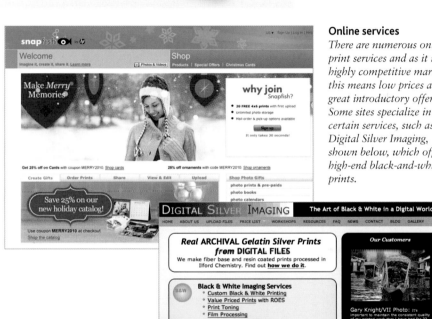

Online services
There are numerous online print services and as it is a highly competitive market, this means low prices and great introductory offers. Some sites specialize in certain services, such as Digital Silver Imaging, shown below, which offers high-end black-and-white prints.

Easy ordering
Such is the popularity of online printing services that some software, such as Apple's iPhoto, has print-ordering built in, enabling you to send your images to the printer with just a couple of mouse clicks.

69

DIGITAL DISPLAY

In contrast to the complexities of color management and the rather complicated relationship between RGB and CMYK color gamuts, viewing your images on a computer screen is simplicity itself. Image capture is digital, the screen is digital, and the well-known computer acronym "wysiwyg" comes into play—what you see is what you get.

That said, operating systems, monitor bit-depths, and types of screen do vary, and it is important to know what your images will look like on a computer screen other than your own. Photoshop has a preview simulation that shows you how it will appear. If you are posting images by e-mail or on the Web, there are some optimization procedures to follow in order to ensure that your image will look as good as possible on the widest range of monitors. Photoshop, for example, has a useful control: the Save for Web dialog. Alternatively you could use a document format, such as Adobe PDF, which is aware of these issues and able to display images correctly across various gammas.

> **Viewing your images on a computer screen is simplicity itself: image capture is digital, the screen is digital**

For the simplest display of all—a single picture—there are any number of programs that will open an image that you have saved in one of the standard formats such as TIFF or JPEG, and an image-editing program is not essential. However, if you want to present your images with a little more professionalism, then a step beyond this is a digital slideshow, in which you assemble a group of images to play as a sequence, allocating the time that each appears on the screen. Most image-editing programs have a simple means of creating a slideshow from your images, often with options that allow you to export it in a format that can be played by another computer.

The various digital display options shown opposite are still digital, but in quite a different way. Digital picture frames that feature a flat LCD or OLED display are improving all the time, although these have perhaps now been usurped by more portable devices such as mobile phones, music players, and handheld games platforms, as well as multimedia devices such as Apple's iPad, with its much larger screen and large internal hard drive.

In addition to these, domestic televisions are becoming ever more integrated into the world of computing, with built-in card readers and USB sockets allowing images and video to be played directly from a memory card or camera. With an increasing number of televisions now providing Internet connectivity, this means there is the option to view images that have been uploaded to websites such as Facebook or Flickr, many of which have a slideshow feature built-in, so you can replay your images in the comfort of your living room, rather than your workspace.

Slideshows

Many of the image browsers discussed earlier, like Adobe Bridge shown below right, allow you to organize your images into a slideshow for playback on your computer; with Lightroom, shown below, you can even export these slideshows as a PDF or Video for playback on other computers or on the web.

Apple iPad

Just one of an emerging class of devices with a large, increasingly high-resolution screen and internal hard disk drive that allows you to store and view hundreds or thousands of images on the move. Indeed it copes equally well with viewing video, browsing the Internet and checking your email, and reading digital books: the key point is "convergence" as digital devices display more than just your digital photos.

Digital devices

There are any number of portable devices with electronic screens on the market now, from mobile phones, through music players, to games systems such as the PSP (below). All can be employed to show photos and some can even do so via a TV screen.

Digital photo frame

A simple, yet popular way of displaying photos is a digital frame that reads from a camera's memory card. A variety of features including remote controls and MP3 playback are on offer, but for the best-quality images, always go for the highest resolution in terms of pixel dimensions.

Internet television

Many new televisions can connect to the Internet, allowing you to access and view images and videos in your living room. Alternatively, you can use a media player such as the one here to access online content using your existing television.

Digital projector

A professional, though expensive, way of displaying images (and video) from your computer is via a feed to a digital projector.

FRAMING
& HANGING

Having produced a striking image, the final step for many photographers is to have it printed, mounted, and then framed, so it can be hung on a wall in the home and enjoyed. It's the final step in celebrating what you have achieved. Any of the usual proprietary glassed frames are suitable for this, and you don't need to spend a great deal of money.

However, there are now countless other ways of displaying your images beyond the very traditional mounted print, ranging from canvas wraps to block mounts, acrylic sandwiches, and even having your images flush-mounted on metal. More expensive options, perhaps, but isn't the picture you have spent so much time photographing and editing worth this special treatment?

Framing your image is the final step in celebrating what you have achieved

Canvas wraps are perhaps the most common of the less traditional print types, with the image printed directly onto canvas that is then stretched around a wooden stretcher. This gives greater physical depth to the image than a traditional frame, with the option of having either white canvas to the sides of the print or having the image "wrap around" the frame.

If your printer can accommodate canvas media, then there's no reason why you can't print and make your own canvas wraps—stretchers of various sizes are available from good art supply stores. However, if you'd rather not go to this trouble—or would prefer something larger than your printer can produce—this is an increasingly popular service offered by most labs, stores, and online print services.

Another non-traditional print type that is often on offer is block mounting. Here, images are flush-mounted on a thick panel (typically 4–6 inches/10–15cm) made of wood, or a lighter material such as foamcore. This gives the print much greater prominence when it is hung on the wall, and again this is something you could quite easily produce yourself. It is worth bearing in mind that a print mounted in this way will be unprotected, so if it is going to be positioned in direct sunlight this may have an impact on the longevity of the print.

Further creative options include sandwiching the image between sheets of clear acrylic to give it a "frameless" appearance, while retaining the protection of the acrylic, or having prints made on transparency material that is then mounted on a metallic surface. This will allow the base material—often a silver-colored metal—to come through in the highlight areas and is particularly effective with black-and-white images. In both cases, this is perhaps beyond the remit of home printing, and best left to a specialist printing service. There is a wide range of choice in this area, so consider both cost and quality.

Canvas wrap (right)
Here the photo print runs all the way over the edges of the frame.

Acrylic sandwich (far right)
Effective for large prints, the image is face-mounted onto a sheet of clear acrylic, producing a "frameless" yet protected end result, as in this example from BumbleJax.

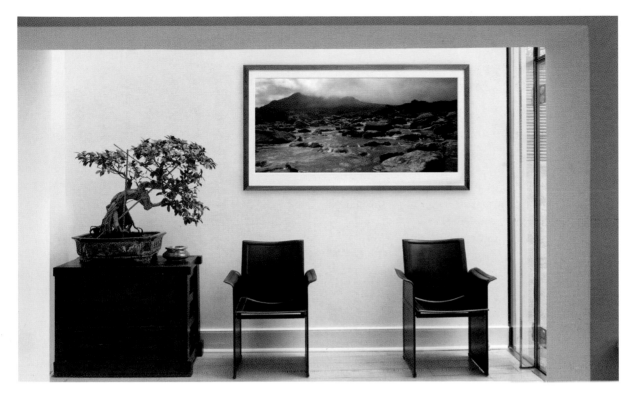

HANGING PRINTS

Hanging photographic prints is not as straightforward as it may seem, with a number of considerations needing to be taken into account.

The first is the size of the print and the viewing distance. For most images, the optimal viewing distance is one that allows the entire image to be taken in at once. There is no precise measure for this, but generally speaking, our eyes take in a viewing angle of around 40 degrees without scanning across a scene, which would suggest a viewing distance of roughly 30 inches (75cm) for an 8 × 10-inch (20 × 25-cm) print.

The height of the print from ground level is also an important consideration, as what may be eye-level for you could be shoulder-height for someone else, or above their eye-line. It is obviously impossible (and impractical) to determine the viewing height with any accuracy, but having the center of the frame around 60 inches (1.5m) from the floor will work well for most standing viewers of "average" height.

The final consideration is lighting. Although you can go to great expense to install specialist lighting, this may be overkill for an image that could be replaced by something different in due course. However, if possible, try to avoid direct sunlight so as to prevent fading, as well as any reflections from windows.

PRINT HANGING PROCEDURE

1 Fix your picture wire or cord to the back of your framed print.

2 Once fitted, lift the wire/cord so that it is at full tension and measure the distance from the highest point to the top of the frame. Make a note of this measurement.

3 Decide on a viewing height for the image that will be neither too high, nor too low for the majority of people you anticipate will be viewing it. Here I'm assuming a height of 60 inches (1.5m) for the center of the frame.

4 From the floor, measure upward 60 inches (or whatever viewing height you have chosen), plus half the height of your frame. From this, deduct the measurement noted in step 2 and make a mark at this point.

5 Fix your nail or picture hanger to the wall on the mark you just made. Your picture should now hang with the center of the frame at a height of 60 inches from the ground up.

WEB DISPLAY 1

The ultimate public forum for photographs is the Internet, which is teeming with sites offering anyone the opportunity to display their pictures, whether artistic, esoteric, or banal. Technically, the web is ideally suited for handling digital images as it is itself a digital platform, so the main issue for anyone looking to put their images online is choosing between building a personal website or choosing between the many companies that will host your images for you.

Seriously web-minded photographers will probably take the step of creating their own website and hosting it through a third-party web-hosting company. To do

The web is ideally suited for handling digital images as it is itself a digital platform

this in a professional-looking way demands effort, no small amount of design sensitivity (or expense if you are hiring someone to design your site for you), and perhaps a working knowledge of HTML (HyperText Markup Language), all of which are beyond the scope of this book.

The benefit of this approach is that you can create a site that is unique to you in both its design and content, with pages that have been specifically tailored to suit your needs; portfolio pages, print sales, news, and possibly even a blog, for example. However, do not expect it to be a straightforward process, especially if you decide to undertake the build yourself, as there are many and varied things that can cause endless frustration along the way.

At the opposite end of the spectrum—and perfect if all you want to do is have your pictures online—are photo-sharing websites such as Flickr and Photobucket. Although you won't necessarily have your own unique web address, and will have to accept a single predetermined design template, there is minimal effort involved in getting your images online with these services. Indeed, most require nothing more than simply registering with the site and uploading your pictures using their instructions. Your photographs will then be hosted for free, although you may find the amount of storage space and some of the more sophisticated features are limited unless you upgrade your account by paying an annual subscription. Depending on your needs, this can be a worthwhile option.

Alternatively, dedicated online printing services can double up as mini galleries for your friends, although the purpose behind these is clearly to tempt people to buy products such as photographic goods and printing services. For that reason, there is often a great deal of advertising on the site and you have little or no say in how your personal album appears.

A personal website
My own website is a self-managed e-commerce site with blog page. The platform I use is PhotoDeck, one of a number of customizable products that do this kind of job. I use it for four purposes: as a stock library offering repro rights for sale, to allow clients to review and upload images I'm shooting for them, as a portfolio of my work, and as a blog to give news and present links to other sites I'm involved with. The e-commerce aspect allows clients to search, price and pay for licensing images automatically.

UPLOADING IMAGES

Unless you've heavily cropped into your image, it likely exceeds the pixel dimensions of most digital display devices. As a result, before uploading your images to the web, it's important to resize them down to a more manageable file size. Doing so properly will ensure they both load quickly and efficiently (no one likes to wait around for an image to load), and also accurately, with the colors correctly reproduced and the dimensions appropriate for the particular viewing device.

Of course, that is easier said than done. Display devices come in every shape and size, and once it's on the web, you have no idea which one will be used to view your image. For a while, the best option was to set the height of the image to about 1080 pixels. This means that a landscape image will take full advantage of an HD screen's real estate, and that a portrait image can be viewed in its entirety, without being cut off at the top or bottom.

However, the inexorable advance of technology is placing new demands on image sizes. Devices like the iPad 3 have considerably higher resolution than HD (useful because tablet devices are held much closer to your eye than a typical TV or computer monitor), and in order to take full advantage of it, the longest edge of any image should be 2048 pixels long. Whether you choose to take advantage of these extra pixels is up to you—the trade off is slower download times on other devices, but with Internet speeds being what they are, that shouldn't be of too much concern. You can also count on the fact that display resolutions will continue to increase, and so future-proofing your images to display at higher resolutions may well be the prudent course of action.

PREPARING FILES FOR WEB OUTPUT

Having spent the time to process your image just the way you want it, it is essential that your image's colors and contrast be preserved when they are saved to a web-friendly format. The essential step here is converting it to the sRGB color space (if it wasn't already). While it is not the most professional color space (AdobeRGB, for instance, has a wider color gamut), sRGB is nevertheless the web standard, and will be how your image is viewed in virtually every mainstream web browser. If you upload a CMYK image, for instance, its colors and contrast will be shifted in unpredictable (and often quite unflattering) ways; so you want to be sure you have complete control over this color conversion yourself.

The Save for Web dialog in Photoshop is an excellent interface for preparing your images for upload. You can view in 2-Up, as shown here, allowing you to inspect the image for any unwanted artifacts or color casts. You can also determine the JPEG compression settings, apply any metadata you see fit, and resize to specific dimensions.

Lightroom's Export dialog contains similar commands, which can be applied to a large batch of images all at once. Usefully, you can specify the dimensions of just the long or short edges of all the images, rather than a particular height and width for one. Lightroom also offers an output sharpening function, where you can specify that the image is meant for display on a screen rather than for print.

WEB DISPLAY 2

Between the two extremes discussed on the previous page are paid-for subscription sites. With services such as SmugMug and Clikpic, you pay a regular fee to host your web album, but this buys you a number of benefits. For a start, you will be able to choose from a number of templates that will help make your finished website a little more personal. Also, you may get your own domain name, or at least be able to attach one to your account, again to create the appearance that it is uniquely yours. From a more practical viewpoint, you don't have to worry unduly about the technicalities of creating, maintaining, updating, and hosting a website as all of this is done for you, with images often added, removed, and updated using intuitive on-screen instructions and semi-automated dialog boxes. In many cases you simply have to locate the image on your hard drive

It's important to make sure that you retain ownership of your pictures

and the online service will take care of the mechanics of resizing it, possibly changing the file format, and positioning it on the page. Likewise, text is treated in a similarly straightforward way, with "wysiwyg" text editing enabling you to change typefaces and font sizes without a need to understand the programming that is happening behind the scenes. In terms of the balance between cost, ease-of-use, and a professional-looking website, this is perhaps the most comfortable compromise for many photographers.

Regardless of where you choose to display your images, it's important to make sure that you retain ownership of your pictures and that you aren't signing the rights away—no reputable organization would try and do this, but it's worth reading the fine print in their terms and conditions to be sure. That said, copyright protection is a complex legal area, all the more so since the web is an interna-

Subscription websites
With a range of options that allow you to customize your website, and no programming skill required, paying an annual subscription to have a professional-looking website hosted can make a lot of sense. Some also allow you to sell your images through the service as prints.

HARDWARE

76

tional medium and copyright laws vary between countries. Posting your images on the web for all to see also runs the risk that someone may unscrupulously acquire them and use them without your permission. In all honesty, this is not as serious a problem as some people like to think, given the ocean of free and low-cost images available, but it is as well to take some precautions. The first and most obvious one is to post only low-resolution images, certainly nothing larger than full-screen, 1024 × 768 pixels.

Another precaution is to physically mark your images with your name and a copyright symbol, so it is clear that the image belongs to you. This will deter almost anyone, providing the text isn't easy to remove, although it will also spoil the appearance of the picture.

The procedure for marking your images, as shown here, is straightforward. In an image-editing program, type the copyright information in its own layer, then choose a blending option that embeds it in the image below. My preference is to type in a light color and blend using the Difference or Soft Light blending mode.

Watermarking is more subtle, in that it embeds coded information in an image that is invisible, or nearly so. However, it is not an infallible system, even though in theory the watermark can be traced. Moreover, watermarking degrades an image, so you should decide for yourself whether or not this is acceptable. For this reason, many photographers choose not to physically mark their images, and instead rely on a low-resolution file as being a good enough deterrent.

WATERMARKING

Embedding a copyright notice
The simplest protection, and a highly effective one, is visible watermarking, provided that you do not mind the obvious interference with the image. In an image-editing program, create a new layer and type a large, bold, and fairly well-centered copyright notice. This is so that it cannot be cropped out. Change the layer's blending mode from Normal to one that gives a blended effect that is less intrusive than a pure color: here I've used Soft Light.

SECURITY ALTERNATIVES

• **Put a visible copyright notice on the image.**
Pros: easy and obvious.
Cons: can be cloned away or cropped out unless it is big and central, in which case it obscures the photograph.

• **Embed a digital watermark.**
Pros: in theory survives resizing and printing, and can be traced.
Cons: in practice does not often survive alteration and can often not be traced; also degrades the image.

• **Limit access to the website, as do stock agencies.**
Pros: major discouragement to theft, which could be traced fairly easily.
Cons: restricts exposure.

• **Protection software that prevents downloads.**
Pros: it works.
Cons: needs a plugin to view.

• **Keep images small.**
Pros: small images are not much use commercially.
Cons: can still be stolen for use on other websites.

HARDWARE

77

SOCIAL NETWORKING

Perhaps one of the greatest impacts of the web is its ability to connect people from around the world. From the earliest Internet chatrooms, computer users could dial up and talk to someone on the other side of the globe, sharing their views and opinions on everything from politics and religion through to such banality as their favorite color or what they had for dinner.

However, it was not until the early 1990s that what we now recognize as "social-networking" sites began to appear. This started when websites such as theGlobe.com and Geocities began to offer their users personal web space, amalgamating the traditionally faceless chatrooms with a more personal web page that gave someone a much greater idea of who they were talking to, and where.

This concept truly exploded a decade later, when the notion of a "personal" web presence was embodied by the aptly named MySpace. Designed to allow anyone to "own" a small piece of the Internet, it enabled its members to tell the world who they were through words, photographs, and more recently, video.

The global giant Facebook was not far behind, and perhaps needs little introduction given that as of 2012 it boasts over 850 million active users. Facebook enabled its users to login and get regular updates on the lives of their "friends," who could be anyone from passing acquaintances, to companies and organizations, or even total strangers—or family members and actual friends, of course. Through status updates, photographs, and videos, people can find friends they had lost touch with many years before, or simply login to find out the latest news from their favorite band, author, or photographer.

There are countless photographers using social-networking websites such as Twitter and Facebook, and their reasons for doing so can vary wildly. For some, this social networking is little more than a means to keep in touch with friends, but for many more it can be another valuable form of self-promotion, allowing

> **There are countless photographers using social-networking websites such as Twitter and Facebook**

KEY SOCIAL NETWORKING SITE TIMELINE

1994	1995	1995	2000
Geocities	theGlobe.com	Tripod.com	deviantART
2002	**2003**	**2003**	**2004**
Friendster	MySpace	Photobucket	Facebook
2004	**2005**	**2005**	**2005**
Flickr	YouTube	Beebo	Buzznet
2006	**2008**	**2010**	**2011**
Twitter	Clixtr	Path	Google+

Facebook + Twitter

It's important to keep any and all social media outlets fresh with new on an almost daily basis, which can obviously get tedious at times. Fortunately, you can integrate Twitter into your Facebook page, so each tweet kills two birds with one stone.

the photographer to share their pictures in much the same way as a website, but in a slightly less formal environment that makes it feel more personal. It's also a great way of meeting like-minded artists from different continents, allowing you to share your ideas and discuss photography as a whole, perhaps each learning from the other.

Of course, if it is purely a place to look at, and talk about, photography, then Facebook, Google+, and their variants aren't necessarily the best places to start. Instead, dedicated photography sites such as Photobucket and, especially, Flickr are a much more focused environment. There are certain similarities between these photo-sharing websites and more general social-networking sites, such as the ability to add

contacts and favorites so you receive regular notification if a photographer whose work you admire updates their Flickr page, but you can also view and comment on other people's work and search for specific themes that interest you—regardless of whether you're recognized as a "friend" or not. In this way it is a much more focused way of looking for—and presenting—photographs to a community of like-minded individuals. Indeed, many professionals now use Flickr as an extension of their portfolio, adding images from a shoot as they're completed, and taking the opportunity to share some of the behind-the-scenes details that would possibly prove distracting on their business website, or simply too time-consuming to add.

YOUTUBE & VIMEO

As this is a book on photography, rather than video, I've intentionally omitted mentioning YouTube and Vimeo in any great detail, but this is not to say that the site should be ignored. There is no reason why a photographer couldn't upload a video-style slideshow of their work, or indeed, as I myself have done, short videos on the more practical aspects of photography. These sites integrate quite seamlessly into other social-networking sites and even most blogs and personal websites, giving you the chance to increase your exposure and rise above the noise of these often-saturated media platforms.

Flickr and Photobucket
Two of the oldest general photo-sharing websites, although with a claimed six billion images on its servers, Flickr is perhaps the biggest and more popular.

deviantART
One of the oldest online artist communities, deviantART hosts art from a variety of genres, including photography, and offers an abundance of discussion and critique, in addition to a full set of print and sales features.

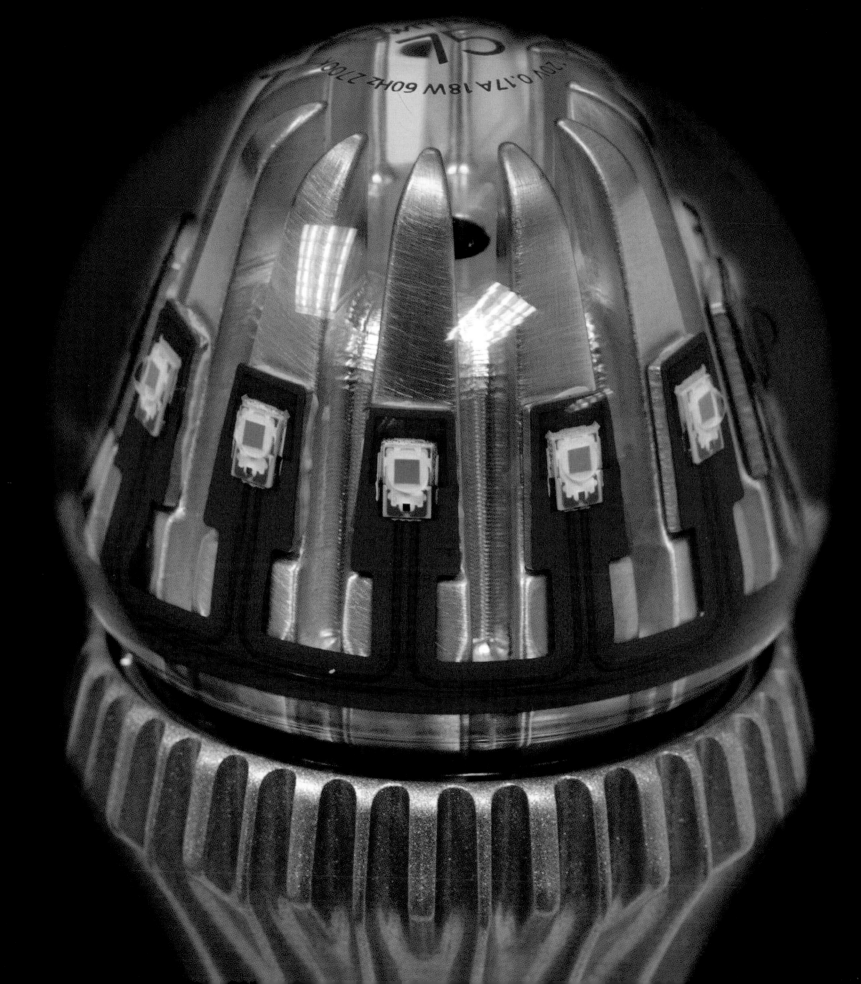

SECTION 2 WORKING DIGITALLY

Once a photograph is on the computer's hard drive, either as an original digital image from a digital camera or scanned from slide or negative, there are almost no limits as to what can be done with it, or added to it. The means are various kinds of software, of which the most relevant by far for photography are image-editing programs. As will become clear in the following section, imaging software is a universe of its own making—an absorbing computerland somewhat detached from reality. There are so many products and processes that only a full-time computer professional could hope to embrace it all. That is not our purpose here. Photography comes first, software engineering afterward.

It is the unique realism of a photographic image that sets it apart from illustration, and creates special requirements of imaging software. Unless you are deliberately converting a photograph into stylized artwork, the overriding principle in image-editing is to maintain the photograph's believability. This means appreciating the ways in which a photograph manages to convey realism, both technically and artistically. Image qualities in a photograph are complex—in tone, color, and texture—and many contain idiosyncrasies that an illustrator would not think of.

From a photographic point of view, there are ascending levels of manipulation in image-editing—a kind of scale of procedure. They are, in increasing order of change and complexity:

- retouching
- repair and correction
- enhancement
- alteration
- image creation

The basic principles of retouching in digital photography are the same as in film photography, but it is easier and more effective. It is mainly concerned with removing dust, scratches, and the new artifacts introduced by digital processes. The next step, repair and correction, involves removing blemishes, tidying up images and salvaging spoiled negatives and transparencies. The new possibilities in digital imaging mean that you can and should judge photographs to new standards—on the one hand, be more of a perfectionist, and on the other realize that a damaged original can sometimes be a perfectly useful starting point.

Beyond this is enhancement, improving the image according to your ideas, unrestricted by the way the view looked at the time. For example, an overhead electricity cable might spoil a landscape or obscure part of a building, the braces on a child's teeth may show up in an otherwise special portrait, or the sky may be boring. These, and countless other similar "problems," can be removed, altered, and replaced according to preference.

At a certain point, particularly when you begin to combine different photographs into one, enhancement becomes alteration. The image is not just an edited version of the original, but something substantially new. This is not for everyone, either technically, because it demands skill and time, or ethically, since it goes against the grain of photography as a true, honest record. Taken to the extreme, however, in creating entirely new images that blend illustrations and even objects generated in the computer, digital manipulation goes beyond photography itself.

WORKFLOW

Much of the digital image workflow is concerned with preparing your photographs for final viewing—ensuring accurate colors, a full dynamic range, sharpness, and so on. Because so much can be done once the image is on a computer, for most conventional photographers it means a radical rethink in their working method. It stands in marked contrast to shooting color transparencies, where very little flexibility in processing means that the photography virtually ends at the moment of shutter release. If anything, it is more akin to the kind of black-and-white photography practiced with an eye to lengthy darkroom work (think Ansel Adams). Digital workflow needs to be planned, and that implies shooting with a good idea of what can (and should) be done later, on the computer.

However, the term "workflow" not only covers the broad idea of image preparation, but also those stages that come immediately before and after. Workflow is, in essence, every step of an image's journey after the shutter has closed: from the in-camera processing through to optimizing, printing, and archiving. Yet while the start point and end point are largely the same for any image, the intermediary steps can vary depending on a number of factors. These start with the types of file you choose—JPEG or Raw—and go on to include the software you use, as well as the nature of the image and the amount of additional work it requires.

The lengthiest workflow procedure will begin with shooting in Raw format, although this also provides the most comprehensive level of control over your images. When you press the shutter in Raw mode, as much information as possible is transferred to the file: the highest bit-depth color your camera is capable of recording, the shutter speed, exposure program, f-stop, aperture value, ISO setting, lens, flash, and so on. Even if you are shooting JPEGs, there are many steps that can be taken on the computer to get the best out of the captured image.

> **Photographs from the digital camera are bitmapped: the obvious way of editing them is a pixel-based program**

MINIMUM WORKFLOW (JPEG)

1 Shooting.
2 Images transferred from memory card to hard drive.
3 Examine the images in a browser, delete mistakes, rotate.
4 Identify selects, optimize, and caption.
5 Save and archive all images.

COMPREHENSIVE WORKFLOW (RAW)

In digital photography, the image workflow typically goes like this:
1 Shoot, ideally as Raw files for control and flexibility.
2 Transfer images from memory card to an appropriate folder on the computer hard drive—from the camera, via a card reader, or from an intermediate storage step such as a portable image bank.
3 Examine the images in a browser, delete any obvious mistakes, rotate where necessary, rename and reorder if appropriate.
4 Basic edit to identify selects.
5 Optimize selects by opening in a Raw converter and adjusting white balance, hue, exposure, shadows, brightness, saturation, and contrast. May also involve basic retouching of dust, as well as noise reduction. Save as 16-bit RGB TIFFs.
6 Continue optimization in editing program (or by switching to editing tools), adjusting black-and-white points, color, curves, and the saturation and brightness of individual hues. Retouch artifacts including sensor dust and reduce noise if necessary.
7 More extensive manipulation of content, if required.
8 Proof certain images on desktop printer.
9 Add caption information and keywords.
10 Save and archive final images as 8-bit RGB TIFFs. Also archive Raw files.

TYPICAL HARDWARE WORKFLOW

Once a picture is taken and processed by the camera, it is stored on the memory card. This is transferred to the computer via a card reader (or direct cable connection) before being processed, and sent to the final destination medium—usually a hard-copy printout and/or archived storage as shown below.

Camera

Memory card (card reader)

Computer

Printer

Archive (Blu-ray, or hard-disk, with redundants kept off-site)

ALTERNATIVE SOFTWARE WORKFLOWS

The specific workflow you follow with your images will depend on the way you work: whether you shoot in Raw, whether you choose to edit any of your files, and which software you choose to use. The first "computing" will always take place in-camera, though with Raw this will simply be saving the information to the memory card, while the final step is archiving—essential for digital photographers. However, the path your images take between these two steps will vary depending on whether you opt for conventional image-editing software, or an integrated workflow program. Both will be explored in greater detail on the following pages.

Workflow Software

In-camera processor *Workflow software (such as Adobe Lightroom)*

Archiving application (typically to DVD)

Image-Editing Software

In-camera processor *Raw converter (such as Adobe Camera Raw)*

Main image-editing application (such as Photoshop)

Image database (keywording and cataloging)

Archiving application (typically to DVD)

IMAGE-EDITING PROGRAMS

WHAT TO LOOK FOR

- Number of features
- Ability to work with high-res, 16-bit color images
- Convenience of interface
- Third-party software support
- Channels and/or layers
- What file formats?
- Efficiency of masking and selecting

There are two different ways of processing an image. One is pixel by pixel, more or less as you see it on the screen (known as bitmapping). The other method works by carrying just the information needed to describe a set of lines or shapes—the mathematical formula—and is known as vector editing. The differences between the two are significant, although not very obvious from what you see on the monitor. The complexity of detail and soft-edged shading that is so characteristic of photography makes bitmapping the usual operation of choice, and most of the software that you are likely to encounter and choose from is of this type.

The screen display is only an approximation of the actual image that you are working on. A bitmapped image can be at a much higher resolution than the screen image, as you can see very easily by zooming in on a detail. Photographs from the digital camera or a scanner are bitmapped, and so the obvious way of editing and manipulating them is a pixel-based program.

As has been the case for a great number of years now, the image-editing software market is dominated by one program: Adobe Photoshop. It is against Photoshop that all other programs are often measured, yet this is perhaps unfair as some of the alternatives have their own special features, which in some instances don't appear in Photoshop, or are perhaps better-implemented. The most popular alternative image-editing programs are: Adobe Photoshop Elements (essentially a slimmed-down version of Photoshop that does away with some of the more specialist tools); Corel PaintShop Pro (a Windows-only program that in many respects sits between Elements and Photoshop); and Gimp. The latter may not be familiar, but it is one of few programs available to Windows, Mac, and Linux users, but, best of all, it is totally free. Provided under an Open Source software license, users can download and use the latest version of the program for zero cost, with an enthusiastic user-

> **The image-editing software market is dominated by one program: Adobe Photoshop**

Adobe Photoshop Elements
Available to both Windows and Mac users, Photoshop Elements doesn't have some of Photoshop's more specialist tools, but is still a powerful image-editing program that will suit most enthusiasts.

Adobe Photoshop
Favored by professional photographers and designers alike, Adobe's Photoshop remains the leading image-editing program and is the one by which others are measured.

base providing numerous plugins, tutorials, and advice for their peers. However, while Gimp offers a sophisticated range of tools, it doesn't match Photoshop for its slickness and ease-of-use, which is perhaps its biggest drawback. Persevere, though, and you will find a program that offers more than Photoshop Elements, for none of the cost.

Yet while all of these image-editing programs have matured over many years, and are now extremely rich in features, they all rely on a "one-at-a-time" workflow. This means an individual image is opened, edited, and then saved (though there is the ability to save a series of adjustments as an "action," which can then be applied

to a batch of images—but it's not a terribly efficient process). As a result, "pure" image-editing programs often require an additional program to import your images from your camera or memory card and a further piece of software (a browser) if you want to catalog and organize multiple images.

This has led to an alternative working method being developed, thanks to a new breed of software led by Adobe Lightroom. As we shall see on the following pages, these newer "workflow" programs are designed to take a more comprehensive approach to working with digital photographs, combining all steps from input to output.

Corel PaintShop Pro
This Windows-only image-editor has been around for as long as Photoshop, and has a similar level of functionality and features. Like Photoshop Elements it now includes organization, as well as editing, tools.

Gimp
With an enthusiastic following, Gimp is distributed under the Open Source software model, meaning it's totally free. Despite a strong set of features, it lacks the sophistication of commercial software, although it will run on virtually any operating system currently around.

WORKFLOW SOFTWARE

Although image-editing software is an established option, it necessarily has to adopt something of a "catch-all" approach to maintain its universal appeal. As a result, tools for photographers nestle alongside those trying to appeal to graphic designers, website developers, illustrators, and even 3D artists, all in equal measure. However, recent innovations have seen the emergence of a number of programs that attempt to offer an image-editing experience designed solely with the photographer in mind—what is commonly known as "workflow" software. Examples of such software included Adobe's Lightroom, Apple's Aperture, and Phase One's Capture One.

The advantage of this form of software is its speed and neatness

What each of these has in common is a holistic approach to the process of managing, cataloging, and editing digital photographs, with a browser to download, an image database to organize, and editing tools for post-production. The advantage of this form of software is its speed and neatness—a dedicated, one-stop solution allows you to concentrate on the essentials, rather than pick through the many features in a more general image-editing program that are of little value to photography. Unfortunately, for those who have "grown up" with traditional editing programs, this requires learning a whole new working methodology, which not everyone is willing to do.

In order to streamline the workflow and create an attractive visual interface and experience for users, the major workflow software programs have, to some extent, buried the workings of the post-production tools that are more transparent in Photoshop, and there are divergent views on whether or not this is a good thing. For photographers with long experience of Photoshop and who prefer to stay firmly in control of image quality, there may be no clear advantage in changing the way in which they work, but for photographers who are either new to digital imaging, or who prefer to limit their involvement to the essentials, this type of software could be ideal.

The main contenders in this software market vary in their approach, and are also constantly upgrading, but three features that are common to all are a Raw-focused approach, strong comparison and selection tools, and nondestructive processing. Assuming that most original files will be in a Raw format is sensible, given the target audience of serious amateurs and professionals, while compare-and-select procedures are essential for a program that promises to handle a large shoot that must be whittled down to a few selects.

Adobe Lightroom

One of the first programs to adopt a workflow-style approach to image management and editing, Adobe Lightroom is a very popular choice for photography enthusiasts. It runs the same advanced Raw-processing engine as Photoshop, but in a streamlined format. It also offers an abundance of distribution options, as indicated by the Book, Slideshow, Print, and Web tabs at the upper right of the screen.

Capture One
Phase One is a company that's perhaps best known for its high-end medium format digital camera backs, but its Capture One software is also a very powerful workflow solution.

Importing images
Unlike a traditional editing program, workflow software incorporates all aspects of image management, which starts with importing batches of your digital photographs from your camera or memory card, and then adding them to an ongoing library. This library can contain tens of thousands of images without slowing down performance, because it displays only previews of each image, and your edits are saved as separate metadata files until you are ready to export your final files. Additionally, as you import your images, you

can add keywords to help in organization, and even select development settings that will be applied automatically as they are added to the library.

However, for many photographers, it is non-destructive processing that proves most useful. In principle, this simply means that the various steps in post-production—such as setting black and white points, curve corrections, sharpening, and so on—are kept as separate instructions, rather than being applied directly to the image. This is very similar to the way in which Raw files are treated, but with this type of editing program the principle applies equally to TIFF and JPEG files as well. As a result, the original image remains untouched, no matter how heavily it is edited, with edited versions processed and exported once you are happy with the work you have done. Even then, the original is still safe.

WORKFLOW

Using workflow software requires a slightly different approach to image "throughput" than a traditional image-editing program. This is simply because it is designed to be a comprehensive channel through which your images pass, covering all stages of the editing process, from input to output.

Import Images
Workflow software will generally allow a wide range of options when importing images, including whether you create a copy of the file, move it into a folder organized by the application, or simply reference it. You can also add your copyright presets and any keywords for the batch of images you are importing.

Organize
A fully-featured browse view will allow you to sort through your images, add and search keywords, rename your files, and so on. Although renaming is permanent, most information about your images is stored in a separate database, rather than altering the files. In some programs you can even add GPS (Global Positioning Satellite) information to your images.

Review, rank, and select
The ability to view images full-screen and/or side-by-side, as well as adding ratings, is a quick way to isolate your best shots.

Process
This is perhaps the key difference between workflow software and databases. With workflow software it is possible to enter an edit mode and make changes to the image, both wholesale fixes and some local repairs. With database programs, this cannot be done.

Distribute
Many programs allow you to generate HTML or Flash web pages, slide shows, contact sheets, and, of course, various photographic prints (including, in some programs, complete books prepared via a third-party printer).

Re-Order
It is always possible to go back to the browser and rearrange or sort your image database, perhaps even re-editing a file if you choose.

VIDEO-EDITING TOOLS

With many digital cameras now capable of recording high-definition video footage in addition to still images, video-editing software may well become an increasingly important part of the photographer's workflow. How involved you want to be with video is entirely your own choice, but as still image capture and video converge it is unlikely that you will be able to ignore it entirely.

As with image-editing, video-editing is based around a workflow, although this is easily integrated into an existing, purely photographic working methodology: Your video footage will be shot on the same memory card as your still images, so can be downloaded at the same time as your photographs. The difference, however, is that editing your video footage is concentrated more on how your video clips are ordered rather than the technicalities of composition, exposure, and focus.

As with image-editing software, there is a broad range of video-editing tools available, which range from those that come with your computer (or are available for free), through to sophisticated, high-end programs designed for professional productions. How

much you wish to invest in editing software will largely be dictated by what you want to use it for, but if all you want to do is trim your video clips and put them in order—editing at its most basic—this is something you can do with any editing program: Windows Live Movie Maker and Apple's iMovie are both obvious, free options for Windows and Mac users, respectively.

However, if you want slightly more advanced features, such as more sophisticated transitions, filters, and effects, there are plenty of programs aimed at video enthusiasts, including Pinnacle Movie Studio and Sony Vegas Movie Studio. In addition, Adobe Premiere Elements and Final Cut Express offer pared-down versions of their pro-spec equivalents (Premiere Pro and Final Cut Pro), in much the same way that Adobe's Photoshop Elements is a lower-cost alternative to Photoshop.

For most photographers looking to explore video with their digital camera, there is no reason to consider anything beyond these programs. Professional tools like Apple's Mac-only Final Cut Pro and Adobe's Premiere Pro may be capable of producing broadcast-quality videos, but unless that is your aim, there is little to be gained by using them for your personal projects.

> ## As with image-editing, video-editing is based around a workflow

Zero-cost editing programs
You don't have to spend any money to edit the video footage from your digital camera: both Windows Movie Maker and Apple's iMovie will allow you to assemble your clips without any fuss.

Windows Live Movie Maker

iMovie

BASIC VIDEO WORKFLOW

The basic video workflow is not dissimilar to an image-editing workflow, although it is good practice to backup your unedited video clips immediately after you have downloaded them to your computer. If you are recording your video footage and sound (audio) separately, you will also need to import your audio files. However, this is more likely for professional or semi-professional projects, rather than for personal video footage.

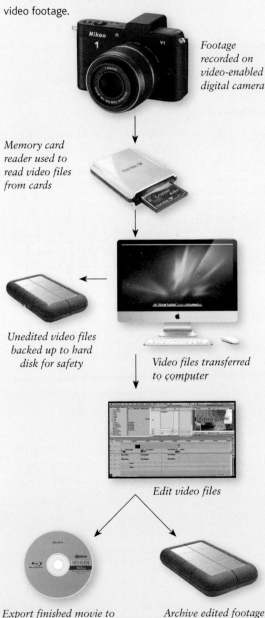

Footage recorded on video-enabled digital camera

Memory card reader used to read video files from cards

Unedited video files backed up to hard disk for safety

Video files transferred to computer

Edit video files

Export finished movie to preferred sharing media (DVD, Blu-ray, or online)

Archive edited footage (hard disk, DVD, or Blu-ray)

BASIC VIDEO EDITING

With video clips that may have been taken over a period of several hours, days, or even weeks, editing your video footage is an exercise in linking these clips together in an order that tells a story. A clip-based program such as Windows Live Movie Maker or iMovie makes this process incredibly simple. The aim is to trim each clip to cut out any unwanted footage, and then place it in sequence with the others.

Versatile editing programs
While programs like Photoshop and Lightroom are mostly meant for still-image editing, recent updates have given them significant video-editing tools as well, making them at least a useful starting point for video projects, and quite possibly all you need for your particular purposes.

High-end editing programs
Final Cut Pro and Premiere Pro are the tools of professional video-makers, offering the advanced features required for creating broadcast-quality productions. Both exist in lower-cost versions aimed at nonprofessional users: Final Cut Express and Premiere Elements.

Adobe Photoshop

Adobe Lightroom

Adobe Premiere Pro

Final Cut Pro

RAW

Shooting in the Raw format may require additional post-production work that will take a little more time, but the benefits it provides can far outweigh this. The main reason is that the image data and the various shooting parameters are stored independently of each other, so what the camera is providing you to work with is the original, "raw" data. Moreover, this image remains at the maximum bit-depth of which the sensor is capable (typically, 12-bit, 14-bit, or 16-bit), which makes for the best possible image quality that the camera is capable of.

However, there are some decisions you need to make about fitting Raw adjustments into your workflow. The first is which software to use? One possibility is the Raw conversion software offered by the camera manufacturer. The advantage here is that the software is likely to be thoroughly integrated with the camera's sensor and processor. As well as providing the essential Raw conversion options, it may also allow you to set or change camera-specific features such as the various preset picture styles and in-camera highlight- and shadow-optimization tools, such as Nikon's Active D-Lighting.

The alternative to the manufacturer-supplied software is a third-party Raw converter, of which Photoshop (and Photoshop Elements) is a popular choice. Both Adobe products include the Camera Raw plugin that allows you to open and adjust Raw files from a wide range of cameras and, as strange as this may seem, it has more sophisticated controls than most camera manufacturer software. The downside is that model-specific functions are likely to be unavailable so, if you can, test it alongside the manufacturer's software and decide for yourself which one you prefer.

Having chosen the software, the next step is to determine which adjustments you will make when you are converting the Raw file, and which ones to make later with editing tools. Exposure and White Balance adjustments are obvious choices for Raw, as they can restore original data, while others, such as Sharpening, are better left until the image is finalized. Depending on your choice, then the bit-depth of your image can be set to either 8-bit or 16-bit. Typically, if no further editing is to be done in Photoshop, aside from sharpening, then 8-bit will suffice, while a 16-bit image can be output if you want to make more changes in your editing package without compromising on quality.

Software manufacturers are producing Raw converters that allow you to undertake more post-production tasks

With shooting Raw proving the best option for creating optimum image quality, software manufacturers are working to produce Raw converters that allow you to undertake more post-production tasks. Raw converters now go beyond exposure, brightness, and color adjustments, with some now offering sharpening, lens aberration adjustments, noise reduction, rotation, and even black-and-white conversion. Extra features vary, with some programs now including localized retouching tools.

CHOOSING A RAW CONVERTER

Although Adobe Camera Raw is probably the best-known Raw converter, camera manufacturers provide their own converter software bundled with their cameras. This may have the advantage that it is designed to work with their specific Raw files.
This is offset by weaker software engineering relative to, say, Adobe. The market for Raw conversion has expanded and become more competitive recently, and there are now many choices, not least among the new class of workflow software, including Lightroom, Aperture, DxO Optics, and Capture One. Ideally, download demo versions of different Raw converter software and compare the results for your camera. A free and open-source alternative is RawTherapee, which can run on all operating systems including Linux, and (so long as you don't mind a rather clunky user interface) offers a full range of conversion tools.

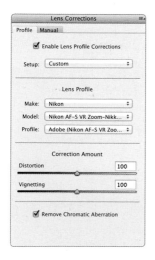

Tailoring your Raw workflow
Adobe Camera Raw (ACR) offers specific profiles for many popular cameras and lenses, automatically correcting lens aberrations and allowing you to calibrate multiple cameras to a common color output.

POTENTIAL RAW WORKFLOW

Using the Adobe Camera Raw plugin, your workflow could follow these steps, which work through the image logically from input to output.

Camera Calibration window

1 Compensate for errors in reading the camera's profile by loading a pre-prepared profile.

Basic window

2 Set White Balance, adjusting with Temperature and Tint sliders.

3 Check Auto adjustment to see what the software recommends, but don't necessarily use this.

4 Adjust Exposure for the overall brightness, favoring the high values and paying attention to highlight clipping (set the clipping warning on).

5 Adjust Contrast to fine-tune mid-tone contrast.

6 Adjust Highlights, if necessary, to recover clipped highlights (using the histogram atop the window as a guide, with Highlight Clipping Warning activated).

7 Adjust Shadows, if necessary, to open up the darker areas, being careful not to overdo it.

8 Adjust whites, if needed, to alter overall tonal range (compressing or expanding the brighter areas without clipping them, provided that the slider is used moderately).

9 Adjust Blacks if necessary, effectively to set the black point.

10 Adjust Vibrance and/or Saturation to achieve the desired color saturation. Favor the Vibrance control, which has built-in protection against clipping when particular hues approach full saturation.

Tone Curve window (optional)

11 If necessary, make fine adjustments to the tonal distribution after working in the Basic window.

HSL/Grayscale window

12 Tweak individual colors if necessary.

Detail window

13 Adjust Sharpness only if aiming directly for a specific output.

14 Reduce noise in a high-ISO image by adjusting Luminance Smoothing to control luminance (grayscale) noise and Color Noise Reduction to control chrominance noise. Otherwise, perform this with a specialist noise-reduction program.

Lens Corrections window

15 Correct color fringing due to lens defects by activating the Defringe tool (choosing either Highlight Edges or All Edges as you see fit).

16 Correct cornershading if necessary (typically with a wide-angle or wide-aperture lens), using the Vignetting Amount and Midpoint sliders.

17 For greater control and to correct or introduce vignetting to crop selections use the Post Crop Vignetting sliders.

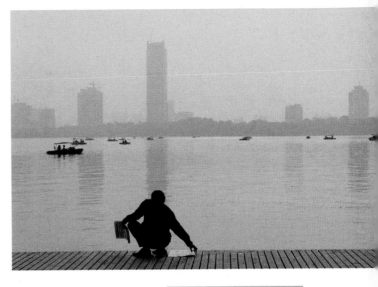

Exposure adjustment
As shot, this image is slightly overexposed, but the Raw converter allows changes to be made to the exposure, white balance, and numerous other settings. The final shot has had its exposure reduced by 1/5 stop, and a custom white balance setting has been applied to the image to enhance the shadows.

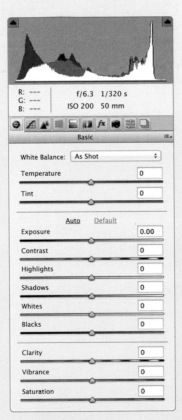

The original, unprocessed Raw image (left) and the final image, after a series of adjustments to color, exposure, and contrast (above).

THE IMAGE TOOLBOX

Usually designed to be so convenient that you hardly notice it, the interface is as important to a piece of software as the shape, feel, and layout of a camera body. It is your first sight of the program, and the means for using it. Software developers spend an inordinate amount of time researching and designing their interfaces, and as a user you should find it comfortable to operate. The Macintosh's early lead in the graphical user interface (GUI) market was one of the reasons for the Mac's original dominance in imaging work. For some time legal reasons prevented Microsoft's Windows borrowing these features, although the systems are now more or less interchangeable.

The most-used part of the interface of an image-editing program is its toolbox

The most-used part of the interface of an image-editing program is its toolbox—the "container" that holds the various imaging tools such as brushes, erasers, and selection shapes. It may float, so that you can place it anywhere on the screen, or dock it next to an edge, or it may be fixed. In either case, the tools it offers are displayed as icons—small representations that are meant to be as intuitive as possible. The other controls reside in drop-down menus along the top, in palettes that can be opened and closed, and in dialog boxes that appear whenever a particular operation offers detailed choices. Many of the controls can also be activated by keyboard shortcuts (or "hotkeys"), and after the initial learning process, these tend to be favored for their speed by people who are thoroughly familiar with the program.

The term "tools" strictly covers any sub-program that applies an effect. They are handled by the cursor on-screen, which the user can move and activate with a stylus or mouse. For many people, however, the true tools are those that work as if held by hand—chiefly the paint and draw tools. These include the pencil, paintbrush, airbrush, eraser, and pen, all of which are designed to work as intuitively as their namesakes, and for this reason above all, a graphics tablet and its stylus are the perfect physical device (*see page 59*).

The pencil draws a hard-edged line, the paintbrush has a soft edge (meaning that the pixel values fade from full-strength to zero across a width of a number of pixels), and the airbrush adds a soft-edged effect as long as you press down on the button. The size of all three can be varied, and even their distinguishing features, like fade-out, can be adjusted. In addition, the eraser can be set, in Photoshop, to work as a block exactly as it appears on-screen. Apart from this last one, which is used for total removal and so should leave no edge when finished, all the hand-tools need anti-aliasing for realistic use on a photograph (*see opposite*).

There are dedicated tools for producing particular effects, such as smudging (pushing pixels rather like a finger on wet paint, and not to be confused with the British vernacular for hack photography), cloning (*see pages 106–107*), dodging and burning, and sharpening and blurring. They use the intuitive hand tools in applying their effects, so that using a brush is by no means limited to applying a color. The Sharpen and Blur tools, incidentally, apply the rough-and-ready versions, not the controllable USM and Gaussian blur, and are not recommended for serious use (*see pages 116–117*).

BRUSHES

Pencil **Paintbrush** **Airbrush**

Capture One

DXO Optics Pro

Adobe Photoshop

Photoshop gives you a choice of cursors, seen here in Mac OS X.

ACTIVE AND INACTIVE ICONS

In many programs, the icon of a tool changes according to its use. For instance, if you select an area of the image and then choose a tool to perform some action on the selection, the icon changes when you move it across the selection boundary.

Adobe Photoshop Elements

Gimp

Adobe Photoshop

Most digital devices, such as monitors, display pixels as adjoining squares. This is perfectly precise for horizontal and vertical edges, but creates problems with diagonals, which reproduce as jagged steps unless they are treated. The solution, essential to use in photography, is anti-aliasing, an interpolation method that smooths the edge by altering the corners so that they merge more gently with the background. As a general rule, always keep anti-aliasing switched on.

Anti-aliasing off
Without the smoothing effect, diagonal edges are jagged because of the individual steps between pixels.

Anti-aliasing on
The corners of the steps are filled with an average between the dark and light sides of the edge.

DIMENSIONAL CHANGES

The image-quality controls on a digital camera give you a choice over the image size when you are shooting. If you are scanning a slide or a negative, you have even greater control. In both these situations, shooting or scanning, it makes sense to decide how you are going to use the image—and so how large it needs to be. You can change it later, but sometimes at a cost to the quality.

Nevertheless, for all kinds of reasons, the size of an image often needs to be adjusted. To take just a few examples, you may want to post a low-resolution version of a high-quality image on the web. In compositing two or more images, you will nearly always need to enlarge or reduce one to make the combination work; you may want to make a print larger than the digital camera delivered. In every one of these cases, resolution, determined by the number of pixels, is the key factor, as we saw in section 1.

Changing the size of a bitmapped image is by no means as simple as it is with a regular photograph

Changing the size of a bitmapped image is by no means as simple as it is with a regular, continuous-tone photograph. The problem is that the pixels that make up the image are not locked into a scaleable relationship—they are only arranged next to each other. If you were resizing a photograph with an enlarger in the darkroom, you would simply change the magnification by moving the lens away from or nearer to the film. With a bitmapped image, however, the computer has to make a series of calculations that either remove some of the pixels (if you are reducing the image) or add new ones (if enlarging). You'll see various ways of

SIZE AND RESOLUTION

With a digital image these two are always linked, and you must specify both. A 5½ x 8¼ in image for the printed page at 300 ppi needs many more pixels than the same size for a 72 ppi monitor. The "Image Size" dialog box in an image-editing program has all the necessary information.

Upsizing
For a demonstration of the relative efficiency of different methods of interpolation—filling in the gaps—I chose this Kodachrome original of two Shaker elders. The original, right, will be resized to 150%, which is close to the safe limit.

expressing this in computer jargon, such as scaling and resampling, but it all comes down to the same basic operation, and not surprisingly, it does not always work well.

Whether the new image is acceptable or not depends on two things: the technique used by the computer to rework the pixels (called interpolation) and the degree of change. Interpolation essentially makes an informed guess of how the new pixels would look, based on the original ones. This is easier and generally more successful when reducing (downsampling) than when you are increasing the size of the image.

As for the degree of change, much depends on what loss of quality you are prepared to accept. As a rule of thumb, try to avoid increasing the size by more than 50%. After resizing, the new image will almost certainly need to be sharpened (using USM, *see pages 116–117*), particularly if it has been reduced. Beyond all this, it may be that the output device, such as a

printer or film recorder, will do a better job of resampling than you can yourself.

More straightforward than resizing are the procedures for changing the area of the image that is displayed. One is cropping, which simply involves cutting into the picture, discarding some of its outer parts. The other is to increase the area of the "canvas," adding blank space to the image on one or more sides. This is an essential step if you plan to extend the image, such as by increasing the sky area or compositing with another image. Another simple dimensional change is rotation, while non-symmetrical changes are distortions, the most useful of which is perspective control.

Cropping
One of the simplest dimensional changes is to crop, and this has no effect whatsoever on the remaining part of the image—shown within the bounding box.

Nearest neighbor
This is the weakest, though fastest, method. When resampling, the quality loss is apparent in the pixel blocking and poor anti-aliasing, which is particularly noticeable in the contrasting spectacle frames. It is more suitable for artwork in the way it preserves hard edges.

Bilinear
Considerably better than the above, although with an obvious softness. This, however, can be corrected with USM sharpening, and the results in this case would be almost indistinguishable from the Bicubic below.

Bicubic smoother
Theoretically the highest quality interpolation method, this gives a result similar to a sharpened version of Bilinear. Even so, it is clear from the clumping of colors that the image would not stand much more upsizing.

LENS CORRECTION

Lens technology is improving year on year. However, as the technology improves the desire for producing zooms with a greater range, from wide angle to long telephoto, have resulted in lenses that often display geometric distortion.

Gone are the days when prime lenses were obviously superior in image quality, but it is nevertheless more difficult to correct distortion in even a high-quality zoom. On a lens with a large focal-length range, it's quite likely that there will be barrel distortion at the wide-angle end, with pincushion at the other, longer-focus end. The problem is the two distortion effects oppose each other, so while it is relatively straightforward to minimize the effect of distortion on a prime focal length lens, correcting one will increase the other in a zoom lens.

> **Producing zooms with a greater range has resulted in lenses that often display geometric distortion**

However, because lenses have individual distortion characteristics, these can be measured, even if the amount of barrel and/or pincushion distortion varies across the focal-length range. This distortion can then be corrected with software, by applying an equal and opposite distortion, effectively cancelling out the negative characteristics of the lens.

Of course, lens distortion matters only if it is noticeable, and as it is chiefly along long, straight lines that are close to the edges of the picture, this often isn't a problem with organic subjects. If it doesn't disturb you visually, there may be little point in correcting it.

To an extent, you could use one of the basic distortion filters in an image-editing program to counter a certain amount of distortion; Photoshop's Spherize and Pinch filters, for example. These, however, do not allow for the variation in the amount of distortion that occurs between the inner and outer parts of the frame, so are only beneficial when the amount of distortion is minimal to start with and an absolute result is not essential.

For greater precision, dedicated lens-distortion correction filters (again in image-editing programs) allow for the different optical characteristics of different makes of lens. The degree of distortion always increases outward from the center, but the way this progresses varies from lens to lens. Without taking this into account, you can end up with corrected straight lines at the edges but under- or over-correction nearer the center. A grid overlay is essential for measuring the effect of the filter, either in the filter window or on the applied result in the editing program—or both. Adjust the spacing of the grid so that the lines are close to those lines in the image that are most important. Image distortion is very demanding of processing ability, and final image quality depends on good interpolation algorithms.

The ultimate answer, however, is to use a dedicated correction program. These are programs that are based on the analysis of the individual lens to produce a specific profile for a wide range of lenses from an equally expansive list of manufacturers. The distortion of the lens is mapped (and, if a zoom, at every focal length),

LENS DISTORTIONS

There are two main kinds of distortion that you are likely to see in your images:

Pincushion distortion
Image bowing inward, so lines at the edges of the frame appear to be "sucked" toward the center. Most common when long telephoto focal lengths are used.

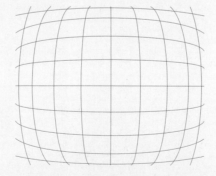

Barrel distortion
Image bowing outward from the center, so lines are pushed toward the frame edges in a similar shape to the sides of a barrel (hence the name). Most common when wide-angle focal lengths are used.

IS DISTORTION APPARENT?

Certain types of lens distortion are only really apparent if there are long lines that should be straight and parallel to one another. If the scene contains no such lines, there may be no compelling reason to do anything to the image. Natural scenery, for example, usually has no clear geometry. With the exception of fish-eyes, most lenses require a small amount of correction, so make a visual assessment first, keeping in mind that digital distortion correction does have a negative (though often imperceptible) impact on image quality.

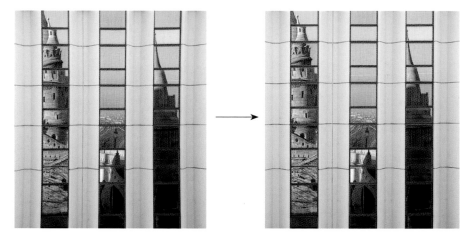

and the profile this generates is used to reverse its effect in the program. Essentially this is what software such as DxO Optics Pro does, and it is completely effective. The only drawback is that it is entirely dependent on the time-consuming analysis that the software manufacturer makes, and there is no way of adjusting, tweaking, or creating a user profile for any other lens.

Adobe, on the other hand, does allow you to build custom lens profiles, in addition to providing ones for many of the most popular lenses. The process entails printing a checkerboard PDF and shooting it at a variety of settings and focal lengths with each lens you wish to profile. These images are then converted into the DNG Raw format, and evaluated using Adobe's Lens Profiler Creator software. Once the profiles are built, they can be automatically applied on all future images with the click of a button.

The new class of Interchangeable-Lens Compacts discussed in Section One has introduced a new, digital method of lens correction. Because these cameras lack a reflex mirror, the images formed by the lens will always be seen via digital playback (either on the display screen or the electronic viewfinder). As a result, lens designers can permit a certain amount of distortion, with the intention that it be corrected digitally both in-camera (instantaneously as it appears on the display/EVF) and during Raw conversion. Because lens design is always a matter of compromise, this means (in theory, anyway) that concentration can be given to other aspects, such as compactness or sharpness. Most of the major Raw converters have the lens-correction profiles built-in, so you never see the uncorrected image; but open-source options like RawTherapee do allow you to get "under the hood" and see the original distortion.

Lens correction
This image (above left) was taken with a zoom lens set at its longest focal length, resulting in clear pincushion distortion. This is easily corrected using Photoshop's built-in Lens Correction filter (above).

FIXING LENS ABERRATIONS

Chromatic aberration, resulting in color fringing as the lens focuses different wavelengths of light at slightly different distances, and vignetting, in which corners appear darker as the light transmission falls off radially toward the edges of the frame, are two common issues with lenses beyond geometric distortion.

If you are shooting Raw images and using Photoshop for your Raw file conversion, Camera Raw's Lens Corrections panel may help. In the latest versions, you simply select Highlight Edges or All Edges from the *Defringe* tool, and the image is fixed automatically. There is also a *Lens Vignetting Amount* slider that brightens the corners when moved to the right (+), or darkens when moved left (−). The *Midpoint* slider alters the spread of the brightening effect; moving right (+) restricts the effect toward the corners, while moving left (−) broadens it toward the center.

SELECTION TOOLS

One of the first decisions in image-editing—often the first step after making simple global corrections—is to select the area that you are going to manipulate. The change may be as little as altering the color, or as great as moving the selected part to another image entirely. Because selection is so important, all image-editing programs offer a choice of different methods; certain subjects are better suited to one method than another, while personal preferences play a part. My personal preference is for working on a mask. With experience, you will be able to find your own preferences. Often, it is a case of which tool to use first, because a combination can frequently be more effective than one alone.

With experience you will be able to assess at the start which selection tool to use

Mask Painting
This image of fingers grasping rose petals, containing differences in edge softness, called for varying amounts of precision in the selection. The choice of tool for this was to paint in a mask layer, using different sizes and precision of brushes. Typically, you would start with a small brush to make the outline, then fill in beyond it with larger brushes.

	Rectangular Marquee Tool	M
	Elliptical Marquee Tool	M
	Single Row Marquee Tool	
	Single Column Marquee Tool	

Marquee tools
Restricted to fixed shape selections, so not often used for photographs.

	Lasso Tool	L
	Polygonal Lasso Tool	L
	Magnetic Lasso Tool	L

Lasso tools
Basic tools allowing freehand selections to be made; Magnetic Lasso attempts to "snap" to subject edges.

	Pen Tool	P
	Freeform Pen Tool	P
	Add Anchor Point Tool	
	Delete Anchor Point Tool	
	Convert Point Tool	

Pen tools
Known more commonly as Paths; good for cutting out clean-edged subjects, but time-consuming.

	Quick Selection Tool	W
	Magic Wand Tool	W

Magic Wand and Quick Selection
Semi-automated selection tools, which are good for selecting objects set against a plain background.

Quickmask
Not a tool, but a mode that allows the brush tool to be used to create accurate masks that can subsequently be turned into selections.

Lasso tool
In this image of a rare shell, the outline was simple enough to follow using one of the most basic selection tools; the freehand lasso. A variation of this is the magnetic lasso, which is partly automated, forcing the line being drawn toward the nearest contrasting edge.

Color range

With this image of a sorbet with wild strawberries, the object was to restore, and even enhance, the reds. This is an ideal task for the Color Range tool, which is found under the Select menu, rather than on the toolbar. Using the dropper, and adjusting the threshold (fuzziness) with the slider, it is easy to select areas of a similar color.

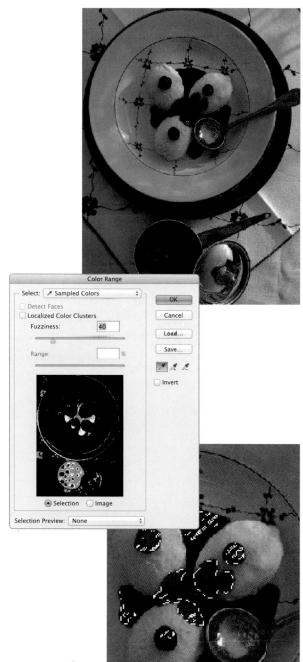

Magic Wand

The original shot of the Shwedagon Pagoda was carefully selected using the Magic Wand tool, then the selection was inverted and the rest of the foreground was deleted, to be replaced with a body of water that reflected the sky and rich, golden colors of the temple. The result gives the impression of a flooded city square, or of these magestic temples rising directly out of the sea.

Paths

For precise, clean edges, as in this Gulfhawk aircraft hanging in a museum, the tool of choice is a path. Bézier curves, adjusted by their handles, can be fitted to any complexity of curve, such as the propellers and cowling. The usual procedure is first to draw the approximate path, then return to it and adjust the handles for a precise match.

CHANNELS & LAYERS

Because colors are recorded and stored individually (red, green, and blue, or cyan, magenta, yellow, and black), each inhabits its own channel. A color image typically has three channels in the case of RGB or Lab, or four if CMYK, and in an image-editing program they behave like stacked layers, one behind another. More importantly, you can add new channels, called alpha channels, in which to store masks (this happens automatically when saving a selection in Photoshop). Channels can be switched on and off individually, both to view and to work, and are a valuable resource in professional-level editing.

Channels can be switched on and off individually, and are a valuable resource in professional-level editing

Color adjustment, as explained on the following pages, makes use of the color channels, and the two most important controls—Levels and Curves—allow channels to be selected and adjusted individually. Selecting color channels directly has only limited uses, but one that you should not ignore is that certain image artifacts, like noise and grain, are more pronounced in one channel than the others. Working just in that channel makes it easier to make corrections, with less interference to the rest of the image.

Masks are held in the alpha channels, and apart from working on them as already described (*pages 98–99*), you can make different masks interact by combining their channels in various ways. For instance, two or more masks can be added together, or one mask can be subtracted from another, or they can intersect. In this way, masks for different parts of a picture can be created individually and then combined.

The only drawback to channels is that they take up space, according to how much pixel information they contain, and as memory and storage are always likely to be at a premium, you will often have to weigh the

Layers
Layers, a vital component of any good image-editing program, are self-defining. Different images or parts of an image can inhabit different layers. The entire image behaves as if you were viewing it from above, with the layers superimposed. The usefulness of layers lies in keeping the images separate for editing, although it is usual to collapse, or "flatten," them for displaying or transmitting the finished image.

CHANNEL CALCULATIONS

Channels can also be used in a mathematical way, by combining them according to the numbers. This means performing the same operations described so far, not by eye but by typing in percentages and other values. Being counterintuitive, channel calculations are understandably not very popular with creative workers, least of all among photographers—most of us prefer to see what we are doing. They do, however, score highly on precision and reproducibility, and for these reasons have a place in illustration and artwork. Two requirements are that the images are identical in size and that all the files are open.

advantages of channels against the disadvantages of slower operation and occupied disk space. Not all file formats preserve channels, although TIFF, PICT, PSD, PDF, and DNG do.

Layers need less explanation: they are a convenient working method in which different parts of a picture, and effects, can be kept separate until everything is finished. As the illustration shows, they are stacked vertically like sheets of film and are transparent until something is added to them. The entire image is the effect of looking down through them from the top. They are optional in that an image straight from the camera or scanner consists of just one base layer; if you want to add a new picture element, you can create a new layer and place the element in it.

The advantage of working with layers—and in some programs you can add hundreds—is that you can continue to adjust each one until you are satisfied with the overall result. Each layer affects only those underneath, and you can change the stacking order; each layer can also be made more transparent if wanted. Layers are virtually essential for compositing, and have every advantage except that they increase the size of the file. They are accepted by even fewer file formats than are channels (Photoshop layers can be saved only in TIFF, PSD, and PDF), and the normal procedure is to flatten the image (that is, combine all the layers) when the work is finished. However, if you have plenty of storage space, it is as well to save a "work file" of the still-layered image somewhere you can access it easily.

RGB

Green channel

Red channel

Blue channel

Channels
A color image contains either three or four channels, one for each color component, depending on whether it is RGB, Lab, or CMYK. Each of these channels can be edited individually. In addition, any number of alpha channels can be created, to hold selections.

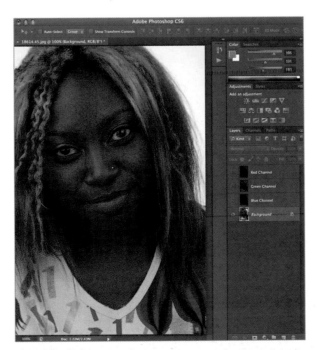
Channels window

COLOR ADJUSTMENT

O ne of the beauties of a digital image is that its colors can be altered in any imaginable way, subtly or radically. All full-strength programs offer a number of ways of adjusting color—perhaps too many. You can apply these to the whole image, or to a selected part of it. The controls are described on the following pages.

There has never been complete agreement on the range of colors and how they work

We live with color all the time, and without thinking about it find it simple and intuitive. In fact, it is complex and its nature is disputed, not least because it is only partly an optical matter, partly to do with perception. Throughout the history of art there has never been complete agreement on the range of colors and how they work. Color adjustment means that we have to go back to the complications of color models, modes, and spaces (*see pages 64–65*).

The three main modes for a full-color image are RGB, CMYK, and Lab. There are arguments for using each of these, but remember that what you see on the screen is RGB; displays are true to RGB mode, but not to the others. Also, as we saw on pages 64–65, the color space of each of these is different, and while you can switch from RGB or CMYK to Lab without losing anything, switching the other direction will throw away color information. Also, each has a few colors that are impossible for the other. As a rule, try to stay in the mode in which the image was created; it will be easier.

Despite all the scientific talk of modes and gamuts, the primary tool in color adjustment is your own judgment, and most of the process has to be done by eye. They are, after all, your photographs, and only you can say how they should look. As long as you trust the accuracy of your monitor display, the first step is to assess the basic image. Does it look too dark or too light? Is there a color cast? If so, is it one you want, or not? Three useful tools available in the Levels and Curves dialog boxes are the white-point, black-point, and grey-point droppers, which make automatic "corrections." Even if you don't end up choosing their effect, they give a good preview.

WHITE, BLACK, AND GRAY POINT BALANCE

Click a part of the image that you think should be a pure white with the white-point dropper and the brightness range will be adjusted accordingly (a refinement is to change the value of the dropper to a few points less than 100 percent, for photographic realism). The same goes for pure blacks, but be aware that most shadows are far from black. Also useful is the gray-point dropper—use it to click on any area that should be neutral (it doesn't matter whether dark or light) and the image will be readjusted around that as a gray tone.

Gray-point dropper
The original photograph of Shaker buildings in the fog at Sabbathday Lake, Maine (above) has a pronounced blue cast from a clear sky over low fog. While this is, in its way,

attractive, it can be corrected by selecting the gray-point dropper and clicking it on one of the wooden walls (below). This automatically adjusts all three curves in an RGB image, as you can see from the breakdown to the right.

An even more powerful ability is that of altering colors in just part of the photograph. For this, simply make a selection in one of the ways described on pages 98–99. The selection can be a physical object in the picture or, more usually, part of the scale of color or tone—say, on the highlights, the mid-tones, or the greens.

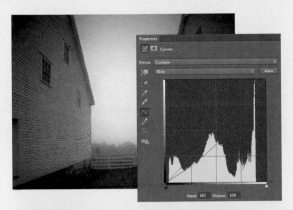

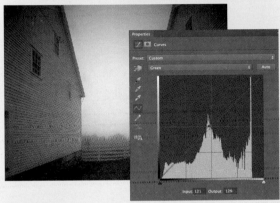

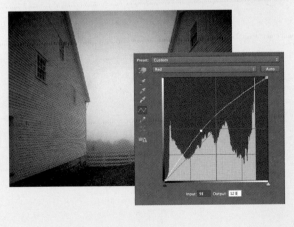

READING THE IMAGE

Conventionally, a densitometer is a highly specialized piece of equipment. In the digital world, however, it costs nothing and can be very useful indeed. You can check, for example, how deep the shadows are in a picture, and how pure the highlights. Typically, once you have opened up this tools window, it will give you a running read-out of the pixels where the pointer is, and for each channel, so that you can measure the color. What gives it special value is that it works independently of the monitor. A deep shadow may look black on the screen, but can in reality be weaker than you want it. Another useful help is employing Photoshop's Threshold command to reveal the highlights in an image.

Changing colors

Among the procedures available for making strong changes to color are the hue slider in HSB, the channel mixer control, and Replace Color, which performs two operations in sequence: a selection and then a hue change. Choose the subject carefully before applying this kind of gross alteration. In this case, the girl was first selected and then held back from the changes.

TONAL ADJUSTMENT

There are numerous ways of adjusting the tonal values in an image, some of them simple, and some that are far from intuitive. The basic methods are often one-click auto options, which may remove complexity, but they hide the fine controls that allow any delicate manipulation and don't always produce a great result. So, for greater control, it is certainly worth exploring the more advanced options.

It is worth the effort of mastering the controls that work on the histogram and characteristic curve

A histogram is not the friendliest of devices, but it is extremely valuable for judging the dynamic range of an image, from shadows to highlights. Essentially, it is a map of the tonal values—overall and by individual color channel—and like a map is easy to read with practice, despite its confusing first appearance. The range of tones is laid out horizontally like a cross-section in 256 steps, the height of each column representing the predominance of that particular tonal value in the picture. For a positive RGB or grayscale image, the shadows are on the left and highlights on the right, with the mid-tones spread out across the middle (obviously).

Adjusting the histogram (using Levels in Photoshop) by means of sliders underneath alters the brightness or contrast. The center slider changes the overall brightness, while closing in the sliders at the ends increases the contrast. Doing this to individual color channels alters color brightness and contrast. Opening the histogram is a useful first step in assessing an image, and if there is empty space at either end, closing in the end sliders will increase contrast without losing information.

As an alternative, there is the Curves tool, which is perhaps the most sensitive and powerful of all tonal and color adjustment methods. By pushing or pulling the initial 45° line, you can change anything. Dragging a point on the diagonal line upward increases brightness; downward decreases brightness; and to increase contrast, make an S-shaped curve (dipping down on the left and sloping up on the right). In other words, you can alter the tonal values of any image at will.

Many image-editing programs have started to include tools that fall somewhere between the advanced and the basic, such as Photoshop's Shadows/Highlights tool. Operated by sliders, it is certainly less daunting than Curves, which requires a very delicate touch to achieve any degree of precision. Used carefully, Shadows/Highlights can be highly effective in recovering detail from the extremes of the tonal range, as well as enabling you to manipulate the mid-tones to improve the overall tonal gradation.

HISTOGRAMS

The histogram of any picture tells you exactly how its tones are distributed. The left image is deliberately low-key, with its tones pressed against the left. The center shows a normal scene with a full tonal range, while the right image, mainly whites, is biased towards the right.

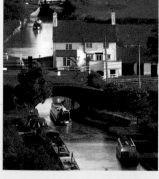

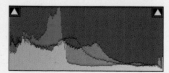
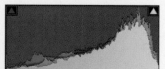

WORKING DIGITALLY

SHADOWS/HIGHLIGHTS

*Although the Shadows/
Highlights tool was designed
to aid the recovery of
highlight and shadow detail,
it can also work well when
used to control mid-tone
contrast, both globally across
an entire image, or locally,
after smaller selections
are made.*

*In this image, detail in
the shaded foreground has
been drawn out, while the
reflected highlights in the
background have been made
less intense and warmed
slightly. The key to using
Shadows/Highlights is to start
at the top of the dialog and
work your way down, going
back where necessary to fine-
tune the result.*

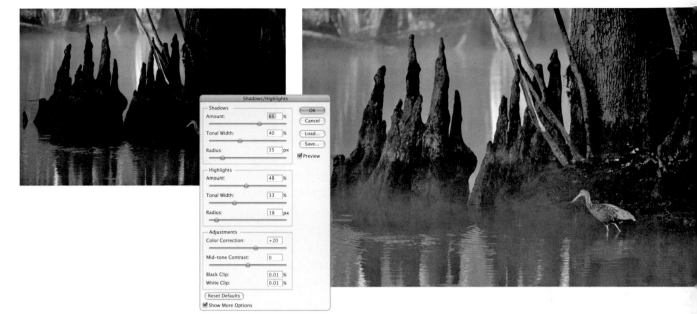

RESTORING A FADED PHOTOGRAPH

Density and color
*Maximum density has lowered
(weak shadows) and the overall
color shifted (towards red), in
this 20-year-old transparency.
With the Curves control, use the
dropper to analyze where on
each of the individual curves
different parts of the image lie.*

Separate curve adjustment
*The key is to adjust each
color channel individually.
Red shadows need strong
reduction, while blue shadows
need to be clipped entirely.
Finally all three together are
tweaked, above.*

CLONING

By the use of a very simple principle—copying from one part of an image to another—one particular digital tool has brought a small revolution to photographic retouching. All serious image-editing programs have a version of the Clone tool, so-called for its ability to reproduce paterns of pixel. First, select with the cursor the point on the image from which you want to copy (holding down a particular key); next, move the cursor to the area you are going to change, and begin applying. The simplicity of the tool belies its powerful effect, as the operation allows, in a small number of brush strokes, the removal of an unwanted object from a picture, replacing it with something that looks realistic.

Photographers tend to rely on both the old and the new tools when it comes to detail

However, as revolutionary as the cloning stamp tool is—and it really was a revolution when it put an end to painstaking manual retouching of prints or film—most image-editing programs now have far more sophisticated versions of the tool. Instead of deciding on the area you want to copy from, you can instead just click on the area of the image that you want to remove. Powerful processing algorithms will assess the target area, and the areas immediately surrounding it, and the program will "intelligently" remove whatever blemish was there. For removing dust marks in a flat sky this is all well and good, with little more than a nonchalant click of the mouse often all it takes to remove a blemish.

DIFFERENT STROKES FOR DIFFERENT TEXTURES

In preparing to clone, look at the textural qualities you will be working with, and adapt the brush to suit them. The two scales that will most affect the operation are from soft to precise, and from random to ordered. While this is by no means a rule, try a soft-edged brush and some transparency for softer textures like clouds, but a harder edge and 100% opacity for precise ones such as the wooden wall below. For random textures like the leaves of a tree, Nonaligned mode and repeated applications may help keep an irregular appearance, while an ordered texture such as bricks may be better copied in Aligned mode—and carefully positioned to match the pattern.

THAI HOUSES

A cut-off image
The scanned original of these Thai houses was shot with a special wide-angle lens that can be shifted for perspective control, but one unwanted by-product was black masking in the corner. Cropping it out would also have lost part of the houses.

Setting the brush
Because the original image was a large-format transparency, scanned to high resolution, a particularly large brush was needed. The radius, measured in pixels, and the hardness, were first adjusted, then cloning commenced (above).

No automated system is flawless though, and when it came to areas of detail, or hard, high contrast transitions, these "intelligent" retouching tools (the Healing Brush tools in Photoshop) would often replace the spot being targeted with a meaningless smear as the algorithms simply failed to identify the detail correctly. Photographers found themselves relying on both the old and the new tools—the intelligent options for the simple removal of a mark surrounded by an area of continuous tone, and the more manual cloning stamp when detail needed to be preserved.

Since the advent of Photoshop CS5, Adobe has overhauled its Healing Brush tools and it is now accompanied by a Content-Aware Fill feature. The addition of those two words—content aware—is a significant one as, once activated, the tool becomes far more powerful, especially when it comes to removing objects from an image.

Traditionally, if you wanted to remove a person from an image who was standing in front of a detailed background, it would require a lot of work with the Clone Stamp tool to ensure a seamless finish. Content

Aware Fill makes it possible to simply select that person (using, say, the Lasso tool), then go to Edit > Fill, set the Use: dialog to Content Aware, click OK, and watch as the computer fills in the selected area with intelligently sampled sections of the surrounding area.

Content-Aware Fill
After simply selecting the area you want to remove, Content Aware Fill takes care of the rest, without you having to indicate the specific area from which it should clone the fill. It doesn't work with all images, but it is well worth trying out yourself.

Angle of attack
Because of the diverging floorboards (courtesy of the wide-angle lens), the angle of aligned cloning needed to be altered with almost each stroke. The orange arrows above show the different angles diagramatically. The relative consistency of the floorboard texture made the cloning operation fairly simple, and certainly effective (right).

GO WITH THE FLOW

Pay attention to the alignment of various elements in a texture, and maintain these with your brushstrokes, changing direction as necessary and reselecting the source frequently. Using many short strokes often assists a realistic effect, as does varying the size of the brush, starting with a large size and finishing up with a smaller one.

BLACK & WHITE

The black-and-white print has always been a vehicle for displaying the craft of image-making, not least in fine-art photography. Darkroom skills, with their emphasis on image control, have played an essential role in black-and-white photography. Digital imaging is now usurping traditional expertise because of the possibilities it offers for even finer control over the image, but this has not meant that the craftsmanship involved is any less. The techniques are new, the process not as messy, but the judgment and eye of the printmaker stay the same.

> **Digital imaging is now usurping traditional expertise because of the possibilities it offers for even finer control over the image**

Grayscale mode is designed for black-and-white images and, because it discards color information, it occupies one channel only. File sizes are correspondingly smaller than RGB or CMYK, and in general you might say that this is a simpler operation all around as the only two adjustments that can be made to an image are tone and contrast. However, simply converting an image from color to grayscale often produces unsatisfactory results, as does using the Desaturate command. The reason for this is both options assign equal values of red, green, and blue to each pixel, offering little in the way of control. A far more sophisticated option, found in Photoshop and many other image-editing programs, is to perform a black-and-white conversion that enables you to control how individual colors are treated when the image is converted.

In the past, this is something that would have been achieved by using Photoshop's Channel Mixer, allowing the bias of the red, green, and blue channels to be manipulated in a way that emulated on-camera color filtration. More recently, however, Photoshop has included a dedicated Black & White tool that not only allows the red, green, and blue values to be adjusted, but yellow, cyan, and magenta also, providing a high level of control over the B&W conversion. In addition, there are a number of preset options that are designed to recreate "classic" black-and-white effects: red, yellow, green, and blue filters; neutral density effects; and even black-and-white infrared.

Another way of getting more out of a black-and-white image is to tone it. At the very simplest, this means applying a subtle color, such as sepia or a dull gold, but if you apply different colors to different parts of the tonal range you can achieve more complex, deeper effects. This is known as split toning, in which different toning colors affect different densities of the image. A commonly used color-combination is warm (sepia) highlights with cool (blue) shadows to provide color-contrast in an otherwise monochromatic image.

SEPIA TONE

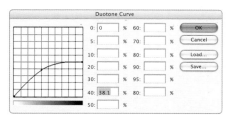

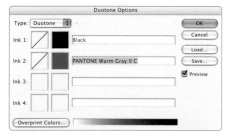

Grayscale original

In this grayscale image of a ruined Cambodian temple, there is a reasonably full range from shadows to highlights, yet it has just 256 tones in digital form.

Duotone conversion

To improve the tonal depth and range on the printed page, the same image is converted to a duotone, with a warm gray ink chosen as the second color. The duotone panel's curves control allows the two inks to be concentrated in different parts of the tonal range— black for the shadows and gray for the mid-tones.

BLACK AND WHITE TOOL

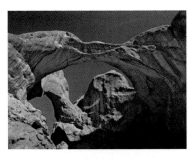

Default
At its default setting, the Black & White tool provides a straight conversion from color to black and white that doesn't favor any one color in the original image. This is similar to using the Desaturate command.

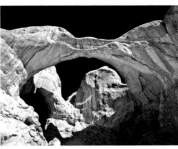

Dark red
Using a high red value is similar to using a dark red filter over the camera's lens. This is a traditional black-and-white filter effect that darkens blue skies, sometimes turning them black.

Color original
Many Black & White tools (as found in Photoshop and Lightroom) allow you to specify which colors to brighten or darken when converting a color image to black and white.

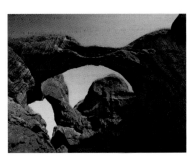

Strong blue
A high blue value cancels out blue in the image, so the sky becomes much lighter. Conversely, the yellow tones in the rocks become darker.

SPLIT TONE

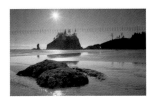

Grayscale beginnings
The starting point is a grayscale high-contrast image of a Washington beach photographed into the sun.

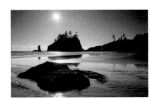

Blending the layers
For even more variations, the balance between the differently toned layers can be altered according to taste. By using the layer blending controls, the warmer tones of the upper layer have been held back from the upper highlights and lower shadows so as to produce a more subtle result.

Convert to RGB
The first step is to convert the image to RGB. These three channels are now available for color adjustment. In one layer the shadows are made cooler, and in a second adjustment layer the highlights are made warmer.

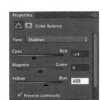

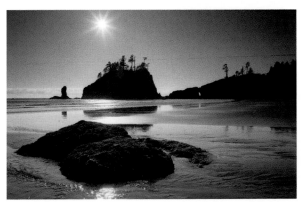

WORKING DIGITALLY

109

COMPOSITING: THE ILLUSTRATOR'S SKILL

A the heart of serious digital manipulation is the combination of different images, a tradition that goes back almost to the beginnings of photography. Anyone who believes that combining photographs is a child of digital imaging should look at the work of Man Ray in the 1920s and '30s, and Angus McBean and Clarence John Laughlin in the 1940s. It seems that the urge to play with our perceptions of reality has always been there; digital imaging now makes it possible to do a perfect, seamless job.

In nearly all photographic compositing, the images should blend together in some kind of relationship

For obvious reasons, layers are ideal for compositing, but the procedure draws on all the techniques that I have just described: selection, scaling, color adjustment. But it also needs the ability, which is much less easy to pigeonhole, to see how different images might work together. This needs an eye for perspective, lighting, and the many subtle qualities that give a photograph its character, for the ultimate success depends to an extent on your choice of images. Color values are easy enough to adjust, but lighting is not. Look at the direction and strength of shadows; if they do not match, it may be extremely difficult to retouch them. Beyond all this, compositing calls for imagination—experimenting is all very well, but for an effective composite you should have in your mind a fairly good idea of how it should finally look.

As we are dealing with photography, I will bypass the common kind of composite in which objects are simply laid down in isolation and at different scales, as

ANALYZING THE COLOR RANGE

One giveaway in a badly composited image is that the elements have color values that are obviously different, perhaps because of different lighting conditions, or they were shot using different cameras or film. These can usually be adjusted, and a rough aid is to convert a copy of each image into indexed color mode, choosing the local palette, which finds the 256 most common colors in that image. Then open its color table to view these.

Similar tones
If, for example, you were looking for a landscape and sky background against which to composite this head, the palette analysis for each shows that they would match reasonably, though with fewer reds in the landscape (this could be adjusted).

STILL-LIFE CONSTRUCTION

Ingredients
The two main elements are a bowl of noodles and Japanese kelp, each selected.

Brush shadow
Inverting the kelp selection, an airbrush is used for a delicate shadow.

Paste behind
The bowl is pasted behind a partial selection of the kelp.

Select soy sauce
Droplets of soy sauce are selected and then pasted under the kelp, as shown in the final image on the right.

in a catalog. That is really a page-layout technique. In nearly all photographic compositing, the images should blend together in some kind of relationship, and in a realistic comp the blend must be seamless. Achieving this complete believability is a matter of skill.

Of the different methods of combining photographs, ghosting is the easiest. In this, one of the images is made slightly transparent, so that the other, full-strength image partly shows through it. Apart from conceptual photographs (for example, a sequence of a figure walking or running, ghosted and overlapping to show motion), the photorealistic reasons for needing this generally revolve around atmosphere, as in the image here of the moon. Place the image, masked as necessary, in its own layer and either adjust the overall transparency or use the blending controls.

Fading is another method; in this, one image blends very gradually into another, usually on one side. If the effect is meant to look artificial, as it usually is, all you need to concentrate on is a smooth and elegant blend. The normal technique is to fade one of the images to complete transparency, using the gradient tool. Either

apply the tool directly (to a duplicate of the image for safety), set to "Foreground to Transparent," or for more control make the gradient in a mask layer.

Most realistic combinations, however, call for a clean comp, and this relies very heavily on good edge control, as described on pages 172–173. Following this, think through the logic of the combination to see what else is needed to help an added object sit more realistically in its surroundings, especially whether there should be shadows or reflections, or both.

MOON BEHIND CLOUDS

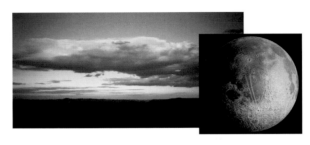

Two elements
Dusk over the Catskill mountains in New England, and a NASA model of the moon.

Paste moon into one layer
A selection of the moon is placed in its own layer, over the background for positioning (below).

Cloud layer to the front
The layer order is reversed, and the two layers blended to weaken the moon.

Retouching
A duplicate background layer is selectively brushed in to strengthen the clouds for the final result (below).

PANORAMAS

The enduring appeal of the panoramic photograph, which traditionally needed a special camera able to create a wide, long image, lies in its all-embracing character. It is the view from an overlook, the sweeping vista, and very much a part of landscape photography. Digital imaging has revived it by simply removing the need for a special camera; software can now construct a convincing panorama from a sequence of regular frames.

The beauty of this is that it needs no planning, no special equipment to carry around, just a reasonably steady hand

The procedure is known as stitching, a variety of compositing in which photographs taken from left to right (or vice versa), overlapping slightly, are joined side by side. It can be done automatically with a special program, and ideally with the original shots taken using a dedicated camera mount. Panoramas are now a feature of many digital cameras, with stitching software such as Canon's Stitch Assist, and Photomerge tool included in Photoshop and Elements. Other specialized stitching software includes Apple's QuickTime VR, Realviz Stitcher, Live Picture's PhotoVista, Roundabout's Nodestar, PanoramIX, Orphan Technologies' PanDC, and VideoBrush Photographer. Photosuite and some camera software also let you stitch vertically, to simulate wide-angle views. Most software will make a passable job of stitching handheld photographs, provided that they are more or less in a line and that there is sufficient overlap for the program to recognize the same features in adjacent images. The beauty of this is that it needs no planning, no special equipment to carry around, just a reasonably steady hand. Nevertheless, for precision, a panoramic head is better. This graduated rotating attachment fits between the camera and the tripod head, and allows you to make consistent steps between the pictures. The alignment is always better with a longer focal length of lens, because there is less distortion toward the edges of each frame, and the mount should allow rotation around the optical center of the lens—its nodal point.

SPECIAL REQUIREMENTS

- A rectilinear lens, as most are, but fish-eyes are not: straight lines in the scene appear as straight lines in the image.
- The camera stays completely level as you rotate it.
- The camera rotates around the optical center of the lens.
- Images overlap by 50 percent.
- Exposure stays the same for each image, not adjusted automatically. A cloudy bright day is easier than bright sunshine.

Dedicated tripod head
This Manfrotto tripod head has a precisely measured rotational unit at the bottom, a system of sliding rails to accurately position the lens' nodal point and avoid parallax issues, and an L-bracket so the camera can be shot in vertical or horizontal orientations.

A purely digital invention that takes panoramas beyond all of this is immersive imaging. Here, the stitched panorama is intended to be viewed on-screen as a kind of film in a window of normal proportions. By means of left and right buttons, or a slider, or by placing the cursor on the image and dragging it, you can pan from side to side. These immersive panoramas, so-called because they give an interactivity that helps the impression of being inside the scene, have been given a boost by the Web, which is an ideal medium for showing them. 360-degree panoramas are common, while the professional and expensive IPIX system delivers a complete sphere-like image. For output, some systems provide their own viewers, which can be a limitation when posting movies on the Web; the most popular viewing format is Apple's QuickTime VR (QTVR), available for Mac and Windows.

Scene photography, as it is called, is just one aspect of immersive imaging. Its reverse is object photography, in which an object rotates in precise steps in front of the camera. This is then converted into a movie in which the viewer can observe the object from different angles at will—perfect for museum pieces and, more commercially, products offered for sale online.

Layout types

You'll be presented with a number of different ways of combining the images into various layouts, but the Auto function typically works very well in figuring out the intended effect.

Arranged as layers

Once the processor finishes chewing through your files (which can be a lengthy process depending on the number of files, their size, and your processor's speed), they'll be arranged each as a separate layer in Photoshop, where you can fine-tune the alignments.

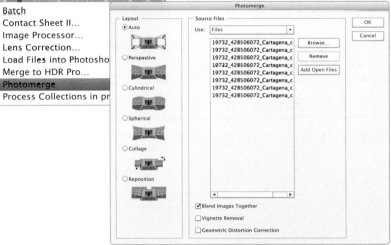

Photomerge

Once you've taken your shots, assembling them into a panorama is easy and largely automated in Photoshop. Simply select the images in Bridge, then use the Tools > Photoshop > Photomerge function.

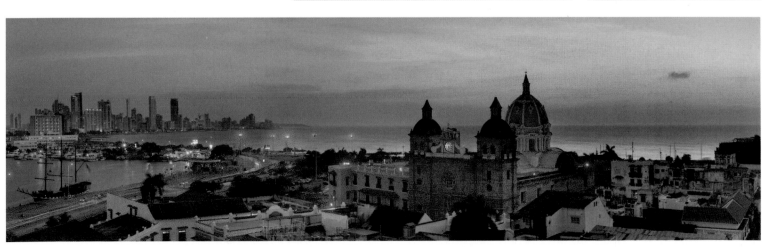

HIGH DYNAMIC RANGE

Despite rapid and significant improvements in the design of sensors, the issue of their limited dynamic range is still a significant one. Although manufacturers are now building in ever-more sophisticated systems that attempt to resolve the problems of recording high contrast scenes, it is still the case today that much of the work needs to be done beyond the camera, using software to resolve this technical issue.

The limited dynamic range of sensors is still a significant issue for the photographer

The main problem is that the majority of 12-bit sensors will record a maximum dynamic range of around 1,000:1, once noise has been taken into the equation, which is the ratio between the lightest and darkest areas in an image that will reveal detail. While this may sound quite high, an outdoor sunlit scene containing bright highlights and deep shadow areas can easily have a dynamic range in the region of 2,500:1, while an interior with a view to a sunlit exterior could have a dynamic range of 5,000:1. If the sun is in shot, these ratios will be significantly higher. Both clearly exceed the dynamic range of the sensor, which means images will suffer from clipped highlights and/or blocked up shadows. There is, however, a solution to this: high dynamic range imaging, or HDRI.

The HDRI process requires implementation at both the shooting and post-production stages to get the best results, and begins with the photographer shooting a series of exposures of their chosen scene or subject. The aim is to ensure that detail is recorded in every part of the scene in at least one of the frames in the sequence, so the exposure is adjusted between shots. Typically this will start with an exposure that reveals detail in the brightest highlights, with the exposure reduced gradually as the sequence is recorded, until the final image records detail in the deepest shadow areas. Or vice versa. Adjustments of 2EV-steps between exposures are usually sufficient.

Once the sequence has been recorded, the images are then imported into a dedicated HDR program, or an HDR tool in an image-editing program, where they can be combined into a single image that contains the full dynamic range of the scene. Most HDR programs use 32 bits per channel to produce these images, but this is essentially unviewable due to the limitations of the display media; most monitors are 8-bit devices and can display a dynamic range of little more than 350:1, while printing paper has a dynamic range of just 100:1. As a result, this means the HDR image has to go through a second process to reduce the high dynamic range, but without losing the detail at either end of the tonal range. This is achieved through a process known as tone mapping.

Full Tonal Range

For this church interior, a three-shot sequence proved sufficient in recording the full tonal range. The difference between each of the exposures was two stops: the first exposure was made for 1 second at f/32, the second for 1/4 second, and the third for 1/15 second. It is important to note that the shutter speed should be adjusted, and not the aperture.

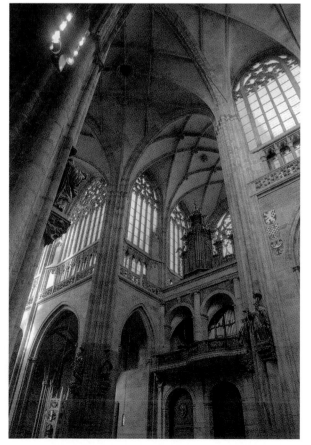

As its name suggests, tone mapping involves reassigning the tones in a high dynamic range so they fit within the limits of low-dynamic-range output devices. Each piece of HDR software uses its own algorithms to achieve this, with some offering far greater user-involvement than others. Photoshop's HDR tools, for example, are relatively primitive compared to those in a dedicated HDR program such as Photomatix Pro, which allows much greater control over how the tonal range is redistributed.

Once tone-mapped—which can be a frustrating and unpredictable experience without practice—the image can then be output as a more conventional 8-bit or 16-bit file for further processing or printing.

CREATING AN HDR IMAGE

1 *Using Photomatix Pro, the first step in the HDR process is to select your images by choosing* HDR > Generate *from the menu. When the dialog opens, use the Browse button to locate your images on your hard drive.*

2 *Photomatix will access your chosen files and try to determine their respective exposure values based on the EXIF data. You can correct this manually if you need to before pressing OK so the program can combine them as a single HDR image.*

3 *The next step is tonemapping, which is accessed by choosing* HDR > Tonemap. *Using the preview as a guide, you can make a variety of adjustments to the image to extract detail throughout the tonal range. When you are happy with the result, you can click Apply to apply the tonemapping and output your final HDR image.*

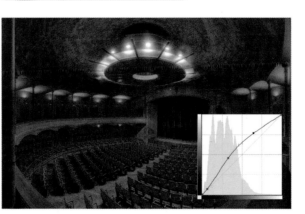

4 *With this image, the post-processing involved cropping the image, applying a curve to lift the mid-tones, and then subtly adjusting the Shadows/Highlights in Photoshop.*

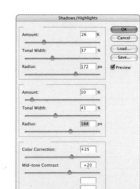

SHOOTING TIPS FOR HDR

• Taking a spot-meter reading from the brightest highlight area in the scene and another from the darkest will give the two extreme ends of your exposure range.

• A two-stop increment between exposures is sufficient: a single EV step will mean you take more shots, but this will not mean more detail in the final image.

• Always adjust your exposures using the shutter speed only, rather than the aperture or ISO. Using the aperture to change the exposure will alter the depth of field across your image sequence, which will result in unusual artifacts appearing when they are combined.

• As the shutter speed is being adjusted, static subjects work better than moving ones for HDR images. If elements move between frames, then "ghosting" is likely.

• Although most HDR software will try to align your source images, it is often preferable to ensure they match when shot. This means mounting the camera on a tripod to avoid misaligned frames.

SHARPEN & BLUR

The workhorse filters of digital imaging are those that give sophisticated control over image sharpness, or lack of it, well beyond the abilities of optical filters. In photography as it was, sharpness was never an issue—simply, you could never have enough. In practice, photographers didn't express it like that, because only two factors controlled it: lens and film. If you could afford it you would have had the highest resolution lens, while with film the compromise was speed: The price for the best resolution was slow response. In either case, few photographers wanted anything but the sharpest image. This, after all, kept medium- and large-format photography thriving long after the sell-by date.

Now, digitally, you can sharpen any image—not just as much as you want, but more than you want

Now, digitally, you can sharpen any image—not just as much as you want, but more than you want. The sharpness of an edge depends on how abrupt the transition is from light to dark, or from one color to another ("acutance" in textbook photography). A basic Sharpen filter simply exaggerates the difference in brightness between adjacent pixels. Sharpen More is an option offered by many editing programs; it just increases the difference. However, this is an unnecessarily crude way of going about things, and I recommend never using either of these. Instead, the sharpening filter of professional choice is the Unsharp Mask.

Its name may sound contradictory, but it comes from a long-established technique used in the printing industry for sharpening detail without affecting smooth-toned areas. In the old-fashioned—and infinitely more time-consuming—way, a slightly-out-of-focus lith copy was sandwiched with the films. The digital version hunts for edges in the picture—line boundaries of pixels that contrast with the pixels on the other side—and applies the sharpening only there. Areas between the edges, which by definition are relatively smooth, are left alone. In practice, the USM filter, as it is usually called, gives you control over this. In the dialog box you can choose not only the strength (Amount) but also the distance from the edge that will be affected (Radius) and how different the edge pixels need to be from their neighbors before the filter gets to work (Threshold).

The occasions for sharpening are many, not least because different outputs call for different degrees of sharpness. You can judge on-screen results and those from your own printer by eye, but if you plan to send the image to a service bureau or repro house, check with them first. It may be that they will want to control the sharpening themselves, and may prefer an unsharpened image. Any significant resizing, up or down, together with distortions and effects, invokes interpolation automatically (*see pages 94–95*), and calls for sharpening afterwards. Always apply sharpening last of all, and if you apply USM in several small amounts rather than all at once, the effect will be smoother.

Blurring calls for less refined judgement than does sharpening because it throws image information away. Usually, as with sharpening, there are three standard varieties: Blur and Blur More, which reduce contrast between neighboring pixels, and the more controllable Gaussian, which is the filter of choice. The Gaussian filter blurs the mid-tones more than the highlights and shadows, and allows you to set the Radius. Specialized blurring filters such as Motion, Radial, and Spin are really effects filters (*see pages 120–121*). Selective blurring is useful in retouching to obscure blemishes, to reduce the apparent depth of field by blurring the background or foreground, and as an aid to smoothing blends.

ALLOW FOR IMAGE SIZE

Sharpening depends on resolution and image size. In a 10MP image, for example, the pixels are relatively smaller than in a 1MP version, and so need a larger Radius setting, and often a greater Amount.

Too much of a good thing
Looking at the far-left image, you'll learn to resist the temptation to oversharpen. The bright edges are clear evidence of this, and 200% is usually extreme.

Better amount, wrong radius
As seen in the middle image, 100% is better, but possibly too little. The slightly blocky effect shows that the radius is too high.

Optimum settings
For the far-right image, these settings work well, with the Threshold increased to protect texture in flat areas that don't require any sharpening.

THREE-PART PROCESS

One obviously expects that sharpness is generally always a desirable element of each and every photograph (notwithstanding Henri Cartier-Bresson's famous quote that "sharpness is a bourgeois concept"), so it will likely surprise you to hear that the vast majority of digital cameras contain a filter—called an anti-aliasing or optical low-pass filter—that sits directly on top of the sensor and intentionally blurs the image before it is even recorded. Counterintuitive as this is, the purpose of this blurring filter is to prevent the introduction of digital artifacts into your images, in the form of either aliasing (where gentle curves are incorrectly recorded as abrupt steps) or moire (repeating patterns in design or fabric that exhibit color shifts) that are created when the separate RGB pixels are demosaiced and interpolated to create a full-color image. It's a necessary step, but one that has to be corrected as soon as the image appears at the other end of the image-processing pipeline. If you are shooting JPEG, the camera's processor is automatically sharpening (to varying degrees, depending on your settings) the images very slightly as they are saved in the file format. If you are shooting Raw, however, the image that you open in your Raw converter will likely look noticeably soft if you zoom in 100% and evaluate fine details.

It's at this point that you need to perform what's often called "capture sharpening," which is a very small amount of sharpening within your Raw converter. This is a standard step in the Raw conversion process, such that many Raw converters automatically apply it as you open the image—but you should check that those automatic settings are optimal in any case.

The next stage of sharpening requires taking a step back and evaluating which particular areas of the frame could use selective or "local" sharpening. Not every image requires this, but many do have one or more particular elements that, when sharpened, can enliven the overall image and add a welcome dimensionality to the image.

The final stage is "output sharpening," and will depend on whether you intend to print or display on the web. At low resolutions, images destined for the screen need only a small amount of sharpening, and can be evaluated directly on your monitor. Those destined for print, however, often require a significant amount more sharpening, so much that it can even look oversharpened on the screen, even if it looks perfectly crisp once printed.

WORKING DIGITALLY

HIGH-ISO SHOOTING & NOISE REDUCTION

In a perfect world, we would never miss a shot due to low light levels, being able to shoot with confidence at any ISO whatsoever, which would then allow us to concentrate on the more creative exposure settings of aperture and shutter speed. While, of course, we aren't living in a perfect world, the technological advances of our imaging sensors does mean that we can shoot at remarkably high ISOs that were simply unheard of in film, and even in the digital age of just a few years ago. The majority of current DSLRs and large-sensor compacts output perfectly usable ISO 1600 as standard, with many models able to reach a stop or two higher (with the professional models pushing the threshold even further).

It is not enough to simply leave your camera set to Auto ISO and never look back

That said, it is not enough to simply leave your camera set to Auto ISO and never look back. High ISOs have their place, and it is not everywhere. Without exception, image quality degrades with higher ISOs—even if noise levels are kept low, dynamic range drops, color fidelity falters, and fine detail is lost. Often these are perfectly acceptable tradeoffs—it's better to have a noisy image than no image at all—but you do yourself no favor to pretend that these tradeoffs do not exist. The key is to understand whether or not they are acceptable for your particular shot, and if they are, how to manage them for optimal image quality.

Generally speaking, genres like studio portraiture and landscape are strictly a low-ISO game. For one, image quality is paramount—you want to see every fine detail in your landscape, and you want the colors and tones of your subject's face, eyes, and clothes to be brilliant and accurate. And besides that, you have much more control over the lighting conditions anyway, either by the use of photographic lights (in a studio) or the use of a tripod (for landscapes). High-ISO shooting, then, is more suited for (though not exactly limited to) street shooting, photojournalism, and sports—situations where movement or unpredictable action forbids the use of a tripod, and low light levels are unavoidable. Other tools available to you in such situations are a fast, wide-aperture lens, possibly stabilized (either in the lens itself or on the sensor), and the use of an external flash unit, though the latter is not always effective (for faraway subjects, for instance) or appropriate (as it can disturb the subject), and the former can be quite expensive.

It's worth noting that there is another, lesser-known type of noise called long-exposure noise, which results from (as you might guess) exposures with exceptionally long shutter speeds, and the heat build-up that results from their use. It is also known as fixed-pattern noise, because rather than a random distribution of noise artifacts, the noise appears as a series of particularly "hot" pixels. Most cameras offer a long-exposure noise-reduction feature, which will follow each long exposure with a second exposure of total darkness (with the shutter closed). The second exposure will record only the hot pixels, which can then be isolated and extracted from the previous exposure. In practice this works very well, and you will not often need to worry about long-exposure noise.

So, having isolated the particular situations in which high ISOs are appropriate, the next question is how best to tackle the resulting noise in post-production.

Luminance noise
Likened to the static on a TV with a bad signal, luminance noise is the more common type, and is in fact necessary in most images in order to visually impart the impression of texture and edge detail.

Chroma (or Color) noise
The worse of the two, chroma noise is immediately unnatural looking and can skew color fidelity significantly. It can also appear as large blotches of completely false color in wide, single-toned areas without much texture.

CLEANING UP THE SEA

Noise reduction has become an essential part of any post-production workflow. What used to be a quite ham-fisted methodology—which, while capable of removing noise, typically did so at the expense of any and all subject detail as well—continues to evolve with each new iteration of algorithms and processors. Nevertheless, it is still far from an entirely automated process, and thus you are much better served by converting the Raw file than leaving such delicate responsibilities to your camera's JPEG-processing engine.

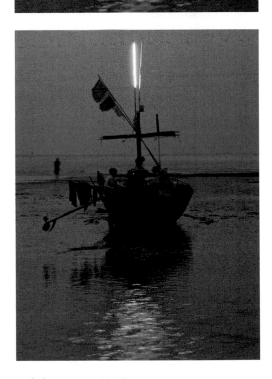

The matter at hand is always one of balance, between removing enough noise to make the subject apparent and the tones clean and pure, but without obliterating detail and ending up with a lifeless, plastic-looking image. This shot of fishermen at sea is a good example of one needing some noise cleanup. It was taken in extremely low light at ISO 3200, not because those were ideal conditions but because they were the conditions available at the time, and sometimes it's better to get a noisy shot than none at all. First I opened the image in Lightroom and scrolled down to the Detail panel (right). Leaving Sharpening alone for the time being, I experimented with various settings of Luminance, Detail, and Contrast, keeping a keen eye on several zoomed-in portions of the image to track their effects, until I found what I judged to be the optimal balance. I also boosted the Color noise reduction significantly, as the noise signature of this particular camera often resulted in rather severe chroma noise at these high ISOs.

Later, having further edited the image in Photoshop, I again checked the noise levels using the Reduce Noise filter to make sure my other adjustments hadn't introduced any more obtrusive noise levels. Note that the Noise Reduction algorithms are typically the same between concurrent versions of Lightroom and Photoshop, which helps maintain a consistent look.

Turbulent seas at 100%

Even at the modest print size shown here, you can observe the high levels of noise—particularly chroma noise, induced by the high ISO and the strong green cast of the light on the boat (which itself was significant in the composition of the shot). Delicate use of noise-reduction software salvaged the shot, but I would still be wary of printing it too large.

EFFECTS & DISTORTION FILTERS

Effects filters are a catch-all collection of filters that do strange and unrealistic things to images. There is no end of them, both from the makers of image-editing programs and third-party suppliers, and recently made extremely popular due to their ubiquitous presence on smartphones, as discussed on page 29. They have an undeniable novelty value, like toys, but for the most part the challenge for users is to find sensible uses for them as it is difficult to take them too seriously. By way of an I example, consider Lens Flare filters, which are a model of clever invention. They might have been invented for photographers to add the imperfection of reality, but the effect stands out a mile, and somehow you can always see when a filter has been used, and when the lens-flare is real.

> **Effects filters have an undeniable novelty value, like toys, but for the most part the challenge for users is to find sensible uses for them**

In addition to effects filters are the filters that change shapes; distortion filters. The effect can be marvelous, but the principle is fairly straightforward. The pixels themselves, of course, are not actually moved, but their values are, which visually amounts to the same thing. The only limit to the kinds of distortion possible is the imagination of the programmer, and the effects of many are so extreme and peculiar that the image is no longer recognizable. A Ripple filter, in its ability to imitate the surface of liquid, has some occasional use, but other distortion filters, such as Spin, Shear, Twirl, and Zigzag, do pretty much what you would expect of them, and are far removed from photographic realism.

With this in mind, few distortion filters are useful for photographic images, but it is important that these are not confused with transformation tools such as Scale, Perspective, Distort, and so on, which *are* of use.

NIK COLOR EFEX PRO

Nik software offers several different types of software packages, which function as either standalone programs or as plugins for Photoshop, Lightroom, or Aperture. They range from black-and-white conversion (Silver Efex Pro) to HDR (HDR Efex Pro) to vintage effects similar to those found on the iPhone (Snapseed—which itself is, in fact, also a mobile app). Here you can see just a few of the stylized filters offered in their Color Efex Pro software; the effects range from subtle and understated to outlandish and surreal, and each of them can be fine-tuned using a complete set of tools via a very intuitive interface. As with many of these special-effects filter programs, one runs the risk of getting lazy or overly ambitious with their post-production if the presets are relied upon to heavily, but if used judiciously and tailored for each individual image, they can offer a unique take on a scene or setting that might not have occurred to you otherwise.

Original

Vintage film efex

Dark detail contrast

Bleach bypass

LENS FLARE

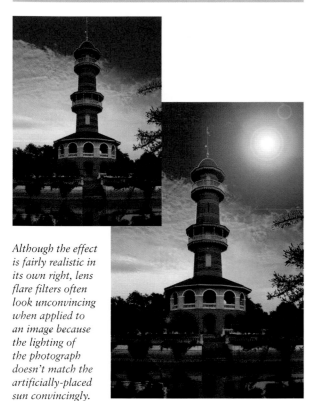

Although the effect is fairly realistic in its own right, lens flare filters often look unconvincing when applied to an image because the lighting of the photograph doesn't match the artificially-placed sun convincingly.

DISTORTION

OK	
Cancel	
Load Mesh...	Save Mesh...

Tool Options

Brush Size: 384
Brush Density: 50
Brush Pressure: 100
Brush Rate: 80
Turbulent Jitter: 50
Reconstruct Mode: Revert

☐ Stylus Pressure

Reconstruct Options

Mode: Revert
Reconstruct Restore All

Mask Options

None Mask All Invert All

View Options

☑ Show Image ☐ Show Mesh
Mesh Size: Medium
Mesh Color: Grey

☑ Show Mask
Mask Color: Red

☐ Show Backdrop
Use: All Layers
Mode: In Front
Opacity: 50

With some limitations, it is possible to apply distortion with a freehand brush. This is preferable to using one of the many distortion filters that can produce unnatural, or even unrecognizable results.

Fuji Velvia emulation

Black-and-white

Cross-processing

Bi-color filter

Retro borders

SECTION 3 TECHNIQUES

In this section I introduce photography's main subject themes, each of which has its traditions, styles, and skills. Naturally, this is from a digital point of view, but most of the fundamentals are the same as for film photography. Whatever kind of camera you are using, if you are shooting a portrait you still need to understand lighting and how to bring character and expression out of your subject. If you are shooting action, you will have to make the same choices of shutter speed and timing. Each chapter begins with a consideration of these basics before moving on to what digital techniques can add.

Photography has always been a peculiar mix of the technical and the creative, often in conflict but with neither able to function without the other. Only a good working knowledge of the equipment and materials allows photographers to express their ideas, but too great a fascination with the technical side tends to be at the expense of the interesting things going on in front of the camera. The digital component in photography opens up wonderful possibilities, as long as you keep them in perspective. In this chapter (and throughout the book), I'm attempting to integrate the two worlds of photography and software, but the anchor is always photography.

In principle, digital equipment and techniques have brought two areas of change to photography. One is in shooting, the other is the follow-up—what a professional would call post-production. It is this second stage that has the potential to alter radically the way photographers think about their craft. The captured image is no longer embedded in an emulsion, but is a string of numbers; this will not necessarily appeal to people who like to think of a photograph as a physical entity. It does mean, however, that the image is now raw material that can be worked on for improvement, enhancement, or whatever.

This is clearly the moment to pause and consider how far to go with digital procedures. Yes, there are ethical considerations, and for the most part they revolve around the well-worn theme of photography being truthful. The great American photographer Edward Weston wrote, "Only with effort can the camera be forced to lie: basically it is an honest medium," and this was in defence of what he called "straight" photography, the product of a clear, enquiring mind and eye rather than "the saucy swagger of self-dubbed 'artists.'" Weston obviously had an axe to grind, but the digital ability easily to manipulate images out of the truth has reopened the discussion.

The editor of a fine but short-lived photography magazine called *Reportage* commented in its first issue, "These changes [electronic manipulation] can be defended as creative interventions. But while photography can, of course, be used for self-expression, for art, its documentary role needs to be protected. It may be difficult to draw a line between these two kinds of photography, but it is essential that we do." Well, without apology, I am not going to suggest how to draw that line. It is a personal matter and you can do that for yourself. Here are the techniques.

NATURAL LIFE

Henri Cartier-Bresson, the greatest of all reportage photographers, believed that photography gave the "opportunity of plunging into the reality of today." As soon as cameras and film were capable of recording scenes in exposures shorter than a few seconds, people and their lives became photography's most popular subject.

The major division is between shooting life as it goes on around us, and stepping in to shoot a portrait of someone face to face

There are endless ways of going about this, but the major division is between shooting life as it goes on around us, and stepping in to shoot a portrait of someone, face to face. In the first case you are an observer, in the second you are creating the circumstances for the photograph.

Observing people is, in fact, the first essential skill for photographing them going about their normal lives. This kind of shooting is all about timing and viewpoint—being in the right position to capture a particular movement, gesture, or expression—and being observant helps you be prepared for what happens next. Of course, what exactly constitutes that telling or elegant gesture is a matter of personal preference, and different photographers will choose differently.

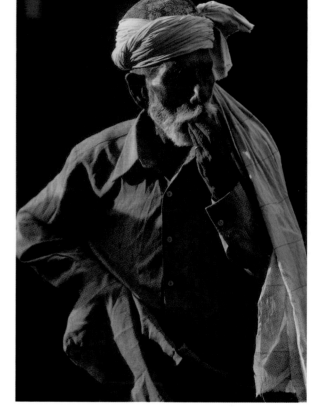

Khat
A Pathan man in Peshawar places a wad of "khat," a popular stimulant that is chewed like tobacco, in his mouth.

Park bench
Head down to read a booklet, an elderly inhabitant of the Umbrian town of Bolsena relaxes on a summer afternoon.

Turning observation into a photograph in this kind of situation means for the most part remaining unobserved. This is not the same thing as being hidden—after all, this is not wildlife photography from a hide—but it does call for blending in with the surroundings. That means being unobtrusive and not behaving like a photographer. Small, quiet cameras are the ideal, and compact digital cameras are the quietest of all. Even if you have seen a likely picture in advance, pointing the camera in anticipation—waiting for someone to walk into the frame or complete some action—will usually ruin your chances. It is much better to wait for the

moment, then raise your camera and shoot immediately. If there is a rule anywhere at all in this, it is not to hesitate, even for a second or two.

Each lens focal length has its own value. A normal focal length (the definition is that the angle of view is close to that of the eye) has much to recommend it, simply because it captures more or less what we naturally see. The long tradition of reportage photography certainly favors it—look at the work of Cartier-Bresson and Robert Frank, for example. Wide-angle lenses are the choice for shooting crowded places and for showing people in their setting. They are particularly easy to use because the framing does not always have to be so precise, and the greater depth of field guarantees overall sharpness without precision focusing. One special use that they have for candid pictures is that if you shoot close to people and frame the shot

so that they are off-center, it will look to them as if you are focusing on something else.

A long focal length lets you put some distance between yourself and the person you want to photograph, and that usually makes it easier to remain unobserved. Given that, you may not have to shoot quite so much on the spur of the moment—several seconds of freedom to choose can make all the difference in capturing the right gesture or expression. The disadvantage of a longer lens in street photography is that there are likely to be more things passing between you and your subject, such as traffic and passers-by.

Remembering the figures on pages 16–17, the focal lengths equivalent to normal, wide angle, and telephoto are different from those for 35mm film cameras, and vary from model to model. A normal lens for an SLR like the Nikon D7000 it is around 35mm.

Cambodian bridge

A new bridge carrying a national highway over the Mekong River at Kompong Cham is transforming life in this once sleepy riverside town.

AT WORK

There is one broad class of situation in which people behave naturally, yet where a photographer does not need to make an effort at staying unobserved. Work is usually considered to be a fairly open activity, although in most circumstances you do require some initial permission before you sit in and take photographs.

Generally speaking, people place their daily work in a different category from their private lives. In particular, because it has a very logical purpose, most find it completely understandable that it should be considered as a subject for photography. They might be suspicious of your motives if you photographed them walking along the street, but for you to shoot them at work makes perfect sense.

People who take pride in their work are likely to be more than usually receptive to a photographer

"Work," of course, covers a wide range of activities, not all of them visually interesting. Indeed, some of them are not particularly interesting even to the people doing them, and the best subjects for photography are those in which the worker takes pride, and those that are unusual. People who do take a pride in their work are likely to be more than usually receptive to a photographer. If you handle the request well, you may find that you are welcome because of your interest—as long as you don't disrupt the proceedings. Usually, the work itself absorbs the person's attention, leaving no time to be self-conscious.

As a subject for photography, work lends itself very well to sequences of pictures that tell a story, and in the case of something being produced, you might consider making a kind of mini-essay that follows the process through from start to finish. The easiest kinds

Tea-making
Chinese tea has a specific method of preparation, demanding skill to capture the subtleties of its flavor. Here, a pot of Pu'er tea is prepared in an old tea-house in the Yunnanese town of Dali.

Garlands
String upon string of marigolds are used in Indian temple offerings and festivals, and their sale is a major industry. Here in Old Delhi, a Sikh seller organizes his wares.

of work to photograph are physical, simply because they have more visual possibilities, and more action. In any case, most have a rhythm and idiosyncrasies, all of potential interest.

In general, this kind of shooting falls somewhere between the reportage photography of the previous pages and the portraits that follow. The workplace and the activity vary too much to suggest a common set of techniques, but the viewpoint—and so the focal length of lens—deserves special attention. If the particular work is continuous or repetitive, you might consider using a tripod: In this situation there would be time to set it up, and in an indoor setting it is a good solution for shooting with available light, because you can use a slower shutter speed.

Digital cameras have a natural advantage here in that not only are they sensitive to low lighting (meaning that you can set a high ISO rating), but you can adjust the sensitivity as you go, from shot to shot. In the old days you would have had to load a new roll of film each time. Nevertheless, if the available lighting is still too low for a reasonable shutter speed, you will have to consider adding light. The professional solution is to set up AC-powered lighting, either flash or continuous tungsten, which turns the situation into something like an elaborate portrait session and cannot help but be disruptive.

In ordinary circumstances, on-camera flash will help (see pages 192–193). At full strength it will do the job of recording the scene, but the quality of lighting suffers. A better alternative is usually a weaker setting combined with available light—fill-in flash, in other words. When there is very little ambient light, one technique is to use rear-curtain flash, available with some cameras, in which the flash is triggered at the end of a longish exposure. There will be motion blur because of the exposure time, but the final flash concludes the movement with a sharp image.

Winnowing barley
Even the simple and widespread act of winnowing grain has countless variations around the world. In Tibet's far west Ngari Province, men winnow the autumn barley crop in the late afternoon light.

Chinese chefs at work in Shanghai's Hyatt hotel
Rather than focus clearly on them, I focused instead on the condensation on the glass, to convey the heat of a busy kitchen working at full pace.

CASUAL PORTRAITS

With a portrait, you have the cooperation, more or less, of your subject. At the least, they know they are being photographed, and will put up with a certain amount of direction. Beyond this, there is a distinction between momentary impromptu portraits, and formal portraiture, in which you plan everything in advance.

In most ways, the casual approach is easier. The ingredients of a successful portrait are simple: an attractively lit good likeness, capturing something of the person's character at its most pleasant. Beyond a few commonsense matters of lighting and the choice of lens, there are no technical rules.

The ingredients of a successful portrait are simple enough: an attractively lit good likeness, capturing something of the person's character at its most pleasant

Expression and gesture are just as important here as in candid reportage photography, so some of the same techniques apply. Many people have a tendency to stiffen up at the idea of having to present themselves to the camera, and rather than make a production of it, you will usually need to preserve what spontaneity exists by being as quick as possible. Do whatever you can to keep the atmosphere as relaxed and light-hearted as possible. If the occasion has that sort of atmosphere in the first place—a party or a gathering of friends—so much the better.

Simplicity is the key, even if it means accepting a less-than-perfect setting. As much as you can, go

SKYLIGHT COLOR CAST

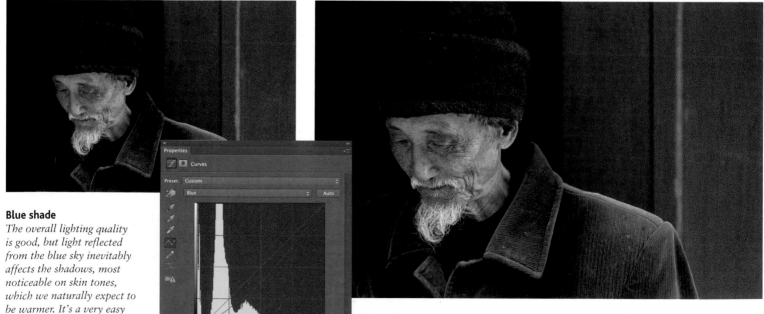

Blue shade
The overall lighting quality is good, but light reflected from the blue sky inevitably affects the shadows, most noticeable on skin tones, which we naturally expect to be warmer. It's a very easy fix in Curves though—simply isolate the Blue channel and pull the curve down to warm up the skin tones adequately.

A quiet moment
Simply waiting for a few minutes may be enough for people to lose interest in the photographer and continue with their lives. An elderly man in a small Chinese town returns to his thoughts—about 13 feet (4m) from the camera.

TECHNIQUES

REMOVING RED-EYE

Red-eye is caused by on-camera flash reflecting directly off the subject's retina. Many cameras have a method of reducing it by making the flash flicker before the full discharge—this causes the person's pupil to contract slightly. In any case, red-eye is easy to remove digitally (indeed some cameras now do this). Zoom in tightly and select the red; use the Saturation slider to remove all color, then darken it. Both Photoshop and Photoshop Elements include a procedure to deal with this, but you can sometimes do the job better yourself by hand.

with what exists. If by choosing your viewpoint you can shoot without asking someone to move, you are likely to gain in mood and natural expression what you might lose in technical perfection. In any case, just a slight change of location may give you a less fussy background or more attractive lighting.

Shooting outdoors usually simplifies the lighting, although some conditions, notably bright high sunshine and a featureless gray cloudy sky, are best avoided. A good compromise, if you can find it, is soft, hazy sunshine, which gives good modeling but avoids hard shadows. A moderately low sun also helps. To lighten shadows on the opposite side, try placing your subject close to a white wall. Indoors almost always calls for flash, because of the lower light levels.

Being absolutely prepared with your camera is essential, and that means being familiar with it. Few people can hold an expression for more than a few seconds, and if you have to fiddle with the camera, you will probably lose that expression. Decide quickly how to frame the person: close in on the face, head-and-shoulders, a three-quarter shot (including the torso), or full-figure. In most cases, the lens focal length of choice is telephoto, simply because it gives the least distorted proportions to the face, and so is the most flattering. Its other advantage is that its limited depth of field helps to throw the background out of focus, and so concentrate attention on the figure.

Pilgrimage
The high point, in both senses, of the sacred circuit around Mount Kailash in Tibet, is the crossing of the Drolma La Pass at almost 6,000 meters. Pilgrims are often ecstatic as they pass under the streaming prayer flags.

In reflection
The air and light were so crisp and clear on this day in New York after rain that they offered an opportunity to shoot reflections like this—and one advantage was that people had no idea that they were being photographed, even from very close.

TECHNIQUES

129

A CONSIDERED LIKENESS

In a planned portrait, the lighting and background are set up in advance, and while there is no chance of spontaneity, you can create an attractive, well thought-out setting. If you have a tripod, this may be one of the occasions to use it; once having decided on the composition of the shot, you can lock the camera onto it and concentrate on talking to your sitter. Bear in mind where you are going to place the person in the frame when you set up. For complete simplicity consider a plain backdrop (in a studio, rolls of seamless paper are standard), but by scouting around the location you should also be able to find some interesting corners.

> **Bear in mind where you are going to place the person in the frame when you set up**

As for lighting, if in doubt go for one large, principal diffused light slightly to one side and slightly from the front, then fill in the shadows on the opposite side with either a reflector or a second, weaker light. There are countless other ways of doing it, but this gives predictably pleasant modeling to the face. If you are using photographic lights (preferably AC-powered flash), fit the main light with either an umbrella, white or silvered, or a softbox, as used in the portrait below.

If you don't have access to studio lighting, diffuse daylight from a window also gives a soft directional

Natural light
For a long time, before the development of high-powered professional photographic lighting equipment, it was standard for every portrait studio to have a large north-facing window, which provided soft yet directional light that could illuminate subjects flatteringly. When using natural light in this way, it's the subject you position rather than the light, and having this subject turn slightly toward the sun provided a nice depth in the contrast between the bright sunlighting and the shadows on the right. It also gave her subtle catchlights in her eyes, which is a useful way to liven up any portrait.

Hand placement
Portrait subjects typically get nervous, and will fidget with their hands in unnatural positions that distract from the finished portrait. There are a number of ways of addressing this, but simply instructing the subject to hold them in one way or the other is often advice that they'll welcome.

effect, but keep the person close to it; avoid direct sunlight, or diffuse it by drawing net curtains if there are any. Use the camera's white balance control to make sure that the overall color is neutral—particularly important if sky visible through the window is blue. When using natural light like this, some fill-in lighting from a camera-mounted flash may be valuable, but be careful not to drown the daylight with too strong a setting. Check the setup with a test exposure; this is always easy with a digital camera.

An extra light from behind the sitter, but out of camera view, can enliven the setup. In a studio, the usual method is to fit one lamp with an attachment that concentrates on the back and side of the head; this highlights the hair. The strongest effect is when the light is just outside the picture frame, but take care that it does not cause lens flare—either use a good lens shade or fix a piece of card a little in front of the camera and to one side to block the light.

Capturing the right moment is equally important as in a casual portrait, but the situation is rather different. Rather than shooting quickly and catching the picture in one or two frames, you already have the composition, lighting, and background worked out. The one thing you do not have is a spontaneous expression, and that may take some encouragement. Some people are easy and natural in front of the camera, but many are self-conscious to some degree or other. If your sitter needs to be put at ease, keep a conversation going—but avoid shooting when he or she is talking, or you will catch them with their mouth open. The traditional photographic advice used to be to shoot plenty of film, despite the expense; with a digital camera there is not even a question of this being an extravagance. Be prepared to shoot a number of frames at the start purely to get the person relaxed and accustomed to the camera. There will be plenty of extra frames, but these can be deleted as you review them later on a computer.

KEEPING FLESH TONES NATURAL

Natural light, and available lighting indoors and at night, varies in its color temperature (*see pages 144–145*), and flesh tones suffer more than most subjects from an overall color cast. Shooting in outdoor shade under a blue sky is a special problem, as at the time it does not seem particularly blue to the eye. The digital solution is to set the white balance in the camera. In any case, however, this is easy to correct later in an image-editing program, provided you shoot in a Raw format.

White point
Sun and blue sky inevitably create a blue cast to shadows. Even though slight in this portrait of a former Miss World, it was important to reduce its effect on the skin tones. The white point chosen was in the clouds directly above the subject.

BASIC RETOUCHING

Simple vanity has kept retouchers busy since portrait photography began. Retouching originally took place on the print, a much easier medium to work on than a negative because of its size and because paper is less delicate than film. The tools were fine camel-hair brushes, and later the airbrush. A painter's skills were essential for a good effect.

Digital retouching comes without the frustration of making a slip that can't be corrected

Skill with a brush is still important in image-editing programs because the paint and draw tools are, sensibly enough, modeled to behave as traditional hand-held tools. The brush is what software designers like to call the metaphor for this. Digital retouching, however, comes without the frustration of making a slip that can't be corrected. It also makes all kinds of retouching possible—whatever you can imagine. Actually, the uncorrectable slip does exist in image editing, but only when the program is not configured to undo mistakes and you have not saved a copy or two. However, there are procedures for avoiding it.

Protecting your work is one part of the working method, and in retouching this is almost as important as the techniques themselves. It applies to all the photographic subjects, not just people, as retouching is common to all, and can make a great difference.

CLOSE CLONING

Among the several tools available for this kind of work, I prefer the cloning tool, used with a slightly soft edge and from very close. In particular, I used this to remove the lines of the face, by cloning from the areas between them. More delicate retouching is possible by setting the brush to Lighten, Darken, or Color, rather than Normal (which replaces everything). I worked at 200 percent magnification for maximum control.

ENHANCING THE ORIGINAL

Clone Stamp, Spot Healing, & Patch tools
For individual blemishes, a single click with the Spot Healing brush will remove them automatically. For larger areas like lines around the eyes or partially obscured details, delicate use of the Clone Stamp and Patch tools allow you to manually indicate the sampled area.

TECHNIQUES

132

A PLAN OF ACTION

It pays to decide in advance what you will retouch, and how far to go with each effect. In this example, I indulged my own vanity—it's my face and I can do what I like with it. First on the list is the crow's feet at the corners of the eyes (and the lines on my forehead). Then the hair: tidy it up, darken the graying at the front and attempt a little restoration (but adding hair, as in real-life surgery, is very difficult and time-consuming if it is to look realistic). Finally, the shadow under the chin.

As retouching is about detail, first examine the image at 100 percent magnification. It is important to remember that on the screen, lesser magnifications simply do not show detailed blemishes; it's not a matter of peering more closely. Go through the image in an organized way, say from left to right and row by row. If you click the scroll bar itself rather than scrolling with the arrows, the display will jump neatly onwards, one step at a time.

With practice, you can assess the retouching that needs to be done as you do it, but to begin with, it may be better to look at everything first and plan the actions. There are two kinds of defect: artifacts from the camera and blemishes on the subject. Artifacts include anything that was not part of the image focused by the camera lens, such as rogue pixel values from JPEG compression, dust marks on the sensor, or scratches on a scanned photograph. Blemishes include anything that isn't desirable: spots and skin imperfections in a portrait, or a stray branch encroaching into a landscape photograph, for example. These are a matter of judgment.

In principle, work on the smallest defects first, then the larger ones, and choose the brush size to suit. Whatever the blemish, it is the background that is important, because that is what you are trying to restore. For this reason, cloning, healing, and patch tools are the most useful, with Photoshop CS5's latest content aware tools proving capable of some truly astounding results with minimal effort.

Retouching
The author before and after, enjoying one form of self-improvement that you can actually achieve.

After
It's easy to get carried away with retouching when you're zoomed into 100% magnification, so back up periodically and make sure you aren't airbrushing away your subject's personality. The result should look clean and youthful, but natural and not at all plastic.

TECHNIQUES

133

IMPROVING LOOKS

There is a fine distinction between simple retouching and cosmetic enhancement. One slides into the other. Digital photography and the possibilities for easy alterations in image-editing make the differences even fuzzier. The techniques are the same, and it may not be any more difficult to do one or the other. With a traditional print, you would have thought twice before launching into any alterations (and flesh tones can be so delicate that major color retouching usually called for a costly dye-transfer print). Digitally, once you start basic retouching, there is no great step into alterations of the kind shown here.

The tricky part here is choosing which parts to leave alone

One of the procedures most in demand is to improve the complexion, which usually means smoothing the texture and making the color more even. A blurring brush will work on a small area, but most changes to the complexion need to be worked over a large part of the face, and for this the procedure is to make a selection and then use a filter. Make sure that you have already completed any basic retouching, because a blurring filter works only on quite fine detail. Large freckles, for instance, will convert into an unpleasant mottling, and need to be removed one by one with the cloning tool.

Prepare this selection carefully. The tricky part here is choosing which parts to leave alone: Even though the cheeks can take a high degree of smoothing out, some of the fine lines around the eyes, nose, and mouth should remain, or the overall effect will look airbrushed and artificial. Whether you prefer to paint all of it as a mask, or begin with a lasso selection, you will probably have to finish off the edges in a masking mode. The idea is to make the edges soft so that the selection will blend imperceptibly, and to vary the density of the selection mask in proportion to the strength of the smoothing effects that you will apply. Save the selection so that you can return to it later if necessary.

The primary filter is the Gaussian blur, which allows control over the radius, according to the strength of the effect you want. For an extra measure of control, applying it to a duplicate layer above the original will let you vary the transparency as well. Next apply any color corrections that are necessary, but only by a very small amount. To reduce any artificiality in the smoothing, experiment with the Add Noise filter.

SOFT FOCUS

A technique used in traditional portrait photography is soft focus (not the same as un-focused), achieved with a lens filter that gives a diffuse effect without losing sharp detail. The digital version is much better, not only because of its variable effect but because you don't have to decide on its use when shooting, but can apply it later. Make a duplicate layer and apply Gaussian blur. Then set the blend option for this layer to Lighten; for extra adjustment, increase the transparency. This treatment is purely a matter of taste, so judge the effects by eye and err on the side of moderation.

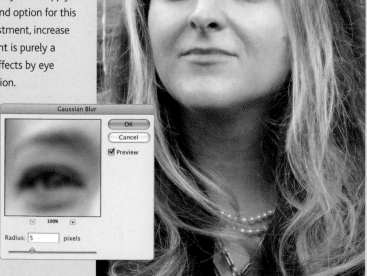

APPLYING LIPSTICK

Color brush
First select the color you would like in the toolbox, and choose Color mode for the brush. This will overlay only color on the lips.

Begin brushing
With an appropriate-sized brush, soft-edged, begin applying the color, just as with a real lipstick.

Cosmetic changes can go much further than this. For instance, the entire skin color can be altered, such as to add a suntan. In this case, begin the selection by color, then add or subtract as necessary in masking mode. You may need to blur this selection to avoid a pixelated effect, in which case apply Gaussian blur to the entire mask channel. After the skin, look at individual facial features: The eye color can be changed (just the iris); the pupils enlarged; teeth made more even and whitened. Adding hair to a receding hairline is very difficult, for the same reason that hair transplants are a challenge—the spacing of the roots. If you really need to do this, try the cloning tool set to "darken," but it is a lot of work.

Select and lighten
To add a gloss effect, first make a selection of the painted area, open Curves, peg the shadows and midtones, and raise the highlights.

Digital lipstick
The final result, almost as good as the real thing. For safety, and comparison, this is usually best performed on a duplicate layer.

BRIGHTENING EYES

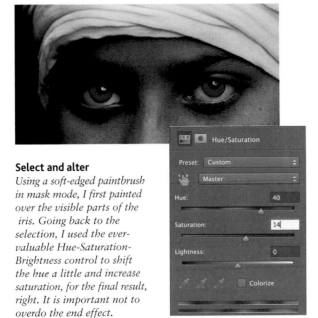

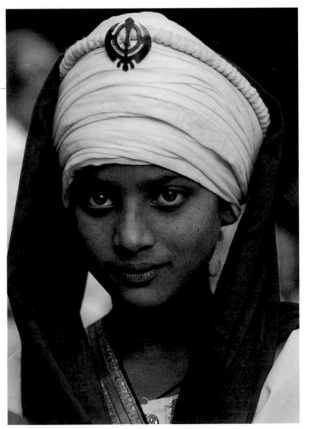

Enhancing green
This young Sikh girl in Amritsar, India, had striking pale green eyes, but it seemed to me that the image had not captured the color as I remembered it.

Select and alter
Using a soft-edged paintbrush in mask mode, I first painted over the visible parts of the iris. Going back to the selection, I used the ever-valuable Hue-Saturation-Brightness control to shift the hue a little and increase saturation, for the final result, right. It is important not to overdo the end effect.

135

DISTORTION

Even small changes in the proportions of a face can have a major visual effect—weight loss, weight gain, a swelling here or there, all can change the overall appearance. Digitally this opens up all kinds of possibilities, without involving any serious retouching skills. The basic tool is a distortion filter of one kind or another.

> ## Even small changes in the proportions of a face can have a major visual effect

The principle here is displacement—moving parts of the image in one direction or another—which is what distortion filters do. In detail, pixels are moved, and if part of the picture is being stretched, values are interpolated to fill in the gaps. If compressed, pixels are removed. One of the simplest filters is the type that either draws the image in toward the center, or expands it away from the center, according to the amount that you specify. In Photoshop this is called, appropriately, a Pinch filter. Positive values "pinch" the image—squeeze it towards the center—while negative values expand it. A Spherize filter has a similar effect in reverse, with the proportions less exaggerated towards the center. One use for this technique is to restore normal proportions to a face that has been photographed close-up with a wide-angle lens.

More interesting is selective distortion, in which you choose facial elements and alter them relatively. In effect, you choose some parts of the image to come forwards and others to go back, and so make it look three-dimensional. The first trick is to make a very soft-edged selection, so that the distortion blends in with the rest of the face, and for this airbrushing in a Mask channel is ideal. The second is to airbrush shading to complement the 3D effect, but very delicately. For more extreme distortion there is dedicated mesh-warping software, available as stand-alone programs, such as Pictureman Rubber, or as part of an image editor, as in Corel Photo-Paint. A freehand alternative is a deformation brush, such as PenTools' Super Putty plugin.

CHANGING FOCAL LENGTH

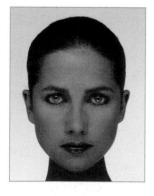

Wide-angle proportions
Photographed with a lens slightly shorter in focal length than normal, the woman's face above has the characteristic slight distortion, especially in the front part of the face and the nose. A digital solution is at hand, however, using the Spherize filter.

Radial gradient
The first step is to apply a radial gradient in a masking layer that will leave the hair,
ears, and edges of the head unaffected. These can be retouched by hand for more detailed control.

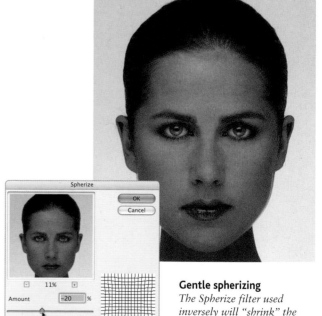

Gentle spherizing
The Spherize filter used inversely will "shrink" the selected area. It does so progressively because the selection has been made as a gradient.

A puffed-up jacket

The idea here was to "inflate" an already bulky bomber jacket. Note the distortion already introduced by the use of a wide-angle lens. The further distortion will be applied to a duplicate layer.*

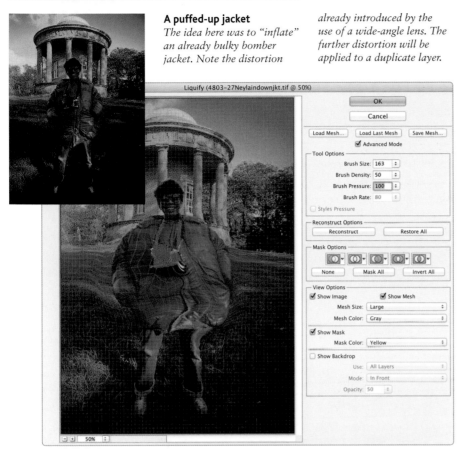

Final retouch

Two important procedures complete the job. The first is to bloat copies of the arms separately, then overlay them. The first distortion actually compressed the originals. The second procedure is to remove the distortion over the background by erasing those parts of the distorted layer, allowing the original to show through.

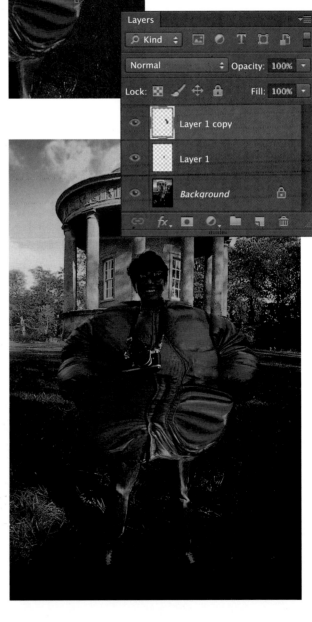

Paint distortion

The program here, Liquify, allows distortions to be previewed in real-time in a large window. A brush has the effect of sweeping areas of the image in a liquid motion. The camera and strap were "protected" with a mask (below) while applying the distortion to the inverse selection.

Checking resolution loss

A close view of the distortion (above), with the protected camera still selected, shows considerable pixel damage to the heavily distorted areas, but since the red jacket contains little in the way of important detail, this needed minimal correction.*

TECHNIQUES

137

MANIPULATIONS

Two of the most practical reasons for making major changes are to remove or replace the background, and to alter the composition of a group shot. Background changes can be as simple as taking out an unfortunate mistake like the clichéd telegraph pole growing out of the subject's head, and as ambitious as transporting the person to a completely different location. Removing someone from a group shot (or adding them to it) has obvious uses, and recalls those anonymous retouching heroes of the Russian Revolution who painstakingly removed purged officials from group photographs in Stalin's time. From our point of view, it makes little difference to the technique or the range of skills used in the operation whether it is the background or the person that is being removed. Both call on the same skills and techniques that were described on pages 94–121.

The two principal techniques are compositing and cloning, as in so much digital manipulation. The more straightforward of the two is cloning, and this may be all that you need if the job is removing a person. Much depends here on the complexity of the background, and in particular on how much of it needs to be replaced. The ideal one to start from is a fairly consistent but anonymous background with random textures, such as trees, sky, or water. In this case, not much invention is needed to create a new background that looks entirely natural and plausible.

Cloning has the advantage of being a rapid, one-step operation, but it works best on a small scale. Copying larger areas is better done by using a freehand drawing tool to make a selection, then copying and pasting it into the required position. If you do this you need to take care over the edges, which will call for careful blending. The pasted selection is easier to work with if you place it in its own layer; then, when you have applied deselection, you can use a combination of Cloning tool and Eraser to work it into the background.

Removing someone from a group shot recalls those anonymous retouching heroes of the Russian Revolution

ADDING A NEW BACKGROUND

Two originals
The background for the shot above was felt to be a little too featureless. A more interesting landscape with similar diffuse lighting (below) was chosen from the files.

Select the figure
Photoshop offers many ways of making selections, but for this shot I used the Quick Selection Tool to isolate the figure, which automatically attempts to detect the edges of various elements within the image. Particular attention needs to be paid to the hair to retain a realistic silhouette against the new background.

Adding a figure is a two-step procedure, and begins with the routine of making a selection—essentially, removing it from its background. The more different this is, the more precise the selection has to be. The job is made easy if you have shot the figures against a plain backdrop; this becomes the selection, which you reverse. In less planned circumstances, your problem area is likely to be the hair, and here smart masking is extremely valuable. Pasting the selected figure behind another involves making a second, partial selection in the receiving image.

Faces are so iconic that they lend themselves to all kinds of manipulation, not necessarily realistic. One technique, useful if you want to create a generic or idealized face, is to split the original vertically down the center, take one half, copy it, and flip it horizontally. Joining this to the original half makes a mirrored image. All faces are to some degree asymmetrical, and this contributes to the character. The perfection of a mirrored face usually gives a strangely depersonalized effect. Another kind of facial idealization is to isolate the elements and apply color and tone correction to them individually until you achieve the desired result.

Mirroring
All faces are slightly asymmetrical from the front. Mirroring one half produces a strange kind of graphic perfection. The first step is to ensure that the centerline of the face, through the nose, is vertical—the original (top left) had to be rotated slightly. As an aid to halving the face, *a grid overlay was brought into view, and on this a thin gradient was applied to a mask (above). This gradient ensured a softer blending when the selected right half was copied, pasted over, and flipped horizontally (left). To avoid an odd central "parting" in the hair I brushed out part of the upper layer.*

Overlay
The extracted figure of the woman is copied into a new layer over the chosen background (above). The area to the left of the image will then be cropped out.

Defocus the background
As the original portrait was shot with a telephoto—and has the lens' characteristic perspective—it is more *realistic to limit the depth of field. This is easily done by applying Gaussian blur to the background (left) for the final image (above).*

TECHNIQUES

139

CAPTURING A SENSE OF PLACE

andscape is deservedly one of the most popular subjects for photography, not least because landscapes themselves have throughout history been scenes for contemplation and enjoyment. Photography is heir to a long tradition in painting, with the major distinction that capturing the image is instant. Digital photography brings its own novel possibilities. On the one hand, the LCD and instant review of shots taken can improve the accuracy and speed of taking a picture; on the other, the opportunities for manipulation intriguingly take us back to the tradition of the painted, interpreted landscape.

One of the appeals of landscape photography is the possibility for individual interpretation

As a subject, landscapes are accessible, familiar to everyone, and present few technical problems. Scenic views are, in any case, established stops on virtually any tourist route. One of the appeals of landscape photography is the possibility for individual interpretation, and even the most photographed views can be treated in new ways—just look at the distinctive work of such masters of the genre as Ansel Adams, Eliot Porter, and Emil Schulthess.

Compressed planes
Shooting down the Grand Canyon from an overlook, a telephoto lens gives the impression of the landscape being stacked in planes. This effect usually looks best with the lens aperture stopped down for good depth of field.

The key lies in recognizing exactly what it is about a landscape that attracts you, and concentrating on that. For example, if it is the freshness of fields at sunrise, you might want to emphasize the dew by shooting into the light. Or it might be the luxuriance of plantlife in a forest, in which case a wide view with green filling the frame might be the answer. Sometimes detail is more telling than a general view; in other situations, widening the view so that the sky dominates may be more effective, and more surprising.

The choice of lens can markedly affect the style of the image, and changing the focal length is often less important for what is included in the frame than for how it changes the character of a photograph. A wide-angle lens not only includes more of the scene, it can capture the sensation of a broad, sweeping view. By choosing the camera position carefully to include a graphically interesting foreground, you can bring depth to the scene and enhance the sense of being there. Viewer "involvement" is one of the classic

Information vs. atmosphere
Seen from a nearby hill in the morning, the ancient Cambodian temple of Angkor Wat has been shot in a hazy view into the sun—a deliberate choice that sacrifices detail for a more evocative, looming image.

DIGITAL TRAVEL NOTEBOOK

Most digital cameras allow extra information of various kinds to be stored alongside the images, sometimes even sound. Make use of this when travelling to keep a record of what and where you shoot—and also any technical details in a tricky situation.

attributes of the wide-angle lens, and exploiting this to the full in a landscape means experimenting with different viewpoints.

In contrast, a telephoto lens selects and isolates elements within the landscape, and gives opportunities to frame any number of graphic compositions. Frame any one viewpoint and there are likely to be more tele-

photo shots possible than wide-angle. Telephoto also compresses perspective, making distant parts of the scene loom large over nearer objects. Given the right position, typically looking down at a shallow angle, a long focal length can give the impression of stacked planes receding into the distance.

Detail and light

The ingredients are common enough—a shell and the sun rising over the Caribbean—but simply by placing them facing each other across a widescreen frame and excluding all other distractions, they neatly convey the kind of tropical seaside mood that triggers a wish-I-were-there reaction.

TRIPOD TECHNIQUE

Landscape photography is firmly in the domain of tripods. This is when you take a slower, considered approach, with a keen eye on optimal composition and ideal lighting conditions; and with enough time for that, there's enough time to set up your tripod.

It begins with the right equipment: There are an abundance of cheap, lightweight tripods available, but like most things, you get what you pay for, and you'll want something sturdy enough to not rattle every time the wind picks up. Carbon fiber is usually the best material, but decent aluminum and even wooden tripods do exist. The tripod head is of equal importance, though these are

a more personal choice. Whether you need a ball head or three-way head is determined by your particular type of photography, though broadly speaking the latter are of a sturdier design.

Beyond equipment, tripods also allow you to optimize image quality by using your camera's mirror lock-up. This feature seeks to eliminate even the slightest vibration caused by the SLR mirror slapping up against the internals of the camera just before the shutter is fired. Of course, if your camera isn't an SLR, there's no need for this feature; but you can still ensure that you don't induce any vibration via the shutter release by using the self-timer.

THE IMPORTANCE OF LIGHT

The English landscape painter John Constable considered light "the essence of Landscape," even complaining about the sacrifices he made for it. The quality of daylight is what enlivens—or deadens—any landscape, and probably contributes to its atmosphere more than any other factor. It varies with the time of day, the season, and the weather, so that the possibilities, if you are able to take full advantage of them, are almost limitless.

The quality of daylight is what enlivens—or deadens—any landscape photograph

The ideal is to have enough time to be able to pick and choose when to shoot a particular view, though this is by no means always possible. If it is, however, the two variables to juggle with are the time of day and the weather. The simplest situation is when the weather is predictable, particularly when that means a cloudless day. In that case, you can time your shooting exactly.

Predictability, however, has its own drawbacks, because there are fewer possibilities

Reflected colors
The light bounces and reflects off the sandstone walls of this deep slot canyon in Buckskin Gulch in the American Southwest. Blue from the bright sky mixes with the red of the rocks.

Clearing storm
After a day and night of rain and strong winds, a cold front brought a brief window of sharp light as the sun rose over Dozmary Pool on Bodmin Moor, Cornwall, where the sword of Arthurian legend is supposed to lie.

for surprise. A well-known landscape like Monument Valley, on the Arizona–Utah border, has been photographed to death at sunrise and sunset simply because it is predictable. Fleeting conditions of light, on the other hand, such as a rare break in the clouds in stormy weather, have the special value of presenting you with a unique combination. Capturing them means being prepared to work quickly, and for this a handheld digital camera has every advantage. Any doubts about exposure and framing can be eliminated by checking the shot immediately on the LCD display.

What makes good lighting for a landscape is partly objective—how it reveals the texture of rocks or fields, or colors and reflections—and partly subjective. Raking light, which on a flat or gently rolling landscape means a low sun, is objectively useful, and also generally well liked. Shortly after sunrise and before sunset in clear weather, there is a considerable choice of lighting all at once, depending on whether you shoot with the sun behind you, to one side, or facing the camera. The only real disadvantage is that this is exactly when most photographers like to shoot, so it can be a little short on originality. At the other end of the weather scale, rain and snow may be less than comfortable, but offer opportunities of a different

kind. The soft light on a rainy day can help saturate colors—perfect for gardens and greenery.

The weather adds another element to the picture besides its control of the light: the sky. With multi-level clouds of different kinds it can be a subject in itself. Not all landscapes include the horizon line, but when they do, the sky becomes a part of the composition. An interesting sky may be reason enough to lower it.

Layered clouds
Typical of tropical mountain weather, the sun breaks through clouds at different altitudes to create a complex pattern of light in the central highlands of Papua, photographed from a helicopter. The nature of such photography makes it difficult to frame the shot. A digital camera's LCD "preview" display allows you to check the framing immediately.

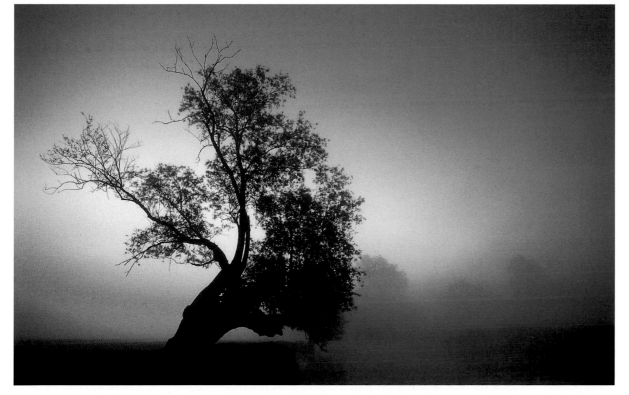

Summer mist
The water meadows of Dedham Vale in eastern England—Constable country—glow softly at sunrise in a ground-hugging mist that will soon clear. Conditions like this are unpredictable and can clear or thicken at any moment, demanding quick camera response. See pages 152–153 for ways to change the lighting digitally.

TECHNIQUES

143

COLOR CONTROL

The nuances of color in changing daylight affect the mood of a landscape—cool, warm, soft, or hard—and in digital photography you can control them, either in the camera or later, in an image-editing program. Even when the changes are modest, as in the main example here, the effects are striking enough to be worth pursuing.

The overall color of a landscape is affected mainly by the color temperature (*see box*) of the light. Accuracy is less important than your own idea of what looks best. Most digital cameras offer a white balance control, which we have already seen in action on pages 26–27.

The nuances of daylight affect the mood of a landscape. In digital photography you can control them

In addition, many offer pre-set refinements, which measure the overall color balance as it is, and adjust it towards one opinion (the manufacturer's) of what it should be. For example, choosing the Overcast setting available on some cameras will remove the slight blueness that is normal under a cloudy sky.

Image-editing programs also allow color correction, but with much more choice—you are not restricted to presets, and while the white point, gray point, and black point (see pages 102–103) will establish neutral at different parts of the scene, you can use any of the controls to adjust color to your taste. Extreme correction can even be achieved by use of the gray point with extra adjustment.

Selective color control opens up much greater possibilities, or at the least the chance to improve any disappointments you may have had with the lighting. This was the situation with the original of Machu Picchu in Peru, shown opposite. The site's situation in relation to the surrounding mountains meant that the best light was in the early morning, but that day the weather was poor. Once again, the first step is to make the selections, and in the case of a landscape there is likely to be more than one. Two kinds of selection are useful: a color range and a physical element. When relevant, color range selection is the easiest, but having made one, you should check the accuracy of its edges before doing anything with it. Examine it as a mask by zooming in on the edge details. You may find that the edges are too sharp, in which case apply a Gaussian blur to the entire mask. Some software includes range selection in the color-correction tools, as shown in the example—that is, you pick the color on the screen, then choose how many color steps are to be included around this in the end result.

Select physical elements in the landscape, such as the sky, foreground, or water, by whichever of the selection tools is appropriate. Described in detail in section 2, they each have their uses. Once the selections have been made (and saved), use the curves, levels, or saturation controls as necessary.

COLOR TEMPERATURE

Color temperature is a color scale that has a particular relevance to photography, especially in landscapes. In practice, it extends from red through yellow, orange to white, and finally blue. In theory, it is the range of color of a notional substance as it is heated up (red-hot to white-hot and beyond), which makes it possible to put a precise figure to each color. On the Kelvin scale of temperature (like Celsius, but starting at absolute zero), white is 5500°K, the color of the midday summer sun, and to the human eye, neutral. Sunrise and sunset are usually somewhere between 3000°K and 4000°K, while open shade under a clear sky is anything in excess of 8000°K.

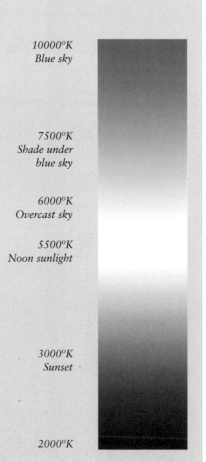

10000°K
Blue sky

7500°K
Shade under blue sky

6000°K
Overcast sky

5500°K
Noon sunlight

3000°K
Sunset

2000°K

1. Weak sunrise
Because of the orientation of Machu Picchu, the best time of day for the light is early morning. If the weather is not ideal, there is no alternative.

4. Enhancing the sky
Hue and saturation adjustments are made to the sky selection, using the HSB sliders.

5. Intensifying the sunlight
For total control, the contrast and color of the sunlit selection are adjusted channel by channel in Curves.

2. Zoning the image
By painting masks, the image is divided into three zones: sky, foreground, and distance. Here, above, the sky is being selected. Handpainting ensures that the wisps of cloud are included.

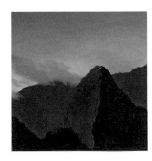

3. Selecting the sunlit areas
In preparation for enhancement, the sunlit parts of the monument are selected by mask painting.

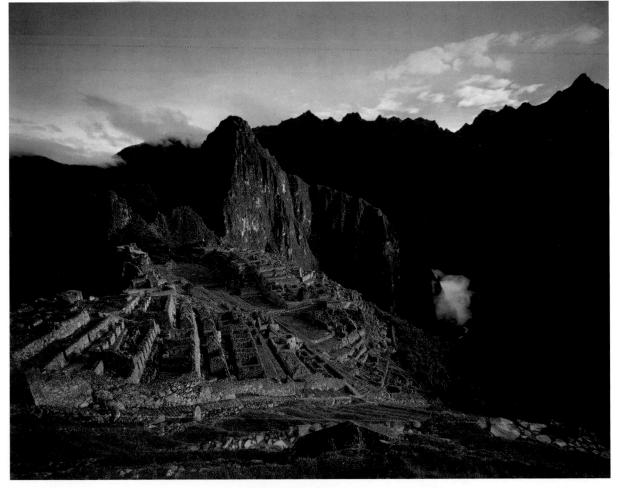

ALTERING DEPTH OF FIELD

Within certain limits, you can choose the depth of field as you shoot. Greater depth of field means more front-to-back sharpness, more detail in view. Less means that the sharpness is concentrated only on one part of the scene, and that part changes with the focus. Both image styles have their uses: Deep depth of field allows the eye to range over the whole picture; shallow depth of field allows the photographer to select what is important and blur the rest.

The limits in straight shooting are real enough, and don't necessarily coincide with how you would like to record your chosen scene. Changing the aperture (small equals deep, wide equals shallow) is only part of the answer, because this depends on the lens focal length. Practically, a wide-angle lens will stop down to greater depth of field, which is ideal for a near–far shot that takes in close foreground to distance, while a telephoto lens cannot often record everything sharply even when stopped down. Conversely, selective focus with a wide aperture and all but one plane thrown into a blur is a natural for a telephoto lens but impossible for a wide-angle lens.

Digital cameras are every bit as subject to these laws of optics as silver-halide cameras, but manipulation in an image-editing program opens up new possibilities. Not only can you change your mind after shooting, but you can also achieve optically impossible results,

Not only can you change your mind after shooting, but you can also achieve optically impossible results

such as highly selective focus in a wide-angle view and perfect sharpness throughout a deep telephoto image.

Reducing depth of field is the easier of the two, because it requires no advance planning. In principle you simply blur the parts of the image that you want to throw out of focus, and the technique is to select these areas and apply Gaussian blur. If the subject that you want to retain sharply focused is physically separated from the rest—on a different plane, in other words—just make a clean selection around its edge. To be more realistic, vary the density of the mask so that when you apply blurring it increases away from the sharp subject.

As the blurring is not bound to follow optical law—you are applying it as you see fit—you can concentrate sharpness on any part of the picture. For instance, blurring an image outwards from one point would give a kind of tunnel-vision effect. Alternatively, you could mimic the effect of using the tilts and swings of a large-format camera by creating out-of-focus blur to the left and right, say, instead of front-to-back.

In a sense, out-of-focusness is a photographic artifact, to borrow computer terminology. Under normal conditions, the human eye does not see in this way. Even digital sharpening cannot restore an out-of-focus image, so you must plan for this operation when shooting. Using a telephoto lens on a tripod, take two or more shots identical except in their focused distances. Later, composite the sharp parts of each image, as shown opposite.

Focusing attention

Selective blurring coupled with extra sharpening of the foreground helps direct the viewer's attention to this pre-Columbian rock carving. The landscape was divided into three zones by painting masks over the rocks, the middle distance, and the far hills. Extra USM was applied to the rocks, and progressive Gaussian blur to the areas behind.

1. The limits of focal length
Using a medium telephoto lens, it was optically impossible to resolve both the fishing boat and harbor light in this view, even at minimum aperture—the distance betwen the two was just too great. Either one

or the other could be sharp, and I shot both within seconds of each other. In an image-editing program, the "sharp harbor light" version is placed in a layer over the other image, and aligned.

4. Make background selection
Still in the Find Edges duplicate layer, I used the automatic selection tool to pick up the white background (above)—that is, everything except the harbor light.

6. Brush in sharp background
With the selection now "protecting" the light, the background was erased with a brush to reveal the sharper image underneath.

2. Remove blurred foreground
The blurring spreads wider than the harbor light, so an initial step in the procedure

is to remove it completely by cloning the water horizontally across it (above and above left).

3. Find sharp edges
I returned to the "sharp harbor light" version, using a Find Edges filter on a duplicate layer (left). To clean up the result, I applied Brightness/Contrast values, giving me a white background.

5. Apply the selection
Switching to the original image layer, I applied the selection—which covers the entire background. However, it is not quite up to the edges of the tower, but this is simply adjusted by expanding the selection by 2 pixels all round.

Expand Selection

Expand By: 2 pixels

OK
Cancel

Properties

Brightness/Contrast

Auto

Brightness: 50

Contrast: 50

Use Legacy

TECHNIQUES

SKY TONES

Not only are skies very amenable to digital change, but they can add to (or detract from) the success of a landscape photograph. The almost endless retouching possibilities exist because the elements that make up skies are, for the most part, soft and vague. Precision detail is simply not an issue. One of the easiest actions is to extend clouds with the cloning tool set to a large, soft brush.

Apart from this kind of local retouching, most operations call for the sky to be selected. This done, one of the most common practical needs is to balance the sky tone with that of the landscape. On overcast days in particular, the difference in overall brightness between the sky and the land often exceeds the dynamic range of the imaging sensor. In traditional photography the solution to this problem was to hold back the sky when printing

> **The elements that make-up skies are, for the most part, soft and vague**

in the darkroom. In an image-editing program, simply adjust the Curves or Levels to your own taste. Beyond this, any of the color controls may be appropriate and can be used.

The problem areas that you are likely to encounter when manipulating skies are mainly to do with gradients, most of all on clear skies. Partly this is because of the inherent delicacy of color and tone in a sky, which is by its nature difficult to add to realistically. Partly, though, it involves the limitations of bit depth in a standard 24-bit digital color image. This may be called "true color" and has a range of sixteen million different colors, but each channel has only 256 steps. If you make a monochrome gradient, such as a darkening layer, and this stretches across a large area of the image, the steps are likely to show up, particularly in the mid-tones, and the result is banding. It is landscape imaging's special concern. The practical solution to the problem is to add a little noise, and to do so

DIGITAL GRAD FILTER

Adjust the Brightness
The Brightness and Contrast sliders give effective control over the strength of the sky darkening when applied to the selection (below).

Gradient mask
The first step is to use the gradient tool from foreground to transparent in masking mode, to create a graded selection for the upper part of the sky (upper right).

Soften the selection
Applying a strong Gaussian Blur to the mask removes banding and softens the effect.

channel-by-channel to increase the random scattering that helps to conceal the banding edges effectively.

A technique from silver-halide photography for adjusting the tonal balance between sky and land is to shoot with a neutral grad filter (glass or plastic dyed to grade softly from clear to darker). The digital equivalent uses the gradient tool and offers more choice of tone and color. Once again, this is more controllable if performed in a separate layer. One method is to set a linear gradient from foreground color to transparent, with the start point of the tool at the top of the frame (work within a sky selection).

Choose the amount of darkening by using the eye-dropper on the top of the sky to set the foreground, then adjust the foreground (double-click the icon) by darkening it. Or use a neutral tone, between light gray and black, and then alter the transparency of the layer. For even more control, make the gradient in a mask channel so that it is a selection. Apply this to the image and adjust the curves or levels. A variation on the theme, which mimics the optics of a wide-angle lens and looks more realistic with a wide view, is to use a radial gradient, following the procedure shown for panoramas on pages 112–113.

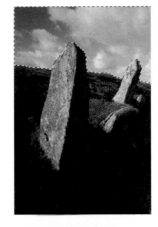
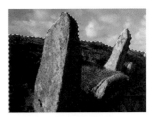

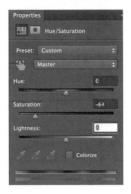

Desaturating the sky
Having made a sky selection (above) from the original image (top), strong desaturation was applied with the HSB slider to lessen the blue.

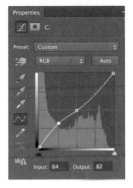
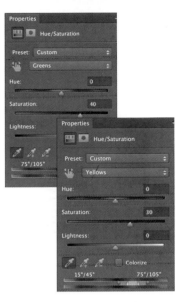

EXTENDING THE SKY

In a typical instance in publishing, this photograph was to be used on a book cover but more space was needed for the type. As usual, the sky is the cleanest place to put lettering, so it had to be extended by 14 percent at the top and 7 percent to the right. The method was to sample the clear sky tones and create a separate file with a radial gradient of these colors. Having compressed this gradient into an oval for a more natural effect, it was copied into a layer, and blended with the slider and eraser. Extra work involved cloning to the right.

Contrast reduction
In keeping with a full cloud cover, the contrast was reduced with the RGB curve (above).

A low sun effect
The selection was inverted to work on the ground; then, the greens and yellows were individually saturated (above) for the effect of strong low sun (below).

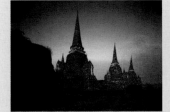
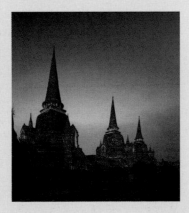

Blending a gradient
The original (above), and the finished image (right) after the extension of the sky.

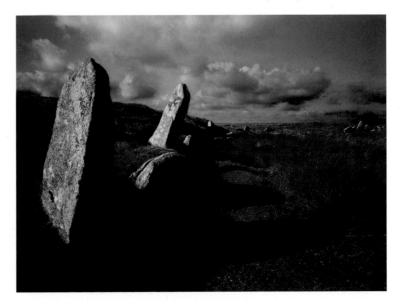

NEW SKIES

Rather than work on an existing sky in a photograph, it might be easier or preferable to use another. As long as your selection technique is perfect, there are few complications, and all that you need is a suitable candidate for the transplant. Naturally, this has to be at the right size and resolution. If it is too large, first compare it to that of the landscape you are working on. After resizing, you will probably have to sharpen it slightly with the USM; to get the right amount, compare it at a high magnification with the sky that it will be replacing.

Technically, all that has to be done is to select the sky in the receiving image, load the new sky, and paste it in

Technically, all that has to be done is to select the sky in the receiving image, load the new sky, and paste it in. If the transplanted sky is slightly larger (always an advantage), experiment by altering its position. Finally, track along the horizon at 100 percent magnification or greater to clean up the edges.

The technique may be undemanding, but visual judgment is very important. Any old sky will not do, and apart from choosing one that will enhance the image, be careful that it matches the landscape. There are certain obvious rules to follow, such as the angle of the sun. Clouds can make this apparent, and if there are shadows on the ground falling in one direction, make sure that the shaded sides of the clouds are approximately the same. Flipping the sky horizontally is a quick fix.

A realistic match also depends on the focal length of the lens. There is a fair amount of latitude here, but a wide-angle sky will look wrong over a telephoto landscape, and vice versa. If the sky is clear, wide-angle optics cause radial shading, while the perspective of diminishing clouds is also a giveaway.

Beyond this, the critical zone for matching sky to ground is just above the horizon. Think of the aerial perspective: most of the features in a sky that you can see, such as clouds and haze, are concentrated in the far distance, close to the horizon. If there is insufficient of this zone in the new sky, the result is likely to look false. It may even be necessary to retouch this area before compositing is begun.

A radical alternative is to ignore real photography and generate a sky from scratch. Immensely difficult to do by illustration, this is simplicity itself with 3D software that has realistic rendering. Provided that you do not attempt some of the more precise types of cloud, like cumulus, CGI skies can be completely realistic, and their lighting and atmospheric qualities are absolutely controllable. The example here was generated in Bryce, a popular tool for 3D designers, illustrators and adventurous digital photographers alike.

A SKY LIBRARY

Good skies are worth collecting, with or without the landscapes underneath. Even before digital imaging became practical, I used to shoot any sky that for me had character, for possible use in special-effects photographs (assembled optically in those days). They became a sky library, now scanned to high resolution and stored on CDs. Included among these real skies are some CGI skies created in Bryce.

SKY REPLACEMENT

Altering proportions

In preparation for adding a new sky, the original image of Glastonbury Tor, in southwestern England (top left), was altered by extracting not just the sky, but also the foreground (above), then resizing to give more foreshortening.

Stronger sky

A sky with more presence was chosen from the same shoot, but a different location (top right). Having used the Extract tool in Photoshop, the newly composited landscape fitted seamlessly over it (right).

A BRYCE SKY

Sky&Fog

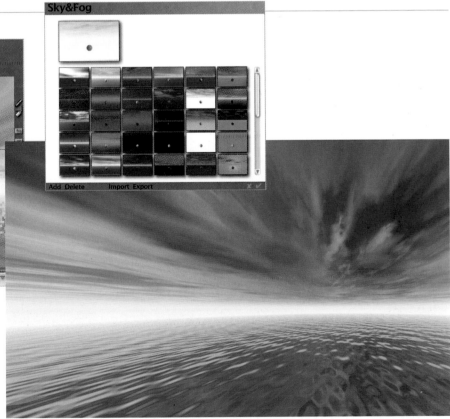

3D modeling

This popular terrain-editing 3D program has excellent tools for creating artificial skies, including libraries of pre-sets (above right) that can themselves be edited. In this example, a water element was included, and the rendering *engine records the correct reflections. In the picture above, the rendering process has just started. Once the camera position and angle (here imitating a wide-angle lens) have been established, it is simple to vary lighting and color (right).*

CREATING LIGHT

T he quality of light, as we have seen, makes a fundamental difference to a landscape. By comparison, the overall color is almost a superficial effect—as evidence the ease with which you can adjust it digitally. Lighting is quite a different matter, particularly sunlight, which throws shadows from every tiny detail. It is so much an integral part of the image that it resists digital manipulation. In theory you could add shadows by darkening, but in practice you would have to do this for every rock, tree, leaf, and so on, which is an arduous waste of time.

Lighting is so much an integral part of the image that it resists digital manipulation

That said, there are some specific effects that can be made. One area of adjustment is in the intensity of sunlight. Changing the existence of shadows may be out of the question, but strengthening or weakening them is perfectly possible. The procedure is to alter contrast, which is straightforward, with the Curves control allowing the most delicate adjustments. When using it, identify where on the curve the shadow tones lie by clicking on one of them, and alter the shape of the curve to favor them. If you are intensifying, allow the shadows only to darken as much as you like, but do not lose the highlights. After this, make a small adjustment to the saturation, increasing it for stronger sunlight, decreasing it for weaker.

Highlights of various kinds are also possible additions, although the occasions are limited. The effect shown here in the photograph of the cave is an atmospheric one—a shaft of light, something to use very occasionally and with care, as it is easy to exaggerate. To keep it delicate and transparent, as it needs to be, work in a separate layer so that you can adjust the

ATMOSPHERIC LIGHT

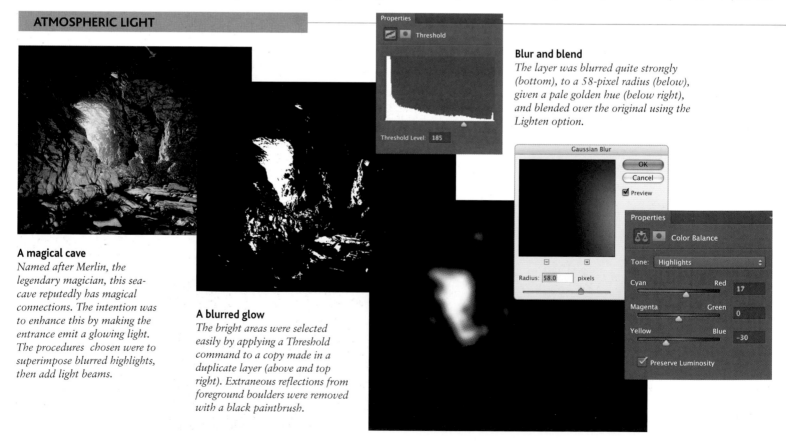

A magical cave
Named after Merlin, the legendary magician, this sea-cave reputedly has magical connections. The intention was to enhance this by making the entrance emit a glowing light. The procedures chosen were to superimpose blurred highlights, then add light beams.

A blurred glow
The bright areas were selected easily by applying a Threshold command to a copy made in a duplicate layer (above and top right). Extraneous reflections from foreground boulders were removed with a black paintbrush.

Blur and blend
The layer was blurred quite strongly (bottom), to a 58-pixel radius (below), given a pale golden hue (below right), and blended over the original using the Lighten option.

transparency, erase parts, and change the position if necessary. One way is to use the airbrush tool with a soft edge and a very long fade-out so that the shaft of light appears to dissipate in the air. Another, used here, is to prepare the shafts with a gradient filter, transform them so they fan out, and then apply them blurred.

One of the most interesting lighting techniques, used in the example to the right, is actually firmly rooted in reality. Nothing is adjusted or added; instead, the lighting from two times of day are combined. The operation needs to be planned before shooting, because you will need two identical shots in which the only thing that changes is the lighting. Not only is a tripod essential, but the camera must not be moved a fraction between the exposures. The best conditions for shooting are when you can fairly confidently expect the lighting to change.

Both images need to be exactly the same size digitally, down to the pixel, which they should be if you shoot digitally, or scan, at identical settings. Save the images uncompressed. Then, with one image in each layer, combine them as you like, either by brushing one in, or by erasing.

Two matched originals
Shooting began before dawn and continued until the low hill was sunlit. The two most contrasting frames were selected, and the sunlit shot placed in a layer over a pre-dawn shot, aligned exactly.

Painting sunlight
The image file was saved, and then the sunlit image erased. I then enlarged it and painted in the sunlight with the history brush in Photoshop, which restored it (left). An eraser brush added fine control.

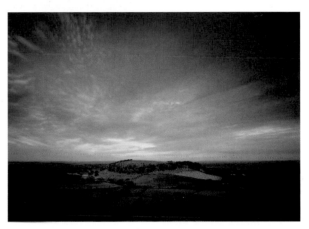

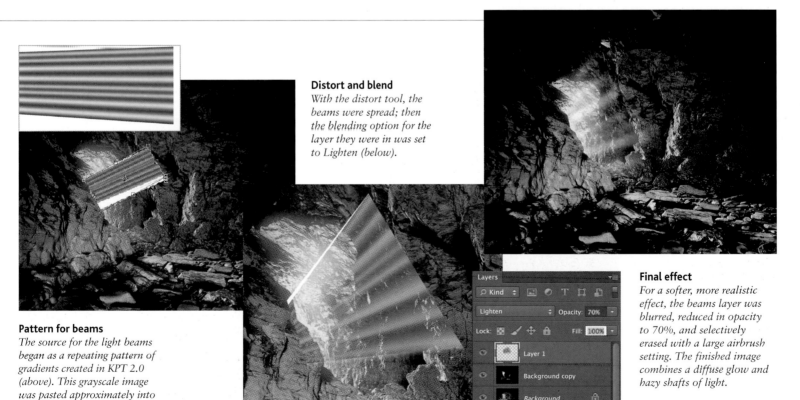

Distort and blend
With the distort tool, the beams were spread; then the blending option for the layer they were in was set to Lighten (below).

Pattern for beams
The source for the light beams began as a repeating pattern of gradients created in KPT 2.0 (above). This grayscale image was pasted approximately into position at the cave mouth.

Final effect
For a softer, more realistic effect, the beams layer was blurred, reduced in opacity to 70%, and selectively erased with a large airbrush setting. The finished image combines a diffuse glow and hazy shafts of light.

TECHNIQUES

153

ENHANCEMENT 1

H ow far should you go with the manipulation? Digital tools themselves do not discriminate, and as with any other subject, they can be used to change just about anything. Landscape photography has always favored a large dose of personal interpretation—witness the many different styles, from the romantic impressionism of Alvin Langdon Coburn to Edward Weston's "straight" photography, and the metaphysical approach of Alfred Stieglitz and Minor White. Now digital manipulation allows an extra level of treatment.

There are numerous third-party filters that will apply set treatments to an image

By using a combination of the techniques just described, from selective color changes to replacement, you can push a landscape more into your own conception of what it should be. In so doing, you will inevitably personalize it, distancing it from more standard photographic treatment.

Even so, it is not a bad idea to have a purpose, if only to avoid mannerism—an addiction to tricks. There are numerous third-party filters, some of which are shown on pages 120–1, that will apply set treat-ments to an image, and while there is nothing wrong with pastiches of painting styles, most of these filters are more like games than anything else. If there is any style involved, it is that of the programmer who wrote the software rather than the photographer using it.

My examples are intentionally not extreme, although elsewhere in the book there are some stranger landscape creations used in different contexts. As for purpose, the aim in each case has been to establish a particular mood, and there were specific reasons for the changes involved.

REMOVING MAN'S TRACES

1. The originals
The photograph of a pre-Columbian tomb shows evidence of lots of visitors having trampled the grass. Here, we restore it to its natural state—and then add a new, looming sky.

2. Extend the best grass color
Where the grass has not been worn away, most of the problems can be solved by recoloring it. The lower right corner has grass in the best condition, so the clone brush is set to "color," and this is brushed into the surrounding area.

TECHNIQUES

154

3. Paste the retouched grass

Once a sufficiently large area of grass has been restored, it is ready for pasting into the worn-out patches near the tomb's entrance. The lasso tool is used to make an irregular selection, and this is copied and pasted into position.

5. Blend with random erasing

The final blending procedure is to erase parts of each layer's selection by soft brushing, using a large-diameter airbrush and much less than full opacity (here 40%). Doing this in a random pattern several times, with different layers, means that the cloned patches no longer look similar.

4. Alter brightness and contrast

The process of copying and pasting is continued from one part to another, taking care not to repeat pasted shapes. Brightness and contrast sliders are used to help blend selections and to avoid total uniformity across the image.

Properties

Brightness/Contrast

Auto

Brightness: 16

Contrast: -1

Use Legacy

ENHANCEMENT 2

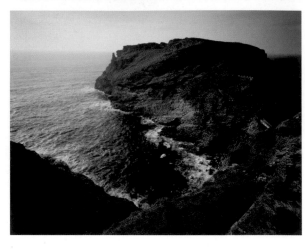

Following on from the remarks on the previous spread, in the case of the pre-Columbian tomb, the problem was the light and the setting. Nothing could be done about either at the time, but the megalith, in San Agustín, Colombia, was an important subject, and I liked the shape and rhythm of it. I wanted to give it a darker mood and the tomb more presence. For this I introduced a stormy sky and made color corrections.

> **Without altering the substance of the scene, I wanted to evoke a little of the atmosphere of mythology**

In the photograph of Tintagel Castle, in Cornwall in the southwest of England, the idea was to create a romantic view, very slightly surrealistic in effect but not altered in any obvious way. By local tradition, this rocky peninsula is one of the contenders for being the site of the legendary Camelot, and the picture was part of a magazine story on the legend of King Arthur. Because of the editorial treatment of the piece, I wanted to convey throughout a slight sense of magic. Without altering the substance of the scene, I wanted to evoke a little of the atmosphere of mythology. The weather and light for the two days that I had set aside for shooting offered nothing special, but at least they were acceptable.

In any case, there was another, pressing need for digital retouching. The English authority that administers historical sites such as this had performed an act of constructive vandalism by building an ugly concrete footbridge visible from every direction, which was also quite effective in destroying the atmosphere. This was one of the reasons for the camera position I chose, but even so my first job was historical restoration, which meant removing the concrete.

After that came the main part of the enhancement, which I foresaw mainly in terms of atmosphere, the color of the sea, and highlighting the rather meager ruins. I worked on the color of the sea in the cove to give it a richer, clearer appearance by adding blue-green, added to the sky and a band of light fog over the peninsula, and increased the brightness and contrast of the castle itself.

1. Original as shot
English weather being what it is, I should have been grateful that there was at least some sunlight on the day scheduled for photography of Tintagel Castle on the north coast of Cornwall. Even so, it fell short of ideal, and I resorted to digital enhancement.

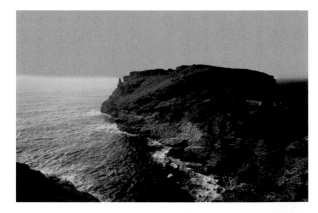

2. Sky removal
I had a better sky in mind already in my stock library. The original sky was removed, leaving a slightly hazy horizon.

3. Site restoration
A footbridge and concrete embankment added by the authorities detract from the view, and were easily replaced with the cloning tool. The castle ruins were made brighter to contrast with the surrounding landscape.

TECHNIQUES

156

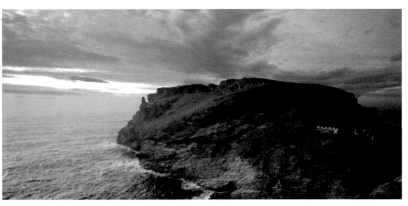

4. Sea color enhancement
To give the sea more depth and clarity, I determined a color shift from dark blue to a more saturated blue-green, and brushed in the change using the mask feature.

Properties

Hue/Saturation

Preset: Custom

Blues

Hue: −17

Saturation: 41

Lightness: 12

Colorize

195°/225° 255°/285°

5. New sky
From stock, a different sky was pasted in, with a sweep of clouds that mirrored the shape of the peninsula.

6. Sea fog
In Bryce, a light, wispy layer of fog was created (above). Opened in an image-editing program, this was pasted over the image using the blending options to keep the edges soft and allow some transparency.

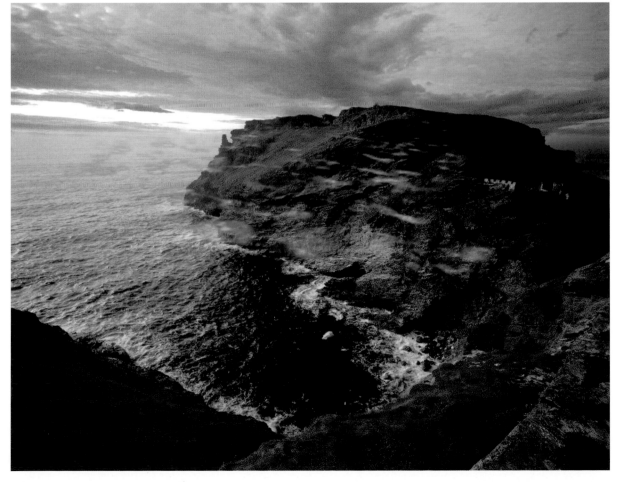

7. Final color correction
A few small color changes, such as to the junction of sea and sky at the top right, were made before saving the final image.

BUILDINGS ANCIENT & MODERN

Spiral staircase
Photographed for a book specifically on the architect Guastavino, who worked on many New York buildings, including the Church of St John the Divine, the aim here was for formal clarity—a view that explains how the design works. Cropping thinly like this also suits the subject.

Apple Store
New architecture often allows much freer interpretation in photography, and for the Apple Store on Fifth Avenue, what caught my eye most strongly was the graphic image of people on the glass steps. Seen from below, only the feet are clear, but the setting is obvious. Compare this slightly unusual view with the more sedate treatment of the other spiral staircase above.

You can photograph urban landscapes as something apart from the lives of the people who live there—in other words, as architecture. This is not just about photographing new office blocks or ancient cathedrals: in reality architecture means all buildings from the vernacular to the formal. It is as much about terraced brick houses in Baltimore and cottages in the Lake District as it is about palaces, castles, and skyscrapers.

Inevitably, viewpoint is the first thing to consider. In a city or town this is often a matter of finding simply a clear view. If you know already what buildings or street you want to capture, be prepared to put in some footwork. Also consider whether you might be better off trying to shoot from an upper level on another nearby building rather than from the street. This will then involve asking someone for permission, which is not always easy to get, but it may well be worth the effort. One tip is to look around from the building you want to photograph—if you have a direct line of sight to a vantage point, then you will be able to see back from there.

Of all city viewpoints, the overlook is often one of the most sought after—a point that takes in a general view. These are often well known locally, and probably feature in postcards. In general, there are three likely prospects: from the top of a prominent tall building; from any high ground such as a hillside; and from the opposite side of any open area like a river or park.

Lighting is as important in urban landscapes as in natural ones—possibly more so as reflections from glass and the shadows of neighboring buildings add greater variety. More than this, artificial lighting can completely transform the view as evening falls, and may even improve it. Street-lighting, the interior lights in buildings, and occasional floodlighting of major public buildings can combine in a colorful effect, although it is impossible to predict unless you know the place already. One thing is almost always certain, that the prime time for shooting night time cityscapes is the very short period just after dusk. If you wait until darkness, the outline of buildings will fade into the night sky. For this reason, winter is usually better than summer, because shops and offices are still open when dusk falls (depending on the latitude).

The color of artificial lighting varies more than our eyes recognize, because human sight accommodates differences quite easily. Fluorescent lighting has breaks in its spectrum, which an image sensor records accurately, and the result is usually greenish. Vapor lighting is often worse in this respect—sodium vapor streetlights give out no blue at all, while old-fashioned tungsten lighting is more orange than daylight. Here, digital photography has the solution, partly in the form of the white balance at the time of shooting, and also later, during image-editing, where even the most intractable color problems are correctable.

> **This is not just about photographing new office blocks or ancient cathedrals: in reality architecture means all buildings from the vernacular to the formal**

Gurgaon Hotel
Contemporary but with historical references is a style that embraces both ends of the spectrum. Here, in a luxury hotel near Delhi airport, the architect has made particular use of reflecting ponds, and shooting in evening light makes the most of this.

CONVERGING VERTICALS

Most photographs are taken with the camera aimed more or less horizontally, and for the most part this is a matter of no concern. If you tilt the camera up or down to photograph something above or below you, the picture will look as you expect it to. With buildings, however, it does matter, because if the camera is aimed upwards, the photograph will look odd, since the building appears to lean backwards. The vertical walls converge.

Digitally you can reproduce the effect of a perspective-correction lens by working on a tilted photograph

This is not some optical aberration: the verticals appear to converge even to our eyes and to the camera lens—but it is a straightforward matter of perspective. The difference is that in the real scene we accept it as normal, but see it as wrong in a picture. The simple answer is, of course, not to tilt the camera; keep it level and the verticals will not converge. In practice this is often far from easy, because of other buildings or the difficulty of getting a good viewpoint.

There is a traditional photographic solution, but it calls for special equipment—a perspective correction, or shift, lens. Using one of these, the camera is aimed horizontally, and then the front part of the lens is shifted mechanically upwards. This relies on the lens elements being able to cover a much wider area than the film (or sensor) frame; shifting it has the effect of moving the upper part of the view down into the frame. Now, digitally you can reproduce this effect by working on a tilted photograph.

The technique is to change the size of the image progressively, from top to bottom, effectively stretching the upper part or compressing the lower. The perspective tool displays a framing rectangle with corners that can be moved by sliding one of them inwards along one edge of the image. The opposite corner on the same side slides inward to meet it, so that any change you

CORRECTING DISTORTION

Filter	3D	View	Window	Help	
Lens Correction					⌘F
Convert for Smart Filters					
Filter Gallery...					
Adaptive Wide Angle...					⇧⌘A
Lens Correction...					⇧⌘R

Keystoning
To fit in both the exterior landscape and the structure of the Greenberg House, created by renowned twentieth century architect Ricardo Legorreta, I needed a very wide-angle focal length, and had to angle it slightly up in order to reach the tops of the building. The result looks as if the building is leaning back away from the camera, and the vertical lines along the side are converging toward the uppercenter of the frame. The correction begins by going to the Lens Correction filter in Photoshop.

choose to make is symmetrical. The new shape is like a truncated pyramid, and the idea is to make its converging sides the exact opposite of those in the photograph. For accuracy, first show the rulers around the frame. Then (in Photoshop) use the measure tool from one corner, running parallel to one outer wall of the building, as far as the opposite edge. Note the point on the ruler along this edge that it meets. Select the perspective tool and move one corner into this point.

Because you are resizing the image, it will deteriorate slightly, so it will need some USM sharpening, applied progressively. To do this, apply a 100 percent linear gradient to a mask layer, with the midpoint set to 50 percent, and sharpen this selection. In this way, the sharpening will be progressive from top to bottom (or vice versa) to match the stretching. As reducing the scale needs less interpolation than increasing it, the image quality will generally be better if you compress the bottom of the image rather than stretch the top.

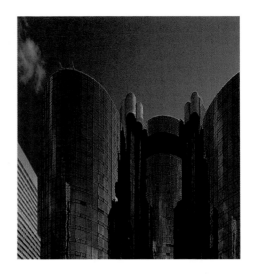

If you apply the perspective tool to the entire image, you will then have to crop it back into a rectangle, and if the width of the building nearly fills the frame, this will mean losing some of it. The alternative is to add more background, or even replace it. If so, it may be better to select the outline of the building and apply the perspective control to that, which will leave you some background to clone from. This will only work, however, if there are no converging verticals in the background.

Extreme correction
This photograph of a group of buildings in Los Angeles was shot with a wide-angle lens from up close, deliberately for the graphic effect. I had no intention of correcting it, and this example is purely an exercise. Full correction has two effects: it requires a much smaller final image to avoid excessive upwards interpolation, and it distorts the upper part excessively.

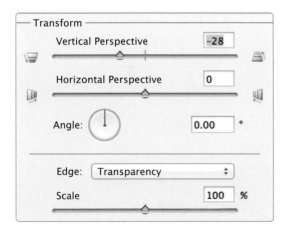

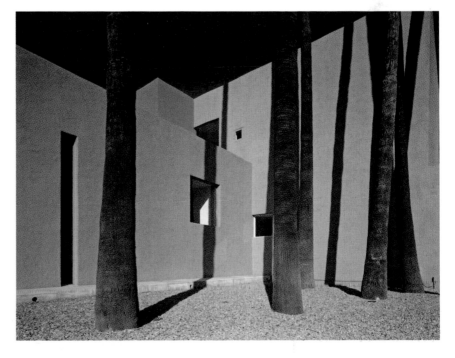

Restoring perspective
Here, it's simply a matter of dialing down the Vertical Perspective slider until the edges of the building are parallel to each other and the frame edges. However, as you can see from the final image on the right, this results in portions of the bottom corners being cropped away, and some of the foreground was then lost to compensate. The image is now slightly elongated vertically as well.

STREET CLEANING

All urban landscapes suffer from visual pollution—graffiti, advertising, telephone lines, scaffolding, and satellite dishes, not to mention bad architecture. Fortunately, some of the more egregious examples, like electricity cables, are also among the easiest to remove digitally, and this is one area where it would be difficult to argue against digital editing.

> **Some of the more egregious examples, like power cables, are also among the easiest to remove digitally**

I am distinguishing here between documentary photography—shooting places and things, warts and all—and architectural photography, where the point is to show the building as it should be seen. You could say that it is the unblemished view that the architect would prefer.

If you know in advance that you will be doing this, there are some steps that you can take when shooting to make life simpler. First, identify the obstructions and other elements that will need removing and check whether the areas they conceal can be cloned convincingly from wherever is visible. A patch of bricks will be easy enough, but something less regular may turn out to be a lot of trouble for a small detail.

You may be able to work around this by shifting the camera viewpoint a little to one side, but check that this does not create a similar problem elsewhere. Another solution is to take two similar photographs a short distance apart, and rely on parallax to make the concealed parts of one image visible in the other. Then clone, or copy and paste, from one to the other. This technique will work with most things in front of a building, although parked vehicles may need some extra shots. If you can go to the trouble, you could shoot details from the pavement to add later as patches.

People walking around in front of a building, or in an interior, can also be taken care of, if they bother you. This is particularly a problem with ancient monuments swarming with tourists. For only a few people, use the cloning tool in the normal way, but for a crowd use the following technique. Without moving the camera (best to use a tripod), make two identical exposures a few minutes apart. Put each picture in one layer of the same image file, and as long as the people are moving, rather than sitting in one place, you can then paint through the visible parts of one image to another.

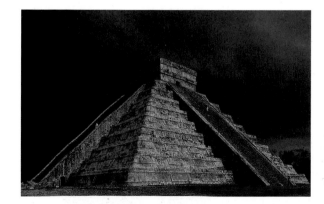

PEOPLE AND SIGNS

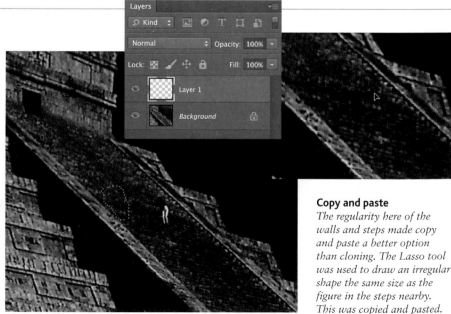

TECHNIQUES

A well-visited monument
As happens more often than not with well-known monuments such as the Mayan pyramid of Chichén Itzà in Mexico's Yucatán, *other visitors clamber over the site. Waiting may be an option, but when the lighting is good, as here, just before a storm, there is nothing to do but shoot and alter later.*

Copy and paste
The regularity here of the walls and steps made copy and paste a better option than cloning. The Lasso tool was used to draw an irregular shape the same size as the figure in the steps nearby. This was copied and pasted.

162

1. Temporary cranes
The original shot (above) of the City of London had its inevitable addition of tower cranes—construction here is neverending.

2. Copy and paste
To achieve the final result (right), the basic procedure was to copy clean sections and paste them over areas containing the cranes, using rectangular selections. Cloning was also used in places.

3. Seamless joins
Skies are particularly difficult to paste over because of their fine shading, but one way to overcome this is to flip the pasted copy horizontally, then join to the edge of the original selection (left). In that way the edges blend perfectly, as they are identical.

4. Window details
The regularity of most buildings (far left) made it possible to copy small selections for pasting over parts of cranes below the skyline (left).

Repeating the operation
The same technique was used for the rest of the building, to cover over a works entrance, signs, and other figures. Pasting in Photoshop automatically creates a new layer, which is useful for retouching.

DIGITAL RESTORATION

What can be made can be altered. Even apart from the sort of tidying up that we just looked at, there are a number of good reasons for making architectural alterations. One of them is restoration—genuine structural problems that for one reason or another have not been corrected in the real building. Another is deconstructing a particular type of building to show how it works architecturally—a kind of photo-illutration. Examples of these are shown here, both coincidentally from Thailand.

What can be made can be altered

In the picture below, the problem was subsidence. The piles of the teak pavilion were sinking slowly into the mud of the lake. While in normal circumstances this could have been treated simply as a feature of the building, and left alone, the composition of the shot made it glaringly obvious. Because this was to be the cover of a coffee-table book, the wooden pillars simply had to be straightened to align with the right-hand edge. Worse, the subsidence was progressive, from left to right, so that the pillars closest to the edge of the frame were the most tilted. Tilting the camera in the opposite direction would have made the lake and the other buildings slope to the left.

The only solution was to do what the clerk of works should already have done: Raise and straighten each pillar individually. As with any major piece of manipulation, it pays to think first about the working method. In this case, the sensible approach was to slice the subsiding part of the pavilion into different portions, according to the angle of tilt, put each one into its own layer, and rotate until straight. In detail, this meant considerably more work retouching the joins, particularly as the fretwork had to be kept regular to ensure that the end result looked convincing.

RESTORING A TEAK PAVILION

The original
As taken, the photograph of the Vimanmaek teak palace in Bangkok emphasizes the leaning pillars of the pavilion, but I liked the composition so much that I was loath to frame it in any other way. Digital restoration was planned from the start.

Rotate selection
Having made a selection of the pavilion, using Paths, a copy of this in its own layer is first rotated to straighten the left edge (below). Showing a grid overlay helped the alignment.

Partly straightened
The result (above) of the first rotation is that the left pillars are now vertical, but more work remains to be done on the others.

Rotate more
A second selection, cut in from the first, is rotated a fraction more to straighten the central pillars.

Wide-angle original
The only camera position possible for shooting this northern Thai rice barn meant a wide-angle shot, which is rather too distorted. The clutter below is inevitable.

Deconstruction
Using Paths, the key components were isolated (right). Hidden pillars were cloned from those visible. Applying a shadow under the eaves, all of these were combined into a single image.

In this other example, the aim was to create clean architectural views that were typical of types of building, and so needed to be more generic than idiosyncratic. To make the job more difficult, this was decided after the photographs had been taken; otherwise the procedure could have been eased by shooting with this in mind. Fortunately, one characteristic of most architecture is that there is repetition in the façade—windows, tiles, bricks, planks, and so on. Traditional Thai wooden architecture uses prefabricated elements, and while the panels, posts, balustrades, and decorations are not precisely identical because they are hand-carved, it meant that only a few sections of each were necessary to build a house digitally.

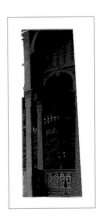

Composite the rotations
The final adjustment is made on a small section close to the right edge. There are now three overlapping sections, each of which is properly aligned, and these are finally combined, with retouching to cover the joins (above).

Final composite
The corrected pavilion is now overlaid on the original image, again with retouching (right).

TECHNIQUES

165

INTERIORS

The interior spaces of buildings, from modest living rooms to grand halls and concourses, are yet another subject with particular and specific opportunities and needs. All but the largest rooms absolutely need a wide-angle lens, and there is little point trying to do justice to a room if the focal length of your lens is no wider than the equivalent of 28mm on a 35mm camera. Fortunately, recent years have brought an abundance of wide-angle (and even ultra-wide-angle) lenses to market.

If you stick to daylight, you are likely to find that most rooms are unevenly lit, with windows on one or two sides only

Whatever the lens, you are likely to find that a corner of the space offers good possibilities, if not the best, for your viewpoint. This is particularly so in a small room, where it is always difficult to back up far enough to take in some sense of the entire area. Also, most domestic interiors tend to be arranged horizontally, which is to say that there is not likely to be much vertical interest, and there are usually only a few opportunities for shooting to a vertical format.

Once the viewpoint has been established, lighting is paramount. There is broadly a choice of three: daylight as it filters in through the windows; available light from the room's existing lamps; and photographic lighting (which for most people means flash). You can combine these, such as by switching on room lights during the day, and using photographic lighting as an additional help for shadows. In all cases, the actual light level will be so much less than outdoors that you will have to find some way of keeping the camera stable for a long exposure. A tripod is virtually a prerequisite.

If you stick to daylight, you are likely to find that most rooms are unevenly lit, with a window or windows on one or two sides only. The result is a fall-off horizontally, not something that your eye may take in because it accommodates it, but it will affect the image, particularly if you shoot with the windows on one side of the frame, which often gives the best modeling. There are two traditional professional techniques to deal with this: One is to aim a flash or some other photographic light into the shadow side of the room to balance it; the other is to use a neutral grad filter horizontally to compensate. Digitally, life becomes much simpler; taking the neutral grad idea as inspiration, an easy solution is to apply lightening or darkening across the image with a gradient fill. A more sophisticated approach would be to shoot two frames, one exposed for the highlights, the other for the shadows, and then combine these in the image-editing program in the way described on pages 170–171.

If you use available lighting, the same issue of color balance applies here as it does to nighttime city views. Once again, the camera's white balance turns what used to be one of the banes of film photography into a simple matter of pressing a button. If there is a color cast that you cannot eliminate in shooting, just take care of it in image-editing.

CORRECTING TUNGSTEN LIGHT

Incorrect original
This is what daylight-balanced emulsion film gives you without a blue filter.

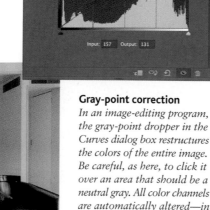

Gray-point correction
In an image-editing program, the gray-point dropper in the Curves dialog box restructures the colors of the entire image. Be careful, as here, to click it over an area that should be a neutral gray. All color channels are automatically altered—in this case, the biggest change is, as shown, to the red channel.

TECHNIQUES

166

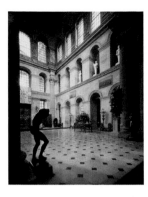

1. Unavoidable window flare
In the main hall of Blenheim Palace, near Oxford, England, the camera position was determined by the statue, but there was unavoidable flare from the upper two windows on the image of the fluted pillar to the left.

3. Copy and paste
This section is copied, then pasted into another layer and moved up to cover the bad flare. This operation is repeated until a realistic blend is achieved.

2. Clone color, then luminosity
To make a clean correction of the less serious flare from the lower window, the pillar was selected to protect the window from any changes. Then, a large, soft cloning brush was used twice—first for color to remove the purple tint, and then for luminosity to darken it.

4. Select a section of pillar
For the more difficult top part of the pillar, a section of the lower, fully corrected area is made, its lower edge softened in the mask. This will aid blending in the final step (above).

TECHNIQUES

ANIMALS

Subjects like landscapes and buildings are so easily available that they lend themselves to interpretation and experiment. Usually, there are time and space to spare. Animals, however, are a very different matter, and while the finest wildlife photography is distinctive in style, the two main considerations are simply getting close and capturing some behavior. There is a sizeable difference here between photographing animals in captivity and in the wild. A zoo, for example, gives you a reasonable chance of being close, but you are less likely to see natural, interesting behavior. In the animals' natural habitat, the reverse is usually true.

Photographing animals relies on both equipment and knowledge; neither one is sufficient on its own. The key piece of equipment is a telephoto lens, and there are very few situations in which you can shoot successfully without one. This begs the question of how powerful a telephoto—its focal length—is.

Longer is nearly always better. Much depends on the kind of animal, how close you can approach it, and the setting, but generally speaking you should have a lens of at least four times normal (remember that a normal focal length is the diagonal measurement of the imaging sensor, which varies from camera to camera). Most professional wildlife photographers use lenses up to ten times normal. These can be very expensive, and while this is not meant to discourage you, you should be realistic about what kind of shooting you tackle. One special advantage of digital cameras that use sensors smaller than 35mm film is the immensely long telephoto lenses that they can support while remaining relatively compact and handholdable.

> **Photographing animals relies on both equipment and knowledge; neither one is sufficient on its own**

The herd
A family herd of African elephants in Kruger National Park, photographed from a helicopter. As part of a relocation program in which entire family units are moved, they are about to be darted and tranquilized prior to trucking to a new location.

Indian roller
Shot in Yala National Park, Sri Lanka, this bird was fast moving and typically unpredictable. Following it for some time (with a very long telephoto and a speedy autofocus system), gave enough shots that I could choose one with an interesting composition.

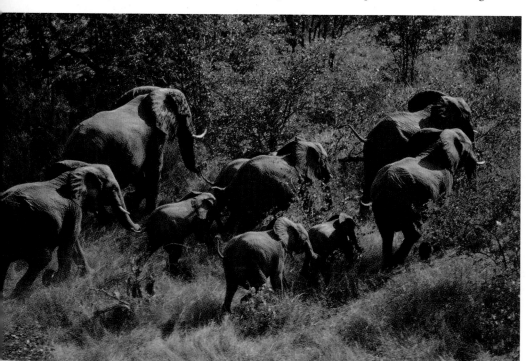

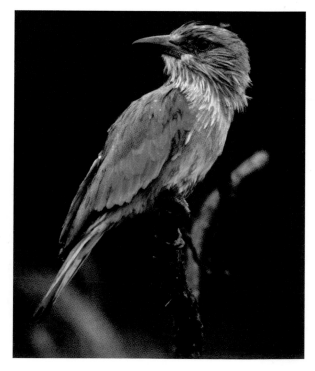

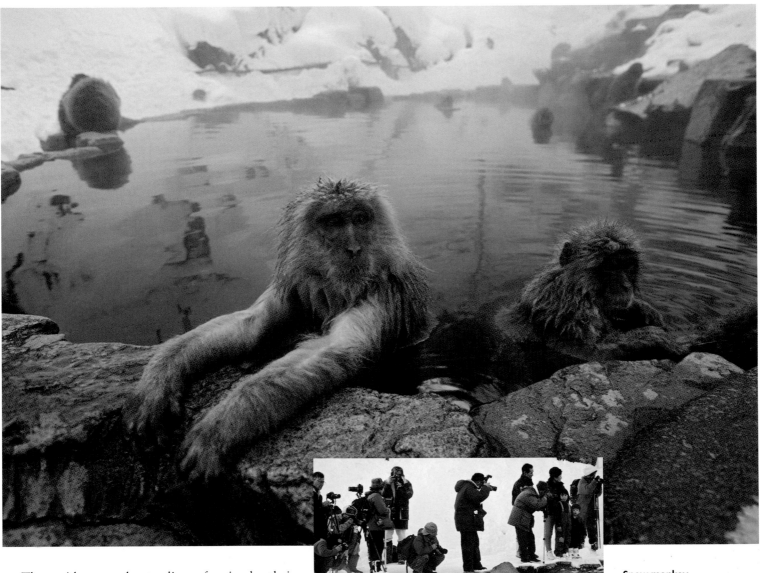

That said, an understanding of animals, their behavior, and their habitats can go a long way toward putting you in the right place at the right time. The very first step is to research the best location—some places are wonderful for photography, others hopeless, and the factors are not always obvious from guidebooks. It is even the case that some zoos and wildlife reserves are, for reasons of layout and design, much easier to take pictures in than others. As an example of this, I include a photograph of a Japanese snow monkey that is successful entirely because I knew where to go when the weather forecast predicted snow. The circumstances of the setting also allows the unconventional use of a wide-angle lens for wildlife.

Action, as in birds in flight, involves skill in shooting quickly and focusing precisely, as well as using a fast shutter speed (which in turn depends on the right ISO setting for the lighting conditions). Fortunately, modern autofocusing mechanisms can generally cope with most movement, but it is still always easier to photograph an animal moving across the field of view than coming towards you (going away from you, which happens all too often if you disturb an animal, is useless for photography, unless you particularly want a back view). For more advice on catching movement, see pages 190–191.

Snow monkey

Groups of Japanese macaques have learned to use the hot springs in the mountains of Nagano prefecture during winter. For photography this involves a different aspect of timing—being there when it snows. The actual shooting was no problem, because the macaques are not disturbed by humans (as you can see—and the contextual shot is a hint at the relative artificiality that goes into some nature shots).

TECHNIQUES

169

DIGITAL SOLUTIONS

The digital manipulation of wildlife photographs has caused more heated debate than most other subjects

Given that capturing good, clear images of animals in the wild is by no means a certain thing, and will produce a high proportion of near-misses, this is fertile ground for digital improvement. The primary issue—and usually the hardest one—is getting close access to the animal, which is why long lenses, remote control, camouflaged blinds, and fieldcraft feature so much in professional wildlife photography. The valuable role that image editing can play is in enlarging and enhancing—adding a telephoto extension, as it were.

A camera's digital zoom is still a gimmick (although this is one situation in which it may be justified), but the useful tools are an image-editing program's re-sizing procedure using its highest-quality interpolation (bicu-

bic in Photoshop), followed by USM sharpening. You may well be pushing this to the maximum, so make use of every trick mentioned in chapter 10 to improve image quality, including experimenting with combinations of Amount, Radius, and Threshold in the USM filter, and applying them in several small amounts.

Also without changing the substance of the image, there are ways to enhance it using various color controls. Saturation, in particular, can help to make an animal stand out more from its background, if you apply it to a dominant color or if you first make a careful selection of the entire animal and apply it to only that. A difference in brightness between the animal and its background will have a similar effect. If the animal is in partial shadow, it may help to lighten this.

Image-editing programs can help in several other ways, such as by dealing with the common problems

TWO-SHOTS FOR OBSTRUCTIONS

Foreground leaves and branches
As often happens in woodland, out-of-focus vegetation got in the way. Here, two shots of a Florida blue heron each have good and bad points—the head is better lit in the lower shot, but blurred leaves obscure part of the body.

Image overlay
The version with the obscured body is placed in a layer over the other, and aligned by rotating so that the neck and body fit properly at their *junction. As with all such alignments, the upper layer is temporarily made half-transparent so as to be able to see the underlying layer.*

Erase to the clear body
All the subsequent operations are made on duplicate layers, for safety. First of all, the *version with the obscured body is partially erased so as to reveal the clear version underneath.*

170

of obstructions in the line of sight. Whether this is a proper role for them, however, is a matter of opinion.

Needless to say, the digital manipulation of wildlife photographs has caused more heated debate than most other subjects. Arguing against it are most professional wildlife photographers, who see it as dishonest, and a negation of the effort they put into capturing real images. Those who argue for it claim that digital manipulation is an extension of the shooting, fulfilling the same task of showing a clear image. I leave you to decide for yourself. Here is what image editing can do.

Borrowing the two-shot parallax technique used to clean up views of buildings, described on pages 162–163, you can overcome foreground obstructions by shooting two frames quickly, moving to one side between exposures. Depending on the circumstances, you should be able to get two similar images in which the obstructions—foliage, for example, or even the bars of a compound in a zoo—cover different parts of the animal. Choose one image as the principal one, and copy and paste clear sections from the other image into it. Success depends on shooting quickly enough for the animal not to have moved between frames.

Lost colors underwater
Even a yard or two underwater, the warm end of the spectrum is stripped away, and without flash, unfiltered photographs appear blue or bluish green, as in the original of this Portuguese man-of-war. Color balance sliders were the easiest tool to correct the blue cast, but in order not to lose the blueness behind, the correction was applied to the jellyfish alone.

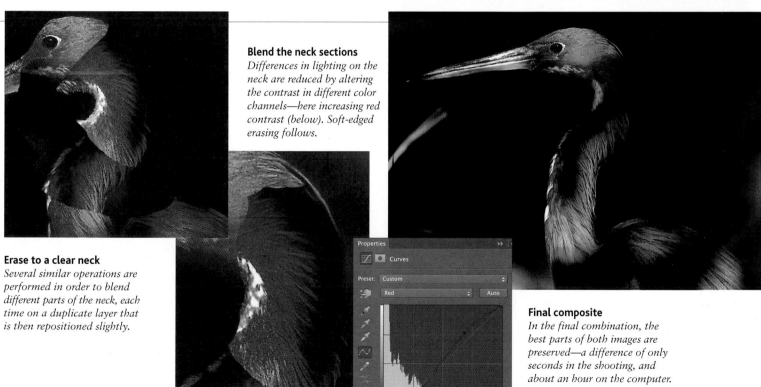

Blend the neck sections
Differences in lighting on the neck are reduced by altering the contrast in different color channels—here increasing red contrast (below). Soft-edged erasing follows.

Erase to a clear neck
Several similar operations are performed in order to blend different parts of the neck, each time on a duplicate layer that is then repositioned slightly.

Properties
Curves
Preset: Custom
Red Auto
Input: 175 Output: 196

Final composite
In the final combination, the best parts of both images are preserved—a difference of only seconds in the shooting, and about an hour on the computer.

COMBINATIONS

n the photograph on this spread, image editing was used to combine two shots taken a few seconds apart, as small flamingos were taking flight. To be honest, I did this more as an experiment than for a genuine need, since both shots were fine as taken. Nevertheless, it demonstrates very well the power of digital compositing, for better or worse.

The base image is of three flamingos taking to the air from a river. The job is to add another flamingo, in full flight, in the foreground. Both photographs were shot on 35mm color transparency film (Velvia), and scanned at 300 ppi to measure 11 × 7½ inches (28 × 19cm)—22MB each. You will always want to be working with as large a file as possible for delicate compositing work—the more pixels the better. The key to this composite is perfect blending,

which means sophisticated edge control. A progressive amount of transparency is applied to the edge, and the information picked up from here allows the program to compute the color contribution of the background. The color cast from the new background will replace the original. Smart masking like this is ideal for tricky edges like hair that are common in nature.

Two final touches are in the depth of field and in the form of the foreground bird. As the photographs were shot with a 600mm lens, which has very shallow depth of field, the background should actually be out of focus for complete accuracy. I applied some blur to simulate this effect, though less than it would have been in the camera because I wanted to keep enough of the detail of the background to convey the situation.

The key to this composite is perfect blending, which means sophisticated edge control

FLAMINGOS

1. Loading the first image
The base image is imported with an Image Insertion command, and sits in its own layer.

2. Silhouetting the second image
In Photoshop, you can load the second image in a separate layer and highlight the area you want to transfer to the alternate background. For a shape like this, against a relatively blurred background, the new Quick Selection tool is ideal—simply paint roughly inside the area of the image you want to select, avoiding the edges.

3. Completing the silhouette
Once the outline looks fairly precise, the inside can be filled, using a Marquee tool over

the entire image (below). The procedure not only drops out the background, but maintains edge information.

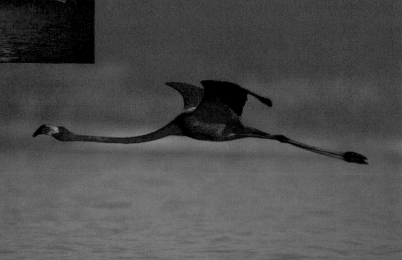

172

4. Edge control

Once your selection is active, it will still need some refinement. Select the Refine Edge button in the Tool Options bar. This allows you to see the selection a numbers of ways—as "marching ants," over a mask, over black,

over white, and in black and white. Here the over black option made the green halo very clear, making it a simple matter to Contract the selection around the bird, sharpen the Feather and tweak the Smooth value. The selection looks much sharper.

5. Mask

Although not essential, it's good practice to use a Mask as the selection can be tweaked later if needed. Using the Reveal Selection option a new Layer Mask was created, then dragged the layer onto the original image (which was also open).

6. First composite

The completed image (above) is a seamless blend of the two original shots, with only one oddity—the depth of field is far too good for the long telephoto (a 600mm lens) that was used.

7. Focus adjustment

For realism, I rework a second composite (left), this time applying a slight amount of blur over the entire base image, using the marquee tool set to "Gradient" in the "Sharpen/Blur" layer.

173

LIFE IN CLOSE-UP

Most of nature is on a miniature scale—plantlife, fungi, and insects—which for photography is rather more accessible than mammals and birds. The main issue when dealing with small subjects is how close the camera's lens will focus, and so how much magnification is possible. With a compact camera, the close-focusing ability of the single lens is set by the manufacturer, but most work at very close range. Moreover, parallax, the bane of close-up work with a viewfinder camera, is hardly an issue when you can see your framing directly on the LCD screen. With a digital SLR you can add a macro lens built for this purpose to your kit, as you would with a 35mm film SLR.

Flowers and fungi are among the easiest outdoor subjects, but the essential skill is, in nearly all cases, to find a way of isolating them visually. Often, other plants get in the way and clutter up the picture; your eye can ignore this but the camera cannot. Sometimes you can improve the composition with a little judicious "gardening," as tidying up is called, although rooting up plants is not a good way of treating the environment, and may even be illegal. Shooting with daylight, a tripod is nearly always essential, to keep the camera steady enough for the inevitable long exposures. Because most close-up subjects outdoors are close to ground level, use either a small tripod or one whose legs can be spread wide. Alternatively, on some tripods the column that carries the head can be reversed so that the camera is suspended.

> **Most of nature is on a miniature scale, which for photography is rather more accessible than mammals and birds**

Raindrops on a lily leaf
This subtle subject, floating in a lagoon off the main river near the Amazon in Manaus, Brazil, could be overlooked easily enough, but getting in very close reveals a delicacy in the texture and contours of the leaf and water droplets that enrich the subject and provide plenty of detail for the viewer to study. A longer-focal-length macro was key here, as it gave adequate working distance (useful for not falling into the water).

Caladium leaves
Getting adequate light for an exposure is always a challenge in macro photography, but sometimes it can come from unusual places. The petals of this flower were thin enough to become translucent when positioned such that the sun overhead was shining through them and directly into the camera. It also reveals an abundance of detail in the veins of the petals.

A key technique is to use depth of field intelligently. The closer you focus a lens, the shallower the depth of field, and this is very characteristic of close-up photography. A flower with a complicated background will usually benefit from having only just enough depth of field to keep it sharp while throwing the surroundings out of focus. This usually works best if you are shooting horizontally rather than downwards, at the height of the flower itself. Use the depth of field preview button, if your camera has one, to find the best compromise aperture setting. Set the shutter accordingly, or use whatever program an auto camera has to give aperture priority. Another possibility is to introduce your own background; black velvet or a white card, for example, hung a little way behind the flower will create a near-studio setting. Here is a tip to deal with the effects of a breeze during a long exposure: hold the flower steady by coiling a piece of soft, thick copper wire around the stem (out of sight), and fixing the other end in the ground.

Flash involves a rather different technique, and for insects and other small animals is virtually essential. For this kind of subject, good depth of field is highly desirable, and this means that the lens must nearly always be stopped down to a very small aperture.

With natural light, even on the brightest day, the shutter speed would then have to be extremely slow—too slow to prevent camera shake without a tripod, and too slow to freeze the movements of an active subject.

On-camera flash, however, has the drawback that the lens extension may block its light from reaching a close subject. More useful is a detachable portable flash that you can position close to the plantlife, fungi, or insect. Although a single flash head is satisfactory, the close working distances often mean that it has to be positioned to one side of the subject, and as a result casts a strong shadow. Better is to position a reflector (mirror, foil, or white card) or a second flash unit on the other side.

A dedicated flash unit, linked to the camera's metering system, is obviously a convenience, but photographers who specialize in close-up work usually devise a fixed set-up, with the flash units in a pre-set position, so that at each of a few lens extensions they are familiar with the aperture settings. With this method, which calls for testing beforehand, even small, inexpensive non-automatic flash units can be used. In any case, a flash extension lead will give you much more freedom in positioning the light; for example, overhead to simulate sunlight.

Stick insect
Because of the uniformity of colors, this stick insect needed to be shot head-on and from directly above to accent its shape against the veins of the leaf.

Backlighting
Shooting into the sun highlights the morning dew. The lens aperture was adjusted carefully to control the apparent size of the sun so that it matched the body of the insect.

TECHNIQUES

175

NEW TREATMENTS

Nature as a whole is possibly the richest source of color and form for photographic experiment, and digital procedures are made for this. The possibilities are almost without limit, but by way of samplers I include two very different ones here.

You can think of a scanner as a kind of camera, and a flatbed model, with its large, open, glass, scanning area, is very adaptable. The automatic focusing and depth of field are surprisingly well suited to three-dimensional objects as well as flat artwork and film, and the level of detail that you can capture is equivalent to that of an oversized plate camera. The two obvious limita-

A scanner's automatic focusing and depth of field are surprisingly well suited to three-dimensional objects

tions are that the lighting is absolutely frontal and the exposure takes a number of seconds, but if you can live with that, a direct scan of flowers or anything motionless can be a fascinating starting point for creating an image. Drawing on the compositing techniques already described, you can build up a final image from the raw material of different scans—and incidentally enhance the apparent depth of field as you do this.

In fact, the frontal lighting is quite different in character from the harsh and generally unsatisfactory effect that results from a camera's built-in flash. The long strip of light that travels along the bed gives a soft, diffused light that cannot be reproduced by normal optics—thus a soft modeling. I now use my flatbed scanner regularly to shoot flowers and other natural objects.

Use the setting for a reflective rather than transparent original, and lay the objects on the bed. The cover will have to stay open, but provided that there is little ambient lighting in the room, the scan should not pick up much of the background above. If it does catch reflections, try covering the objects with black cloth (velvet reflects the least light). Alternatively, experiment with adding lighting from the side, and with different background coverings.

Another, less documentary, approach is to use natural subjects as a kind of still-life component, and incorporate them into other settings and scenes. Once again, you have the full array of digital manipulation techniques at your disposal, beginning with the all-important selection procedures. If you know in advance that you will be doing this kind of compositing, try to shoot the originals against backgrounds that are fairly plain and contrasting in color—that will make it easier to create a selection outline.

In the example to the right, the idea was to have the brightly colored lizard emerge from an old map of tropical South America, something that could be achieved only with digital techniques.

SCANNER AS CAMERA

This selection of dried plants and fungi from a potpourri was an ideal subject for scanning. The lotus bulbs, corn husk, and fungus were scanned together in one pass, with the flatbed scanner head fully open. A black velvet cloth over the objects kept the background black. In a second pass, a cluster of dried pine cones was scanned, at a different scale. Both images were cleaned up in an image-editing program (with objects like these, dust and bits fall onto the platen, where they register brightly), and then composited.

1. Lizard selected
As a first step, the lizard was selected and isolated from its original background, a leaf.

2. Paste in
The lizard selection was pasted into a layer over the specially shot still life, and positioned approximately (left).

3. Scale down
Slightly too large for the map, the lizard layer was resized (below).

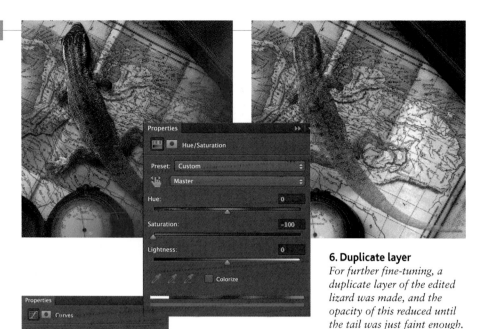

6. Duplicate layer
For further fine-tuning, a duplicate layer of the edited lizard was made, and the opacity of this reduced until the tail was just faint enough.

5. A gradient selection
In masking mode, a gradient was applied so as to create a gradual selection of the lizard, grading from full at the tail to none at the mid-point of the body (top left). Lightening and desaturation were then applied, one at a time, to the lizard layer, using the Curves dialog box and the HSB dialog box.

7. Gentle fading
Finally, a soft eraser brush was gently applied to parts of the original lizard layer, to fade it selectively to the duplicate, low-opacity layer above. The result (below) is a perfectly controlled fade.

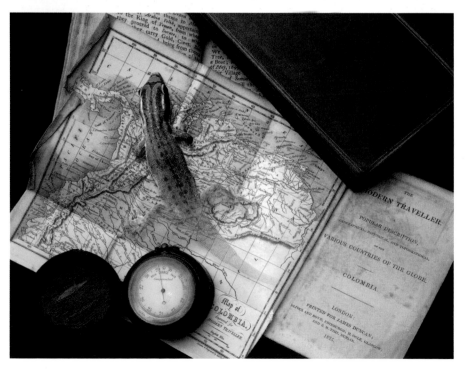

4. Drop shadow
A soft shadow was added, using Photoshop's Layer Styles feature

(above), being careful to match the direction and diffusion of the still-life lighting.

STILL LIFE

T he epitome of object photography is the still-life composition, a tradition of imagery that goes far back into painting and drawing. It first came to prominence with Dutch painters of the seventeenth century, and has attracted a wide range of artists ever since. Much of the appeal of still-life photography, as with still-life painting, lies in its exploration of composition and lighting. Indeed, one way of approaching the still life is as a kind of exercise in the problems of imagery—such problems as how to reveal texture, the play of light between objects, modeling, and balance—regardless of the importance of the actual objects.

Much of the appeal of still-life photography lies in its exploration of composition and lighting

Coming hard on the heels of a painterly tradition, photography brings its own technical influences to the still life, although now we have a new freedom to experiment even more. There is a basic difference between the planned and the found still life. Considered, ordered arrangements are typical of the studio, which includes any makeshift studio at home. Typically, the photographer selects from a group of interesting objects and proceeds to compose and light them in a completely controlled way. A contrasting approach is the found still life—the discovery of a natural arrangement at a moment when the available lighting works some magic.

The method of arranging objects is a major part of the creative process, and for this reason is subject to no rules. Certainly, there are recognized harmonies in composition, but any formula that you follow is likely to be sterile, and it is much better to go with your feelings for how things fit together. While there need be no compulsion to fill the frame every time, the relationship between its shape and edges and the objects inside it is cru-

St. John's Bible
The subject of this cover story and of the still life to the right is the first illustrated Bible with hand calligraphy to be commissioned in over 500 years.

Depth of field
What was needed here was to show the entire illustration but concentrating on fingertip detail. A wide-angle lens was used from low, with the smallest aperture. In addition to the diffused overhead light, smaller spots lit up the rolls in the background and the burnishing tool a few inches from the camera.

cial. This is much easier to appreciate in two dimensions than through a viewfinder, and for this a digital camera, with its digital preview screen, is ideal. It goes without saying that a tripod is particularly useful, so that camera and view are fixed, allowing you to concentrate on the arrangement.

Lighting is fully a part of the composition, for it not only reveals form, texture, and color, but through the combination of shadows and highlights it plays a

major role in the balance of the image. The quality of the light—chiefly the degree and type of diffusion or hardness—is of great importance, and is worth experimenting with. Expensive professional lighting attachments are convenient but by no means essential, and any household material that can pass light or reflect it has a potential use. The one essential is that the lighting should not be boring.

Close-up photography can also be a form of still life, subject to the same possibilities in composition and lighting. It has the added advantage that at this different scale there is a fresh range of images. Depth of field is naturally shallow at these magnifications, but this can be used to focus attention and to add layers of softness.

A classic arrangement

This antique military uniform (left) was left in an old, uninhabited country house, but piled up. It needed rearrangement to be photographed, but I did not want to completely abandon the idea of it being "found." The composition is a compromise between order and casualness. Though a similar image could have been created with a film camera, there is no denying that the use of the digital camera's preview screen (along with the option of taking test shots that are immediately visible) is a significant aid in both creative and compositional terms.

Pearls in close-up

These rare orange pearls (above) were an exquisite subject for close-up photography, revealing color and texture under a simple diffused light not immediately obvious to the unaided eye. They needed a contrasting background for both the color and the texture; I chose water-washed pebbles painstakingly blackened with shoe polish. The geometry of compact digital camera optics and smaller imaging sensors is such that extensive depth of field is possible—successfully used here to enhance the textures. Many such cameras have "macro" capabilities that can produce imagery that is not readily possible with equivalent full-frame cameras.

CLEANING UP

A fair proportion of object photography calls for clean, neutral backgrounds, and still-life studios keep a selection of seamless backdrops, from rolls of plain paper to still-life light tables with curved sheets of translucent Plexiglas for backlighting. Commercial product photography, in particular, often isolates objects. White or lightly shaded backgrounds are the most common choice because they are the least obtrusive, and in this case one of the exposure issues is to peg the brightest part close to the minimum density, without losing any detail.

Digitally excising background may be the only way of isolating very large objects

Scanning digital backs for large-format cameras are capable of recording a greater dynamic range than film, and are perfect for this kind of shot, although very expensive. (This quality is one of the reasons for their being adopted so readily by professional studios.) Handheld digital cameras suffer in this respect, but color correction during image editing is able to take care of the problem. When shooting, use the white

ADDING A GRADIENT BACKGROUND

One of the standard professional studio backgrounds is a seamless curve of plain material, which if lit from above naturally shades off behind the object. Digitally you can create this by applying a gradient to the inverse selection of the object. However, beware of banding—deal with it by selecting the dithering option in Photoshop, and by applying a small amount of noise in each channel, one at a time.

balance point to make sure that nothing is irretrievably overexposed; check with the in-camera histogram if there is one, and later use the Levels or Curves controls to extend the highlights.

It may be worth selecting the background to apply color and tonal changes to it alone. Having gone this far, it may be easier or more effective to replace the photographed background entirely, with a gradient or a digital texture, or both. In any case, digitally excising the background has an important part to play in object photography, and may provide the only way of isolating very large objects.

The clean, sharp edges of most man-made objects need a different treatment from natural landscapes, people, and animals (where foliage, hair, and fur rule). The technique of choice is the Paths tool. It takes time to make an accurate outline, and some skill in manipulating Bézier curves, but has the considerable advantages of being precise and occupying very little file space.

PATHS AND BÉZIER CURVES

The ideal technique
The flowing lines of Thailand's finest example of a walking Buddha (which could not be moved) are ideally selected with Bézier curves.

Complete the outline
Draw the outline, dragging slightly at each anchor point to approximate the curve.

Adjust the curves
Once the path is complete, go back to correct the curves by tweaking the handles.

A path is a vector outline, meaning that it is calculated by its shape and location, and not by the pixels it connects. Indeed, it is resolution-independent, so that once you have completed it, you need to convert it into a selection of pixels—a simple, one-command operation. Drawing a path makes no change to the pixel image; you use a "pen" cursor to locate points around the edge of the object, and these are connected automatically by line segments.

These points are known as anchor points, and the lines can be straight lines or curves. The curves, known as Bézier curves, are controlled by pairs of handles, which can be pulled in or out and altered in their angle—a procedure that is easier to show than to describe. Typically, you would work around the outline, placing anchor points at corners and changes in direction as necessary. Complete accuracy is not important at this stage, because once you are finished, you go back with the editing tool to move the anchor points and adjust the handles so that the curved segments match the outline precisely. You can add and delete anchor points as necessary.

More anchor points give a more detailed outline, but require more processing power. Moreover, a smooth curve is better followed with one or two segments rather than many. Judging the number of points that you really need comes with experience, but as a guide, work on what you can see at 100 percent magnification.

A SMOOTHER BACKGROUND

1. Original
This painted sculpture by artist Yukako Shibata had to be photographed in situ.

3. Inverse selection
A selection is made from the path, inverted, and the background deleted.

5. Correct the verticals
Back in the sculpture layer, the distortion tool is used to straighten up the converging verticals.

2. Make a path
The sculpture is outlined with the path tool, working close at 100%.

4. Gradient background
In a separate underlying layer, a new background is created with the gradient tool, from top to bottom.

6. Shadow procedure
To create a drop shadow, the sculpture selection is duplicated, and filled with black.

7. Remove upper shadow
Only the lower part is needed for a shadow; the upper is erased (above).

8. Shadow blur
The remaining black shadow is blurred strongly.

9. Blending the shadow
The opacity of the shadow layer is weakened to give a realistic tone, and the entire selection moved down so that it appears below the sculpture. The finished result is as if the sculpture had been photographed under controlled studio conditions.

TECHNIQUES

REWORKING LIGHT

With lighting playing such a critical part in still-life photography, digital adjustment is particularly valuable, usually in correction and fine-tuning. Heavy manipulation is beyond the scope of bitmap image editing, as we saw in the previous section on landscapes, but in still-life photography you have the option of changing the lighting itself as you shoot.

Still life's problem materials are those that reflect and refract—chrome, mirrors, glass, and so on—and a number of specialized techniques have been developed over the years by studio professionals to deal with these. A curved, highly reflective surface is difficult because it shows up all of the studio surroundings, including lights and the camera itself. One classic solution is to surround the object with a seamless translucent material such as tracing paper or milky Plexiglas, just out of view, and place the lights outside this. A small hole is cut in this "light tent" for the camera's lens to shoot through.

This is not, however, a complete solution, as the lens is still likely to be reflected, and the almost shadowless lighting that results may not be what you would have wanted for any surrounding objects or background.

Here, digital retouching comes into its own. Small reflections, intractable for traditional photography, are so easy to remove with a cloning tool that they don't have to influence the way you set up the lighting. Larger reflections can be blurred, and the shading lightened. An important precaution is not to overdo any of this; the equivalent technique in early black-and-white product photography was airbrushing of the print, but it often introduced a patently false perfection.

Glass objects, particularly when filled with liquids, also need special care in lighting. To prevent them looking

> **Small reflections are so easy to remove with a cloning tool that they don't have to influence the way you set up the lighting**

ENHANCING BACKLIGHTING

Colored glass
Backlit colored transparent objects like this antique perfume bottle nearly always benefit from brightening. Simply increasing the backlighting or the exposure only causes flare.

Select blue
Only the colored glass is to be enhanced, not the silver attachments, so the first step is to select the color, using Color Range in Photoshop. For precision, the exact blue is sampled.

Color Range

Select: Sampled Colors

☐ Detect Faces
☐ Localized Color Clusters
Fuzziness: 100

Range: %

OK
Cancel
Load...
Save...

☐ Invert

○ Selection ○ Image

Selection Preview: None

Properties

Curves

Preset: Custom

RGB Auto

Input: 96 Output: 160

Alter curve
On this selection of blue, the entire RGB curve is pulled upwards in the center, which brightens the color. This is sufficient enhancement (right), and there is no need to increase saturation.

"dead," some kind of backlighting is usual, but some parts, like the shoulder of a bottle, can refract awkwardly. Again, cloning, blurring, and tone control are the digital help. One problem with backlighting is that certain shapes, especially rounded ones, may lose their definition—edges that curve away from the camera have a tendency to reflect the background, and if this is bright, they may appear to merge with it. You can correct this digitally with a gentle, thin darkening of these edges.

Light involves color, and as all these techniques are, in a sense, ways of focusing attention on the principal subject, another interesting digital technique is to selectively desaturate the setting. There are any number of ways of doing this, but in the example here, worked in Photoshop, the entire image is desaturated, and then the History brush is used to paint back in the original color. An alternative would be to make a selection of the object that you want to preserve, invert this, and desaturate. In this case, the desaturation is total, but a slight amount would give a more subtle enhancement to the subject.

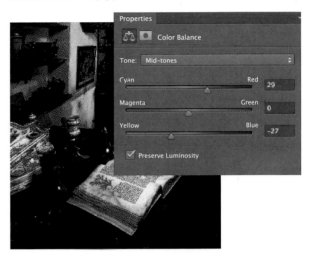

Background tint
With the book restored to full color, the background can be altered, first by selecting it with an auto select tool (left).

Desaturated background
In this photograph of an old apothecary's shop, the aim is to enhance the book. As a first step, the color image is completely desaturated using the HSB sliders (above).

History brush
The original color can now be selectively painted back in with Photoshop's History brush (above). Any mistakes can be corrected by stepping back through the History palette.

Sepia tone
By increasing yellow and red in the mid-tones (top), the background is given the effect of sepia toning—a warm brown (above).

TECHNIQUES

183

REWORKING SHADE

T he reverse side of lighting is shadow, and if you make digital changes to one, you will have to consider the other. For example, if you are replacing a background completely, as on the previous pages, the object will need to have its natural shadow restored. The purpose of this is to help it sit realistically in its new setting. In fact, shadows are a digital speciality, and are both easy to add and very effective in locating an object on an apparent surface.

The important issue is that the shadow looks right rather than is optically accurate

In principle, you add a shadow by creating a blurred percentage of gray underneath a selection of the object but over the background, so this is essentially a layer operation. A common piece of computer layout jargon that crops up is "drop-shadow," meaning an edge of shadow offset below an object. This is used frequently with images viewed from directly above. If you were

A QUICK 3D GUIDE TO SHADOWS AND REFLECTIONS

Using a basic shape, such as a cube or a sphere, you can see how shadows and reflections appear according to the three important variables: lighting, textural quality of the background, and camera angle.

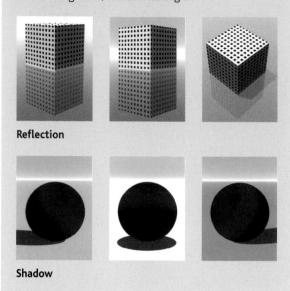

Reflection

Shadow

PERSPECTIVE SHADOW

An unsatisfactory shadow
This strongly angled, spotlit, still-life of a Dunhill table lighter and its pocket companion has one problem—the lumpy shadow at the base of the object. A longer, more shapely shadow would be better, and would not look inaccurate.

Shadow plugin
A third-party shadow creator, here Alien Skin's Eye Candy, comes to the rescue. With the object selected the long shadow option is chosen. At its default setting it is not quite what is wanted so, by selecting the shadow modifier, the shadow can be altered to suit. The shadow opacity and blur are also adjusted.

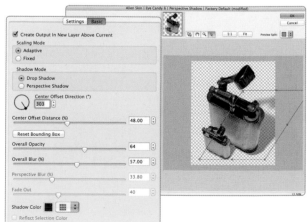

TECHNIQUES

184

shooting straight down onto an arrangement of objects, with the light source above and to one side, this is the shadow effect you would see—a soft darkening around the outline of each object on the side opposite the light.

Although this is only one kind of still-life arrangement, the digital technique used to reproduce it can be translated to most setups. The idea is to make a copy of the object itself, turn it into a solid block of black or gray, blur it, and slip it under the object. There are three things to consider: the direction of the light (the shadow must fall opposite); the quality of the light (the more diffuse, the softer the shadow edges); and the height of the object above the surface on which it sits (the lower, the closer and denser the shadow will be). Most of this is intuitive and a matter of observation.

With a tall object and a low light, the shadow will be long, so another factor to consider is perspective. Having created the basic shadow selection by copying the outline of the object and filling it with gray, use one of the distortion tools to stretch it lengthwise and compress its width at the far end. Alternatively, third-party plugins can do this for you, such as Perspective Shadow in Alien Skin's Eye Candy. However you do it, the important issue is that the shadow looks right

rather than is optically accurate, so judge it by eye.

Very occasionally, you may need to introduce reflections when you transfer an object from one background to another. This depends entirely on the reflective qualities of the new background. The principle is, once again, to use a copy of the object: invert it vertically and apply an amount of transparency. The texture of the background, and the angle of view, will both have an effect, and for realism you will probably need to apply some distortion, such as with a customized displacement map, as well as fading the reflection out progressively.

Manually controlled shadows
For a watchface overlaid on a landscape as if floating, new shadows were added one at a time in separate layers with a gradient tool. Shadow boundaries were limited to selections created with paths drawn as cones from the sun.

A longer shadow
Experimenting with the shadow angle (above), I decided that a longer and harder shadow angled more to the right would give a better composition, but if applied, I would also need to add a shadow from the smaller lighter falling across the vertical side of the larger one.

Refining the effect
The shadow filter is applied, as before, to a selection of the lighters (above). However, a separate selection had to be made of the smaller lighter; also its shadow needed a distortion correction in Photoshop to change it from a horizontal surface to a vertical one.

TECHNIQUES

ALTERING FOCUS & FOCAL LENGTH

Even lens characteristics can be changed later in the computer. In certain kinds of still-life photography, one technique that moves in and out of fashion is selective focus, in which only a small part of the image is sharp, the rest being a blur of color. Food photography in particular makes great use of this for its impressionistic effect. In the camera this is achieved by extremely shallow depth of field—a lens with a wide maximum aperture used wide open, sometimes aided by lens panel swings (a feature of large-format view cameras). The effect is hard to pull off with a small-sensor camera because of the inherently good depth of field.

Digitally, however, selective blur is easy to apply—and with much greater creative freedom than in the camera. You are not bound by the laws of optics, only by your skill at selecting the appropriate areas of the image to unsharpen. Real depth of field is progressive, meaning that it falls off more and more from the point of focus both towards and away from the camera. The tool to reproduce this effect digitally is a gradient, and the simplest method is first to apply a transparent-to-foreground radial gradient in a masking layer, centered on what is to be the point of sharp focus. Then use Gaussian blur on this gradient selection. Between the two tools there is considerable choice and range of effect. For more control, make a blurred copy in a separate layer and erase it selectively, using brush or airbrush.

As we previously saw with filters, one of the great advantages of working digitally is that you don't necessarily have to commit yourself to one technical style

> **Even lens characteristics can be changed later in the computer**

SELECTIVE FOCUS

1. Deep-focus original
For full control over selective focus, start with an image that has full depth of field. The technique here is to paint in from a blurred version.

2. First blurring
The entire image is blurred quite strongly, to a radius of 5 pixels. Then, using the History window, it is reverted to its original, sharp state.

3. History brush
Photoshop's History brush allows the blurred state to be brushed back in over the original—and of course, any mistakes can be recovered by stepping back in the History window.

4. Second blurring
For the parts of the image farthest from the camera, the blurring is repeated to a 15-pixel radius. In the History window this strong blurring is then brushed in with the History brush.

at the time of shooting. As long as you don't use JPEG compression, digital copies are always exact and perfect. In fact, there is a good argument for capturing the maximum information in the camera (good depth of field in this case), and using this as the raw material for out-of-focus effects. Blur is a kind of image degradation, so it is better to do it on a copy unless you are absolutely certain of what you want to do.

Focus is not the only lens characteristic that can be altered after the fact. With rather more effort, and a knowledge of how focal length affects the proportions of an object and its setting, you can turn a telephoto shot into a wide-angle, and vice versa. There is a cer-tain amount of work involved, so this may not be a procedure to undertake casually, but you may want to do it when compositing images, for more realism.

First see what effect a spherizing filter has, as shown on pages 96–97. As you are looking only for a good visual match rather than an optically exact result, you are not likely to need any extreme distortion. In addition to this, you will also need to consider parallax. My example here is an aircraft, the SR-71 Blackbird. Moving closer and using a wider angle lens would have hidden more of the engine nacelles. Shortening the "focal length" digitally meant selecting parts and moving them inwards, behind the main body.

TELEPHOTO TO NORMAL

1. Telephoto original
The starting point here in making a photograph look as if it were taken with a different lens is a 600mm shot of the SR-71 Blackbird.

2. Selecting the aircraft
The first digital step is to select the aircraft, here using smart masking.

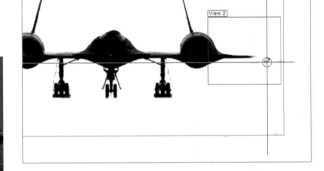

4. Selective distortion
In the image-editing program used, Live Picture, applying the distortion brush counter-clockwise enlarges the area it touches (lower left). This is applied to the main fuselage *to change the perspective. Then the engine nacelles are enlarged and shifted slightly to mimic the parallax effect of a closer viewpoint. A last touch was to change the background (below).*

3. Wings and cockpit
Using cloning and painting tools, the wings (which were clipped off in the original shot) are extended, and the cockpit is closed. Given *the symmetry and smooth monochrome surface of this titanium aircraft, these are both quite simple jobs to achieve realistically.*

ADJUSTING THE COMPOSITION

Earlier in this chapter I touched on the importance of composition in still life. The process of careful arrangement and rearrangement is integral to this genre, and can take as long as you are prepared to give it. Digital photography, in post-production, offers a new possibility—digital composition. Provided that you follow certain rules of lighting, scale, and perspective, you can partly create—or adjust—a still life on the computer. One reason for wanting to do this might be in order to achieve a juxtaposition that is physically impossible, such as putting together objects that were not available to shoot at the same time, or when it was difficult to hold several things together in position. Another reason is simple flexibility—deferring the creative decisions until later. The latter was the chief motivation for the food image that is shown below. The plan called for a series of photographs of different kinds of noodles, each of which was treated in a slightly unusual way.

The solution was to shoot all the components together at the same time, under the same lighting, backlit on a light table for easy selection, and with the camera aimed straight down. These components included the final dishes as well as the individual ingredients, both cooked and uncooked, to act as a kind of deconstruction. The backgrounds were to be digitally created separately on a computer. In this way, the creativity of the shoot was moved from the camera to the computer.

Provided that you follow certain rules of lighting, scale, and perspective, you can partly create—or adjust—a still life on the computer

DIGITAL ASSEMBLY

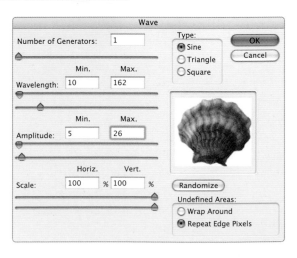

Adding layers
The components were added, a layer at a time and individually selected, beginning with the bowl of noodles. The scallop shell, which was to appear submerged, was first given a ripple-like distortion using the Wave filter in Photoshop (below).

Digital water
The basic water texture was a digital creation from a software supplier—Xaos Tools' Artist In Residence series. The original color (left) was altered with the Color Balance sliders toward blue.

Ingredients
For this still-life food shot, all the components were photographed separately to allow freedom in composing them. This dish of seafood ramen included shrimp and scallops.

CONTENT-AWARE SCALING

From CS4 onward, Photoshop has included content-aware scaling, which works in a radically different way to traditional scaling tools. Using complex algorithms, Content-Aware Scale (*Edit > Content-Aware Scale*) allows images to be scaled in a semi-intelligent fashion, preserving the proportions of key elements that would otherwise be distorted using conventional resizing tools.

Of course, no computer algorithm is entirely infallible, and there will be occasions when the software will struggle to preserve areas you want to be distortion-free. If this is the case, you can select the area, or areas, of the image that you want to preserve using one of Photoshop's selection tools. If you save the selection (*Select > Save Selection*), you can choose it from the Protect dropdown menu in the Content-Aware Scale tool to ensure these areas change as little as possible as the image is resized.

If your image includes people, clicking on the person icon in the options toolbar will set the Content-Aware Scale tool to identify skin tones. When the image is scaled people remain distortion-free. By combining both selections and skin tone preservation, it is possible to radically alter the proportions of an image without the picture looking obviously squeezed, distended, or compressed.

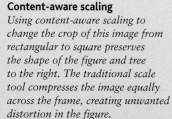

Content-aware scaling
Using content-aware scaling to change the crop of this image from rectangular to square preserves the shape of the figure and tree to the right. The traditional scale tool compresses the image equally across the frame, creating unwanted distortion in the figure.

"Regular" scale tool

Content-aware scale tool

Underwater blending
The rippled scallop, a smaller copy of it, and the shrimp, each in its own layer, were blended to appear as if underwater by choosing the Lighten option in the blue channel, and slight adjustments to the opacity. Note that they appear under the water layer, even though their layers are, in fact, above it.

MOVEMENT IN DETAIL
& IN FEELING

For good reason, action provides many of the most telling images in photography. These are moments that are frozen, never to be repeated, and one of the still camera's irreplaceable functions is to reveal motion as a slice of time in a way that the human eye cannot see. Whatever other talents are involved in photography, shooting action calls for the most basic of all skills—perfect and immediate camera handling. Uncertainty and fiddling around with the controls is guaranteed to lose you the shot. In other words, capturing fast movement is mainly a matter of confidence—of being thoroughly familiar with your camera and practicing.

Capturing fast movement is mainly a matter of being thoroughly familiar with your camera, and of practicing

For the most part, you need a high shutter speed, and because this cuts down the light reaching the sensor, you will then have to either open up the aperture or increase the ISO setting, or both. Exactly which shutter speed will freeze the action depends not so much on how fast the subject is moving, but how fast it moves through the frame. Imagine a cyclist on a track in front of you. If the figure takes up just a small part of the image frame it might take a second or two for him or her to cross from left to right, and a shutter speed of, say, 1/125 second, might be sufficient to capture the image reasonably crisply. Now rack the zoom forwards so that the cyclist almost fills the frame. You would need a much higher shutter speed because the figure would be in and out of shot in a fraction of a second. The same applies to direction: stand on the track itself and if the cyclist is approaching you, there will be hardly any movement across the frame (although there would be a focus issue, which might be problematic).

One of the most obvious techniques for dealing with continuous movement like this is panning, which comes naturally. It simply means following the movement with the camera, keeping the subject more or

Timing and speed
This is the classic treatment of action: a fast shutter speed and the perfect moment. Here, in this shot of a Japanese macaque leaping across an icy river from boulder to boulder, the shutter speed was 1/500 second and the midair moment was anticipated.

less in the center of the frame, which is what most people would do anyway. Then what happens if the shutter speed is still not fast enough is that the background becomes blurred with streaks, and this is no bad thing. Motion blur, as it is called, helps to convey the sense of motion, often better than a completely frozen image. As long as the essential details of the subject are sharp enough to be recognizable, this might be the most effective kind of image.

PANNING

Panning is often a desired look, and certainly stylistically notable in any portfolio; but reliably capturing motion in this manner takes some degree of practice. Fortunately, it's quite an easy technique to rehearse. First pick a location with plenty of predictable horizontal movement from right to left (any reasonably busy street without too many obstructions will serve perfectly). Match your focal length to the expected distance to your subject, and be sure to deactivate any image stabilization or vibration reduction features built into your lens (though it's worth noting that some cameras and lenses offer the ability to deactivate only one axis of the stabilization, for instance, leaving the vertical axis stabilized by ignoring the horizontal, which makes a horizontal pan even smoother; read your manual to see if this could be a useful feature for you).

Once you're set up, get in a stable shooting position: legs shoulder-width apart, camera held tight against your face with your elbows tucked in. When a subject approaches, follow it for some time first, by rotating at your torso, in order to gauge its speed. As it passes in front of you, roll your finger over the shutter release, but continue rotating and following the subject with completely uninterrupted fluidity. And even once you hear the shutter close, continue rotating for a follow through. Then pick another oncoming subject and practice again. With time, you'll get in a rhythm and be able to follow subjects with surprising grace.

Low speed
Reducing the shutter speed to 1/30 second and panning the camera to follow the movement gives a different impression—and to my mind better. Key parts remain sharp because of the panning, while the blur of legs, wheel spokes, and background give a sense of motion.

High speed
Two contrasting treatments were used for these shots of a horse and carriage driving at Syon House near London. In the frame at left, the shutter speed was 1/250 second, just fast enough to freeze the trotting movement of the horse.

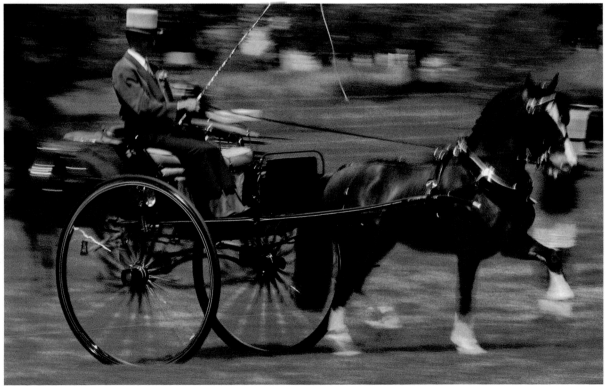

EXTERNAL FLASH

Flash is quite often associated with some of the most unflattering portraits imaginable—that deer-in-headlights look so typical of built-in flashes (to say nothing of the red-eye phenomenon). However, when used properly, external flashes can allow you to achieve photographs that would otherwise be simply impossible. Adding your own light to a scene takes a considerable degree of skill (it is difficult enough already to know how to properly expose for a dynamic found-lighting situation; factor in balancing that light with your own photographic light and the situation becomes challenging indeed), but with a little care it's well worth exploring what flash can add to your photographic repertoire.

> **External flashes can allow you to achieve photographs that would otherwise be simply impossible**

First off, your best bet for improving your flash technqiue is to get a dedicated external flash unit. Not only does this raise the flash away from the lens axis to help prevent red eye, these units often also have tilt and swivel capabilities that allow you to bounce their light off nearby surfaces (walls or ceilings, usually), and back onto your subjects. Along the way, the light from the flash will spread out and be a much more flattering, diffuse kind of light by the time it reaches your subject. Additionally, these external units are considerably more powerful than those built into your camera, and they do not (typically) drain the camera's battery life—though they do need their own supply of batteries.

Flash is useful for so much more than simply illuminating otherwise dark subjects. For instance, while it may seem counterintuitive, one of the best and most common uses of flash occurs in the middle of the day

Flash for still-life
Still-life studio shots are an excellent time to practice your flash technique, as you can embrace the trial-and-error process that goes into flash setups without boring your portrait subjects or missing out on a decisive moment. These two still life shots also show the range of possibilities that flash offers—a completely bright, cheery feeling created by exploiting transparent subjects against a backlit surface (far left), or a dramatic, high-contrast capturing of a morose subject surrounded by drop-out black created by the delicate use of chiaroscuro lighting (left).

TECHNIQUES

in bright sunlight. In such lighting conditions, portrait subjects often have unflattering shadows cast vertically down their faces due to the sun being directly overhead. By firing the flash directly at their face, you can fill in those shadows with added light (hence the name "fill flash"), and balance out the exposure with the surrounding ambient light.

There is one particular camera specification that will bear relevance to your flash photography: flash sync speed. The vast majority of DSLRs and CSCs have what is called a focal-plane shutter, which consists of two separate curtains: The first curtain is closed at the beginning of an exposure, and begins traveling across the sensor—exposing it to light—the moment you press the shutter release button (hence the name); the second curtain follows the first after a certain amount of time (the shutter speed). Now, because the travel of these curtains is not instantaneous, there is a minimum shutter speed at which the complete sensor is exposed to light; any slower than this shutter speed and the second curtain starts covering up the sensor before the first curtain has finished its travel. Therefore, if a flash were to fire, it would only illuminate a portion of the frame. Therefore, you can only use your flash at full power up to that minimum shutter speed (which is why it's called the flash sync speed—the fastest speed at which the exposure can "sync" with the flash). This makes it difficult to use your flash in bright conditions without narrowing down your aperture to compensate for the abundance of light being let in at the relatively slow shutter speed.

You can also use an external flash unit to capture motion in a dramatic and effective way, using flash synchronized to the end of a slow exposure. With focal-plane shutters used in SLR cameras, this is called rear-curtain sync because the flash discharge is timed for when the shutter blind closes. For the indoor Real Tennis example below, the camera was fixed on a tripod to keep the surroundings sharp, and the shutter speed set to 1/30 second. The result is blurring of the player, racket, and ball, but it all trails back from a sharply frozen image caught by the flash.

Fill flash
Gone are the days of flash or nothing. With TTL metering it is simple and more realistic to use flash to add to a scene rather than to overwhelm natural lighting, as in this into-the-light shot of "legging" through one of England's oldest canal tunnels (below).

Rear-curtain sync
For a game of indoor Real Tennis, ambient lighting had to be used to show the setting and spectators, but even at a high ISO sensitivity there was insufficient light to capture the action. On-camera flash was used (with a second flash in sync from the right), and was synchronized with the closing of the shutter at a speed of 1/30 second.

DIGITAL MOTION

As we saw on the previous spread, motion blur is often considered an asset in an action photograph, but it is difficult to plan for and predict. Digitally, this is a popular enhancement, and there are several motion-blur programs available. In the example of a Chipmunk aircraft, the original photograph is a success in that the image is sharp—always an issue when shooting air to air through an open window, because vibration and the buffeting airflow increase the risk of camera shake.

Digitally, an extraordinarily effective treatment is to stitch the series together into one image

Focusing accurately under these circumstances is never easy, with everything moving quickly, and a high shutter speed is essential, in this case 1/500 second. Any accurate kind of motion trail from the subject is out of the question at the time of shooting, but there are alternative post-treatments you can try.

The standard filter available in Photoshop allows the direction and length of the trail to be set, but this must then be composited with the original. The normal technique is to apply the blur to a duplicate image in another

COMPOSITE PICTURES

Motor-drive sequence
The originals were a panned burst at high speed of the flight of a Changeable Hawk Eagle towards its handler.

Layered combination
First, each image is placed in its own layer in one image file. With the middle shot in the series as an anchor, each image is then repositioned to fit perfectly. The layers are set at 50% opacity.

Clone blend
The images are then blended by a combination of gentle erasing at the edges with a large-diameter airbrush, and cloning from one to another to fill in gaps, particularly in the height of the composite.

Final composite
Once seamless blending has been achieved, the layered workfile is saved (in case of any need to retweak the image), and a flattened copy is made (below).

TECHNIQUES

layer, and then use blending controls to meld it to the original. The leading edge of the blur must then be erased. Third-party filter manufacturers usually try harder, since this is their sole business, and the Eye Candy plugin available from Alien Skin gives more options, as the screenshot shows. More important, it applies the trail in one direction to a selection (which you must first make and load before opening the filter dialog box), and so is a one-step operation. Here, one trail has been applied as long streaks, another in an optically more accurate, but degraded way, and a third applied just to the background.

This is a fairly standard way of mimicking what happens in real shooting—or at least a cosmeticized version that looks right—but there are other ways of revealing motion that go beyond the single photographic image. The five images of a hawk eagle launching into flight at a falconry center were shot at four frames a second at 1/250 second with the camera panned so that the bird remained more or less center frame. In the ordinary way, either the best frame would have been chosen, or they could all have been reproduced as a strip. Digitally, however, an extraordinarily effective treatment is to stitch the series together into one image so the eagle flies across a single landscape.

The technique is similar in principle to other forms of stitching, but because of the panned and largely out-of-focus background the frames are very easy to blend by brushing with an eraser. The essential preparation is to align the frames in a single composite file before starting, which is done one at a time, from left to right.

MOTION BLUR

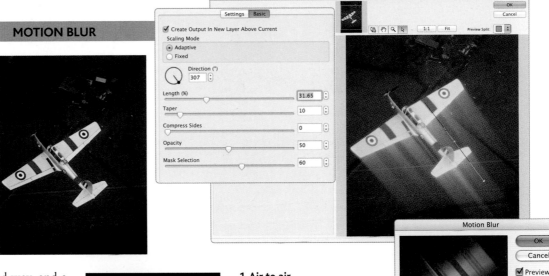

1. Air to air
The original (top left) is a 1/500 second shot of a Chipmunk aircraft. The dialog box (above) for Eye Candy's filter gives full control. The plane (left) was selected and the trail applied.

2. Photoshop blur
Motion blur in Photoshop has a more limited range of controls (right), and so here is applied to a duplicate layer.

3. Bidirectional streak
The Photoshop-blurred image is combined with the underlying original using the blending option (above). The shadow point slider of the upper layer is moved inwards to remove the darker areas of the blurred layer.

4. Blended and retouched
With the blend adjusted to a more subtle effect than that above, the blur trail at the front of the aircraft is erased, using the inverse of the aircraft selection (right).

TECHNIQUES

DIGITAL IMPROVEMENTS

Adding motion blur is easier than removing it, but the problem is that only certain kinds of streaking and unsharpness are acceptable. Personal taste comes into this, but as a general rule the key details of the subject—however you define them—need to be sharp. If you inadvertently set too slow a shutter speed, or even if you are deliberately trying for a partly blurred image, there will be times when the sharpness is not in the right place. The only possible recourse is digital sharpening, despite the limits to what it can do.

> **There will be times when the sharpness is not in the right place**

COMBINING MOMENTS

Paste and blend
The dark, almost featureless earthen floor of the cockpit made an easy background for pasting in the birds, but to aid the realism of the composite, a slight amount of noise was added (right) to the birds to simulate grain.

The trick here is to sharpen selectively, just in the key areas. The obvious tool might seem to be a sharpening brush, but beware, because almost all of these apply the crudest form of sharpening on the digital menu. As discussed in the Filters chapter, basic sharpening works on all the pixels indiscriminately, and this is a particularly bad idea if there are smooth non-detailed areas in the photograph. And that is exactly what you have in a motion-blurred image—soft streaking that will simply gain a grainy appearance. The way around this is the USM sharpening filter, which allows you to set the threshold—in other words, you can leave the very smooth areas alone, and concentrate on the nearly sharp edges.

This alone is not likely to be enough. The technique of choice is to paint over the areas to be sharpened in a mask layer first. Use a soft-edged brush to blend in the eventual sharpening with the rest of the image, and set the mask color to a fairly light opacity so that you can see what you are doing. Loading this as a selection, experiment with the USM controls in preview until you reach the maximum sharpening that appears natural. For people in motion, the face and eyes are likely to be the areas that should be sharp.

There is another digital procedure for improving an action shot that is not completely honest, but might be justified occasionally. This is to combine the best action captured from two frames. It often happens if you are shooting rapidly and continuously that of all the things going on in the picture some work better in one frame, and some in another. If the basic framing is more or less the same, there are no special difficulties in stripping a part of one image into another, and creating a combination.

The best of both
In a sequence of shots of a cockfight in rural Colombia, the two best pictures each lacked something—the audience reaction of one and the birds leaping in the other.

Fighting cocks
The best shot of the two birds in midair was selected and copied for pasting onto the best of the overall shots, using a mixture of autoselection and mask painting (for the blurred wings).

1. Slight blur

In this photograph of Tibetan pilgrims in the dark interior of a gompa near Mount Kailash, the blur from a slow shutter speed helps the sense of action, but the man's face should be a little sharper.

3. Retouch mask, resharpen

For a second round of sharpening, the mask was reduced (left) and more high-threshold USM was then applied (above).

4. Extra hair sharpening

Finally, a small dose of sharpening was applied to the central strands of the man's hair. The result (below) adds a small but still significant improvement to the original photograph.

2. Paint mask and sharpen

Sharpening was applied in stages. In the first step, a mask was painted over the entire face bit by bit (above), and USM sharpening applied (below) with a high threshold to protect the skin smoothness.

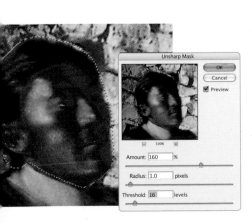

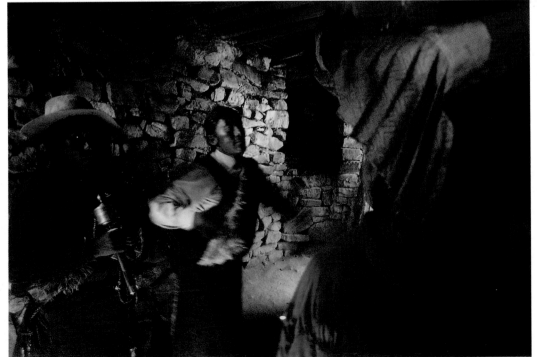

TECHNIQUES

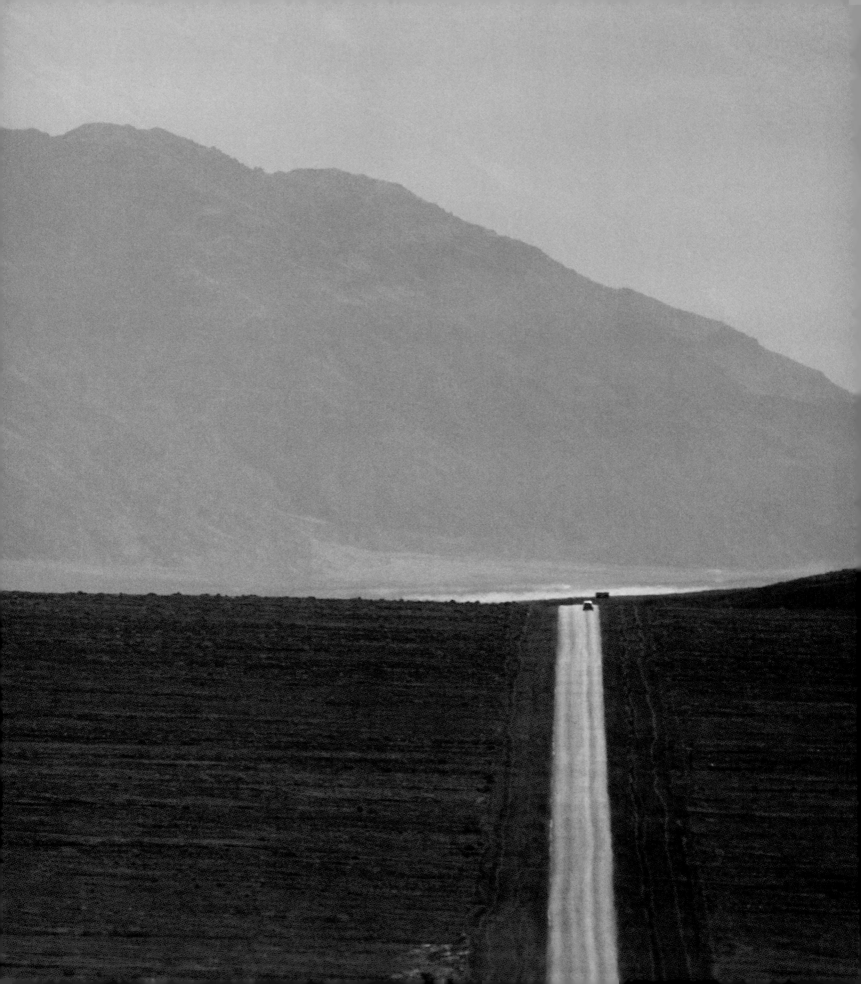

SECTION 4 ON THE ROAD

Digital cameras have taken photography to a new level of portability. As it was, setting out for a day's shooting in the countryside or in town could be a weighty affair. Typically, you would take a shoulder bag and cram it full of equipment, adding film (of different types if you thought you might switch between color and black-and-white, slide or print, or need high-speed film for low-light situations, or type B for tungsten-lit interiors), possibly a second body into which to load the alternative film, filters, and for an SLR, different lenses. Now, the digital alternative to all this is not much more than one camera, really. The enormous simplification of photographic gear, due mainly to the special advantage of digital processing and partly to the continuing improvement in optics and materials, is a boon to anyone traveling with their camera—and getting out on the road is the occasion when most photographers take their greatest number of images.

There are two reasons for this lighter, freer approach to shooting and traveling—the way in which digital cameras are constructed and what they can do. With no need for a film transport mechanism, or the space to hold the film, and with most mechanical functions replaced by electronics, digital cameras can be more compact. The average size of a sensor is also smaller than a frame of 35mm film, which means that everything related to this can be that much smaller—lenses in particular. Lightweight materials are more practical with so much less mechanical movement, and zoom lens design is now more efficient than ever, allowing greater ranges in tinier barrels. The second reason is that digital cameras are more self-contained than film cameras ever could be. They have all the choices built in that formerly called for a selection of films and filters,

and that made a second camera body useful. At the very least, you can now make choices on demand and on the spot, from three basic options—ISO sensitivity, color balance, and image resolution. Most cameras offer even more possibilities, such as contrast, sharpness, saturation, etc., and even a more recent trend toward advanced "digital filters" that perform advanced processing to images in-camera. In other words, the accessories and attachments that were commonplace in film-based imaging are being replaced by dial-up features built into the camera.

Of course, digital cameras have their special needs, different from those of film cameras, and it is essential to prepare for these when you are setting out on a shoot, whether for a day or for a couple of weeks. Power is a basic need and consumption is considerably higher than for film cameras because all the functions depend on it. Digital cameras are used not only for shooting but for reviewing and showing images, much more time-consuming than the actual photography. For efficiency, most camera batteries tend to be rechargeable lithium, custom-designed for the particular model, and this makes being able to recharge from a utility source an important consideration. Just as important is the way in which images are managed on an extended shoot. Digital photographs cost nothing extra to shoot, but they *do* need to be named, placed in retrievable folders, and kept safe. They are extraordinarily easy to delete, which is useful at the time of shooting, but this carries the obvious danger of losing images by mistake. Rule one is to have your own procedure for editing, filing, and storage. And then, of course, you will want to send copies to other people, or even back home when you are on the road. The choices of online delivery are now many and attractive—they complete the digital photography circle.

TRAVELING LIGHT

Photography and "traveling light" are, to a certain extent, mutually exclusive ideas; by its very nature photography demands you have to have a certain amount of equipment, and when you're traveling with a digital camera, this need increases. You not only need to be certain you have lenses to cover most shooting eventualities, but with digital photography you also need to make sure you have enough storage space in the form of memory cards for your daily photography requirements, as well as enough battery power to keep your camera running. With video recording becoming an increasingly integral part of digital cameras, it is also becoming even more important for digital photographers to have the facility to back-up their files on a daily basis, not simply to make sure

There are ways of keeping the weight of your traveling kit to a minimum, which starts with your choice of camera

they are securely stored, but to free up their memory cards for the following day.

However, there are ways of keeping the weight of your traveling kit to a minimum, which starts with your choice of camera: a pro-spec SLR will undoubtedly weigh more than an enthusiast-level one, and will be significantly heavier than the most recent mirrorless, interchangeable lens camera models. The following options cover the bare essentials of a traveling photographer's kit (including file storage) where weight is the prime concern. Although bulkier than dedicated portable storage devices, a laptop computer remains the most versatile backup option, not only providing you with the necessary storage space on its internal hard drive, but also allowing editing (to fill in the time at airports, while traveling, and late at night in the hotel) and an email connection.

Durable & weather-resistant
The interchangeable-lens compacts discussed on pages 32–33 are an easy choice for any travel kit, and lately they've been becoming much more serious in terms of spec and build-quality. This Olympus OM-D E-M5 is weather-resistant, shoots nine frames per second, and has accessory gribs for better ergonomics and battery power.

Quality in a small package
A smaller kit doesn't necessarily mean you have to sacrifice image quality—this zoom lens from Panasonic sports a constant maximum aperture of f/2.8 and is weather resistant, but at only 305 grams it's 1/3 the weight of the full-frame Nikon equivalent lens.

Lightweight, portable tripod
Even if your camera has image stabilization of some sort, a tripod is still useful, allowing you to use very slow shutter speed in low-light conditions or for creative effect, without getting a blurred result.

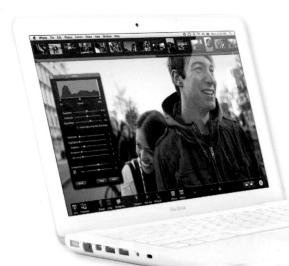

Laptop
Although bigger and bulkier than portable viewers, a laptop is still the most versatile solution when it comes to storing and viewing files while you are on the move.

Tablets
These devices are is lighter than a laptop, and sure to appeal to traveling photographers. Your post-production options are limited, but not impossible; and you may need an accessory card reader in order to transfer your images onto the tablet.

Spare memory cards
The days when carrying a single spare memory card was often sufficient for an extended photographic trip are gone: it is likely you will need two, or maybe three cards per day if you intend to shoot a mix of still images and video clips.

Spare batteries and charger
Keep at least one spare battery, more if you tend to shoot heavily between recharge times. Check the average time that a battery lasts on a full charge.

POWER NEEDS ON THE ROAD

Most digital cameras use rechargeable batteries, which makes it possible to keep a spare fully charged. Recharging at the end of the day is a priority and, if abroad, make sure you have the right adaptor. If the battery is NiCd or NiMH, avoid recharging until the battery is completely empty, but this is not normally an issue with Li-Ion; follow the manual's instructions on this. Some camera manufacturers make available a separate AA-compatible battery pack, which can be useful in an emergency.

PRO TRAVEL KIT

Tripod
A sturdy tripod may add weight to your kit, but if you want to use slow shutter speeds, it's essential. Carbon fiber tripods and magnesium tripod heads are the lightest options, while maintaining outstanding rigidity, but this does come at a higher price.

While it's possible to travel with minimal equipment if you're photographing for pleasure, a professional photographer on assignment doesn't necessarily have that option as they need to pack for every eventuality. A professional has to make sure that their camera bag contains everything they could possibly need for the assignment, as well as being confident that if something untoward happens they can still meet their brief.

This "belt and braces" approach can easily mean doubling-up on a certain piece of equipment; taking lenses that overlap in terms of their focal length, for example, so if one should develop a fault another can be pressed into service, and perhaps taking a second camera body in case their main SLR is damaged, lost, or even stolen. This is especially important for overseas and/or for remote assignments, where simply going to a camera store if you've forgotten something is out of the question.

> **You need to make sure your camera bag contains everything you might need for an assignment**

In addition to the camera and its immediate accessories, the images themselves also make demands on the equipment that needs to be taken, or at the very least considered. Beyond memory cards for on-location image storage, a laptop and hard-drive(s) for backing up the files will help minimize the risk of losing any shots, while a portable storage device—especially one that can be tethered to the camera for immediate backup—adds another level of protection. If there is access to the Internet (at a hotel, perhaps), images can also be uploaded to an online storage site, and a cell phone with a computer connection upgrades this potential even further, allowing files to be transferred beyond more conventional Internet access points. The following are just a few of the many items a professional photographer would need to consider packing before heading on assignment, in addition to those mentioned on the previous pages.

SLR(s)
A professional SLR isn't going to be the lightest option, but it is designed to stand up to the rigors of everyday use.

Lenses
There are countless lens options, and the nature of the brief and your personal shooting style will largely dictate which focal lengths you go for. Fast aperture zooms covering a wide range of focal lengths are a staple of the pro's toolkit.

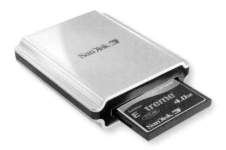

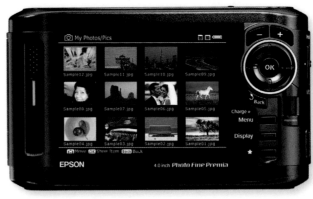

Portable storage
Combining storage with viewing capabilities, the Epson P7000 has a 160GB hard drive that provides plenty of space for backing up your images. It also allows you to shoot with it tethered to your camera, providing instant backup and viewing options as you shoot.

Portable memory card reader
If your laptop doesn't have memory card slots built in, a portable card reader that plugs into the USB slot will allow direct downloads from the memory card.

GPS
Some cameras have a built-in GPS capability that will record the latitude and longitude where a picture was taken at the time of capture. If not, a GPS module can be used, which will allow you to "geotag" your images when they are downloaded to the computer, adding the precise location to the image's EXIF data.

Polarizer and ND Grad filters
The effect of a polarizing filter can't be recreated using image-editing software because it takes effect at the time of shooting. A graduated ND (neutral density) filter is also used to optimize the exposure when a shot is taken, so both of these need to be packed.

USB camera cable
For downloading images from the camera to a computer or a compatible storage device.

Cell phone
As well as allowing you to keep in contact with people, a cell phone that can be connected to a computer and used as a modem can enable you to upload your images to the Internet in locations where there isn't a "regular" Internet connection.

Lightmeter
A handheld lightmeter will allow both incident and reflected light readings to be made, helping in tricky lighting conditions where even the most sophisticated camera may struggle.

Spare memory cards
Although high capacity cards are available, such as this 64GB card, many professionals prefer to use a greater number of smaller capacity cards: if one fails, they have others they can still use.

EVENT SHOOTING

Event shooting can be fun and rewarding when you get out on the road with a camera. It provides a wide range of picture opportunities, from portraits and high-speed photography to close-ups and cityscapes. What events have in common is that they are organized, have a theme or purpose, and are full of people (this part is, of course, relative).

Events encourage heavy shooting as seen here on these pages

Most events turn on one or two key moments, such as the high point of a procession, and the first priority for most photographers is to secure these. This means being in the right place at the right moment, and this in turn means planning in advance.

At the same time, don't ignore the other picture possibilities, which include the asides, unpredictable actions, behind-the-scenes preparations, and the faces and reactions of spectators. It's not unusual for the best picture to come from serendipitous moments rather than the completely obvious. To cover as much as possible, try to seek out in advance the sites that offer the best viewpoints—higher ground may offer the best option, even though it might be farther away from the action.

Including the crowd
Events and performances have a natural center of attention, but including the context of the spectators and surrounding crowd—such as with a wide-angle lens shot of these dancers in front of the band—add an important part of the story to your collection.

PROFESSIONAL CROWD-BEATING TIPS

You may not want to go to this trouble, but if the shots are important, follow the professionals who do this kind of thing:

- Using a short, lightweight stepladder guarantees a clear view over the heads of other people (but may displease those behind you).
- Some professionals secure their viewpoint by chaining their tripod or stepladder to a railing or similar.
- You could hire someone to hold your place until you reach it.

PREPARATIONS

In the run-up to the event, which may take a few hours or even days, there are always many good opportunities. During these times, which include rehearsals, the pressure is usually off, participants are less keyed-up, and you will usually have much better access than during the event itself. This is the time to hang around and get the background. Immediately prior to a parade, for example, participants will gather in one or more staging areas and these too can offer a particular kind of "backstage" image.

The key shot
When the main action takes place at the head of the parade, look for a clear viewpoint such as from a street corner, as in this telephoto shot of the annual Lord Mayor's Show in the City of London (below left).

Fun in the sun
In the thick of the action at Carnival in Kingston, Jamaica (above). A medium telephoto lens was used to fill the frame, and the shot taken from the gap between two groups of dancers.

The big day
Event shooting doesn't always mean a crowd scene. This picture (right) shows the joy of the bride on her big day. The professional wedding photographers will take care of the formal shots, so it makes sense to concentrate on the impromptu and more relaxed moments.

THE BIG EVENT

The big event varies in style and organization from place to place, but there are usually some consistent features that lend themselves to the following type of shot:

- Long-shot from head-on. Usually, this only works with the head of the parade or wedding party, for example, or if there are distinct breaks between different sections.
- Long-shot from above, cropped in and compressed, showing a mass of people.
- Wide-angle from close, taking in the energy and the crowd reaction.
- Close shot of the main character/float/center-piece. Often difficult, and you may need to react quickly and choose the appropriate focal length without delay.

SPECTATOR REACTION

At intervals, take your attention away from the action in front and turn to look at the spectators/central protagonists/guests (or use a telephoto to shoot across to the opposite side). Their reactions—rapt, excited, amused—can make good images in themselves.

DETAILS

At any time look for close-ups, even extreme ones, of costumes, dress, uniforms, decorations, and so on. Some of these may be quite special and brought out only for this occasion.

LOW-LIGHT SHOOTING

The ends of the day, life indoors and the entire range of nighttime activities offer a rich and large source of subjects for photography, now more accessible than ever before. And it is digital photography, with its many continuing advances that has made it more accessible. What we are talking about here is extending the shooting range into situations that, because of insufficient light, could not be handled as freely as film photographers would have liked. Photography has always had technical limits, but then photographers have always learned to accommodate and to work within them, and the quantity of light and the sensitivity of the recording medium has always been one of the most basic limitations.

Photography has always had technical limits, but then photographers have always learned to accommodate them

Digital photography and its recent changes have ushered in a new era in low-light photography by extending the range of time and situations that can reasonably be captured, making it possible to use a camera under conditions that would have been unthinkable without resorting to invasive techniques such as flash and artificial setups. Sensor sensitivity has improved hugely in recent years and this, combined with in-camera and post-production processing, has reduced the collateral damage to images from noise—a major preoccupation in this kind of shooting and in this book.

Because low-light photography is constrained by performance limits, shooting always involves compromise, adjusting the camera settings to sacrifice one technical function in favour of another. Longer shutter speeds (enabled by proper tripod use) are the best solution for static objects, as you can use a lower

Fire parade
Festivals and processions at night are frequently illuminated by brilliant incandescent light that makes for a dynamic scene and a hellish exposure. Because there is so much action, a tripod is out of the question, so you must rely on either high ISOs, wide apertures, or flash in order to keep your shutter speeds sufficiently high.

Temple by the moon
Static subjects, such as architecture shots, are easily shot at night with a tripod. Monuments and other significant buildings also frequently have brilliant lighting schemes that make them worthy low-light subjects.

ISO (for a cleaner, noise-free image) and the optimum apertures of your lens (typically two to three stops down from its maximum aperture). Of course, things do tend to move, and tripods aren't always going to be a realistic option. The next option is a wide-aperture lens, something at least $f/2.8$, but the wider the better. Naturally, primes are a good fit here; but particularly if you're on the road, you may have opted for the versatility of a zoom with a slower aperture. In that case, you're down to two options: raise the ISO or use flash. External flash units can be a godsend when used correctly, but you're unlikely to be able to illuminate distant objects with them; so if the action is occuring some ways off, you might as well not bother firing the flash. Higher ISOs, already discussed on pages 118–119, come with their own tradeoffs, but if you expose correctly at the start and practice proper noise-recduction techniques in post-production, you should end up with a perfectly useable image.

These are the tradeoffs, and it's easy to see them as a permanent set of difficulties, but practically it usually works better to treat them more positively, as ways of getting you closer to images that are only recently possible. At this edge of technical acceptability there are bound to be failures and disappointments, perhaps many for each shot, which that makes this edge-pushing worthwhile. If you feel this, and are happy living with the uncertainty, low-light photography has a permanent level of excitement.

Expose what's important
Spot metering can be extremely useful in low-light situations such as this intimate scene of subtle fire-lit faces shown above, because you need only to expose the center portion of the scene and can fully allow the periphery to fall off into pure black. A matrix metering mode would have slowed down the shutter speed trying to brighten up these irrelevant areas.

Twilight
The hour or so just after sunset (or just before sunrise) often has rich, deep blue skies that require a longer exposure (or wider aperture) to capture, as seen below.

THE DAILY EDIT

T here are two basic procedures in browsing and editing a take of photographs: to discover the best and to organize them into related groups. This done, the images are in principle ready for use, whether personally, editorially, or commercially. I use the word "discover" deliberately, because the process of reviewing, analyzing, and comparing photographs is a creative process in its own right. What you achieve might be different from what you set out to shoot, and as visual surprises are the diet of photography, particularly when traveling to new destinations, you can expect to change your mind as you sift through your results. On pages 86–9 we looked at the software means; here we deal with the method, and the box opposite (*Selection Procedure*) shows one set of steps.

Digital photography shifts the editing goalposts, because you can perform these reviews on the spot, or at worst at the end of the day. In other words, you can get regular feedback as to how your entire travel shoot is going and make the necessary changes. For example, if it seems that part of the way through a trip you are lacking images of local people, then you can start to remedy this immediately. To the original aims of selecting the best and grouping related images, digital photo-editing adds a third: guiding the creative progress of the shoot.

There remains, however, one real danger in on-the-spot editing. It is actually far too easy to throw images away, and once you've bought into this different shooting culture with its over-shooting for safety and choice, you are likely to feel compelled to discard a proportion of the images.

Certainly, this daily assessment can sharpen your eye for editing, but it may be dangerous to feel obliged to take fast decisions. We often come back to images that we may not have rated highly at the time, to discover that they do have value after all. See the *Digital Rejects* box below.

> **We often come back to images that we may not have rated highly at the time to discover that they do have value after all**

AUTO RENAME

Rename the images to make them easier to identify. One method is to give one name to the entire trip; another is to name each day separately; another is to have a continuous sequence of numbered folders, as here. Automatic renaming procedures (depending on the specific software) add numbers sequentially after the root name that you have chosen.

Examine carefully
Look at each frame at full-screen magnification and then zoom in, to check for focus or camera shake issues. Most importing and browsing software offers this option. Here, using Photo Mechanic, a separate window opens for this purpose, and also allows IPTC information to be added to images.

SELECTION PROCEDURE

Tagging your selects
Having edited out the rejects, start on choosing the selects. This is a highly personal choice, and you may change *your mind later when you come to review the trip once back at home or in the studio. A basic first step is to tag your immediate favorites.*

DIGITAL REJECTS

Clear mistakes are best deleted immediately, to avoid confusion, but in cases where there may be some doubt, or when you might have second thoughts, a safer procedure is to move them to a separate folder for temporary rejects. You can check through these later.

FILING & STORAGE

Digital photography has drastically altered the logistics of shooting and at no time is this more obvious or important than when traveling. No longer do you have to estimate the quantity of film you will need, or plan to replenish stock at dealers along the way. But you do have to plan for storing the images in digital media; more than that, you need to have a planned "production flow" of image transfers that will keep pace with the way you shoot on a trip.

The numbers involved are very easy to calculate, and they start with the file size of one of your typical images. This depends not only on your camera's resolution, but also on what use you want to make of it—in other words, which of the choices of image quality you go for (this should usually be the highest resolution, but the choice of JPEG or Raw is more down to personal preference). Memory cards of whatever capacity are only temporary storage and you will need to transfer the images from

The most efficient strategy is to have just enough memory cards to last until a download

them at regular intervals. For example, a 2GB memory card will accommodate just over 100 images shot at the finest JPEG compression, or in Raw format on Canon's 18-megapixel EOS 700D, for example. Larger memory card capacities alter the equation somewhat, as a common-enough 8GB card can store four times this amount. Still, that is only about 400 top quality images, which might not get you through the day. Moreover, the rather high price of some of the newer, larger memory cards makes cost-effectiveness a key part of the calculation.

The most efficient strategy for long-term shooting (highly relevant to traveling) is to have sufficient memory cards/miniature hard drives to be able to continue shooting until you can empty them conveniently onto a larger hard drive. The quantities depend on your individual way of shooting and on the kind of subjects that you expect to come across on a trip—parades and special events, for instance, tend to consume images faster.

Back up
Shooting on the road, unless you have a laptop, can lead to storage problems. Make sure you either have enough memory cards or a portable storage device on to which you can download your images.

Keeping CDs and DVDs safe
A padded case for carrying a number of CDs or DVDs is a useful space saver and can be bought at most music stores.

210

Portable storage
Carrying a laptop on a shoot means that you can instantly store and download images, ensuring that they are saved and kept safe. A model such as Apple's MacBook Air will keep the weight to a minimum, although they do not have built-in CD or DVD drives.

Then you will need somewhere to download the images. The ideal, though an extra item to carry, is a laptop. Download the images on to its hard drive, either by connecting the camera (usually through a USB cable) or by plugging the memory card into a reader. If the laptop is capable of burning DVDs, so much the better, because this allows you to make secure back-ups on the spot (or at least in a hotel room). An alternative is a device made specially for image storage. There are now several makes of palm-sized, stand-alone storage devices, such as the Epson media storage viewers. They typically feature capacities of at least 40GB (the top of the range model houses a 160GB hard drive) with a color monitor on which you can view images, and the most recent models also allow tethered shooting. These paperback-sized devices are convenient enough to consider carrying in a shoulder bag as you shoot. All of this bypasses the computer completely, although at the end of the trip you will still need to download from them and make secure back-ups to CD-ROM or DVD. Alternately you might be able to find an Internet café or business center of a hotel where you can download your images and burn them on to a CD or DVD, or upload them to a remote, previously set-up Internet site. As a precaution, carry your own card reader and USB connecting cable.

BURN TO CD/DVD

If you use a laptop on the road, make sure that it has the ability to burn CDs or DVDs—still the cheapest and most secure form of non-magnetic storage.

Most laptops have CD/DVD writers built-in; if not, buy a separate lightweight burner that connects by Firewire or USB.

Burn from Windows
When you insert a blank disc, choose to burn it using Windows. From the two choices offered, a Mastered CD is the safest way to store data, but must be burned all at once.

Burn from OS X
If you're using Mac OS X, create a Burn Folder anywhere you like using the Finder's File > New Burn Folder option. Drag files into this until it is full then click the Burn button.

SENDING IMAGES

Digital photography brings immediacy and with it the opportunity to send images electronically to clients and friends. Transmitting photographs while you are still traveling opens up new possibilities: for professionals the ability to deliver an assignment quickly and to submit images to a stock agent, and for anyone to send digital postcards, to update a personal website, and even to archive images for safe keeping on a remote server.

The standard image compression system used in digital cameras is JPEG, which is at the same time an image file format. Originally developed for electronic transmission, it is ideal for sending by email. JPEG images need no further encoding before sending, and can be read by any of the usual operating systems—Windows, Macintosh, Unix, and Linux. All you need to ensure is that you have email access in the destinations to which you are traveling and this increasingly involves relying on WiFi "hotspots."

The majority of laptop (and desktop) computers are now WiFi-enabled, which means they have a transmitter built into them that allows them to connect to a wireless network, which in turn has a "hard wired" connection to the Internet. It is now quite common for a home computer to be connected to the Internet in this way, with the computer transmitting (and receiving) information wirelessly via a router that acts as the gateway to the Internet, as well as allowing multiple computers to connect to a single printer, hard drive, or to each other; again, without the need for wires.

A WiFi "hotspot" essentially uses the same technology, allowing multiple computers within the hotspot to connect wirelessly to the Internet to browse websites, upload images, or download information. These hotspots are appearing and growing the world over, with many airports now providing a wireless Internet connection, as well as an increasing number of bars and cafes, which means that accessing the Internet from your laptop is getting easier every day, regardless of where you are in the world. For traveling photographers this is great news, as images can often be uploaded from the convenience of your hotel room to a secure online storage site, your personal website, or social networking sites such as Facebook and Flickr, as well as offering you the chance to catch up on your emails.

Your laptop will need to be WiFi-enabled though. Then, when you are in a WiFi hotspot, your computer should be able to automatically identify the wireless network, and allow you to connect to it.

> **Digital photography brings immediacy and with it the opportunity to send images electronically**

Wireless laptop

Wireless computer

Wireless router

Modem

Internet

Wireless access
A simple wireless network, whether in the home or a WiFi hotspot, uses a router (sometimes combined with a modem) that acts as a gateway to the Internet. The router has a hard-wired connection to the Internet, but uses WiFi to pass data to and from wirelessly-connected computers.

FTP

Email is fine for sending smaller, medium-quality snaps, but FTP is the quickest and most efficient method of transferring high-resolution image files. A specialized program, such as Captain FTP, makes the process as simple as dragging and dropping files from one folder into another. There are many FTP programs on Mac and PC, as well as FTP functions built into Mac OS X (via the Finder) and Windows Internet Explorer.

NAMING NAMES

File name protocol is essential if you want your files to be transmitted successfully. The standard points to follow are:

- The only punctuation in a file name should be a dash (-), underscore (_), or the dot before the file extension.
- When sending a JPEG file, add the file extension .jpg.
- Use lowercase throughout.
- In a sequence of similar images, use a number sequence to differentiate eg. grandcanyon-01.jpg, grandcanyon-02.jpg.

MIFI

Produced by Novatel Wireless, a MiFi is a WiFi hotspot "creator" that uses cell phone networks to create a mobile broadband connection to the Internet, rather than a hard-wired ethernet connection. As long as there is a cell phone signal, the MiFi unit can create a wireless Internet connection that multiple WiFi-enabled devices (such as laptop computers) can then use. Although in its infancy, MiFi is the natural successor to "cell to modem" technology, in which a mobile phone handset is connected to a laptop (see right).

Mobile connectivity

Many professionals when out on a job use mobile phones to supply their offices with images instantly. The phone can be connected wirelessly, via Bluetooth, to a laptop computer and will act as a modem, allowing the user to send files via standard FTP software (see above). This can be extremely useful when in remote places, although you might be able to find a wireless (WiFi) Internet hotspot, or create your own with a MiFi device (see box).

ON THE ROAD

213

GLOSSARY

Computing is awash with jargon. No, worse than that—it *breeds* jargon, making a large part of most computer magazines, for example, unintelligible to all but the initiated. This probably has much to do with the persistence of acronyms and odd terminology—understanding the language is a sort of *de facto* diploma in the self-education that all computer users have to go through. It is, of course, fairly childish and ultimately it should prove to be unnecessary. Unfortunately, right now it *is* necessary as a form of shorthand to refer to things that would otherwise need wordy explanation.

Despite rigorous attempts at editing, I realize that this book still uses a fairly full complement of jargon, and to be honest, removing any more than I already have would not help. A term such as "clipboard" may be unfamiliar when you first open the book, but it is such a basic idea that to have to explain it in several words every time would simply become irritating to read, as well as to write. I'm afraid that we're stuck with much of this jargon—and in any case, as photographers we already have a jargon of our own. The best solution seems to me to have a substantial glossary to cope with it. In fact, I began writing the first edition of this book here, with the glossary, as a way of getting to grips with computing myself. It is one of the components that contribute to yet another piece of computing's ingrown language—its "steep learning curve."

3-D Effects (program) Program that creates images that look three-dimensional.

accelerator board Board added to a computer to increase its processing speed. Some accelerators add support for additional monitors. *See also* VIDEO CARD

access time The speed at which the computer can communicate with its hard drive, measured for a desktop computer in milliseconds (ms).

active matrix display An lcd monitor using tiny transistors to generate the display. *See also* LCD (LIQUID CRYSTAL DISPLAY)

additive primary colors The three colors red, blue, and green, which can be combined to create any other color. When superimposed on each other they produce white. *See also* RGB *and* SUBTRACTIVE PRIMARY COLORS

ADSL (Asymmetrical Digital Subscriber Line) The most common method of delivering broadband over copper phone lines. *See also* ISDN (INTEGRATED SERVICES DIGITAL NETWORK)

algorithm Mathematical procedure that allows the step-by-step solution of a problem.

aliasing The jagged appearance of diagonal lines in an image, caused by the square shape of pixels.

alpha channel A grayscale version of an image that can be used in conjunction with the other three color channels, such as for creating a mask.

anti-aliasing The smoothing of jagged edges on diagonal lines created in an imaging program, by giving intermediate values to pixels between the steps.

application (program) Software designed to make the computer perform a specific task. So, image-editing is an application, as is word-processing. System software, however, is not an application, as it controls the running of the computer.

artifact A flaw in a digital image.

ASIC (Application-Specific Integrated Circuit) A silicon chip that is dedicated to one particular function, such as to graphics processing, or to a specific program, such as Photoshop. Used in an accelerator board, this is a fast solution, but it has limited uses.

aspect ratio The ratio of the height to the width of an image, screen, or page.

authoring (program) Programming instructions designed for creating presentation software, such as multimedia products.

backup A copy of either a file or a program, for safety reasons, in case the original becomes damaged or lost. The correct procedure for making backups is on a regular basis, while spending less time making each one than it would take to redo the work lost.

banding Unwanted effect in a tone or color gradient in which bands appear instead of a smooth transition. It can be corrected by higher resolution and more steps, and by adding noise to confuse that part of the image. *See also* NOISE FILTER

baud The frequency of switching (and so bits) per second in a communications channel.

baud rate A measurement of communication speed—at lower speeds equivalent to the number of bits-per-second (bps), although at higher speeds equivalent to two or more bits-per-second.

Bézier curve A curve described by a mathematical formula. In practice, it is produced by manipulating control handles on a line that is partly held in place by anchor points.

bit (binary digit) The basic data unit of binary computing. *See also* BYTE

bit depth The number of bits-per-pixel (usually per channel, sometimes for all the channels combined), which determines the number of colors it can display. Eight bits-per-channel are needed for photographic-quality imaging.

bitmap (bitmapped image) Image composed of a pattern of pixels, as opposed to a mathematically defined object (an object-oriented image). The more pixels used for one image, the higher its resolution. This is the normal form of a scanned photograph. *See also* OBJECT-ORIENTED (IMAGE)

bits-per-second (bps) A way to measure communication speed. *See also* BAUD *and* BAUD RATE

BMP Image file format for bitmapped images used in Windows. Supports RGB, indexed color, grayscale and bitmap.

brightness The level of light intensity. One of the three dimensions of color. *See also* HUE *and* SATURATION

buffer An area of temporary data storage, normally used to absorb differences in the speed of operation between devices. For instance, a file can usually be sent to an output device, such as a printer, faster than that device can work. A buffer stores the data so that the main program can continue operating.

bus Electronic pathway for sending data within a computer or between a computer and an external device. A "data highway."

byte Eight bits—the basic data unit of desktop computing. *See also* BIT

cache An area of information storage set aside to keep frequently needed data readily available. This allocation speeds up operation.

cache card A card that can be added to a computer to increase its performance. It contains certain common instructions and data in a special form of memory that the computer's processor can access quickly. A cache card acts as a kind of acceleration, but is less expensive than an accelerator board.

calibration The process of adjusting a device, such as a monitor, so that it works consistently with others, such as scanners and film recorders.

CCD (Charge-Coupled Device) A tiny photocell, made more sensitive by carrying an electrical charge before it is exposed. Used in densely packed arrays, CCDs are the recording medium in low- to medium-resolution scanners and in digital cameras.

CD (Compact Disc) Optical storage medium originally developed by Philips.

CD-R (Compact Disc-Recordable) A writable cd-rom. Designed for desktop production using a relatively small recorder, CD-R discs look like ordinary cd-roms and are compatible with cd-rom drives, but have a different internal structure. They can be used as high-volume removable storage (700MB), and for producing multimedia projects and portfolios.

CD-ROM (Compact Disc Read-Only Memory) A optical disc storage medium in which the information can only be read, not altered. The information is "written" onto the disc by a laser that creates small pits in the surface, and so cannot be changed.

CD-RW (Compact Disc Rewritable) A CD on which data can be rewritten any number of times. *See also* CD *and* CD-R

CGA (Color Graphics Adapter) A low-resolution color video card for PCs.

CGI (Computer-Generated Image) Electronic image created in the computer (as opposed to one that has been transferred from another medium, such as a photograph).

CGM (Computer Graphics Metafile) Image file format for both bitmapped and object-oriented images.

channel Part of an image as stored in the computer; similar to a layer. Commonly, a color image will have a channel allocated to each primary or process color, and sometimes one or more for a mask or other effect. *See also* ALPHA CHANNEL

clip art Simple copyright-free graphics stored on disks or CDs that can be copied for use in a layout or image.

clipboard Part of the memory used to store an item temporarily when being copied or moved. *See also* CUT-AND-PASTE

clip library Collection of simple units in any recordable media (such as graphics, photographs, sound) stored on disks or CDs that can be copied into an application.

clip photography Photographs stored on disks or CDs that can be copied into an application.

cloning In an image-editing program, the process of duplicating pixels from one part of an image to another.

CMOS (Complementary Metal-Oxide Semiconductor) Energy-saving design of semiconductor that uses two circuits of opposite polarity. Pioneered in digital cameras by Canon.

CMS (Color Management System) Software (and sometimes hardware) that ensures color consistency between different devices, so that at all stages of image-editing, from input to output, the color balance stays the same. *See also* PANTONE

CMYK (Cyan, Magenta, Yellow, Key) The four process colors used for printing, including black (key).

color depth *See* BIT DEPTH

color gamut The range of color that can be produced by an output device, such as a printer, a monitor, or a film recorder.

color model A system for describing the color gamut, such as RGB, CMYK, HSB, and lab.

color separation The process of separating an image into the process colors cyan, magenta, yellow, and black (CMYK), in preparation for printing.

color space A model for plotting the hue, brightness, and saturation of color.

Compact Flash card One of the two most widely used kinds of removable memory card in digital cameras. CF cards are used by Canon, Fuji, and others.

compression Technique for reducing the amount of space that a file occupies, by removing redundant data.

continuous-tone image An image, such as a photograph, in which there is a smooth progression of tones between black and white. *See also* HALFTONE IMAGE

contrast The range of tones across an image from highlight to shadow.

CPU (Central Processing Unit) The processing and control center of a computer.

cropping Delimiting an area of an image.

CRT (Cathode Ray Tube) The imaging system for a monitor—and in a television—in which a cathode fires a beam of electrons

onto a screen that is coated on the inside with phosphors; these glow when struck. *See also* LCD

cursor Symbol with which the user selects and draws on-screen.

cut-and-paste Procedure in graphics for deleting part of one image and copying it into another.

DAT (Digital Audio Tape) Tape medium commonly used for backups.

database A collection of information stored in the computer in such a way that it can be retrieved to order—the electronic version of a card index kept in filing cabinets. Database programs are one of the main kinds of application software used in computers.

default The standard setting or action used by a computer unless deliberately changed by the operator.

densitometer Software tool for measuring the density (brightness/darkness) of small areas of an image, monitor or photograph.

desktop The background area of the computer screen on which icons and windows appear.

desktop computer Computer small enough to fit on a normal desk. The two most common types are the PC and Macintosh.

device Hardware unit that handles data, such as a scanner, printer or modem.

dialog box An on-screen window, part of a program, for entering settings to complete a procedure.

digital A way of representing data as a number of distinct units. A digital image needs a very large number of units so that it appears as a continuous-tone image to the eye; when it is displayed these are in the form of pixels.

digital zoom A false zoom effect used in some cheaper digital cameras; information from the center of the CCD is enlarged with interpolation.

digitize To convert a continuous-tone image into digital form that a computer can read and work with. Performed by scanner.

dithering The technique of appearing to show more colors than are actually being used, by mingling pixels. A complex pattern intermingling adjacent pixels of two colors gives the illusion of a third color, although this gives a much lower resolution.

DMax (Maximum Density) The maximum density—that is, the darkest tone—that can be recorded by a device.

DMin (Minimum Density) The minimum density—that is, the brightest tone—that can be recorded by a device.

download Sending a data file from the computer to another device, such as a printer. More commonly, this has come to mean taking a file from the Internet or remote server and putting it onto the desktop computer. *See also* UPLOAD

dpi (dots-per-inch) A measure of resolution in halftone printing. *See also* PPI

drag Moving an icon or a selected image across the screen, normally by moving the mouse while keeping its button pressed.

drag-and-drop Moving an icon from one file to another by means of dragging and then dropping it at its destination by releasing the mouse button. *See also* DRAG

draw(ing) program Object-oriented program for creating artwork, as distinct from painting programs that are pixel-based.

drive Hardware device containing one or more disks.

driver Software that sends instructions to a device, such as a printer, connected to the computer.

DVD (Digital Versatile Disc) a storage disc similar to a CD-ROM on which a large amount of data can be stored (up to 17.08 gigabytes). *See also* CD *and* CD-ROM

dye sublimation printer A color printer that works by transferring dye images to a substrate (paper, card, etc.) by heat, to give near photographic-quality prints.

dynamic range The range of tones that an imaging device can distinguish, measured as the difference between its dmin and dmax. It is affected by the sensitivity of the hardware and by the bit depth.

EPS (Encapsulated PostScript) Image file format developed by Alsys for PostScript files for object-oriented graphics, as in draw programs and page layout programs. *See also* OBJECT-ORIENTED IMAGE *and* DRAW(ING) PROGRAM

extrude, extrusion 3D technique for extending a 2D object along a third axis.

fade-out The extent of any graduated effect, such as blur or feather. With an airbrush tool, for example, the fade-out is the softness of the edges as you spray.

feathering Digital fading of the edge of an image.

file format The method of writing and storing a digital image. Formats commonly used for photographs include tiff, pict, bmP, and jpeg (the latter is also a means of compression).

film recorder Output device that transfers a digitized image onto regular photographic film, which is then developed.

filter Imaging software included in an image-editing program that alters some image quality of a selected area. Some filters, such as Diffuse, produce the same effect as the optical filters used in photography after which they are named; others create effects unique to electronic imaging.

FireWire The Apple bus that allows for high-speed transfer of data between the computer and peripheral devices. Data can travel up to 400 megabytes-per-second. *See also* BUS

frame grab The electronic capture of a single frame from a video sequence. A way of acquiring low-resolution pictures for image-editing.

fringe A usually unwanted border effect to a selection, where the pixels combine some of the colors inside the selection and some from the background.

gamma A measure of the contrast of an image, expressed as the steepness of the characteristic curve of an image.

GB (GigaByte) Approximately one billion bytes (actually 1,073,741,824).

GIF (Graphics Interchange Format) Image file format developed by Compuserve for PCs and bitmapped images up to 256 colors (8-bit), commonly used for Web graphics.

global correction Color correction applied to the entire image.

graphics tablet A flat rectangular board with electronic circuitry that is sensitive to the pressure of a stylus. Connected to a computer, it can be configured to represent the screen area and can then be used for drawing.

grayscale A sequential series of tones, between black and white.

GUI (Graphic User Interface) Screen display that uses icons and other graphic means to simplify using a computer. The Macintosh GUI was one of the reasons

for Apple's original success in desktop computing.

halftone image An image created for printing by converting a continuous-tone image into discrete dots of varying size. The number of lpi (lines-per-inch) of the dot pattern affects the detail of the printed image.

handle Icons used in an object-oriented draw program which, when selected with the cursor, can be used to manipulate a picture element. They usually appear on-screen as small black squares. *See also* DRAW(ING) (PROGRAM) *and* OBJECT-ORIENTED (IMAGE, PROGRAM)

hard disk, hard drive A sealed storage unit composed of one or more rigid disks that are coated with a magnetically sensitive surface, with the heads needed to read them. This can be installed inside the computer's housing (internal), or in a separate unit linked by a bus (external). *See also* BUS

hardware The physical components of a computer and its peripherals, as opposed to the programs or software.

HDRi (High Dynamic Range imaging) Software-based process that combines a number of images taken at different exposure settings to produce an image with full shadow to highlight detail.

histogram A map of the distribution of tones in an image, arranged as a graph. The horizontal axis is in 256 steps from solid to empty, and the vertical axis is the number of pixels.

HSB (Hue, Saturation and Brightness) The three dimensions of color. One kind of color model.

hue A color defined by its spectral position; what is generally meant by "color" in lay terms.

icon A symbol that appears on-screen to represent a tool, file, or some other unit of software.

image compression A digital procedure in which the file size of an image is reduced by discarding less important data.

image-editing program Software that makes it possible to enhance and alter a scanned image.

image file format The form in which an image is handled and stored electronically. There are many such formats, each developed by different manufacturers and with different advantages according to the type of image and how it is intended to be used. Some are more suitable than others for high-resolution images, or for object-oriented images, and so on. *See also* BMP, CGM, PCD, PICT, SCITEX CT *and* TIFF

imagesetter A high-resolution optical device for outputting images on film or paper suitable for reproduction from a digital file.

indexed color A digital color mode in which the colors are restricted to 256, but are chosen for the closest reproduction of the image or display.

interface Circuit that enables two hardware devices to communicate. Also used for the screen display that allows the user to communicate with the computer. *See also* GUI

interpolation Bitmapping procedure used in resizing an image to maintain resolution. When the number of pixels is increased, interpolation fills in the gaps by comparing the values of adjacent pixels.

inkjet Printing by spraying fine droplets of ink onto the page; by some distance the most common home printing technology.

ISDN (Integrated Services Digital Network) A digital telecoms

technology for transmitting data faster than by traditional modem. *See also* ADSL (ASYMMETRICAL DIGITAL SUBSCRIBER LINE)

ISO (International Standards Organisation) The body that defines design, photography, and publishing elements.

JPEG (Joint Photographic Experts Group) Pronounced "jay-peg," a system for compressing images, developed as an industry standard by the International Standards Organisation. Compression ratios are typically between 10:1 and 20:1, although lossy (but not necessarily noticeable to the eye).

KB (KiloByte) Approximately one thousand bytes (actually 1,024).

kilobyte *See* KB

Lab, L*a*b* A three-dimensional color model based on human perception, with a wide color gamut.

lasso A selection tool used to draw an outline around an area of the image.

lathing 3D technique in which a 2D image plane is rotated around one of the axes, like a piece of wood being turned on a lathe. The result is a 3D object which, viewed along the new axis, is a disc. Used for creating symmetrical objects.

layer One level of an image file, separate from the rest, allowing different elements to be edited separately.

LCD (Liquid Crystal Display) Flat screen display used in digital cameras and some monitors. A liquid-crystal solution held between two clear polarizing sheets is subject to an electrical current, which alters the alignment of the crystals so that they either pass or block the light.

logic board The main circuit board in a computer that carries

the cpu, other chips, ram, and expansion slots.

lossless Type of image compression in which no information is lost, and so most effective in images that have consistent areas of color and tone. For this reason, not so useful with a typical photograph.

lossy Type of image compression that involves loss of data, and therefore of image quality. The more compressed the image, the greater the loss.

lpi (lines-per-inch) Measure of screen and printing resolution. *See also* PPI

luminosity Brightness of color. This does not affect the hue or color saturation.

LZW (Lempel-Ziv-Welch) A lossless compression process used for bitmapped images using at least a 2:1 ratio.

Mac OS X The standard operating system on Apple Macintosh computers. Different computers have either PowerPC or Intel processors, but the operating system remains—from the user's perspective—the same. Paid-for updates are often known by their pre-release codename (10.4 "Tiger," 10.5 "Leopard," 10.6 "Snow Leopard,"etc.).

macro A single command, usually a combination of keystrokes, that sets in motion a string of operations. Used for convenience when the operations are run frequently.

mask A grayscale template that hides part of an image. One of the most important tools in editing an image, it is used to make changes to a limited area. A mask is created by using one of the several selection tools in an image-editing program; these isolate a picture element from its surroundings, and this selection can then be moved or altered independently. *See also* ALPHA CHANNEL *and* SELECTION

MB (MegaByte) Approximately one million bytes (actually 1,048,576).

menu An on-screen list of choices available to the user.

MHz (MegaHertz) One million electric vibration cycles per second; a measurement of the clock speed of a computer. 1,000MHz is equal to 1GHz.

microdrive Miniature hard disk designed to fit in the memory-card slot of a digital camera and so increase the storage capacity.

mid-tone The parts of an image that are approximately average in tone, midway between the highlights and shadows.

millisecond (ms) One thousandth of a second.

mode One of a number of alternative operating conditions for a program. For instance, in an image-editing program, color and grayscale are two possible modes.

modem (MOdulator/ DEModulator) A device for transmitting data on a telephone line. It converts the digitized information from the computer to the analog, modulated form that telephone systems use (designed that way to transmit human speech, which is modulated). Modems can be internal or external, and the connection with the telephone socket is made from the computer's serial port.

ms *See* MILLISECOND

MS-DOS (Microsoft Disc Operating System) The old operating system used in IBM (and compatible) computers. Windows provided an easier-to-use front end for this text-based operating system, though later versions of Windows have moved away from direct compatibility.

noise Random pattern of small spots on a digital image that are generally unwanted, caused by

non-image-forming electrical signals.

noise filter Imaging software that adds noise for an effect, usually either a speckling or to conceal artifacts such as banding. *See also* ARTIFACT *and* NOISE

object-oriented (image, program) Software technology using mathematical equations rather than pixels to describe an image element. Scalable, in contrast to bitmapped elements. Paths and bézier curves are object-oriented.

paint program A variety of pixel-based image-editing programs, with tools and features geared to illustration rather than to photography.

Pantone Pantone Inc.'s color system. Each color is named by the percentages of its formulation and so can be matched by any printer. *See also* CMYK *and* CMS (COLOR MANAGEMENT SYSTEM)

parallel port A computer link-up in which various bits of data are transmitted at the same time in the same direction. *See also* SERIAL PORT

paste Placing a copied image or digital element into an open file. In image-editing programs, this normally takes place in a new layer.

PDF (Portable Document Format) An industry standard file type for page layouts including images. Can be compressed for Internet viewing or retain full press quality; in either case the software to view the files—Adobe Reader—is free.

peripheral An additional hardware device connected to and operated by the computer, such as a drive or printer.

Photo-CD A proprietary cd-rom format developed by Kodak for storing photographs.

photo-composition The traditional, non-electronic method of combining different

picture elements into a single, new image, generally using physical film masks.

PICT A file format developed by Apple that supports RGB with a single alpha channel, and indexed color, grayscale and bitmap modes. Very effective at compressing areas of solid color.

pixel (PICture ELement) The smallest unit of a digitized image—the square screen dots that make up a bitmapped picture. Each pixel carries a specific tone and color.

plugin module Software produced by a third party and intended to supplement a program's performance.

PNG (Portable Network Graphic) A file format designed for the web, offering compression or indexed color. Compression is not as effective as JPEG.

PostScript The programming language that is used for outputting images to high-resolution printers, originally developed by Adobe.

ppi (pixels-per-inch) A measure of resolution for a bitmapped image.

processor A silicon chip containing millions of micro-switches, designed for performing specific functions in a computer or digital camera.

program A list of coded instructions that makes the computer perform a specific task. *See also* SOFTWARE

RAID (Redundant Array of Independent Disks) A stack of hard disks that function as one, but with greater capacity.

RAM (Random Access Memory) The working memory of a computer, to which the central processing unit (cpu) has direct, immediate access.

ramp Gradient, as in a smooth change of color or tone.

real-time The appearance of instant reaction on the screen to the commands that the user makes—that is, no appreciable time-lag in operations. This is particularly important when carrying out bitmap image-editing, such as when using a paint or clone tool.

render(ing) The process of performing the calculations necessary to create a 2D image from a 3D model.

Res (RESolution) Abbreviation used for metric resolution. Thus, "Res 12" is 12 lines-per-millimeter.

resampling Changing the resolution of an image either by removing pixels (lowering resolution) or adding them by interpolation (increasing resolution).

resolution The level of detail in an image, measured in pixels (e.g. 1024 by 768 pixels), lines-per-inch (on a monitor) or dots-per-inch (in the halftone pattern produced by a printer, e.g. 1200 dpi).

RGB (Red, Green, Blue) The primary colors of the additive model, used in monitors and image-editing programs.

RIP (Raster Image Processor) Either hardware or software that controls the imaging of a bitmapped picture. RIPing is the process of converting a vector graphic to bitmap.

ROM (Read-Only Memory) Memory, such as on a cd-rom, that can only be read, not written to. It retains its contents without power, unlike ram.

rubber-stamp A paint tool in an image-editing program that is used to clone one selected area of the picture onto another. It allows painting with a texture rather than a single tone/color, and is particularly useful for

extending complex textures such as vegetation, stone, and brickwork.

saturation The purity of a color; absence of gray, muddied tones.

scanner Device that digitizes an image or real object into a bitmapped image. Flatbed scanners accept flat artwork as originals; slide scanners accept 35mm transparencies and negatives; drum scanners accept either film or flat artwork.

screen dump/screen grab Printout of the current display on the monitor screen.

SCSI (Small Computer System Interface) (pronounced "scuzzy"). Aging interface standard for peripheral devices such as scanners, printers and removable storage drives.

selection A part of the on-screen image that is chosen and defined by a border, in preparation for making changes to it or moving it.

serial port Old-fashioned port used for sending and receiving information in a continuous stream of bits. Used particularly for connecting a computer to modems and other computers. *See also* PARALLEL PORT

slot Connection in a computer for an additional circuit board to enhance performance or capabilities.

SLR (Single Lens Reflex) A camera which transmits the same image via a mirror to the film and viewfinder.

software Programs that enable a computer to perform tasks, from its operating system to job-specific applications such as image-editing programs and third-party filters.

stylus Penlike device used for drawing and selecting, instead of a mouse. Used with a graphics tablet.

submarining Screen display fault in which the cursor temporarily disappears when moved.

subtractive primary colors The three colors cyan, magenta, and yellow, used in printing, which can be combined to create any other color. When superimposed on each other (subtracting), they produce black. In practice a separate black ink is also used for better quality. *See also* RGB *and* ADDITIVE PRIMARY COLORS

SuperCCD A CCD in which the pixels are oriented as diamonds. Processing the readout of each line of pixels requires some interpolation, but gives a resolution higher than the pixel count.

thumbnail Miniature on-screen representation of an image file.

TIFF (Tagged Image File Format) A file format for bitmapped images. It supports CMYK, RGB, and grayscale files with alpha channels, and lab, indexed-color, and it can use LZW lossless compression. It is now the most widely used standard for good-resolution digital photographic images.

tiling A method of creating or reproducing a large image area by adding adjacent sections all in the same basic shape, usually a square. For instance, a texture can be extended across the entire screen by copying a small square of the texture and joining up the copies. One essential is that the joins are seamless, to give the appearance of being continuous.

tool A program specifically designed to produce a particular effect on-screen, activated by choosing an icon and using it as the cursor. In image-editing, many tools are the equivalents of traditional graphic ones, such as a paintbrush, pencil, or airbrush.

toolbox A set of programs available for the computer user, called tools, each of which creates a particular on-screen effect. *See also* TOOL

trackball An alternative input device to a mouse, used to move the cursor on-screen. Mechanically, it works as an upside-down mouse, with a ball embedded in a case or the keyboard.

TTL (Through-The-Lens meter) A device that is built into a camera to calculate the correct exposure based on the amount of light coming through the lens.

TWAIN A cross-platform interface developed as a standard for acquiring images from scanners and digital cameras and the computer software, solving compatibility issues.

upgrade Either a new version of a program or an enhancement of hardware by addition.

upload To send computer files, images, etc. to another computer. *See also* DOWNLOAD

USB (Universal Serial Bus) In recent years this has become the standard interface for attaching devices to the computer, from mice and keyboards to printers and cameras. It allows "hot-swapping," in that devices can be plugged and unplugged while the computer is still switched on.

USM (Unsharp Mask) A sharpening technique achieved by combining a slightly blurred negative version of an image with its original positive.

vector graphic Computer image in which the stepping effect of bitmapping is removed to give smooth curves. *See also* OBJECT-ORIENTED (PROGRAM)

video card A board installed in a computer to control or enhance a monitor display.

virtual memory The use of free space on a hard drive to act as temporary (but slow-to-access) memory.

WiFi A wireless connectivity standard, commonly used to connect computers to the Internet via a wireless modem or router.

Windows Operating system for PCs developed by Microsoft, using a graphic interface. From a relatively shaky start, Windows has become a strong desktop operating system with unrivalled software support. Recent versions (XP and Vista) include support for 64-bit processors.

workstation A computer, monitor, and its peripherals dedicated to a single use.

wysiwyg (what you see is what you get) Pronounced "wizzywig," this acronym means that what you see on the screen is what you get when you print the file.

BIBLIOGRAPHY & USEFUL ADDRESSES

BOOKS

The Complete Guide to Light and Lighting in Digital Photography
Michael Freeman

The Complete Guide to Black & White Digital Photography
Michael Freeman

The Complete Guide to Night & Lowlight Photography
Michael Freeman

The Photographer's Eye
Michael Freeman

The Photographer's Mind
Michael Freeman

The Photographer's Vision
Michael Freeman

The Photographer's Story
Michael Freeman

Perfect Exposure
Michael Freeman

Mastering High Dynamic Range Photography
Michael Freeman

Pro Photographer's D-SLR Handbook
Michael Freeman

The Art of Printing Photos on Your Epson Printer
Michael Freeman & John Beardsworth

WEBSITES

Note that website addresses may often change, and sites appear and disappear with alarming regularity. Use a search engine to help find new arrivals.

Photoshop sites

Absolute Cross Tutorials www.absolutecross.com

Laurie McCanna's Photoshop Tips www.mccannas.com

Planet Photoshop www.planetphotoshop.com

Photoshop Today www.designertoday.com

ePHOTOzine www.ephotozine.com

Digital imaging and photography sites

Creativepro www.creativepro.com

Digital Photography www.digital-photography.org

Digital Photography Review www.dpreview.com

Short Courses www.shortcourses.com

Software

Alien Skin www.alienskin.com

ddisoftware www.ddisoftware.com

DxO www.dxo.com

FDRTools www.fdrtools.com

Photoshop, Photoshop Elements www.adobe.com

PaintShop Photo Pro www.corel.com

Photomatix Pro www.hdrsoft.com

Toast Titanium www.roxio.com

USEFUL ADDRESSES

Adobe www.adobe.com

Apple Computer www.apple.com

BumbleJax www.bumblejax.com

Canon www.canon.com

Capture One Pro
www.phaseone.com/en/Software/Capture-One-Pro-6

Corel www.corel.com

Epson www.epson.com

Expression Media
www.phaseone.com/expressionmedia2

Extensis www.extensis.com

Fujifilm www.fujifilm.com

Hasselblad www.hasselblad.se

Hewlett-Packard www.hp.com

Iomega www.iomega.com

Kodak www.kodak.com

LaCie www.lacie.com

Lightroom www.adobe.com

Microsoft www.microsoft.com

Nikon www.nikon.com

Olympus www.olympusamerica.com

Pantone www.pantone.com

Philips www.philips.com

Photo Mechanic www.camerabits.com

PhotoZoom www.benvista.com

Polaroid www.polaroid.com

Ricoh www.ricoh-europe.com

Samsung www.samsung.com

Sanyo www.sanyo.co.jp

Sony www.sony.com

Symantec www.symantec.com

Wacom www.wacom.com

INDEX

· ·

SPD's (silicon photo diodes) 12–13
Spherize distortion filter (Photoshop) 96, 136–7, 187
spot healing brush 132
spot metering 20, 21
Stieglitz, Alfred 154
still-life photography 178–85
 cleaning up background 180–1
 close-up 179
 digitally adjusting composition 188–9
 nature composites 176–7
 reworking light 182–3
stitching and stitching software 112, 113, 158
Super Putty plugin, PenTools 136

T

tagging, geotagging 13, 203
techniques 122–99
telephoto lenses 17, 34–5, 141, 146, 168
 altering shots digitally 187
 see also zoom lenses
television, internet connectivity 70, 71
TIFF files 23, 61, 101
 noise and 15
 workflow software 87
tonal adjustment 104–5
 high dynamic range imaging (HDRI) 114–15
tonemapping 115
travel kit
 light 200–1
 professional 202–3
tripods 36, 37, 200, 202
TTL metering 20, 21

U

Unix 40
urban landscape
 and architecture 158–163
 removal of clutter 164–5
USM (UnSharp Mask) filter 92, 95, 116, 146, 150, 161, 174, 196–7

V

video editing, workflow 88–9
video file formats 62–3
video recording
 3D lenses 35
 camcorders 34–5
 digital SLR 35
 High Definition 13, 35

W

websites
 display of images 74–7

image security 79
 subscription websites 76
Weston, Edward 123, 154
white balance 26, 27, 158
white, black, and gray point balance 102, 144
White, Minor 154
wide angle lenses 16, 33, 125, 141, 146, 166
 altering shots digitally 187
WiFi, transmission of images 212–13
wildlife and bird photography 33
Windows *see* Microsoft Windows
Windows Live Movie Maker 88
.WMV (Windows Media Video) files 62, 63
workflow 82–3, 87
 software 83, 86–7
 video editing 88–9

workstation 38–9

Y

YouTube 34, 79

Z

Zacuto, accessories 35
zoom, digital zoom 174
zoom lenses 17, 33
 distortion correction 96
 see also telephoto lenses
Zuckerberg, Mark 78

Acknowledgments

The publishers would like to thank Nikon UK Ltd for the loan of a camera and the following for their help in supplying software: Deneba, Extensis Europe, DXO Optics Pro, and Paragate Systems.